cultural identity, and the construction of public memory in postcolonial societies and their museums."—Christopher B. Steiner, Director of Museum Studies, Connecticut College.

"I came away [from reading *Transforming Museums*] with the view not only that every museum worker in South Africa should read this book, but that those dealing with anything even remotely political—especially anything touching upon race or contentious history—should do so too."—Sharon Macdonald, Sheffield University.

Transforming Museums

Mounting Queen Victoria in a Democratic South Africa

Steven C. Dubin

First published in 2006 by
PALGRAVE MACMILLAN™
175 Fifth Avenue, New York, N.Y. 10010 and
Houndmills, Basingstoke, Hampshire, England RG21 6XS
Companies and representatives throughout the world.

PALGRAVE MACMILLAN is the global academic imprint of the Palgrave Macmillan division of St. Martin's Press, LLC and of Palgrave Macmillan Ltd. Macmillan® is a registered trademark in the United States, United Kingdom and other countries. Palgrave is a registered trademark in the European Union and other countries.

ISBN-13: 978–1–4039–7411–2
ISBN-10: 1–4039–7411–X

Library of Congress Cataloging-in-Publication Data is available from the Library of Congress.

A catalogue record for this book is available from the British Library.

Design by Newgen Imaging Systems (P) Ltd., Chennai, India.

First edition: August 2006

10 9 8 7 6 5 4 3 2 1

Printed in the United States of America.

Leave the breechloader alone
And turn to the pen.

<div align="center">* * *</div>

Load it, load it with ink.

<div align="right">"Weapon," I.W.W. Citashe</div>

[There is] [n]othing that memory cannot reach or touch or call back.
Memory is a weapon.

<div align="right">*Memory is the weapon,* Don Mattera</div>

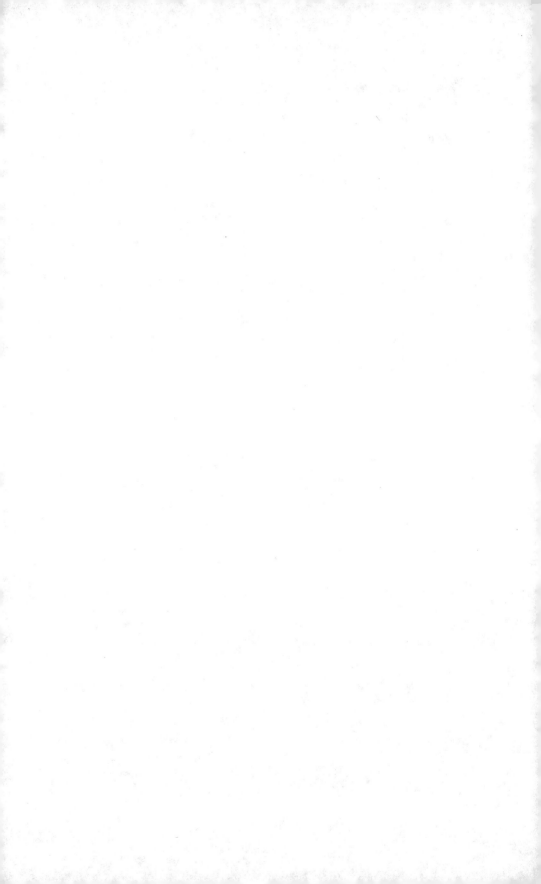

CONTENTS

List of Figures

PREFACE

She was a classic beauty, with the body of a dancer, a model. And I spotted her against a suitably smart backdrop, the Johannesburg Art Gallery [JAG]. But her abject situation shocked me: she was lying on her side, as if toppled by the sort of political cataclysm that has propelled places such as Srebrenica, Kabul, and Baghdad into the world's consciousness. Moreover, she rested on a floor that was severely buckled, sections of it chaotically jutting out like parched squares of earth in a drought-stricken zone. But here's the twist: she was the victim of a flood that wrecked the lower level of the museum prior to my first visit there in August 2000.

She is *Grande Bagnante No. 7*, by sculptor Emilio Greco (1968). And although I was taken aback when I saw her, my curiosity was also piqued. How could such an important venue be in such terrible shape? Was this an anomaly or rather was it characteristic of the condition of cultural sites in a postapartheid world? During more than a half-dozen additional visits to South Africa, totaling more than two and a half years time, I have doggedly sought answers to these questions, and many more that grew out of that initial encounter.

Since the first democratic general election of 1994, South Africa is a society rife with contradictions—a far cry from the condition of moral clarity regarding good and evil that the apartheid system afforded for both its supporters and opponents. South Africa today is simultaneously more open and more closed up; concurrently tribal and universalistic; both inclusive and alienating; and alternately buoyed by optimism and laden with hopelessness. Its people work in concert with one another or at defiantly cross-purposes.

Despite official pronouncements that South Africa is a vibrant "rainbow nation," all manner of things are now decidedly gray. (One friend wryly notes that he hears more talk of "nation" and fewer references to "rainbow" as the country steadily takes shape.) As Lotus-FM, a Durban-based radio station aimed at South Africa's Indian population cleverly puts it in a promotional jingo, "Not everything is black and white."

Perhaps not surprisingly, some things still are. Pollsters find that black South Africans commonly cite unemployment as the number one problem in the country; whites mention crime. That sums up, in capsulated form, the immense racial divide that still exists between the experiences and opinions of South Africans. Half the population does not engage in cross-racial socializing, and blacks who move within white circles may be derided as "coconuts"

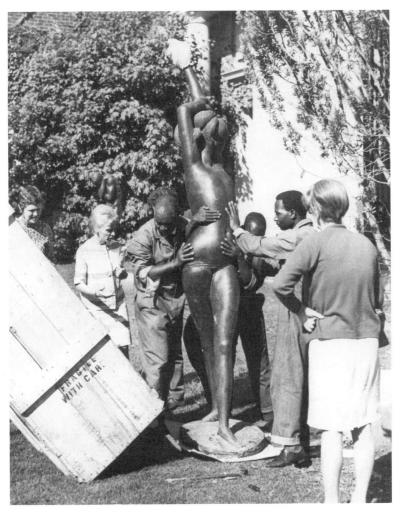

Figure 1 Assembling the sculpture garden, 1971, featuring *Grande Bagante No. 7*, by sculptor Emilio Greco (1968)

Source: Photo courtesy of Johannesburg Art Gallery.

(dark on the outside, white on the inside), and whites who mix with blacks risk being labeled "litchis" (white on the outside, dark on the inside).[1]

Fiction captures this same deep-rooted fissure: in a novel about the forced dislocation of tens of thousands of nonwhites during the apartheid era, a young black African girl is awestruck when she visits the home where her mother toils as a domestic. The first thing she notices is the entry gate opening for them, seemingly on its own accord. "Is it magic?" she quizzes her mother. No, the woman replies, "It's electric."[2] Whereas the deliberate and arbitrary separations enacted by apartheid legislation have been abolished, their detrimental social and psychological effects are not so easily erased.

And what are the political and cultural consequences of these incongruities? How, for example, do institutions as central to civic identity as museums respond to budding social developments? How do they reassess past collecting and exhibition practices and accommodate new demands? What should be the fate of monuments, memorials, and street names that commemorate events of parochial interest or valorize discredited public officials? And how do the formerly disadvantaged now seek to represent themselves in various cultural venues?

It is a bitter irony that South Africans have erected ever more physical barriers between themselves and others in the postapartheid era. Contemporary South Africans, irrespective of class, color, or locale, obsessively buttress their habitats against intruders (and the outside world in general) as much as they are able. They use stone, brick, and cement; install alarms, motion detectors, and aggressive dogs; and erect electrical, palisade, and razor wire fencing. And should you see a home without such significant fortification, it is a sure bet that the owners are elderly, on a fixed income, or otherwise lack the resources to keep up with protective trends (simple barbed wire or chain-link fencing seems almost comically, preposterously out of sync with the times).

One shrewd Johannesburg estate agent even capitalized upon what might be a liability in other markets, turning it into an asset. Advertising a home that was almost completely obscured from outside view, she played up the sense of intrigue: "What's behind the wall? Norwood charm at its best!!! A must to view."

And then there are the ubiquitous signs from armed security companies that embellish virtually all (still predominately white) middle-class and wealthier suburban South African homes. The array of commercial symbols they adopt for themselves is impressively vast. Animals signify watchfulness and power, whether they are indigenous to South Africa or not: tigers, cheetahs, and elephants; a rearing stallion or a striking black mamba. Mythic men of strength—notwithstanding their era or place of origin—are also vigilant: an archer, a crusader, or shogun warrior. And, directly from Southern African lore, there is the tokoloshe, a dodgy creature of the dark.

All these defenses signal an architecture of apprehension. But, paradoxically, they stoke the very fears they are meant to allay. These measures intensify anxieties rather than quell them. And the process seems neverending.

This escalating quest for enclosure and protection has a profound social outcome: it increasingly privatizes experience to the point where public spaces are typically no-go areas for some segments of the populace. Places of business and shopping malls are "safe" spots for whites—safe from a security point of view, that is, but also numbingly predictable and socially homogeneous. On the other hand, the streets of the CBDs [Central Business Districts], the parks, and many plazas, arenas and other venues have become practically monopolized by African traders, customers, and leisure seekers.

That puts enormous pressure on institutions such as museums to become places where differences may be confronted, memory explored, and new identities negotiated. It is a challenge of immeasurable magnitude and acute importance.

Many things struck me on that first visit to Southern Africa: the beauty and diversity of the natural landscape; the generosity and goodwill of so many people; the enormous weight of past history and the crucible of more contemporary events that is forging the New South Africa. It occurred to me as well that so much of the public debate I was hearing sounded familiar.

From the late 1980s onward—with something of a respite in the aftermath of September 11, 2001—Americans have struggled with one another over core values, identity, and history. These battles became collectively known as the "culture wars," the rubric itself spurring additional controversy. There is, however, substantial agreement that these disputes were sparked by the singular conjunction of a variety of factors, such as America's loss of its cold war enemies, dramatic technological changes, a substantial swelling in immigration, civil rights movements that have won increased rights for formerly disenfranchised groups, and the growth of identity politics along the lines of race, religion, gender, sexual orientation, or nationality.

To a certain extent, and with some variations, these factors echo similar trends in South Africa, thus raising the probability that culture wars are not a unique phenomenon.[3] More to the point, democratic societies, whether nascent or mature, routinely struggle with key questions regarding their aspirations, direction, and national character. In the first instance, as in the case of South Africa, people must fashion a new collective character from the remnants of past regimes. They will share growing pains as they explore various models of governing and citizenship.

In the second instance, more like the United States, a populace is likely to suffer the aches and pains of communal, social aging. To remain supple and enduring, they must continuously revitalize cultural components of their national identity. And yet in both cases, similar existential questions must be answered. "Who are we?" "What do we stand for?" "How do we differ from others?"

I was delighted to discover that many of the themes I had explored in my previous research, including transgressive art and artists, controversial museum exhibitions, censorship and freedom of expression, and public funding for culture were being openly contested in South Africa. But what stood out in particular in South Africa was the sense of urgency that so many people

display: the urgency to redress old wrongs. The urgency to play a part in "nation building." The urgency to show the world a different face.

Contemporary South Africa churns with energy and blazes with the desire to transform. And indeed, "transformation" has become one of the most commonly repeated phrases in the country. My goal will be to capture that vigor and probe the ingenuity that South Africans have mustered to carry out a radical social makeover.

That cleverness surfaces in refreshing, surprising ways. Consider, again, the Johannesburg Art Gallery. Attendance down? Employees uncooperative? Relations with the local community strained? What museum director has not been forced to address such essential concerns during his or her tenure?

The services of a high-powered management consultant or a big-ticket public relations firm may well be called for. But sometimes the problems are too endemic, their roots too deep; such interventions simply cannot remedy the situation. So in South Africa you might engage the services of a *sangoma* [traditional healer] to throw the bones in order to divine the source of the problems. And the *muti* [medicine] that is prescribed possibly could cure those institutional ills.

Such was the scene at the JAG in November 2000, shortly after my initial visit. Located in Joubert Park, once a pristine apartheid-era showplace, the JAG now overlooks a teeming, boisterous urban space. Whereas this "commons" was once a whites-only preserve upheld by law, it has become "Africanized." It is now de facto segregated, a venue where blacks unquestionably dominate.

In an emotionally charged half-hour session, JAG Director Rochelle Keene and Makhosi Fikile Dhlamini faced one another, seated on a grass mat in the museum's courtyard. The ceremony of throwing the bones had to be performed through an actual person, so Keene stood in for the museum.

Dhlamini lived literally around the corner, but had never been to the JAG before. She had no idea that admission was free, extending to everyone. And that was one of the issues: JAG was *in* the Joubert Park community, but not *of* it.

With candles burning in the background, Dhlamini entered a very deep trance. She began her incantations straight away—loudly, rapidly, intensely in isiZulu. She had entered into conversation with the spirits of the place.

The sangoma encountered a jumble of ancestors: traditional African spirits were dwelling alongside that of JAG's founder Lady Florence Phillips, wife of one of Johannesburg's early Randlords. She discovered that coexistence reigned between the parties. But their late twentieth-century descendants in eGoli, isiZulu for the city of gold, were falling short of the mark in achieving the harmony that these predecessors had attained with one another.

Dhlamini quickly uncovered the crux of the problem: JAG must open itself up, invite the community in. According to the transcript of the event, the sangoma revealed, "The gallery and its ancestors should be addressed, remembered and introduced to the people. The director wanted to make the

gallery a nice place, but the meaning, roots and ancestral context of the gallery is a deep and profound affair that needs special ancestral attention."

She advised that a big party cum blessing ceremony be held, supplemented with a ritual whereby seven white chickens would be slaughtered. Moreover, she cautioned, "Without integration and opening of the space and the energies which comprise that environment, the gallery will be out of balance and in conflict."

Bié Venter, a prime mover in the Joubert Park Public Project [JPP, part of the Creative Inner City Project], immediately related to this pronouncement. It had been Venter's idea to engage the sangoma, and Venter believed that she and her cohorts represented those white chickens. They had set up the JPP, a bold, not-for-profit scheme intended to involve residents of the area in the arts, and to stimulate revitalization of the precinct. And from her outlook, their exhaustion aptly symbolized the required sacrifice!

The recommended blessing ceremony was staged some weeks later, featuring a group of sangomas dancing and chanting, and with the burning of colored candles and *mpepo* [an African herb that produces a dense, strong-smelling smoke]. A threshold moment had been attained: community members mingled with museum stalwarts. But have the ancestors been appeased?

JAG's attendance has swelled. And the mental border between the park and the museum, although still very real, has been breached to a minor degree. Dhlamini even brings her apprentice students to view traditional beadwork and ritual items in the JAG collection, many of which are unfamiliar to contemporary urban African dwellers.

Observers of South Africa commonly note that the so-called first and third worlds push up against one another in this country. Can there be a more vivid example than this?

Contemporary South Africa lurches between hope and despair. One must continually navigate between the Scylla of skeptical and open inquiry and the Charybdis of Afro-pessimism. Some days the country feels as though it's on the brink of collapse. On others, it seems to be successfully taking tentative steps toward a stable, secure, prosperous, and more equitable future.

But whatever one's outlook, you must remain vigilant: at present *Grande Bagnante No. 7* has been installed in an out-of-the-way spot between the elevator and the men's loo on JAG's lower level, without a proper label. A great deal has changed since the museum purchased the work in 1971, earmarking it for its new outdoor sculpture garden. The now empty pedestal where she originally stood continues to bear a plaque pinpointing the name, artist, and date, and a ghostly blue-green outline marks where the bronze leached into the cement.

Because this monumental bather is made from a costly metal, museum officials have relocated her from her once prominent al fresco position. In today's Johannesburg the work is at "high risk" from potential thieves, ever on the lookout for something of value to scavenge.

ACKNOWLEDGMENTS

Once when I visited a retired South African curator at his home, he was bewildered to discover that I was white and not black. That in turn puzzled me, so I queried him about why he had held such an expectation.

"Simple," he replied. "You said on the phone that you were interested in talking about the 'transformation' of museums in this country. I assumed that if you were white, you would have referred to the 'deterioration' of museums."

I have come to relish such unconsciously revealing moments for their mix of misapprehension, outrageousness, pathos and farce, and for the unique occasion they provide to unravel how a person customarily constructs meaning in his world. Invariably, a state of affairs that one man deems an opportunity another experiences as heartbreak.

I first came to South Africa on holiday. But over the past five-plus years my personal and professional lives have increasingly become rooted there. That has forced me to reassess nearly everything I could formerly take for granted, including what I think I know about language, history, politics, and race. And yet in a society that often seems disastrously at odds with itself, one aspect of my experience has been consistent: irregardless of personal background or circumstances, South Africans have been extremely genial and big-hearted in their dealings with me. I have reaped unexpected emotional dividends, discovering an enormous amount about hospitality, friendship, and love, at the same time that I have learned a great deal about a complex and changing society.

I am grateful to have received financial assistance from the Purchase College—State University of New York Faculty Support Fund and from the New York State United University Professions. Moreover, a Fulbright-Hays Faculty Abroad Research Fellowship in 2003 enabled me to devote 13 months exclusively to this study. During that time I traveled throughout South Africa and visited a wide array of museums, explored innumerable archives, and conducted over 100 interviews.

I am indebted to a number of specific individuals who have facilitated this research as well. I have called on Jo Burger, librarian at the Johannesburg Art Gallery, countless times with a ridiculously wide range of questions. She unfailingly uncovered the information that I requested, for which I thank her. Belinda Eisenhauer and Tersia Perregil, librarians at the Durban Art Gallery and Transvaal Museum, respectively, have also successfully fielded

numerous queries. Cecilia Kruger of the Voortrekker Monument, Wayde Davey of the Apartheid Museum, and Bonita Bennett of the District Six Museum have assisted me in a variety of ways, too.

Kristine Roome gave the manuscript a comprehensive reading and offered beneficial suggestions. Carol Brown of the Durban Art Gallery, Brendan Bell of the Tatham Art Gallery, and David Morris of the McGregor Museum not only proved to be informative and stimulating interviewees, but have offered ongoing commentary regarding museum matters. And my numerous South African friends, through whose lives and households I continuously drift in and out, have been hugely enriching companions.

James Boyles has provided the same robust enthusiasm and encouragment for this project as he has for others of mine in the past. Elza Miles, a more newly acquired comrade, has been a delight and an inspiration.

Horst Meyer embodies all the aforementioned affirmative attributes and has been there steadfastly since the inauguration of my travels. He has intrepidly trudged with me through such venues as the National Museum in Dar es Salaam, Tanzania where the revered Julius Nyerere is mistakingly memorialized as the "diseased" (rather than "deceased") "father of the nation"; the Museu da História Natural in Maputo, Mozambique, where we were astonished by the gory wildlife dioramas and awed by a quality and breadth of local creative expression previously unfamiliar to us; and the Zanzibar Museum in Stone Town, where it was confounding to discriminate between specimen and infestation once we had opened various storage drawers.

This book is for him.

Figure 2 "State Coronation Portrait of Queen Victoria," a copy by Charles Van Havermaet (1901–1904), after Winterhalter (1837)

Source: Courtesy of Tatham Art Gallery, Pietermaritzburg.

Using War to Put Food on the Table: Reflections on a Decade of Democracy

These days, history repeats itself, the first time as photo op, the second time as coffee mug.

Keller, 1994

"The New South Africa." "The African Renaissance." "The Rainbow Nation." "The New Dispensation." South Africans habitually invoke these phrases. And each captures the sense of optimism and anticipation of elemental social transformation that has invigorated the bulk of the public since democracy was established in April 1994. Although deep chasms remain between the promise and the reality of this fledgling state, there is a palpable sense of amazement and relief that the actual regime change itself occurred amidst a minimum of disorder and violence.

When the apartheid government was dismantled, some photographs of discarded monuments turned up, but they were noticeably scant. And images of decapitated behemoth statues, defaced public murals, or ransacked cultural sites and museums were strikingly absent, unlike the experience in Iraq at the end of Saddam Hussein's reign, or during the disintegration of the former Soviet Union.

The impulse to start anew has held many such destructive urges at bay in South Africa. Throughout the first decade of the renewal of this African state, stakeholders have struggled to come to terms with how the country's history and collective identity have been presented in the past, and to square existing representations with current sensibilities. If democracy is the theory, *transformation* is the practice.

MUSEUMS AS CONTESTED SITES

South Africa is a country in the making. Its constitution is in the vanguard of comprehensively bestowing equal rights upon all its citizens, apart from any

of their personal attributes. The postapartheid government has thereby promoted a doctrine of reconciliation regarding the past and a policy of non-racialism regarding the present and future. Museums and associated cultural spheres are central arenas in which these ideals are given material form, and this is to either the delight or contempt or disregard of various groups.

Conflict and negotiation habitually occur over museums and what they do, as well as at related social locations such as monuments, place names, burial grounds, and historical archives. Rival claims are validated or rejected at these sites; contradictory narratives are confirmed or nullified; different publics are inspired or humiliated or overlooked. Above all, diverse parties use these places to persuade others to endorse their ideas, manifest in revival, or reawakening dormant beliefs and values; in reaffirmation, asserting the importance of particular principles and standards; in recommitment, directing energies toward communal goals; in reclamation, asserting ownership over objects or knowledge that has been forbidden or denied; in repatriation, procuring what was seized by outsiders in the past; in recuperation, reinscribing personal narratives that have been suppressed or erased; in resanctification, restoring what has been profaned; and in reconciliation, developing new relationships between the past, the present, and alternative visions of the future.

Pivotal to understanding contemporary South African museums is an event from Heritage Day in 1997. On that occasion President Nelson Mandela inaugurated the Robben Island Museum, on the very site where he had been held as prisoner 46664 for 18 of his 27 years of captivity. He took this occasion to openly flog the country's museums with a blistering critique.

Mandela characterized these places as by and large disgraceful to the majority of its citizens. "Ninety-seven percent" of their displays reflected colonialist and apartheid points of view, he alleged. Members of the general public refer to Mandela as an "angel" or a "saint"; Rebecca Goldberg's reconfiguration of the Last Supper places him smack in the center as Jesus, and a headline once blared "Madiba turns water into wine in his second miracle."[1] Coming from a man with such immense charisma and moral authority, his criticism stung. It stung terribly.

Marilyn Martin, director of art collections at Iziko Museums in Cape Town,[2] lucidly recalls the dress she'd worn to that noteworthy occasion and remembers the television cameras panning to capture her reaction to the speech. "He kicked us," Martin declares, "but I feel no guilt. I [do] feel some anger because President Mandela has never been to this institution." And Dr. Patricia Davison intuitively knew that the South African Museum, where she was then based, was a main target of Mandela's finger-pointing, even though he'd not identified the place by name.

Mandela demanded an end to this state of affairs: museums must catch up with the times, reflect democratic ideals and the experiences of the bulk of the population, and not simply focus on a privileged few. "[C]an we afford exhibitions in our museums depicting any of our people as lesser human beings, sometimes in natural history museums usually reserved for the depiction of

animals?" he implored. "Can we continue to tolerate our ancestors being shown as people locked in time?"[3]

President Mandela also referenced the new Legacy Project, which was designed to broaden representation by endowing new museums and establishing monuments and memorials using national funds. Mandela believed this program was crucial because museum exhibitions were important places for perpetuating stereotypes and injustices: "They demean the victims and wrap [*sic*] the minds of the perpetrators," he argued.[4]

Some museum personnel felt that Mandela's 1997 criticism was timely and on target—a wake-up call. But many others were resentful, thinking that his criticism was "a cheap shot." For them, Mandela (or his speechwriters) was overlooking the efforts they'd already expended to transform their institutions. He was playing to the masses, but not being totally candid, they thought.

To put Mandela's 1997 comments into context, it is critical to understand that that year is an artificial benchmark for gauging change in South African museums. In other words, not everything presented by them was dreadful up until that time, nor has all been remedied since. More importantly, pre- and post-1994 are likewise arbitrary distinctions. The most professionally active museum personnel throughout the country were in fact debating issues regarding ideology, history, representation, relevance, and audience access well before democracy was officially established. But while those introspective discussions might have been highly animated, they would not have been very obvious beyond this rather cloistered world.

A galvanizing event for local museologists had occurred some years before, in 1987. Dr. John Kinard, director of the Anacostia Neighborhood Museum in Washington, DC, addressed delegates to the annual conference of the Southern African Museums Association,[5] held in Pietermaritzburg that year. In his speech Kinard encouraged museum workers to make their institutions instruments of social change. Rather than avoid controversy, he exhorted them to conduct outreach to the impoverished, broaden their narrow cultural focus by reflecting more than European history and experience, and to envision the future, rather than merely chronicle a partial past.

Kinard did not stop there: "He told delegates that South African museologists knew less about African people than they did about African animals."[6] Moreover, he "slated South Africa as the 'worst country on the face of the earth,' and said South African museums were in need of 'intensive care.' "[7] His comments, harsh as they were, fell on many receptive ears.

But the exhilaration and sense of challenge that those delegates felt switched to anger once Mr. Eugene Louw, administrator of the Cape, openly condemned Kinard from the podium, threatening that any future harangues of this sort from invited speakers could possibly jeopardize government funding of museums. In an unprecedented act of defiance, more than 70 of the 200 delegates walked out on the official. Kinard was stunned that so many people would stage such a hearty show of support, one that might compromise their own positions. And those emboldened attendees prolong the memory of this dramatic event to the present day.

One simply needs to scan the titles of some of the articles appearing in the Southern African Museums Association Bulletin [*SAMAB*] during this time to appreciate the sense of the debate: "Ringing the changes: A call to South African museums";[8] "Bastions of ideology: The depiction of precolonial history in the museums of Natal and KwaZulu";[9] "Stating the case: A synoptic view of the position of museums and the problems they face, in the changing and divided society of contemporary South Africa";[10] and "Cultural history museums in developing countries: Expensive luxury or vital institutions?"[11]

Audience surveys were conducted to accurately assess who museums were attracting and the specific ways in which different racial groups were satisfied or dissatisfied with what they saw.[12] Writers argued that the segregation of European history in cultural history museums and the black native past in natural history museums promoted mutual isolation and misunderstanding between the races.[13] And the need for consultation between groups to replace the domination of some by others was energetically endorsed.[14] As one writer cautioned, "Systems of values rooted in Western cultural traditions are being critically examined and even rejected by *our restless Black communities*. As museologists we must not merely react to events; we ignore the future at our peril, so we must plan for the different South Africa on whose threshold we now stand."[15]

Whilst many museum personnel were acutely aware of how their institutions were flawed from the mid-1980s onward, and in what ways they needed to be transformed, they were handicapped in actually following through on their insights. They were one sector of South African society that could imagine a different future for the country. But they lacked the wherewithal—having neither ample financial backing, nor broad-based social support—to enable them to translate that vision into actuality.

Mounting Queen Victoria

Mounting Queen Victoria will examine a broad range of museums, from those focusing upon art, cultural history, natural science, and natural history, to agriculture, military matters, and traditional crafts. They extend from major institutions in large cities, to small-town museums of rather parochial interest, to historic houses and relatively remote sites.

All these establishments are fraught with the history of South Africa's past. *As a general rule*, however, the colonial legacy has been felt most acutely in art museums, where ideology was directly incorporated into traditional works of painting and sculpture and fortified by collections constructed along doctrinaire lines. The apartheid legacy is most apparent in cultural history, natural science, and natural history museums, where the ideology was interwoven into the narratives that their curators composed, and it dictated the decisions they made about what to highlight, and how they chose which phenomena "innately" belonged where. In actuality, these legacies blended together; these broad observations do, nevertheless, hold true.

Of necessity, I will also reach beyond the walls of museums. Customary functions such as collection, conservation, research, and exhibition; interpreting historical accounts, projecting shared identities and nation building are not confined within these institutions. This is particularly the case in South Africa: pre-1994, for example, critical accounts were not presented institutionally but primarily via "informal media" such as slideshows and works of popular history.[16] And mural art "provide[d] a public forum for counter-narratives, for ordinary people's 'story' to be told in visual images."[17]

The "formerly disadvantaged" thus question the legitimacy of formal organizations such as museums that earlier endorsed a racially exclusive perspective.[18] They also feel the necessity to reorient public perceptions of themselves, a task they may prefer to direct on their own. Furthermore, overwhelming social problems such as massive unemployment, housing shortages, and an acute health care crisis (amplified by an appallingly high incidence of HIV/AIDS) necessarily draw off scarce governmental and nongovernmental funds, leaving those working in the cultural sector relatively undercapitalized and thereby seriously restricted in what they can accomplish.

Throughout this book, certain key ideas will surface again and again. These include transformation, the politics of representation, the politics of reception, and social and collective memory.

Transformation

One of the most recognizable buzzwords in contemporary South Africa is "transformation." Most definitions encompass the goals of inclusion, assimilation, participation, collaboration, and, sometimes, eradication. Transformation is one of the most highly valued aims within all aspects of South African life. But how does it translate specifically to the museum world?

Transformation in museums moves along four distinctive but interconnected pathways. First, transformation is sought in exhibition policies. Displays in the not-so-distant past were narrowly focused upon the European experience within South Africa, largely disregarding the majority nonwhite population that stems from Bantu, indigenous, and Asian roots.[19] When those people were depicted, it was typically in biased, inaccurate ways. The goal now is to broaden the scope of exhibitions: to be as inclusive as possible and to incorporate multiple perspectives into them.

Second is the closely related area of acquisition policies. Museums are central organizations in defining a society's general knowledge base. They collect material that corroborates some points of view, to the omission of others. Many South African museums are playing "catch up," striving to fill in what they recognize as wide gaps in their holdings, as well as insufficiencies in their awareness and understanding of the world. Some crucial areas where museums are focusing their attention include collecting traditional arts and crafts; utilizing indigenous knowledge systems [IKS] and gathering previously overlooked native information about flora and fauna; and appraising native

cosmologies and medicinal lore in order to understand how they may complement Western scientific knowledge and practice.

Third is the transformation of human resources. Up until 1994, museums were staffed almost exclusively with white people. One of my earliest interviewees related how she'd fought for several years to retain her professional-level position during the pre-democratic period; by law, it was "reserved" for whites. She confided in me: "As a black woman, I was not entitled to work here," even though she possessed highly specialized qualifications.

I was "gobsmacked," as a local might say. From my American perspective, I had failed to grasp the subtle dialect cues and faint physical indicators that would have classified her as "coloured" under apartheid; "Cape Malay," more specifically; and thus "black," more generally. I responded to her disclosure by noting that she could easily pass without notice as one of my "white" Manhattan neighbors or colleagues, or even as a member of my own family. This encounter served as my abrupt initiation into the peculiar world of apartheid categories.

The past constraints on who could work in museums helped guarantee that only certain perspectives would be aired. With staffs now being integrated with people from diverse backgrounds, multiple outlooks can potentially be harnessed to address everything from different decision-making styles, alternative aesthetic preferences, and fundamentally dissimilar worldviews.

And finally, efforts have been initiated to transform audiences. Most South African museums did not specifically bar the access of nonwhites. They didn't need to: few nonwhites had the relevant information, interest, leisure time, or cultural capital to facilitate crossing those portals. And very, very few did.

Virtually all museums at present seek to cater to what has up until recently been a vastly underserved audience. That means providing wall labels and other explanations in more than one or even two of South Africa's 11 official languages; previously, English and Afrikaans were the lingua franca within this realm. That means conducting outreach to townships and rural settlements, where the bulk of nonwhites live, especially to schoolchildren and teachers there. That means adjusting the physical and psychological barriers that once intimidated nonwhites and prevented them from attending museums; these places have thus had to peel away some of their layers of formality and social selectiveness. And that also means assembling displays that are relevant to this expanded clientele. All of this can be expedited, of course, by the increased visibility of black staff members.

Transformation, then, refers to undermining those exclusive social structures, and the myopic modes of thought and behavior, which were spawned in an earlier era. By design, transformation entails constructing new ways of thinking and doing and understanding.

That is transformation, *hypothetically*. It will be my task to uncover how successfully transformation's multiple goals are actually being implemented.

The Politics of Representation

The apartheid regime officially promoted group cultures solely in order to emphasize the dissimilarity between peoples. It was a blatant ploy to justify its strategy of isolating groups within racial/tribal/ethnic enclaves—Bantustans, locations, townships, and the like. Today, not surprisingly, South Africans are acutely sensitive to how they are publicly portrayed, and by whom. The politics of representation speaks to this in two interrelated ways.

The first issue is, "From a curatorial perspective, who has the right to portray the life experiences of others?" "Does group membership automatically confer legitimacy, or can nonnatives produce valid depictions as well?" "How do you reconcile 'speaking for' with 'speaking oneself?' "

The manner in which many groups have been exhibited in South African museums in the past has been trivial at best, disparaging at worst. As noted, that has left people reluctant to cede control over how they shall be represented to any persons outside the fold. The painful lessons of the past strongly dictate otherwise. But invoking such essentialist notions inevitably hamstrings cultural production, to the impoverishment of participants and would-be participants alike.

Curator and critic Okwui Enwezor, although highly critical of how white artists have typically portrayed the black body, in the end argues against racial franchises: "Identity must never be turned into a copyright . . . [whereby a group] retains exclusive user rights of its images," he maintains.[20] But many black South Africans firmly believe that a great archive of stories about their lives is being raided by outsiders, the bounty commandeered, distorted, and commercialized for the behalf of others. In numerous instances this connotes strangers universalizing accounts and events, whereas those people who experienced them would prefer that they remain more particular and personal. On an emotional level, acting in a proprietary manner in regard to cultural matters makes a great deal of sense. But it is more difficult to defend this stratagem after a period of detached reflection.

The second issue centers upon the question, "Who is a genuine spokesperson to impart a group's concerns?" In other words, is a "leader" chiefly promoting his or her personal interests, or have they in fact been empowered by a group to be a conduit to express collective matters of interest and opinion?

It is a significant challenge for museum personnel to sensitively differentiate the charlatan from the genuine article. Only particular people have the requisite time, resources, and political and organizational savvy to navigate between their cohort and the formal, bureaucratic sphere of government departments. Most do not. Such potential liaisons must therefore be carefully interrogated.

Furthermore, "traditional leaders" are a significant feature of the South African social landscape, and they are frequently a fount of archaic knowledge. Identifying who these leaders might be, gaining access to them, and then effectively communicating across significant cultural gulfs, is both a delicate and difficult course of action. But by not carrying through with

this process, there may be hell to pay. At the very least, there's the risk of incurring the wrath of the ancestors.

This, of course, also raises fundamental questions about "community": how is it reckoned, by whom, and with what underlying motives? There's a great deal at stake by successfully demarcating group boundaries, having them publicly recognized, and then using these distinctions as a power base in the rough-and-tumble world of contemporary local and national politics. Museums generally recognize only some claims of legitimacy; others will be cast aside. But that can lay the groundwork for future problems: disgruntled contenders may well challenge whichever narratives a museum chooses to present.

The Politics of Reception

It is folly to assume that audiences "read" exhibitions as curators intend for them to. Clearly, they do not. Audience reception can range from unqualified acceptance to violent rejection, and anything in between, including mistaken identities, cynical manipulations of meaning, and unknowingly erroneous interpretations. Only the most naïve curator assumes that audiences as a whole will "get it," and this is especially the case the more diversified that their offerings become.

Problems do not simply evolve from misreading or misunderstanding; different factions of people may be armed with an array of motives for consenting to or rebuffing what they see in a museum. Curatorship is always fraught with difficulties, not the least of which is that museum personnel work in institutions that according to a well-known formulation, have changed from temples into forums.[21]

Exhibitions can become highly visible stages from which influential individuals may preach to the converted and the nonbeliever alike; spell out social or political agendas and issue manifestos; and increase their visibility and consolidate their power. Exhibitions may provide different audiences an excuse, an opportunity, and a target—all of which spring from conditions and objectives peripheral to the raison d'etre for their preparation in the first place.

Many museologists have been blindsided by political punches they did not or could not anticipate. It is not possible to accurately predict from which direction a controversy might materialize, or what will provide the nucleus around which it will form.

Memory

Any observant visitor to South Africa is certain to be struck by the acute sense of yearning to recover what apartheid destroyed. In almost every locale, residents will invoke the name and memory of a nonwhite or mixed-race community that the government ripped apart and scattered to far-flung spots. Some of these have attained mythic status, such as Johannesburg's former Sophiatown, or Cape Town's District Six.

But how does one represent loss of this magnitude? How do you resummon a sense of community? How do you imagine opportunities that were systematically denied? How do you recuperate from the harmful effects of restrictions so rigidly regulating everyday intercourse that they've left indelible and pervasive residual traces?

Older blacks still, on occasion, address white men as "Baas" and "Master." And although the vast signage that once demarcated "European" and "non-European" buses, park benches, ablution facilities, and such are rather familiar, the Greytown Museum features an exceptional, hefty metal sign that formerly officiated over the borough's fishing areas. Its very existence magnifies the sweep of the petty apartheid system.

The notice stipulates that the dam wall and North bank are reserved for the use of those designated as Europeans. Non-Europeans, in contrast, are restricted to the South bank, "by order." This vestige of a bygone era demonstrates how absurdly barriers were once legislated between the races—down to such details as speciously dividing a body of water that sustains them both, lest one group "contaminate" the other's share.[22] Rigid regulation of this sort obviously has continuing repercussions for individuals and for communities.

Collective and social memory have attracted great scholarly interest in recent years. Studies of how the Holocaust has been memorialized are a prime example.[23] So too are studies of societies that have experienced significant political upheaval, such as Cambodia,[24] and the states that formerly made up the Soviet Union.[25] Scholars have used the collective memory approach to analyze phenomena as wide-ranging as the Vietnam Veterans Memorial in Washington, DC, and its initial widespread rejection and subsequent public acceptance;[26] Art Spiegelman's "comic book" *Maus*, and how it magnifies or dishonors the significance of the Holocaust;[27] and the myriad transformations of Shaka Zulu—the man and the myth—by groups bearing widely different interests at different times.[28]

Collective memory concerns the dynamics of how, why, and what societies remember, and what gets consigned to the far reaches of the cultural archive. Collective memory is about constructing and reconstructing histories and identities. Collective memory relates to the multiplicity of meanings contained within cultural goods and social actions, and how people use, resist, and transform them. Collective memory is shaped through "mnemonic battles" by which different constituencies push to have their particular spin on history formally recognized.[29] In a country with a past as burdened as South Africa's, it is noteworthy that many black Africans bear bluntly conceptual names that are at the same time grandiloquent and guileless, such as Lucky, Trust, Success, Justice, or the highly improbable Always Innocent.[30] One can also glimpse the affecting monikers Remember, Witness, and, yes, even Memory in an occasional news article, or embossed on a worker's nametag.

South African writer Don Mattera has asserted that "memory is a weapon."[31] When a select few suppress the collective memory of a larger population, it disarms them in a fundamental way; it leaves them more compliant to the dictates of others. But when people who at one time have been

exploited begin to excavate buried memory it significantly enhances their ability to rally to their own defense. Memory assists them to regain their name and advance their own cause.

OUT WITH THE OLD

South Africa is an extremely complicated, challenging, and perplexing society to make sense of. Its nature is frequently revealed within the interstices: in snatches of casual conversations, from snippets of talk from radio chat shows, as portions of news stories that don't always warrant banner headlines, and by heated public squabbles that briefly flare up and are just as rapidly doused. Such minutiae comprise the social environment within which museum personnel now conduct their business.

The character of contemporary South Africa is inscribed on the body of 83-year-old *gogo* [female elder] Lina Nkosi, for example. Decades of labor have inexorably worn away her fingerprints, and now an unyielding governmental bureaucracy refuses to issue her an official identity document. But without such authentication, she's unable to collect a state pension to compensate those countless years of work that literally erased her individuality.[32]

White South African households continue to heavily depend upon the domestic labor of women such as these; increasingly more black households do so as well. But fashionistas now claim that workers' uniforms need not be dowdy. Heightened style can allegedly enhance employees' "self-esteem" and, presumably, their output. Designers create garments using colors that are vibrant, "now."

Scores of black male day laborers linger on street corners and seek work from passing motorists, any sort of work, clad in their ubiquitous blue garb. But the same company that manufactures those uniforms now promotes ensembles for their female counterparts made from *seshoeshoe* [shwe shwe] cloth. Originally a nineteenth-century colonial import, seshoeshoe's distinctive mono-color and white design, embellished with intricate floral or geometric motifs on cotton, was appropriated by black African woman as a material that now spans tribal distinctions. "Indigenous haute couture graces suburbia!" an ad in an upscale design magazine trumpets. "From Durban to Paris, Milan and back, traditional Shwe Shwe cloth has made a bold fashion statement," it explains. "A sassy approach to workwear, for a domestic goddess who carries herself with pride, dignity and an undeniable sense of swish."[33]

In some new designs, cell phones can be easily accommodated in a special pocket,[34] a knowing affirmation of the pervasiveness of mobile communication here. But is this a perk, or simply an extension of surveillance and control? The extreme economic disparity between the races remains fundamentally intact, if ever so slightly cloaked in such bright new guises. A "domestic goddess" still cleans and scrubs the way a "maid" always has.

This sort of household chic has its parallel in the machinations of enterprising civic promoters. The sprawling black township of Soweto has been seared into history as the destination for tens of thousands of people forcibly

uprooted and removed by the government, the scene of the 1976 uprising by its children against inferior "Bantu education," a flashpoint in battles between different political factions during the liberation movement, and a generator of authentic contemporary black culture. Soweto has been pivotal to defining the black experience in South Africa for decades.[35]

But today it sports a new acronym, and a fresh personality: SOJO, South of Johannesburg. A major nationwide real estate company has opened sales offices there, and a magazine geared to professionals in the industry has featured the area in its pages.[36] Moreover, in 2003 a liquor company sponsored a Caribbean-style beach party there, dubbing the tons of sand and dozens of palm trees it carted in as "Soweto-on-sea."[37]

"Soweto treats," recipes excerpted from the glossy book *Life Soweto Style*, confirmed for readers of a major Johannesburg daily newspaper that good eating may derive from economic deprivation and political oppression.[38] *Shack Chic* makes the same point in regards to interior decoration.[39] But is a site of such historical and contemporary struggle so easily transformed for the benefit of the trendy consumer?

The thinness of this attempted repackaging is easily exposed: a celebration of Tourist Month in 2003 included putting up 40 dignitaries overnight in Soweto B & B's. But getting them there without incident necessitated commandeering a fleet of police escorts from neighboring Johannesburg, personnel who are in notoriously short supply in a city wracked by crime. According to a supercilious and breathlessly favorable report by a society gossip columnist, "I do hope they weren't needed elsewhere that night."[40]

Is the Future of
South Africa Its Past?

Daily life in contemporary South Africa often contains this distinctive sense of having been scripted by an absurdist playwright. Tastemakers regularly sanitize, bowdlerize, efface, and reconfigure history.

A tiny former slave dwelling that was once on the outskirts of Cape Town is now incorporated into the hip Sea Point area. Colorful walls and a skylight cheer up an otherwise claustrophobic interior; a once rudimentary structure becomes a "bijou," a "delightful little *pied a tere* for the working week."[41] And weekend getaways can be spent relaxing in "Zulu Zen Style," a minimalist aesthetic that blends bush adventures into the natural environment, thereby intruding as little as possible upon unspoiled surroundings.

As is so often the case in today's globalized world, history becomes fashion, and revolution becomes stylish cliché. The image of slain Black Consciousness leader Steve Biko has virtually become synonymous with the Afro-urban-chic South African design firm Stoned Cherrie. On the one hand, there's the argument that t-shirts adorned with his portrait "return" Biko to "the people." But this is no cheap knock-off; it will set you back R300 (approximately $50 in mid-2004 terms).[42] This is "conscious fashion,"

"funky, fashionable, contemporary ethnic wear for big-bottomed girls with disposable income."[43]

And a print ad for communications giant MTN features the drawing of an upraised fist, clutching a cell phone. The company's bold, revolutionary pledge, "One day every African will have a voice."

History, politics, and indigenous cultures have become as valuable a natural resource to quarry as the rich mineral deposits of the Witwatersrand. In fact, tourism contributes up to twice as much to South Africa's GNP than gold currently does.[44] Imaginative tour operators have designed "pink safaris" (to attract an international gay clientele), yoga, rehab, and cosmetic surgery tours (cut rate self-improvement in an exotic setting), as well as "sperm on safari" (fertilization for gay and lesbian couples).[45] And *SA Millionaire* magazine advises its readership, "There has never been a better time to invest in the art [and craft] of Africa."[46]

When the heritage industry capitalizes upon history it amalgamates elements of Disneyland, *Back to the Future*, and the glossiest "lifestyle" magazines. The Village People @ Sun City, for example, is a recent addition to this popular casino cum entertainment mecca, featuring a "cultural village" environment with eight different South African language groups represented. Multiple cultural essences are thus extracted, boiled down, and served smorgasbord-style in an environment comfortably disinfected for the tourist masses.[47]

Moreover, Xhosa Land Tourism, which touts itself as a "Black Touring Company," offers a range of genuine experiences in the Eastern Cape Province. Customers can spend a night in either a shack or a "cosmopolitan Xhosa home" for the same charge. And on an escalating price scale, they can also chat with a chief, herd cattle, or—perhaps providing the ultimate in intimate traditional encounters—witness a circumcision ceremony. One has to wonder if the company retains a supply of eligible boys, or if this is strictly available "in season."

European heritage is served up to the adventurous as well: a travel article touts an ox wagon camp where "[t]he 200-year-old wagons have been restored to make sleeping a luxurious event." The experience advertises itself to be "in true pioneer style," albeit with the anachronistic addition of insulated floors, crisp white linen, and down duvets.[48]

Furthermore, an article in *House and leisure* highlights a stylish lodge nearby the scene of numerous bloody encounters during the nineteenth century between various combinations of the British, the Boere [Afrikaner farmers], and the Zulus. It vividly describes the emotional battle tour that a renowned local guide offers "on consecrated ground." Lest readers be turned off by the weightiness of the subject, however, the author reassures them that gin and tonics will flow once they return to cozy, professionally designed quarters.[49]

The director of the KwaZulu-Natal Arts and Culture Trust states, without irony, what a lucrative resource such battlefields have become: "We want to do everything possible to use the war to put food on the table," he declares. "It is a great inheritance our ancestors left us."[50] In a particularly odd twist of

fate, those towns that were blessedly spared being sites of armed conflict during the nineteenth century are today impoverished by that lack of history to exploit.

Many types of places are vulnerable to the profit motive. Liliesleaf Manor House was once an isolated homestead with a few huts, outside Johannesburg. Forty years ago it was the secret headquarters for Umkhonto weSizwe [MK, "Spear of the Nation"], the armed wing of the African National Congress [ANC]. It is now an upscale guesthouse and conference center in the tony suburb of Rivonia. The walls of the suites are decorated with photos of the 1963 raid that captured members of the ANC leadership, which then led to the milestone Rivonia Treason Trial that sent Mandela and others to prison.[51]

Plans to expand the facilities to include a three-story hotel led many local residents to question how committed the present owners are to heritage concerns. To appease the opponents to some degree, a museum has been promised for the development as well.[52] And the former site of the World Trade Center in Kempton Park, also outside of Johannesburg, the place where pre-1994 peace negotiations were held, is now Caesar's Palace, a popular casino.

Packaging an experience with a tourist bent can easily debase or undermine its significance. For several decades an old building in the center of Cape Town held the cultural history collection of the South African Museum. And then a significant archaeological discovery was made in 1998: investigators located the steps leading to the slave cellar, and they unearthed hundreds of eighteenth- and nineteenth-century artifacts reflecting daily life during those times.

Prior to this time, no reference was made within the exhibitions to the system of slavery that literally propped up both the economy and this specific edifice. Only now, in the officially renamed Slave Lodge, is that history being dealt with: once the site where the Dutch East India Company billeted its workers in abject conditions, it is being converted into a museum devoted to slavery.[53] According to Iziko Museums CEO Jatti Bredekamp, the objects on display will resonate with the voices of the slaves and the slaveholders as well. And in the words of Dr. Patricia Davison, director of social history collections for Iziko, "It has been incredibly therapeutic to see all those old displays [for example, colonial artifacts like furniture and silver, and relics of ancient civilizations such as the Egyptians, Greeks, and Romans] removed."

But the gravity of the subject would be subverted if a proposal made by a Cape Town-based historian, a specialist on slavery, were acted upon: "Many of the features of the Lodge could be celebrated in a courtyard restaurant, the stones of which were laid by slaves," he suggests. "Authentic food and wine from that period could be served by waitrons in period dress. . . . This restaurant could be a great money spinner for the museum."[54] The boundaries between genuine homage and camp would dissolve in this instance, demonstrating that when profit is the driving force, history can rapidly become farce.

At the same time that history is being commodified and aggressively marketed, the general South African public betrays a conspicuous lack of interest in the subject. The appeal of studying history is rapidly drying up. Just over a decade postapartheid, university students are ignoring it as a major field of study, and it also sparks scant attention at the lower levels of education. Furthermore, to the so-called born-frees, the history of the past half-century seems as remote, foreign, and irrelevant as prehistoric times.[55]

Whereas officials generate grand designs for new national symbols and fresh traditions, the masses often have other priorities. For example, Nelson Mandela established Heritage Day in 2003 to honor diversity and historical sites. But in 2003, a restive crowd in Pretoria derailed the government's plan for the celebration. When the impatient throng loudly complained about the heat, and the tedium of the speeches, they were directed to water taps to refresh themselves.

But that wouldn't suffice. The people were eager for beer and entertainment, not the platitudes of politicians. They had hoped to party, not to mull over serious concepts.[56]

Cultural commentators note with dismay that Youth Day—honoring the anniversary of the momentous student uprising in Soweto, June 16, 1976—is simply a day to sleep in for the lion's share of today's learners. Moreover, voter registration ratios reveal a significant generational gap: in the 1999 general election, 48 percent of 18- to 20-year-olds registered to vote, as opposed to an astonishing 97 percent of 40- to 50-year-olds and 99 percent of 50- to 60-year-olds.[57]

COME TOGETHER: THE SEARCH FOR UNIFYING SYMBOLS

Consider Orania, a whites-only *mini-volkstaat* [people's state] dedicated to preserving the Afrikaans language and culture, an anachronistic homeland claiming up to 600 residents. It lies in the Bo-Karoo, the northern edge of a vast arid plateau region. Originally erected as an outpost for construction workers building an irrigation system, it was bought in toto in 1991 by a determined group of Afrikaners committed to establishing a self-sufficient community. Even though Orania has the drab look of a prefab suburb plopped down into a barren corner of the world, it so fascinates people that even as unlikely an outlet as *South African Country Life* has profiled the place within its pages.[58] With its own currency, and watched over by the flag of the old Boer republic of the Transvaal, the residents of Orania are tribal stalwarts of the old regime, isolated in voluntary, internal exile.

The town's major products include melons, pecans, and coffins; the later help to satisfy the great demand generated by the AIDS crisis that is wracking the country. Farmers work independently but jointly market their harvest, mirroring to a degree the type of socialist economy that the Afrikaner's National Party heartily rejected during its reign. Their separatism from the larger world incurs costs: residents must rely upon their own labor for everything, upending

the standard South African distribution of the most tedious and strenuous tasks to blacks.

Orania appears acutely aware of the importance of museums and monuments. As small as it is, a monument to Irish soldiers who fought with the Boere in the Anglo-Boer War sits close by a statue of former Prime Minister Hendrik Verwoerd, the architect of apartheid, which surveys the town and its surrounds. It also boosts an Afrikaner history museum, and another dedicated specifically to Verwoerd; its garden has become the final resting place for three apartheid-era sculptures of his head, displaced from public settings after 1994.

Among its distinctions, the town also lays claim to the world's only monument to the *koeksister*, a doughy concoction that is fried and then drenched in a sugary syrup. Its afficianados include former president Mandela, and they are every bit as adoring of this sweetmeat as its detractors are dismissive. The crudely modeled, two-meter high fiberglass sculpture was unveiled in 2003. It represents a culinary icon of Afrikaner culture, the acme of consummate housewifery, and a declaration of what is unique to these people.

And yet the matter is not so clear-cut. The monument depicts the so-called twister, a pastry made from braiding two pieces of dough together. But another version called the *koesister* is smaller, more dumpling-shaped, incorporates a number of spices into the mixture, and is brushed with coconut. Its genesis is in Indonesia, the point of origin of slaves brought to the Cape Colony beginning in the 1660s. The Ur-koesister thus has Muslim roots, irrespective of how many Dutch Reformed Church socials the koeksister has presided over through the generations.

A plaque attached to the monument acknowledges the koeksister's derivation, but it also notes that the name refers to two sisters gently gossiping on the *stoep* [porch, veranda] and it emphasizes how central it has been to cultivating a sense of Afrikaner sisterhood and sharing. So probably to the chagrin of the citizens of Orania, they cannot claim this delicacy as exclusively theirs after all. Like so many aspects of South African culture (including, of course, the language of Afrikaans,[59] mother tongue for Afrikaners, and many "coloureds" [people of mixed-race ancestry][60] alike), the koeksister has evolved through a process of syncretism, and it was not divinely inspired for the sole use of a particular group.

Just as new public displays bare a great deal about a particular community, the reinterpretation of established symbols can be revelatory as well. Also in 2003, the wife of a Dutch Reformed dominee [clergyman] in the Cape Town area created a uproar when she declared that the eight-meter high tower next to the church's entrance represented a massive male organ, making love to the goddess of the sky.[61] She demanded that the church pull down the offending structure (at an estimated cost of R100,000), referencing as it did ghastly inappropriate pagan rites.

Church elders failed to buckle under pressure and media scrutiny. But the hysteria over this supposed "vision" exposed the declining influence of the

Dutch Reformed Church, once the official bulwark of apartheid, and its retrograde struggle against the allegedly sinister forces of modernity.

TRUE COLORS AND HITTING
THE RIGHT NOTE

One of the principal challenges of nation building is to design symbols that herald a new political status quo, while at the same time allude to the past. South Africa's distinctive six-color flag aims to encompass both these goals. Adopted in 1994, each hue represents some feature of the South African political, social, or natural landscape. Red stands for the blood that was shed throughout the country's history; blue, open skies; green, the land; yellow, natural resources; black, the black African people; and white, the descendants of European settlers. These colors are drawn together about a horizontally placed "Y" shape to signal the successful merging of these diverse elements. Among the rejected proposals was a design depicting a large black cat and a small white mouse with their tails entwined, and a hammer and sickle composed of a banana and an assault rifle.[62]

But a roadside flag vendor outside Pretoria reports that Nazi and South African flags from previous regimes outstrip the sales of the current banner.[63] And in a decidedly racialized, conspiratorial disclosure—one of those encounters where a person of the same race assumes a "natural" affability and affinity with you simply because of shared skin color—a shop clerk in East London once enthusiastically revealed to me what she believed to be the concealed meaning of this flag. According to her interpretation, the two white bands represent the timeworn cleavage between the major European-based groups: the English and the Afrikaners (descended primarily from Dutch, German, and French settlers, but with dashes of "other blood," the generally unspoken consequence of them mixing with slaves and the locals).[64] And the yellow represents the fence necessary to hold blacks in check, in this case preventing them from invading the valuable green *mealie* [corn] fields. From this perspective, the South African flag conveys a narrative of division, not unification.

But no national symbol has generated more objections and displeasure than the national anthem. *Nkosi Sikelel'iAfrika/Die Stem* represents a conscious fusing of two songs—one revered by blacks, the other by whites—to stand for a reconciled South Africa. Both bear the authenticity of time, and both have been exploited to rally insular communal sentiments in years past.

No one would argue that it is great music; its cobbled nature is immediately apparent. *Nkosi Sikelel'iAfrika* ["God Bless Africa"], composed in isiXhosa, is typically sung in isiZulu and Sesotho as well; *Die Stem van Suid-Afrika* ["The Voice of South Africa"], in Afrikaans. Moreover, their melodies are jarringly dissimilar.

Critics commonly dismiss this "marriage of convenience," this "mutilation," this "bastardization," this "obnoxious concoction," this "heterophonic fiasco of alarming proportions" as an unnecessary capitulation to the former

Afrikaner oppressors.[65] This same amalgamative approach was used to denote the newly formed province of KwaZulu-Natal after 1994, combining regions so named by black and white constituencies. But it also has its opponents.

One writer angrily compared the South African experience with neighboring Botswana by arguing, "They never thought of appeasing their former colonial masters by concocting their new anthem with *God save the queen*. The problem with us seems to be that we are very determined to lick our oppressors' backsides until they shine!"[66] The situations are different, of course. The former rulers withdrew from Botswana, whereas those who had most recently dominated South Africa remained, presumably with equal rights.

An earnest gesture, calculated to gratify the greatest number of individuals, has instead angered more people than it has pleased. *Nkosi Sikelel'iAfrika/Die Stem* is an artifact of the initial stages of building the "Rainbow Nation," a time when it was considered vital to accommodate different groups and their distinctive forms of expression. But those sentiments no longer command as much respect. That idyllic notion commands more respect and is more noticeable in advertising campaigns than it is in the day-to-day lives of most South Africans.

Although Nelson Mandela resolutely embraces the joint anthem, many others feel it is irrelevant to the present day. In fact, a Johannesburg newspaper editorialized that the dual anthem be scraped because the ANC itself ignored singing the Afrikaans section at its 2004 National Assembly. The writers felt that this unfortunately gave a green light to other political parties to endorse their own anthems, including *Die* Stem. To their minds, this would sadly signal a return to an apartheid-like divisiveness.[67]

MADIBA: THE MAN AND THE BRAND

Nelson Mandela has been lionized and lampooned, venerated and caricatured. Affectionately referred to as *tata* [term of respect for father, a married man] or Madiba [his isiXhosa clan name], Mandela has become the most recognized "brand" in South Africa, rivaling Coca-Cola. A *New York Times* writer in 1994 discussed "liberation collectibles" with a note of relief that "[i]t has not yet come to F.W. de Klerk soap-on-a-rope, or Nelson and Winnie salt and pepper shakers."[68] But not very long thereafter, the visages of former presidents de Klerk and Mandela, corecipients of the Nobel Peace Prize, were indeed preserved as sets of salt-and-pepper shakers, historical artifacts eagerly sought by collectors nowadays.

Since 1994, "Oppression," a Monopoly-like board game, has "re-created" the apartheid experience; the "Y" design from the South African flag has been transposed upon men's Y-front briefs; a straight measure has been inscribed with the lyrics of *Nkosi Sikelel'iAfrika* along with the motto "Mandela: Our New Ruler!"; and Madiba himself has been en-shrined (or debased) within countless everyday objects (plates, neckties, and

watches); fictional characters (the flamboyantly attired superhero "Madibaman" in the cheeky *Bitterkomix*); and unique works of art.

Gargantuan statues of Mandela, or of just his arm, have been proposed. And they have been rejected, for the most part, as more appropriate to a fascistic than a democratic regime.[69] In 2004, a spectacularly peculiar rendering of him made up of 48,000 pieces of bubblegum set a Guinness record for portraiture in such a medium.[70] Moreover, the ruling African National Congress has floated the idea that Madiba's mummy be displayed in a glass crypt, á la Lenin, to provide a future site of pilgrimage for succeeding generations.

Perhaps the most bizarre appropriation of Madiba's image was by two entrepreneurs in 2001: they launched what they hoped would become a chain of "Nelson's Chicken and Gravy Land" franchises. Even though the company's logo featured a face that was noticeably similar to Mandela's, and the restaurant's menu included "Nelson's Freedom Meal," "Nelson's Peace Meal," and "Nelson's Liberation Family Meal," these white businessmen claimed that they were promoting an invented personage. Nonetheless, pressure from the ANC prompted a change of heart, and marketing strategy, within days.

What all this adds up to is the strong impulse to concretize and embody the essence of contemporary South Africa within powerful and instantly identifiable symbols. But currently the border between kitsch and patriotism is quite permeable and imprecise.

THE SAD TALE OF HAPPY

For all the rhetoric to the contrary, South Africa is far from being a "nonracialist" society. Moreover, how could any reasonable observer expect otherwise, given the tortured relationship that has prevailed between the races for the past 350 years? But time and again, certain government officials and civic boosters speak as if the rigid classification system that previously kept people apart has been effectively dissolved.

The chronicle of Happy Sindane reveals just how absorbed South Africans remain with the subject of race. When Happy Sindane wandered into a rural police station in Mpumalanga Province, he simultaneously leapt into the headlines, where he remained for months. The curly haired 19 year-old made a fantastic claim: he was a white child who had been abducted from Johannesburg by a black domestic worker when he was 6, and brought up in a black township. Speaking fluent isiNdebele, his account of alleged abduction, captivity, and eventual flight riveted the country in mid-2003.

Almost immediately, various people made bids for the boy, including at least two white couples who insisted that Happy was their long-lost offspring. He fit their narratives of loss, and they confidently recognized a physical resemblance between themselves and the supposed foundling. But DNA testing invalidated both family's claims.

When the truth eventually surfaced, it turned out that his mother was in fact the black domestic worker whom he'd believed had kidnapped him.

Happy's father was likely a white man who had employed her, thus rendering Abbey Mzayiya "coloured" in apartheid parlance. As a young boy he'd been cast off to a black family; they provided him a home that neither his black kin nor his white kin proffered. After he'd discovered his actual roots, and his pretensions to the throne of racial privilege were invalidated, Happy/Abbey settled into a trade "appropriate" to his status: washing cars for R15 each.

Happy's fabricated saga echoes the many narratives of Europeans seized by Indians during the early colonial era in America, and similar stories generated in other frontier societies such as Australia. In those tales, "savages" snatched women and children from the bosom of civilization, to the great sorrow and revulsion of their families. These defenseless captives would then be refashioned according to a heathen way of life, rendered unrecognizable to their true families.

These are all stories about boundaries, the dangers of intergroup contact, and the possibility of cultural "contamination." These tales also suggest that "civilization" is but a fine veneer, easily worn away by exposure to other influences. It is doubtful that a black boy claiming to be abducted would have generated the same sort of media frenzy.

Happy was a naïf, until he blossomed briefly under the media's glare into a hip youngster with cool sunglasses and a stylish haircut. The Dulux Paint Company also jumped on his story to promote their products, running a now notorious print ad featuring the boy's picture, along with three paint samples of different hues, and the logo "Any colour you can think of." The advertisement appeared, ironically, on Youth Day; the general opinion was that it was a bit too cheeky, crass, and opportunistic. And it raised the uncomfortable issue of race being a variable, not a fixed concept. The South African Human Rights Commission deemed the company's conduct "reckless" and Happy ended up with a R100,000 settlement.[71]

Happy's hubris at trying to represent himself as someone he was not instigated his downfall. The boy turned to drink and *dagga* [marijuana] to assuage his loneliness, depression, and confusion; and he reportedly attempted suicide. Less than a year after he'd publicly appeared, he also suffered near-fatal injuries when struck by a minibus taxi.

Happy's story likewise echoes melodramatic Hollywood B-movies such as *Pinky* [1949] and *Imitation of Life* [1959 (1934)]. It is, ultimately, a cautionary tale against racial passing. In this instance, however, some measure of personal harmony was eventually attained when a recovered Happy/Abbey honored his late foster mother's memory with a suitable grave marker. But the boy obviously still feels caught between two worlds: he completed an Ndebele initiation ceremony in 2005, indicating his identification with this African culture, but also desires to find a white wife.

RACE AND ENDURANCE

The intensity with which racial boundaries are defended in contemporary South Africa is amply displayed by the general public's response to some popular entertainments. Many eyebrows were raised in 2003 when a white

Jo'burger bearing an obviously Afrikaans name captured the first-ever title of Mr. Africa. Attracting far more attention was a pan-African version of the television reality show *Big Brother*. In previous run-throughs, the residents had been a cross section of South Africans, and the series was hugely popular, generating daily—yes, daily—updates and analyses in the major newspapers.

Big Brother Africa, produced by the same South African principals, highlighted race in an intriguing way. The contestant representing neighboring Namibia was a handsome and affable young man called Stefan. But his selection had divided his home country. Some argued that a white man, the personification of Namibia's German colonial past, could not legitimately symbolize the nation. Others disagreed. To them, Stefan demonstrated the multicultural nature of the continent.

Stefan's personality (and good looks and hunky body) won over the other housemates and many of the critics, but the racial heritage of the contestants overall proved to be a thornier issue. One journalist reflected, "I had had a rude shaking up of my preconceptions of what Africans today look like. Of the 12 [contestants], only six would have fitted the 'Bantu' label in the bad old apartheid days."[72] Throughout the run of the series, commentators noted the allure of paler skin tones amongst the residents, sometimes offhandedly, sometimes disapprovingly. A dark-skinned Zambian woman ultimately took the prize, putting an end to this phase of the larger debate regarding who is "African," and who is not.

This is an issue that dogs contemporary South Africans and others throughout the continent. At the opening of an exhibition at the historic Cape Town Castle called *Memórias, intimas, marcas* [Memory, intimacy, traces] in 1997, for example, a heckler got into a fistfight with one of the artists, who considered himself to be Angolan. During the incident, the audience member challenged the artist to "[g]o back to Europe," indicating that he did not believe the man to be authentically "African."[73] And at a panel discussion held at the Museum for African Art in Queens, New York, with artists participating in the exhibition *Personal affects: Power and poetics in contemporary South African art* (2004), one woman complained that she and her work had sometimes been characterized as "non-African" because of her white racial heritage. She proposed adopting the label "non-European" instead. While her original ancestral roots may have been elsewhere, the place where she was born and that unmistakably continues to shape her sense of self and identity is Africa.

Racial advocacy achieved a much more contentious level in public discussions of two other so-called reality shows: *Idols* and *Coca-Cola Popstars*. During the first two seasons of *Idols*, white contestants took the prize, beating out a final field that was dominated by other whites. Yet of the top 60 finalists on 2004's *Coca-Cola Popstars*, all the contenders were black.

Charges of racism were rampant, and the inevitable references to an "apartheid" of entertainment were common. The seriousness with which some people took the matter was intense: "Stop singing the rainbow nation song, the country is burning," one man wrote. "Pause for a while because

so much is wrong," he continued. "Let's cease praise for the political miracle we think we are, for we are sick inside."[74]

Some observers claimed that an antiblack bias was built right into *Idols*: the show aired on a network that was available by subscription only, thereby attracting an audience that was skewed toward whites because of the racial distribution of resources within South Africa. This channel is better known for its coverage of rugby, widely considered to be a "white sport," rather than for focusing on matters of concern to the racial majority.

But *Idols* was broadcast during an "open-air" time, accessible to everyone. That detail undermined talk of conspiracies. Perhaps more pertinent to the outcome was that *Idols* emphasized individual pop performances, whereas *Popstars* culminated with training an R & B group, assembled from the crowd of aspirants. Whites were more likely to excel in the first sort of competition, blacks in the other. Nonetheless, when people carped about the suspected unfairness of one show or the other, it was because they saw and heard things that seemed distressingly familiar to them. These results confirmed their expectations that race continues to dictate all manner of outcomes in South Africa.

About A(nother) Chicken

The racial categories of the apartheid system created significant barriers between different groups, ensuring that their values, beliefs, customs, ceremonies, and languages remained relatively exotic and incomprehensible to one another. Not entirely, however: museum director Marilyn Martin argues, "Our society has always been intracultural, transgressive and unpredictable."[75] Even so, the big difference today is that cultures are facing off and interpenetrating one another to a much greater extent than ever, provoking confrontations that apartheid had previously limited.

Try to envision the following scene: Parliament is in session in Cape Town, not long after the milestone elections of 1994. New ministers and legislators are acclimatizing themselves to this fresh, democratic beginning. Suddenly the imposing chambers explode with the recitations and *ululating* [a staccato yowl produced by rapid movement of the tongue] of *iimbongi* [praise singers], whose traditional responsibility has been to proclaim the arrival and departure of African royalty, honoring them with the proper degree of respect.

It left some officials traumatized. One female minister declared, "I mean a praise-singer in Parliament, *and* dressed the way he is. And clapping and ululating. It used to be a very dignified place and this is a terrible cultural shock for us." In a less emotional, prescient reflection, she realized that cultural affairs—part of her portfolio, as it turned out, and one area that she intended to aggressively advocate for—"can be a binding factor, or a minefield."[76]

Or, take the story of Veronica the chicken. She played a minor supporting role in Brett Bailey's *iMumbo Jumbo*, itself a story of cultural clash: Chief Nicholas Gcaleka's contemporary quest to Scotland for the skull of Xhosa

chief Hintsa, who was beheaded in the nineteenth century, proved to be megalomaniacal foolishness. Bailey fully flaunted his distinctively frenzied theatrical style in this play, incorporating traditional African rituals, dress, and music into a furious theatrical extravaganza.

He included real-life sangomas in the troupe who entered trance states and performed their customary rites. And that meant ceremonial sacrifice to summon the ancestors and to carry out healing. But the animal slaughter was in fact simulated every night, until the final performance of an engagement in Cape Town in 2003. To the astonishment and dismay of some members of the audience, the chicken met its ceremonial fate that evening.

In point of fact, an understudy was substituting in the role created by Veronica. Veronica had so endeared herself to the rest of the cast that they could not bear to witness her dying for her art.[77] Uproar ensued nevertheless: some viewers angrily stormed out of the theater, and the SPCA later threatened to lay charges.

iMumbo Jumbo had had a noncontroversial run at the annual National Arts Festival in Grahamstown, shortly before its Cape Town appearance. But another event at that festival presaged the difficulties of performing ritual sacrifices at the intersection of traditional and contemporary worlds. There a sangoma sacrificed a goat to the ancestors at a fabricated Xhosa village. The meat was eaten, the bones burnt, and the horns displayed on a pole, all in traditional fashion. And although only three festival goers witnessed the ceremony, advocates and opponents of what had occurred nosily defended their positions.

The chief of the village complained, "The whole issue is brought by white people who want to change our tradition and culture—even though they don't know it." He concluded, "If we had a *braai* [cookout or barbecue], white people would not complain. Instead they would join us because it is their culture."[78] On the other side, a letter writer to a newspaper in the region grumbled that people will not speak out against ritual slaughter for fear of being accused of intolerance. For him, "South Africans have exchanged racist tyranny for the tyranny of political correctness."[79]

Adherents of traditional ways defend ritual sacrifice as their right to express vital religious beliefs. Those with a more present-day orientation—whose lives are largely insulated from the mechanics of the butchering of animals—tend to focus on the degree of humaneness with which the act is carried out, hygienic considerations, and the din often created during days of continuous celebration. "Not in my backyard" has attained a new meaning as black Africans have moved into previously all-white areas, and brought their traditional forms of celebration, cleansing, and healing with them. The growing regularity of these cultural clashes has led Johannesburg lawmakers to pass regulations to permit such rites to continue in residential areas, while also guaranteeing that neighbors are notified in advance, and that these observances are conducted with sanitary and compassionate considerations in mind.

WHAT'S IN A NAME?

As their relative fortunes wax and wane, different groups also collide over place names and monuments that reflect a now reviled past. Admittedly, this is not a phenomenon limited to South Africa. In New Delhi, roads with "colonial sounding names" are being "Indianized" or "internationalized." Aboriginals in Australia and Inuits in Canada are demanding that their national governments chuck out place names that they feel are insulting, and correct what they consider to be unknowing but disrespectful misspellings of their names by officials in the past. And in Namibia, proponents of changing street names in the resort town of Swakopmund, a place heavily infused with German culture, are meeting tough resistance from traditionalists. For example, Kaiser Wilhelm Street would become Dr. Sam Nujoma Street, honoring the country's founding president.[80]

In Johannesburg's arty Newtown precinct, street names such as Bezuidenhout, Sydenham, Pim, Goch, and Wolhuter were changed in 2004 to honor individuals such as artist Gerard Sekoto, singers Dolly Rathebe and Miriam Makeba, sculptor Noria Mabasa, *Drum* magazine journalist Henry Nxumalo, and cofounder of the Market Theatre, Barney Simon. And in Soweto, there is some support for changing streets named after African councilors who are now seen as apartheid stooges. Curiously, however, no serious efforts have been made to abandon "Soweto," itself an historical artifact of white supremacy. Although the term "sounds African," it's an acronym for South Western Townships.

A high-ranking government official recommended in 2003 that "South Africa" be changed to "Azania," a name used by resistance movements during the apartheid era to envision an independent, majority-ruled society. Two letters to the editor appearing in the same edition of a KwaZulu-Natal newspaper demonstrate how entrenched the opponents in these struggles can become. One writer took a "love it or leave it" approach, suggesting that anyone supporting the status quo regarding outmoded names had no role to play in the New South Africa. "Pack your bags, you don't belong," he challenged such allegedly unenlightened folks.[81] But his counterpart advocated changing the country's name to "Azendia" or "Azolia." Situated as the nation is at the southern end of the continent, "We can be [called] real Azoles."[82]

An ad for cable television station M-Net merrily captures the current sense of flux: "Live in Pietersburg one day and Polokwane the next," it declares. Meaning what? These designations describe the same town, at different historical moments.[83] This feverish drive for change was rendered suspect when provincial government officials announced that Witbank would become Emalahleni, isiZuzu for "place of coal." They provided no historical evidence to support the suitability of the name, however, and a spokesperson rather dismissively stated, "It is not our duty to check the factual accuracy of any proposed new names."[84]

A particularly nasty debate broke out in 2003 after the Pretoria city council proposed changing the name of this, the administrative capital, to Tshwane. "Tshwane" already denoted the surrounding municipality of 13 local councils. The word is interpreted as derived from a Setswana term that means "we are the same," or "we are one because we live together." Another account pegs it as the name of the native chief who ruled the area before white settlers arrived en masse in the nineteenth century.

All arguments in favor of the change fell on deaf ears at the Tshwane Business and Agricultural Chamber. Its membership voted unanimously against the proposal. Their aggregated influence convinced the councilors to table the suggestion.

Much of the public discussion focused on the name change as being superfluous, and potentially quite costly to institute. Average citizens expressed greater concern over crime, rates and taxes, and delivery of essential services.[85] Also on many peoples' minds was a recent "horror hijacking" in the Pretoria area in which a one-year-old baby, her mother, and grandmother were all brutally murdered (the two adults were raped as well). The father of the child suggested that rather than spend money on the name change, those same resources could instead be funneled to people mired in poverty and struggling against crushing social problems; perhaps this would alleviate some of the pressures that might lead them to turn to crime.

Despite all these objections, a decision was finally taken in March 2005 to retain "Pretoria" to cover a few block area of downtown but change the rest of the city to "Tshwane." Resistance continued however, ranging from efforts to have the decision legally reversed to defacing road signs bearing the new designation.

In the recent past, people have become much more aware of the power that language wields, and to what degree language shapes our everyday view of the world. And that has heightened their desire to deliberately mold it. Many African-American community activists, for example, bristle at the use of the word "slave," preferring "enslaved" instead. While this might sound like nitpicking, they reason that "slave" refers to someone's essence; "enslaved" is more accurately a condition. Circumstances can change; essences are more enduring.

Concurrent with the Tshwane controversy, an even more acrimonious squabble erupted over a proposal made by SA National Parks [SANParks] to remove a monumental bust of former state president Paul Kruger, watching over one of the gateways to the world-famous national park that bears his name. Scores of people rushed to "*Oom* [Uncle] Paul's" defense.

Park officials justified their decision by citing recent scholarship demonstrating that Paul Kruger was not a visionary conservationist. Opponents of the monument habitually alluded to Kruger's attitude toward wild animals as seeing them as little more than prospective morsels of *biltong* [dried jerky]. They also situated President Kruger in the extensive register of white tyrants whose images can be an abrasive reminder of past minority racial domination. According to SANParks' chief executive, Mavuso Msimang, his department's

mandate was to care for the local flora and fauna and not to conserve man-made embellishments.

But critics of the park board's proposal pointed out that portraying Paul Kruger as a "white oppressor" was based upon faulty reasoning. Such an allegation missed the point that Kruger (1825–1904) lived long before the implementation of apartheid in 1948. Moreover, some revisionist historians and comrades from "the struggle" now embrace him for combating the British, and claim him within the panoply of South African anticolonial free-dom fighters that they trace extending through Nelson Mandela and his cohorts. For these people, removing Kruger's likeness would be a racist act, pure and simple.

Stepping back a bit, we need to ask, "Is Kruger Park the edenic treasure that tourists fix in their memories?" or, "Are there troubles in paradise?" The park, in fact, has been at the center of a number of political firestorms in recent years, which helps to explain this particular dispute.

Administrators proposed culling elephants in 2004, a highly controversial form of population control that had been on moratorium for a decade.[86] Furthermore, several million people live on the periphery of the park, most of them poverty-stricken. Benefits have trickled down to only a few of them. Indigenous people, some of whom have won claims against parkland, now demand a greater voice in decision making in the area. (Some argue that the rubric of "ecotourism" is simply a new guise for those who are well heeled to dominate territory and its inhabitants.)

And charges of mismanagement, theft, and corruption have dogged park officials and focused an intense light upon their professional conduct. SANParks officials, like Pretoria city councilors, had good reason to divert the general public's attention away from their activities, as well as prevent the citizenry from assessing the shortcomings of their performances. Just as *veld* [open grassy country] fires command attention when they threaten the human presence in the park, extinguishing politically generated blazes likewise draws public interest away from other matters.

Some of the more generous critics of the plan to eject Oom Paul sug-gested that history be broadened, not abbreviated: whenever the opportunity arises to assign new names on park property in the future, they could reflect the stories, traditions, and wisdom of local indigenous people. Moreover, monuments to native leaders could complement those dedicated to notables from European backgrounds.[87]

The issue was concluded, at least temporarily, by a clarification of contra-dictory bureaucratic claims. SANParks, as it turns out, does not control the Kruger monument, or any others located within the park; the South African Heritage Resources Agency [SAHRA] does. And that bureau was not assem-bling teams of movers, or demolition crews.

GIVE ME SOME [WO]MEN

How do you announce a program designed to encourage entrepreneurship among rural women? A public notice by a partnership between a major

petroleum company and a banking group shrewdly pictured a black woman in traditional garb, walking as African women commonly do while carrying something on their head. But in this case it was neither water, nor food, nor wood she'd gathered; instead, she was expertly balancing a briefcase. The overall image was an evocative symbol of where women have been situated in South Africa, and the direction in which some of them are now moving.

This unnamed individual represents one component in the process of "nation building," a concept bandied about a great deal these days in South Africa. Nation building implies testing limits. Nation building means fusing old structures and components with new ones in order to create a spanking new entity. And nation building also suggests experimentation, missteps, and gaffes.

In 2003, the Eastern Cape's office of the premier issued a restructuring plan for itself. It came together in an organogram, a formal organizational chart that South African businesses, government agencies, and nongovernmental organizations [NGOs] typically create. These particular officials pushed the idea of an organogram to an improbable conclusion, however, linking major areas of their operation to parts of the female reproductive system—complete with an anatomically correct chart! The uterus stood for the provincial strategy think tank; the fallopian tubes, the cabinet secretariat; the vagina, provincial communications. Colored arrows going into and out of the vagina represented day-to-day office functions.

Once the concept had been publicized, the premier's office expressed surprise that people took it "so literally," or that they saw something sexual in this representation. Nomaxabiso Mahlawe, executive general manager of the premier's cabinet office, invoked contemporary feminist rhetoric to both explain and justify that she chose the metaphor to systematize this workplace, as well as "to also promote awareness of 'the significance of the reproductive role of women in the current predominately patriarchal society.' "[88] In truth, this exercise foolishly reduced women to their genitalia; it was more laughable than liberating.

Another example of principles and oratory running amok was a tiff regarding the work of one of South Africa's most distinguished citizens. Nadine Gordimer's books have garnered her both the Booker Prize and the Nobel Prize for literature. Three of her novels were banned during the apartheid era. For a legion of readers both at home and worldwide, Gordimer's writing embodied life during extremely turbulent times.

In 2001, the press reported that Gordimer's *July's People* (1981) had been banned from a list of books accepted for high school senior certificate exams in Gauteng Province, where both Johannesburg and Pretoria are located. *Hamlet* was also bounced. Shakespeare was alleged to be "too Eurocentric"; Gordimer's story was faulted as "deeply racist, superior and patronizing. The novel seems one-sided and outdated."[89] The selection committee reportedly sought books that promoted "post-apartheid values of tolerance and egalitarianism" and "accessibility of language."[90]

This represented an ironic and disheartening twist of fate. Gordimer's books were once officially embargoed as a threat to the regime, at the same time that they were widely considered to be a source of insight to readers outside South Africa. But the new government, deliberately based upon principles of democracy and equality, now seemed to be negatively sanctioning a long-standing advocate of those very values.

A representative of the education department sought to vindicate his agency. He explained that books were rotated every five years; Gordimer and the Bard were thus presumably victims of a predictable fate. He tried to assure the general public that no wholesale sort of purging was taking place.[91]

Does this represent a bureaucratic snafu, unrestrained political correctness, or a media-generated event? Whatever the explanation, both these examples demonstrate the sort of ill-conceived, illogical, excessive, and simply wacky decision taking that is part and parcel of the colossal task of nation building.

PLAN OF THE BOOK

Pulling together these disparate threads, it's plain to see that all these issues coalesce in South Africa's museums. Integration of the past with the present versus deliberate amnesia about history: do you obliterate or amend previous accounts? The intersection of indigenous and contemporary points of view: how can they be accommodated, and allowed to cross-pollinate one another? Tribalism versus universalism: how do people abide the tension between parochial group allegiances and more inclusive, common aspirations? Cultural clashes: how can different groups come to understand and respect one another?

Moreover, how, where, and by whom are representative symbols, iconography, and icons generated? Is history a narrative to be collectively decoded and appreciated, or a legacy to be commodified and exploited for commercial gain by a few? And what are the enduring legacies of colonialism and apartheid, and how does the persistence of race as a key mode of classification remain a divisive factor in South African society?

In chapter 2 I examine how and why white museum personnel complied with apartheid beliefs and restrictions, as well as the ways that they sometimes subverted, evaded, modified, or challenged them. I also consider the meanings and significance that museums have customarily held for South Africans from different racial groups. In chapter 3 I look at how indigenous people have customarily been exhibited and the fate of such displays in an era of heightened ethnic identity and mobilization. I highlight *Miscast*, a landmark exhibition that critiqued museum practice, but at the same time became the focus of a great deal of controversy itself. In chapter 4 I consider the life of Sarah Bartmann, a nineteenth-century indigenous woman whose fate was intertwined with museums in knotty ways. In chapter 5 I investigate the memory work facilitated by the District Six Museum, a place that commemorates

a multiracial community intentionally destroyed by the apartheid regime. The transparent and draconian way in which countless South African neighborhoods such as these were destroyed is contrasted with similar experiences brought about by urban renewal in the United States, but where collective memory has been allowed to fade.

In chapter 6 I explore museum and historical site "makeovers," ranging from relatively minor adjustments to a more comprehensive form of conversion that has transformed sites of state terrorism, or bastions of extremely myopic, official ideology, into places of reinterpretation, reconciliation, and multiculturalism. Robben Island, Constitution Hill, and the Voortrekker Monument are examples. In chapter 7, I examine museums that have been established since 1994 to address the "memory holes" that created significant gaps in the public record during the years of apartheid. I look at institutions such as the Ncome Museum, Freedom Park, the Apartheid Museum, and the Hector Pieterson Museum, all of which address previously unstated issues or underrepresented perspectives, thereby engaging older sites in an active dialogue. In chapter 8 I focus on the practicalities of running today's museums: funding (or lack thereof), personnel issues like affirmative action, reorganization schemes that amalgamate a variety of institutions under a "flagship" structure, and jurisdictional disputes between cultural workers and bureaucrats. And in chapter 9 I assess the strategies that museums have developed to transform the exhibitions they present, paying particular attention to the differences between art venues and places specializing in natural science and history.

WHAT'S IN A TITLE?

Why *Mounting Queen Victoria?* The Tatham Art Gallery in Pietermaritzburg owns an outsized portrait of Her Majesty, which imperiously reigns over the stairway connecting its exhibition floors: "State Coronation Portrait of Queen Victoria," a copy by Charles Van Havermaet (1901–1904), after Winterhalter (1837). Dispatching her to storage has not been an option, really: the museum has no proper space to accommodate her. The museum has instead "mated" her with a comparably sized portrait of King Cetshwayo kaMpande, a successor to the legendary Shaka as leader of the Zulus.

Since the museum did not possess such a painting, it organized a competition to produce one. A blind decision was rendered, meaning that the judges evaluated the entries without access to any information about their creators. In the end, all top five finalists turned out to be white.

That is not surprising: the systematic prohibition of black Africans from a wide range of training opportunities places them at a distinct disadvantage in this type of contest. Nevertheless, a significant number of entries came from blacks, as well as from Afrikaners.

The staff of the Tatham withstood the criticism launched by some politicians and members of the local public that the choice of winner perpetuated the exclusionary policies of the past. But they pushed ahead with commissioning

the work, despite some controversy. The Tatham desired the most compelling rendition, not necessarily one with a particular racial "pedigree" attached.

Two sovereigns, the queen and her steadfast black consort, now hold sway over what previously had been the private territory of only one of them. Her fate and her future speak volumes about the ferment in South Africa's museums these days.

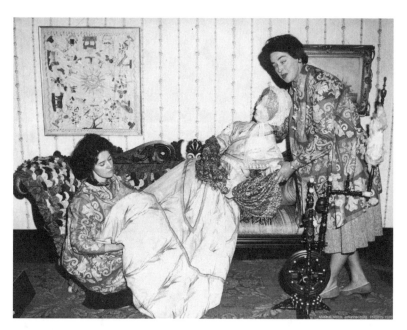

Figure 3 Africana Museum staff putting up an exhibition in 1961
Source: Courtesy of MuseuMAfricA.

CHAPTER 2

A White Step in a Black Direction:
Inertia, Breakthrough, and Change in
South African Museums

We South Africans fight against real consciousness, apartheid consciousness,
we know what we struggle against. It is there for all the world to see. But we
don't know who we ourselves are. What does it mean to be a South African?

Sachs, 1990

Fort Amiel sits above the small coal mining and factory town of Newcastle. It is a venerable, late nineteenth-century garrison, positioned strategically atop a windy knoll. Expansive views of the KwaZulu-Natal countryside unfold beneath it.

The British constructed the buildings and adjacent fortifications from native-hewn stone, betraying the manpower, diligence, and expertise that went into preparing the materials and erecting these imposing structures. This military installation was deliberately designed to act as a sentry: to safeguard the surrounding region and to repel any would-be attackers. It was designed to endure.

As it turned out, Boers occupied the town without firing a shot. Quartered there now is the Fort Amiel Museum. It is a slight venture in relative terms: the museum's priority a propos the municipality's assets, rock-bottom; its budget, slim; display space, severely restricted; holdings and exhibits, paltry; professional staff, limited to a rather new jack-of-all-trades sort of guy who has foresight, but only the tiniest reservoir of information and goods on which to build a destination of any note.

On first pass, it would appear that there would be nothing to learn from such a place, beyond it representing the similarly forlorn situation of many other small-town museums in South Africa. But curator Louis Eksteen, with his institution's meager holdings as his stepping off point, insightfully discusses how museums can reconnect groups of people to their supposedly "innate" legacies.

These are heritages that apartheid severed in many instances and urbanization further eroded: "It is perceived that if you are, for instance, an Afrikaner, you will automatically know how the *Voortrekkers* [nineteenth-century Afrikaner pioneers] lived, or how the Boers actually lived on farms. But I [as an Afrikaner], for instance, haven't even touched a cow or a horse in my life."

Eksteen does not believe that his experience is unique, however: "That's the same with the Zulu people. They do not know their traditional lifestyle anymore. They don't know many sorts of things of their culture and also farm life or rural life, for that matter."

He describes an eye-opening encounter with some visiting Zulu children that finely focused the matter of cultural estrangement for him: "One day I had a group here and there's a picture of a Swazi prince, [posed] with his battleaxe. And the little Zulu children, immediately when they saw this picture, they said, 'Oh, King Shaka, Shaka, Shaka.' And I just said, 'King Shaka?' And I thought, they don't even know how Shaka looked; they just saw a black face in traditional clothing and they immediately thought that is Shaka. And the battleaxe is not even a traditional Zulu sort of axe; it looks different, you know."

Eksteen continues, "So I immediately realized that those children haven't got a clue about their own history. And because of that I also decided 'No,' one should actually display more Zulu cultural artifacts, tell something about them, and display them with the original Zulu names, so that they can understand their own culture."

Of necessity, transformation up until this time has been primarily a white enterprise. Steven Sack, a longtime, ranking arts administrator, makes the point that since the late 1980s, initiatives to expand the reach of museums in any respect were "all done by white management, white curators, white intelligentsia. There had not been a culture of black South Africans going to these institutions. And there certainly wasn't a sense of ownership."

As was the case with Louis Eksteen, Corrine Mahné at the Vukani Collection Museum in Eshowe, has similarly noted black school kids to be seriously in need of knowledge of their own culture: "A number of them have no idea, they have been educated in the 'white' sense of the word, and some of them don't even speak Zulu." She concludes with a sense of assurance that her role is to help offset such cultural decay by making her museum a repository of evidence of things past: "We are very important for the Zulu culture," she asserts.

Throughout the country, traces of knowledge have decomposed from lack of use. Curator after curator will tell you that cultures are "vanishing," "disappearing," "destroyed," and "forgotten." Objects that people once regularly touched, associated with rituals that they actively practiced, are now collected, categorized, and closeted. Now and again, they are displayed.

Ildiko Kovacs, curator of the Empangeni Art and Cultural History Museum, declares, "They [black Africans] are busy losing their own culture." It is an oddly constructed statement seeming to mix intentionality, sorrow,

and denunciation. And Jurgen Witt, founder and director of the Tzaneen Museum, reports that tribal chiefs now and again seek him out to explain the use of sacred objects or to clarify the minutiae of antiquated ceremonies. Their birthright has steadily rusted away to the point of inscrutability.

It will be impossible to ever take the full measure of the impact of apartheid on individuals, groups, the landscape, or the nation's identity. It will be impossible to ever quantify the brutality, the feelings of terror, the loss, the anger. And although South Africa has now entered its second decade of democracy, psyches remain horribly damaged; pain and bereavement still pulsate with intensity. The new world is unfolding but the old one still tugs at the collective consciousness.

As actress and writer Phillippa de Villiers movingly puts it, speaking from her personal experience, "I think if you put animals in cages, and you open the cages, sometimes they'll just still stay in those cages for a l-o-n-g time. The whole 'Build the New South Africa' thing keeps saying to people, 'Come on, come out of your cages. Be entrepreneurs, be this, be that.' But it's very hard. Those things are very complex, plus there . . . is a whole other system that operates below the, below what seems to be reality."

Brushing Aside the Ideological Cobwebs

Many writers argue that museums and the material that they display transmit as well as validate dominant ideologies,[1] and that who controls them determines both the way a society perceives itself, and the face it presents to the world at large.[2] More specifically in regard to Africa, Annie E. Coombes has demonstrated how anthropological museums, colonial exhibitions, the popular press, and other organizations and forums created for a nineteenth-century British audience were complicit in the imperialistic program of establishing one group's superiority at the expense of others.[3]

But institutions can be revamped when there is a profound ideological shift. A comprehensive reexamination is underway at the Musée Royal de l'Afrique Centrale just outside Brussels, for example, an institution about colonial Africa, but obviously not located in Africa. Nor was it intended for African eyes, for that matter.

The museum has recently brought together European and African scholars to challenge archaic interpretations of Belgium's conduct in Congo with contradictory knowledge that has been uncovered regarding the exploitation and atrocities their countrymen committed there.[4] However, Director Guido Gryseels discovered that long-standing inequities are not easily overcome: he says that Congolese professors earn only approximately $20 per month, and that in order to support their families they must supplement their income by farming, driving taxis, and private tutoring, thus leaving scant time for scholarly activities. Moreover—and remarkably—the sole remaining Belgian historian of African colonial history retired in about 2002.[5]

The museum's point of view has hardly been disguised in the past; Gryseels readily admits that it was established as a propaganda tool for the government. For instance, a sculptural group that is nestled in an elevated niche of the imposing marble entrance hall features a white missionary clutching a young boy, while a diminuitive native man looks intently upward at the religious figure. The work's title, "Belgium brings civilization to the Congo," recapitulates the time-honored version of the colonial period. And the Gallery of Remembrance lists the names of 1500 European soldiers and traders who died there. But until recently, there had been no mention of the estimated 10 million Congolese who were reportedly murdered or worked to death there as well.

The museum remained frozen in time since Congo's independence in 1960. Its renewal is such a gargantuan undertaking that the expected completion date is 2010, although *Memory of Congo: The colonial era*, an exhibition mounted in 2005, demonstrated the museum's commitment to opening up a dialogue about the nation's past conduct. Near the end of the exhibition, designers heralded Congo's autonomy by threading a score of vibrant lengths of vintage African fabric around hoops and then suspending them above visitors' heads, turning the material into giant, airy cylinders. Imprinted with the confident faces of new leaders and maps bearing fresh place names, these colorful tubes swirl and dance about, scarcely betraying the next troubled stage in this region's history.

In present-day South Africa, there is much work to be done to accomplish a comparable degree of restructuring. The Johannesburg Art Gallery [JAG], for example, emphasized British painters and sculptors since its 1915 opening. One writer has argued that it was intended to "create a cultural infrastructure" that would nourish British settlers.[6] Just as likely, it was designed to "tame the wilderness" that they found themselves in. With only one exception, the purchase of a Gerard Sekoto painting in 1940, JAG bought no works by black artists until 1972.

A significant step forward occurred with the exhibition *The neglected tradition* in 1988, featuring work by those who had previously been excluded because of their race. At least one critic faults the show because it focused only on those working within the Western canon,[7] although presenting pieces such as these might in fact have been the most strategic way to introduce new audiences to an unfamiliar realm.

Likewise, the Africana Museum collection in Johannesburg was first established in 1933, drawn largely from a private benefactor. European settler culture was represented; black indigenous cultures were not. The first ethnologist's post was only established in the 1960s, and the museum gradually broadened its focus to include native cultures in the 1970s. The collection did not truly become inclusive until it was used to form the heart of the new MuseuMAfricA in 1993.[8]

With slight variations, idiosyncrasies, and exceptions, the histories of the bulk of South Africa's older museums parallel these prototypes.

THE WEIGHT OF THE
COLONIAL LEGACY

Ann Pretorius, director of the William Humphreys Art Gallery in Kimberley, focuses the present predicament with great succinctness: "What do you want us to do? Throw out all the white people? Throw out all the European legacy? Get rid of Queen Victoria, you know, send her into the dungeon?"

We have already noted how the Tatham Art Gallery in Pietermaritzburg answered the challenge, by coupling their portrait of Queen Victoria with one of Zulu King Cetshwayo. Soon after director Brendan Bell and his staff commissioned the painting of the king, they sponsored an additional competition for the design of its frame. According to Bell, the goal was to "try and get something that doesn't overwhelm the painting but at the same time says, 'I am a new addition to the collection. I belong to the twenty-first century. I am different from Queen Victoria, even though I am and forevermore perhaps hanging alongside her.' "

The contradictions, the paradoxes, the ambiguities that characterize contemporary South African museological practice are clearly embodied in Dudu Maddnsela of the Nieuwe Republiek Museum in Vryheid. Vryheid is one of those anomalous places where an early historical episode deeply embosses the area's subsequent character. Vryheid means "freedom" in Afrikaans. This town was one of a handful of tiny, short-lived independent republics (1884–1888) that the Voortrekkers established in the late nineteenth century, repudiating the growing British influence in the country. To this day, Vryheid retains a sense of stubborn individuality. One quirky, antiquated building just off the main business strip is split down the middle: an egg distributor takes up one half and a funeral business occupies the other. The town, according to a postcard issued by the museum, is "where history shall not be forgotten!"

The Nieuwe Republiek Museum is housed in what once served as the Cape Dutch Revival residence of the republic's president, Lucas Meijer. Its elegant detailing and period furnishings epitomize the highest echelons of the white frontier past. Dudu Maddnsela is its most recent curator (2003), a self-assured and feisty 20-something black woman.

Maddnsela possesses a solid background in education, and she was appointed by the local municipal council, a body dominated by black elected officials. But that outraged the museum's board, comprised of whites. Within the first few weeks of her tenure, board members personally confronted Maddnsela and told her that they had no trust in her. They demanded her resignation; Maddnsela defied them.

Individuals have called her *kaffir*—the despised epithet that is comparable to *nigger* in America—right to her face. She has borne the pain. She reports, "Afrikaner people would come here to tell me, 'You kaffir, you don't belong here. This is our fatherland, this is our father-prophet.' " Maddnsela has even been physically attacked within the museum by would-be

robbers, although her pleas for protection have been ignored. And yet she stands her ground.

Dudu Maddnsela takes the personal example and the moral philosophy of Nelson Mandela seriously to heart. She asserts, "We must learn to tolerate, we must learn up and until it is being absorbed by them [Afrikaners] that now it is another time." She views herself as part of the continuing struggle for racial understanding and coexistence: "What the other people before us experienced, I am experiencing it right now."

And yet for all her seeming autonomy, free thinking, and sheer spunk, Maddnsela morphs into a white Afrikaner mouthpiece once she launches into her tourist-oriented spiel regarding the Nieuwe Republiek Museum. Her rendition of history sounds like a rote recitation from an apartheid-era textbook, enumerating the abuses the Brits imposed upon the Afrikaner people: "In the eighteenth and nineteenth centuries, the British were busy with this thing of imperialism," she explains. The Afrikaners' Great Trek was thus a righteous quest for freedom. According to this account, the Voortrekkers would be entitled to speak their own language, practice their customs, and govern themselves without extraneous interference in this newly occupied territory.

Maddnsela's compliance with this particular narrative is doubly odd. It celebrates the struggles of the people who subsequently subjugated millions of people like herself. And it is at odds with her own family's history: Maddnsela's parents moved their family to Natal Province, believing that it would be easier for their children to be well educated in an English-influenced section of the country.

On the other hand, she bristles when she shows a visitor the trivial nod to Zulu culture that previous curators have incorporated into the museum. "Does my skin look like that?" Maddnsela asks with evident irritation when she points out the Zulu-attired mannequins standing in a side room that are colored a deep metallic gray.

This young curator scrupulously deconstructs these representations, exposing the mistakes made by people who were unfamiliar with Zulu traditions or simply indifferent to accurately portraying them. Some pieces of clothing and adornment are inappropriately displayed on the wrong sex. In other instances, signifiers of style are confused: attire restricted to a married woman is shown on someone not yet of marriageable age, for example. And contemporary pieces of clothing are carelessly mixed with the traditional.

Dudu Maddnsela simultaneously personifies the narrow, ideologically conceived history of the apartheid era, the burgeoning resistance to biased portrayals, and the patience of someone who understands that resolving such profound inconsistencies will take a great deal of time.

"Cleaning house" of colonial and apartheid residues is neither an easy, effective nor necessarily desirable strategy. The Tatham Art Gallery's director Brendan Bell cautions against employing a knee-jerk reaction, such as assuming that colonial necessarily connotes bad and should therefore be eliminated. He explains, "One of the reasons for not getting rid of the Victorian paintings,

particularly the Victorian narrative paintings, is that what we find is that our black visitors really engage with those paintings because they are accessible, they are readable to a general public." And this is an insight that Bell claims has been confirmed by black staff and visitors.

An action that might be motivated by sincere concern on the part of white museum professionals to "modernize," and in deference to the sensibilities of black audiences, may instead thrust them into the confusing realm of contemporary, nonrepresentational artwork, where viewers must be specially equipped to understand what they're viewing. To get rid of the colonial legacy in toto could render museums even more mystifying to a newly broadened audience.

Artist Clive van den Berg and architect Luis Ferreira da Silva faced a similar dilemma when they collaborated to design the structurally and aesthetically dazzling Northern Cape Provincial Legislature Building outside Kimberley (opened 2003). Their emphasis was on fostering an organic relationship between their buildings and the surrounding landscape. Their guiding principles and procedures were thus the antithesis of the colonial paradigm for government centers: plopping monumental, classical cubes around an artificially created park or square.[9]

But van den Berg and da Silva's vision collided with the scheme that government officials endorsed; they expected a building that *looked* like a seat of government, a place that would inspire awe and would announce in an unequivocal manner what sort of business was being conducted inside. van den Berg discovered that doing something different was a hard sell: "The reflex position for government that I've dealt with is to go with the colonial precedent, in building type, in dress, in furnishings. All the kinds of status of government, the apartheid, the colonial government, have been accepted as the norm."

This echoes the debate that continues in former British colonies such as Kenya over whether to continue with the tradition of jurists and politicians wearing white horsehair wigs. Opponents feel that the hairpieces look ridiculous, and denote continued submission to oppressive colonialist policy and practice. Adherents counter that the wigs successfully symbolize "the weight of their offices."[10]

The unproblematic approach for van den Berg and da Silva to adopt in Kimberley would have been to stick with the familiar colonial model—give the people "what they want," or "what they know." But they were not content to carry on within traditional limits. Van den Berg recalls, "One of the biggest challenges for me was to convince the client that that was a convention, it was a constructed convention. This is not a norm, not like from heaven. . . . I addressed the Cabinet . . . [and had] months of discussions with the ministers for arts and culture, public works. The colonial precedent would have made people absolutely more comfortable."

To placate people, or to provoke them: these are the two main options at present. The first approach respects and safeguards an audience's comfort zone, but it does not goad them beyond what they know. The second approach challenges the audience, but may also baffle it.

Ann Pretorius envisions an intermediate approach. Rather than pander to her visitors or overpower them, she conceives of the museum as actively steering them into artistic terrain they neither knew existed, nor are equipped to understand straight away. She explains, "A lot of contemporary art is like rocket science to most people, and it needn't be. If you can bring them in at a lower level and gradually entertain and educate them 'til they are prepared to actually look at something they don't understand, without feeling mentally incompetent, then I think you are winning."

Putting platitudes into practice, Pretorius has plopped a gargantuan, semi-abstract sculpture smack into the entrance hall of the William Humphreys Art Gallery. The piece incorporates such recognizable elements as oversized African drums, but the connections between the various components are less concrete and more elusive. Moreover, she has furnished the area with a variety of styles of comfy chairs, encouraging relaxation and contemplation. As she describes, "We live in the *platteland*,[11] and the community here is out of the mainstream, so the collections are quite conservative. Now you bring a piece in like that and everybody says, 'What does it mean?' And 'What are you doing?' 'Is the new director mad?' 'What is this thing?' Which is fantastic."

Pretorius continues, "It involves the viewer, makes them participate against their will because they don't have an idea about what it is." She exploits this sense of bewilderment to get people to reflect in new ways: What do *you* think it looks like? How does it make *you* feel? For the first time in most viewers' lives, their opinion has merit; their opinion bears hearing.

Pretorius concludes, "I want people to understand that every relationship between the viewer and a work of art is unique. For as many people as there are looking at that sculpture, there will be interpretations. And all of them are valid. I don't like descriptive explanations; that becomes academic and that is what frightens people away. I want the viewer to think, and to start to believe in their own conclusions."

Playing by the Book

Twenty years ago, an exhibition strategy such as this would be unprecedented and preposterous. According to Yvonne Winters, museologist at the Campbell Collections in Durban, "The mainline galleries of South Africa were collecting neo-impressionists and neo-expressionists" at that time. The choice of what to display was self-evident, its interpretation dictated by experts. Things were done by the book.

"Everything was in a 'school,' " she argues, "and [black] Africans at that stage were not allowed into mainline universities to do art; they had to go to mission schools like Rorke's Drift."[12] For the most part, before the 1980s, the canon of Western fine art trumped popular expression, and anything deemed to be high culture was referenced and evaluated in relation to what was going on overseas. As professor and critic Ivor Powell scornfully noted, this relentless contrast was "hopelessly oedipal in character:" "[T]here has

always been more rejoicing over the one who shows decorated eggshells in London than the 99 (hypotheticals) who produce *Guernica* at home,"[13] he groaned.

Within the country, anything "traditional," "mass," "popular," and "contemporary" received short shrift. English institutions such as the University of the Witwatersrand and the University of Natal emphasized social anthropology and social systems. Studying ethnographic material culture, according to Winters, was "almost like a no-no."

The Afrikaans educational system, on the other hand, was based on *Volkekunde* ["the study of people"], an essentialist approach where race and psychology were considered fixed, and where material cultural *was* a legitimate focus. But as Winter further explains, "For the English universities, material culture was too closely associated with the Afrikaans universities, and the 'homelands,'[14] and the politics of the time, which was 'divide and rule.' The Nationalists used the whole thing to do with traditional cultures for their own ends." Investigating or promoting indigenous cultural expression was a second-rate endeavor at best, a tainted one at worst.

Gradually, however, some arts faculties became interested in studying and collecting African crafts. This was especially the case for the technikons, a lower tier of schools emphasizing more applied than theoretical training. Professors there could legitimate themselves by studying this relatively unexamined field of African culture, thereby establishing expertise in such media as baskets or pottery.

These factors—looking to European standards and precedents, the split between Afrikaner and English universities, and the disdain for distinctly African expression—started to lose their salience when South Africans became more self-reflective. Their introspection was spurred by a number of reasons.

Antiapartheid activists had enforced a cultural boycott, a mixture of restrictions imposed by artists worldwide against working in South Africa, since the 1940s. The boycott was particularly in evidence from the 1960s through the 1980s, but was rescinded in 1991.[15] To artist, writer, and activist Sue Williamson, "we were isolated as artists by the cultural boycott because South Africa was not even on the radar of the world art community."

But South African artists then began to reengage with the world and to monitor and participate in contemporary artistic discussions. A fresh debate over what "South African art" had been, and what it would entail in the New South Africa, was thus opened. Jill Addleson, former director, and now curator of collections at the Durban Art Gallery, recalls that "[w]hen the world came to South Africa we were forced to look out, and that created a kind of dynamism, and that was very healthy."

The public proceedings of the Truth and Reconciliation Commission likewise generated a great deal of collective soul-searching and engendered fundamental questions about South Africa's past, and its potential future. And postmodernist theorists, who emphasized collapsing cultural hierarchies, examining how multiple discourses construct social categories, and interrogating the

microphysics of power and knowledge, were particularly appreciated in a place where people were redefining themselves, reevaluating their history, and reconstructing their society.

All of this created intellectual interest and support for contemporary African art, and the subsequent appeal of local African crafts. This change of orientation represents an interesting conjunction of rationales. On the one hand, establishing a new form of government provoked an interest in breaking through South Africa's time-honored and specific social and political barriers. This strongly impacted the art world, as it did every realm of activity within the country. And on the other hand, the global impact of postmodernism, which simultaneously encouraged privileging formerly dishonored people and forms of expression and blurring established boundaries, was also welcomed.

As these factors coalesced, they provided the basis for some breakthrough exhibitions.

BREAKING THE MOLD

Few exhibitions merit the distinction of "watershed." The expression implies a defining moment, a turning point, a paradigm shift. Displays are seldom as revolutionary, as consequential, as trendsetting, as the *Salon des refusés* (1863), or the *Armory show* (1913). But in the case of *The neglected tradition: Towards a new history of South African art (1930–1988)* [Johannesburg Art Gallery, 1988–1989], the label fits. If there is a storied art exhibition in South African history, this is it. *The neglected tradition* changed the way "South African art" was defined henceforth.[16]

The people involved in putting it together were aware of its importance from the outset: JAG's director Christopher Till invoked the term "watershed" on the opening page of the exhibition catalogue. And its significance is still appreciated today: David Brodie, JAG's curator of contemporary art in 2003, considered *The neglected tradition* "a kind of wake up call for a number of South African museums. That was a pivotal show," he remarked.

The exhibition presented the work of 100 artists, the majority of them black, previously unexhibited, and relatively unknown. It also featured a catalogue essay by guest curator Steven Sack that systematically uncovered and surveyed a 60-year history of black creativity that heretofore had been ignored by white-dominated mainstream institutions.

Sack was well suited to the task. He was a young white man active in cultural politics such as antiapartheid theater, and a prime mover in the Funda Centre in Soweto, where he set up sorely needed art training for black students. Sack had the pertinent political outlook and social connections. But because the cultural boycott had raised critical issues about creativity and collaboration, Sack carefully mulled over his participation.

Some of his artistic and political contemporaries advised him not to contribute to the project; while its aim was commendable and overdue, it could grant legitimacy to JAG, which they considered to be an apartheid institution.

The show would give apartheid "a human face." This was a classic collision of liberal and radical perspectives. But in the end, Sack decided that this venture was simply too important to pass over.

Sack recalls that the initial text he assembled for *The neglected tradition* had a "struggle" character to it; it was, in that respect, a reflection of the super-charged tenor of the times. But without claiming censorship, he acknowledges that subsequent input from his wife as well as JAG personnel made it more "subdued," "cleaned up," "objective."

The neglected tradition was intended to be a corrective: to the tyranny of aesthetic hierarchies, as well as apartheid divisions. It was thus objectionable to those who were deeply invested in the artistic and racial status quos. Sack reports, for example, that some right-wing city councilors said "outrageous things" to JAG's director, "about what was he doing to the gallery, bringing in black art? And they may have used even more racist language than that in the gallery." If the names of artists such as Noria Mabasa, Bonnie Ntshalintshali, Johannes Maswanganyi, and John Muafangejo were little known before then, their public profiles changed dramatically afterward. And if the art historical record had held significant lacunae, these were being addressed at last.

Steven Sack notes that museums were late in beginning to collect the work of black artists: "It certainly caused all the museums to review their collection policy and to proceed rapidly to acquire work. And it also impacted on a number of important private collectors." Once major museums had introduced such work, collectors altered their buying patterns accordingly. In fact, a scramble of sorts commenced, triggering a modern-day South African gold rush.

For Sack, "The greatest neglect in a sense was the neglect of the key custodians, which were the museums themselves." Because of this, JAG found it necessary to borrow a great deal of work from the aforementioned Campbell Collections in Durban, one of the few places that possessed a stockpile of contemporary African art. Built upon the eclectic holdings of a wealthy benefactor, its development had not been corseted by inflexible aesthetic restrictions, conservative boards of directors, or political autocrats. According to Yvonne Winters, "When the galleries wanted to transform and jack up their collecting policies, we were the ones that supplied them with loan material, until they established new policies and started collecting retrospectively. Everybody was courting us because we had the holdings."

But the impact of *The neglected tradition* did not merely entail identifying unnoticed artists and delineating an "alternative" canon. It denoted a sea change in how creative output as a whole was regarded. Steven Sack says, "I felt very strongly that this was not a history of black South African art. That this was the history of the forces and the environment and all the conditions that formed the work of black South African artists."[17]

Sack thus took into account how economic policies, rural and urban social conditions, religious beliefs, and artistic and craft traditions all impacted upon what black artists produced. And whereas harsh restrictions both prior to and

during apartheid severely curtailed the training black artists could receive and what they could achieve, not all of them were cut off from the "art world." By including a few white artists such as Cecil Skotnes and Edoardo Villa in the exhibition, Sack demonstrated that some noteworthy creative interactions had crossed the racial divide, with black and white artists mutually enriching one another's output.

The legacy of the exhibition's revolutionary outlook is apparent in a later generation of scholars, curators, and artists who have received a very different sort of education than the one that reflected the narrow perspectives of historical and national traditions, and individual genius. Today there is substantial consensus that some of the artists showcased in *The neglected tradition* are to be counted amongst South Africa's most gifted creative individuals. But the fact that they were black superseded their accomplishments at that time.

At the opening of *The neglected tradition*, Steven Sack mentally went down the roster of names, and their respective fates: "dead," "dead," "dead," "jail," "exile in London." Rare were the artists who were able to personally witness or savor their initial moment of triumph.

Exploring New Waters

For all the importance of *The neglected tradition*, an exhibition held in a commercial gallery a few years earlier also helped shatter established frames of reference. That show was *Tributaries: A view of contemporary South African art* (1985), sometimes referred to as the *BMW show* because of its sponsorship by the South African subsidiary of the German car manufacturer. Corporate support of cultural endeavors has drawn increasing criticism from artists and scholars in the intervening years, but such an assessment was anticipated and deflected by a well-known art critic, right at that time. He wrote, "Purity is neither relevant nor possible in the South African political and aesthetic contexts today. Everything comes already tainted and the issue is what the organisers have done with the sponsorship, not where it came from."[18]

Presaging a technique that has become popular in major South African galleries post-1994, organizers freely mixed paintings and sculptures with dolls, dancing maces, a *kraal* [homestead, with animal enclosure] guardian figure, a ceremonial mantle, a bridal veil, and *mapotos* [Ndebele married women's aprons]. The serendipitous affinities that emerged from this catholic strategy encouraged visitors to view all of these objects in new ways. Curator Ricky Burnett thereby troubled a number of basic distinctions between art, craft and ethnology, "high" and "low" culture, and center and periphery. *Tributaries* confronted aesthetic hierarchies within the art world and the repressive racial hierarchies beyond it. This exhibition signaled the "democratisation of the object."[19]

Moreover, the 111-piece show was presented at a new gallery in the complex of buildings that housed the renowned Market Theatre; a few years

later MuseuMAfricA would be located nearby. The venue, therefore, was not burdened with the traditional solemnity of a museum setting or the authority of exhibition conventions and audience expectations. An exuberant newspaper review by artist Andrew Verster declared, "After the BMW exhibition opens nothing in our art world will ever be the same again. I can be so certain for this show does what no other collection of South African art has every [*sic*] done."[20]

Burnett consciously chose the "tributaries" metaphor: "[F]or all the main rivers or streams, there must be branches which feed it (or feed our art). In our country of diverse cultural traditions, and many streams of artistic endeavors, I felt that the word 'Tributaries'. . . was an appropriate one."[21] Accordingly, he searched for work falling within four broad categories: rural traditional, rural transitional,[22] urban black, and urban white. In his introduction to the *Tributaries* catalogue, Burnett recalled, "Our investigative journeys took us to . . . opulent collections, grass woven beehive huts, city centres, barren settlements and some very pretty villages."

Diversity was the key here. Burnett concluded, "South Africans cannot, and ought not, to lay claim to a common culture. But there is, we hope, in this collection a sense of a common humanity."[23] And yet for all its groundbreaking attributes, it was also a product of its time. Four of the five artists profiled and interviewed about their work in an article about *Tributaries* were urban whites, well-credentialed and highly educated urban whites, at that.[24] And in the catalogue itself, three black Africans were given the opportunity to discuss their own work, while eight white artists (and one white curator/collector) were afforded that chance.

NO IVORY TOWER

Building upon the collective legacy of these shows, today's museum workers face situations their predecessors could not have imagined. Gilbert Torlage of the Heritage and Museum Services Unit of KwaZulu-Natal Province describes a collecting mission to obtain the objects he required for an exhibition about the Mthethwa people. To gain the necessary permissions, he strictly adhered to a time-honored African protocol: proceeding from the chief, to his son, down to the headman.

Torlage met these leaders and assembled villagers under the proverbial tree, where important group matters are customarily deliberated according to African tradition.[25] And by speaking to them in fluent isiZulu, which he had mastered as a child, Torlage was able to significantly reduce the social distance between the parties.[26]

To help put his point across, Torlage brought artifacts along with him that he'd previously collected from other Zulu groups. He hoped this would lessen any suspicions the Mthethwa might possess by demonstrating that other groups had already entrusted their traditional objects to him. As he tells it, "I started pulling out things and they were absolutely delighted to see these items we had collected. And 'Yes,' they have things similar to that as

well, and they would be able to help us. When we went back later the message had obviously been spread, and we got marvelous assistance."

But encounters such as these do not begin and end at the initial point of contact. Relationships were established; obligations incurred. Villagers therefore trekked to view the exhibition on the first day it was open to the public. Here they slaughtered a beast, heartily sang and danced, and then concluded by blessing the building, as custom dictated on a momentous occasion such as this.

The spirited morning episode was followed by an official ceremony later that same day. According to Torlage, "In the afternoon people in the formal jackets and ties pitch[ed] up and there was kind of a white opening as well. . . . the [first] one was interesting and full of light, the other one was deadly dark."

In the same vein, Barry Marshall, director of the South African Heritage Resources Agency [SAHRA], relates the story that in 2004, to mark the 125th anniversary of the Anglo-Zulu War, the South African Monuments Council decided to erect a memorial to the Zulu dead at the famous battle site of Isandlwana. The English suffered a staggering defeat there, and their dead have been commemorated ever since. For that reason it has become the destination of many British pilgrimages. But the native casualties have never been similarly honored.

The council commissioned a design and then took it to the House of Traditional Leaders, which enthusiastically endorsed it. But with this proviso: the chiefs strongly felt that they should shoulder the costs. So what would the tariff be? Supplying a beast would discharge the debt for each of them. And in a nod to contemporary practices, they could opt to transfer cash into the agency's bank account instead. In Marshall's words, "We must have collected at least 60 or 70 [heads of] cattle. There were 190 chiefs. Some of them put money into an account; [with] the rest [it] was, 'just come and fetch the animals.' "

The actual job of gathering and then selling the livestock fell to Marshall. But rather than this becoming a nuisance, Marshall found it to be a deeply satisfying experience: "In a very real sense it [the monument] is the property of the nation, it is what they wanted." Queried about his preferences for contemporary monuments and such, Marshall makes it clear: "We want the memorials we put up not to follow the 'big phallus symbol' [model], like somebody on his horse. We'd like them to be sort of home grown. Afro-centric. From this part of the world."

The Unbearable Weight of the Status Quo

Both *The neglected tradition* and *Tributaries* were mounted during the apartheid 1980s. And yet why didn't museums act more daringly before 1994? The most simplistic and dismissive answer would be that museum workers were active agents of a virulently racist government. But a more incisive explanation requires a deeper excavation of motives and outlooks.

Kevin Cole, director of the East London Museum, is strongly committed to incorporating multicultural depictions into the exhibitions his staff develops. But why does this interest surface at present and not previously? He explains, "When we address issues of frontier wars, for example, we try to address the issues from what we know now, but [also] to try and fill in the gaps. The only trouble is, we never thought about the gaps. Where are the gaps?"

And this realization has prompted new methods of inquiry: "So we need to elicit inputs from people who could raise questions or point out the gaps. It is a whole different thought process now." In this respect, the explanation lies not in explicit apartheid restrictions, but rather in a mode of thinking in which entire realms of experience were automatically overlooked, neglected, rendered absent.

For Rochelle Keene, retired director of the Johannesburg Art Gallery, and past president of the South African Museums Association, "I don't think that it was a deliberate thing about exclusion, I think it was about representing the political balance at the time and short sightedness." But Keene believes this was not a uniquely South African issue: "I think it was a museum problem all over the world, that you represent who is in power at the time. And I think that it is a shame in a way that museums didn't more proactively change what their displays looked like."

She continues, "In foreign museums there was a major shift in the late eighties, and the shifts that were going on internationally were also very much reflected in what was going on in South Africa." But while the questions being posed may have been widespread, the decidedly politicized nature of South African society at the time heightened the attention they received.

Colonel (retired) Frik Jacobs, director of the War Museum of the Boer Republics in Bloemfontein, argues that these lapses also extended beyond the museum realm: "Very few if any historians in this country found the need or the time to write down the suffering of black people, the rural life of blacks, the disruption of their tribal traditions. It was not considered a no-no. It was considered unnecessary because they were writing to create nationalism."

When asked what sort of reaction would have occurred if a museum had tackled significant social issues in the past, Carol Brown, director of the Durban Art Gallery, answers, "Nothing particularly happened, but there just wasn't a great deal of support or interest or whatever." She believes that because of the various declarations of states of emergencies, which included the power to ban specific artwork or exhibitions, "I think a lot of the artists were nervous to come out, a lot of artwork perhaps was not being made."

On occasion, curators used subterfuge to exhibit work that they suspected could be officially deemed objectionable. Rochelle Keene provides a good example: JAG obtained the portrait of a black man who'd been murdered by agents of the government. To display it was one thing; however, to provide a label that precisely identified it might be tempting the fates, and the police.

Consequently, "Alter piece for Thomas Kasire" was identified only by the generic description of "portrait in a landscape."[27]

But the key factor in explaining the consistent narrowness of representation in museums is probably this: apartheid regulations effectively kept people apart. Brown reflects, "You somehow never really knew or spoke to or interacted with a lot of . . . [struggles, and fails, to complete her thought]. You really didn't meet black people very much. We never grew up knowing them, or going to school [with them], and it is only perhaps the last ten years that I've sort of been to black peoples' homes, and had friends, and interacted with them."

As a result, the conventional white South African's *habitus*—Pierre Bourdieu's term to describe how individuals internalize and act out the practices and preferences of their particular social setting and position[28]—led them to acquiesce to the conventional ways of doing most things. The majority did not, or could not take a critical step backward to grasp the broader view. Exploring the "black experience" did not come to curators' minds; it resided in a landscape that was either physically separate, or hidden in plain sight: "Perhaps we were a bit complacent," Brown now acknowledges. "We did a little bit, what we felt we could do. We never had the confidence maybe to do more."

Talking 'Bout Evolution

One notable topic *did* stir the pot, and that was evolution. South Africa's influential Dutch Reformed Church supported a strongly antievolutionary position. And Dr. Bob Brain, retired director of the Transvaal Museum in Pretoria, ran directly into that obstruction in the 1960s when he developed an exhibition on the subject. The display showed various family trees and demonstrated how humans had evolved from earlier hominids. But church people took strong exception to this. They argued that humans were created as such by God and they did not develop from previous forms.

Brain allowed for members of the public to leave their comments at the end of the exhibit, which elicited scores of antievolution remarks. "A lot of it was abusive," he recalls. Moreover, "It was quite funny, like 'Maybe you come from a bloody baboon, but I certainly don't.' "

Brain remembers that an impassioned series of letters to the editor in the Pretoria papers in the early 1970s brought the issue to the forefront. "They [critics] couldn't care a damn if evolution occurred in the so-called lower animals," he continues, "it's only when you get up to the human level [that there's a complaint]." According to the antievolutionists, " 'We are the pinnacle of creation,' and the rest of the lower animals, grovel around at our bequest." But Brain believed differently, that humans are a late offshoot of a very long process of evolutionary succession.

Significantly, although the Transvaal Museum has scrapbooks of press clippings extending back many decades, the sections of those volumes that

would be pertinent to preserving this debate are missing—a discovery that I made in the course of my research, but an interruption of the historical record that the staff of the museum's library was not previously clued into. When the head librarian queried longtime staff members about the matter, they were not surprised about the hole. They too recall those highly emotionally charged times, and they realize that any number of people may have wanted to expunge the official record.

Dr. Manton Hirst, principal human scientist at the Amathole Museum in King William's Town, corroborates the difficulty of broaching this topic: "The evolution of man and life is a very interesting theme which has emerged in my own lifetime, which at one time was quiet. You could only whisper about it in South Africa because there are people with serious religious ideas who wouldn't want to hear anything about this."

The Transvaal Museum's curator of mammals, himself an Afrikaner, eventually squared off with representatives of the church and local government. To his surprise, a government minister found the man's scientific arguments to be compelling, and he declared to his fellow politicians that the debate over human evolution was henceforth closed. Even so, after additional work was done on the evolution display in 1987, 70 percent of visitors who left written comments rejected the concept, with more people responding in Afrikaans favoring a creationist perspective than those reacting in English.[29]

David Morris, archaeologist at the McGregor Museum in Kimberley, likewise discloses that some people strained at the bit, refusing to toe the official line regarding curriculum: "I recall organizing behind-the-scene visits for high school classes. In those days things, admittedly, were already changing, but precolonial history was still to a significant extent down-played, stereotyped, and even denied, and evolution was certainly not taught." He continues, "I remember not only discussing with high school groups the impact of archaeology on these matters, highlighting where the archaeological findings directly contradicted the old propaganda (e.g., whites and blacks entered South Africa simultaneously) but also debating around the issues as to why these things were excluded from the curriculum."[30]

And not everyone complied with the apartheid government's classification of museums as either "Own affairs" or "General affairs." Paralleling the concept of the Tricameral Parliament, whereby "whites," "coloureds," and "Indians" (but not black Africans) were allocated their own legislative bodies, the national government also devised an "apartheid of museums."

"Own affairs" museums were to concentrate on the history and culture of groups having European roots, that is, the English or the Afrikaners. Museums designated as "General affairs" would have a more expansive focus, which could include natural history, as well as black history and culture(s). A critique of this oversimplified division appeared in the *SAMAB* with the clever and cheeky title, "Grey history: A pox on general and own affairs," where the writers argued, "History is not black and white, it is grey."[31]

Pam McFadden, curator of the Talana Museum in Dundee, had "a major row" with the government over this distinction: "We said, 'Absolutely no way.' We refused point blank to be classified as 'Own affairs,' " she reports. "How do you separate the wounded British soldiers from the Indian doing [handling] the stretcher who was carrying him?" she questioned. McFadden won out: the Talana Museum was classified as "General affairs," thereby allowing the broader scope that she and her museum desired.

The accepted boundaries were tested in seemingly slight, but determined, face-to-face ways as well. One museum director, who requested anonymity on this point only, distinctly remembers when she wished to add the first piece of African art to the collection. Official policy prohibited her from doing so. To plead her case, however, she carted the piece in question to a city council meeting, waited for the members to exit, and then showed them the work. This direct approach persuaded otherwise reluctant and dubious councilors to procure the initial bit of Zulu material for this museum.

But Is It African?

When Ali Hlongwane, chief curator of the Hector Pieterson Museum in Soweto, recounts his personal history of familiarity with museums, he speaks for a vast public as well. And that includes many other black people working within these institutions at present. His first visit did not take place until he was 21 years old, and not in South Africa, but as an exchange student in the United States. It was to a museum featuring what South Africans commonly describe as "Red Indians," that is, Native Americans.

"I had never even bothered to go to any of the museums in South Africa because, in a way, they did not appeal to us [blacks]," Hlongwane declares. Denmark Tungwana, a deputy director at the Robben Island Museum, recalls, "As a young person, I went to a museum once and then never went back again." And Neo Malao, manager of the National Cultural History Museum in Pretoria, divulges a "tribal confidentiality" by stating unequivocally, "If you want to see [how] whites make a joke out of you, go to a museum."

Alien. Irrelevant. Unfamiliar. Peripheral. Black people use these adjectives time and again when describing the relationship between members of their communities and museums. And while most South African museum officials would today deny that there were explicit restrictions against admitting black Africans during apartheid, others remember those times differently. A controversy broke out in Kimberley in 1997, for example, when the then director of the William Humphreys Art Gallery issued a statement to the effect that the museum had not engaged in apartheid practices. A provincial official quickly countered the validity of that claim, saying that employees of the division of arts and culture could personally attest to being barred from the place, or were " 'subject to greater scrutiny' than other visitors."[32]

Yvonne Winters reports that she once asked a fellow museum staffer who was black what he thought of when he thought about museums, and he replied, "dried giraffes." That jibes with personal experience when I have asked for directions to museums at petrol stations, on countless occasions throughout the country. Attendants typically draw a blank when I first query them. Only after I repeat the name of the local institution several times, and describe some of their possible holdings, will the workers eventually crack a large smile and reply that that's where the old stuffed animals are kept.

Tshidiso Makhetha, curator of education at the Johannesburg Art Gallery, wryly characterizes museums as "white elephants." The term is richly apt. Museums are sizeable creatures. They have been predominantly white-oriented places in the past. And to many people, they appear to be outmoded, something to scrap.

"Who" and "what" is African is questioned a great deal in contemporary South Africa. On many occasions the discussion devolves to individuals claiming that particular practices (homosexuality), certain racial groups ("whites"), or specific institutions (museums) are European imports that are "unnatural" and illegitimate, or threaten the "purity" of indigenous African customs and innate heritage.

To tag something as "un-African" is to discredit its authenticity and tersely dismiss it. Said about a black person's conduct, it would connote demonstrating bad faith, having been seduced, ensnared, and tainted by foreign influences. Said about a white person, it questions the legitimacy of anything they say or do.

From this perspective, what is "African" is for all intents and purposes reduced to peoples and cultures that existed before colonization. Ironically, this freezes culture into an ahistorical limbo, thereby refuting the notion that cultures are dynamic, and discounting the fact that one of the important ways by which they change is through contact with other traditions.

Many museum officials understand that a serious challenge for transformation is that different groups hold a fundamentally dissimilar attitude to these institutions. Colonel Frik Jacobs argues, "People of European descent understand museums, and museums have a relevance for them. The real African people are still not comfortable with the museum concept. So there's some *missionary work to be done*" (emphasis added). While raising significant points, Jacobs (in all probability, unconsciously) reiterates the type of condescending perspective that continues to drive a wedge between black and white South Africans.

Henriette Ridley, assistant director of the Voortrekker Museum in Pietermartizburg, understands that change is as critical to institutions as it is to individuals. She reflects, "I feel very hesitant in saying this: in my opinion what appeals to the African South Africans is much more things like oral history [or] a living museum where there is dancing and singing. I think they want a more interactive place."

Accordingly, Bongani Ndhlovu, manager of the Ncome Museum at Blood River, has learned the value of making a museum less conventionally

"museum-like." If you look over the visitor's log at Ncome, you will notice that visitors can be markedly sporadic. But since Ndhlovu began to schedule regular native dancing events, people have been flocking there.

And Colin Fortune, director of the McGregor Museum in Kimberley, understands that a significant proportion of the local black population considers his establishment a "white building." Demolishing it would not necessarily change peoples' perceptions of the museum's collections and activities. But promoting a new institutional attitude might: "What we are trying to say to them, 'Take ownership of this museum. It may be a very Euro-centric, a very Victorian structure, but the labor, the skills, the artisans, came from the black and brown populations,' if I can use those terms."

At the end of the day, Colonel Jacobs fully understands what a hard sell the concept of the museum can be when it is transplanted from one location to another: "Quite frankly, if I were sitting in Kenya [as an example], I would much rather have running water and medical facilities than have another museum."

Da Vinci in Arcadia Park: Whose Renaissance?

Can museums be made more relevant to black Africans? And to do so, is it necessary to pitch exhibitions to some lowest common denominator?

These issues and others were underscored when the Pretoria Art Museum hosted the traveling exhibition *Leonardo da Vinci: Scientist, inventor, artist*, in mid-1999. This museum is noteworthy for curiously contradictory reasons. On the one hand, it mounted a dozen exhibitions between 1967 and 1985 that included work by black artists from the region. These incorporated both crafts and fine arts, and featured work by some of the same artists who were later represented in *The neglected tradition*.

On the other hand, the Pretoria Art Museum opened its doors in 1964, and an undated architectural drawing in the museum's archives demonstrates that it was also an institution reflecting its specific historical period. This diagram of the interior area shows a staff toilet, with amenities for "European males" and "European females" abutting it on either side. Other toilets designated for "Bantu males" and "Bantu females" are deliberately separated from them by the strategic placement of passageways. The walls of this museum were, therefore, integrated far in advance of its hygienic arrangements.

The *da Vinci* exhibition concentrated on this legendary man's work as a scientist and inventor. It primarily presented facsimiles of his notes and sketches, along with models of his inventions. Attendance soared, the numbers inflated by hordes of schoolchildren dutifully trudging through it. Chief curator Dirkie Offringa believes that the museum still holds the South African record for most visitors: 125,000 people in 3 months. But newspaper articles of that period tell an additional story. Entitled "Africans wary of this

master," and "Is da Vinci relevant for blacks?" they forewarn today's reader that the exhibition generated both heat and light.[33]

Critics let fly charges of elitism. Artist Kendall Geers, no stranger to carrying on well-publicized disputes in the press, blasted the exhibition in his dispatch to a major South African daily.[34] Geers's reasoning, in effect, toted up a philosophical and damning version of connect the dots: da Vinci symbolized Renaissance thinking; colonization and apartheid were a direct consequence of these ideas; da Vinci, therefore, personified evildoing and contemporary irrelevance. This white liberal screed rejected the exhibition out of hand.

But art historians and curators defended it in grandiose terms, proposing a counter syllogism: da Vinci symbolized the creative spirit courageously breaking away from the strictures of tradition and the church; inventiveness and liberation were a direct consequence of these ideas; da Vinci personified a life force beyond time and place, thereby offering a significant model for an emerging African Renaissance.

One detractor dismissed Geers's allegations as "factoidal gumff," and suggested, "Instead of remaining couched in the Dark ages and broadcasting backward-looking, boorish skepticism, we should reawaken ourselves from our beer-swilling bondage of *boerewors* [sausage], *pap* [cooked maize meal, an African staple] and bananas and embrace the cognitive curiosity that the exhibition provides."[35] Truth be told, each side overdramatized its claims.

Black opinion, when it was solicited, also found that the exhibition had merit, albeit of an exotic and abstract sort. One art student, sounding eager to please his interviewer, observed, "I cannot say that da Vinci has any significance for me but I can obviously learn a lot from him."[36]

And the operator of the Soweto Neighbourhood Museum bemoaned the fact that a lack of exposure to art hindered many of the formerly disadvantaged from understanding and appreciating what museum exhibitions might offer them. He lamented that fellow blacks "climbing the corporate ladder would rather spend money on luxury cars instead of art because they have not had art education."[37]

This man was alluding to members of the "Wabenzi" tribe: the *nouveaux riches* for whom awareness of South Africa's lengthy political struggle and any sense of responsibility toward their contemporaries are relegated to the background. Of prime importance to them is personal enrichment, symbolized by acquiring the totemic Mercedes Benz. So yet again, the ideas and sentiments underpinning museum exhibitions, and the interests of the bulk of the black African population, were revolving in different orbits.

STILL, RACE MATTERS

The Happy Sindane affair and several additional examples in this chapter have demonstrated that race remains a central feature of South African life. It is not farfetched to characterize it as an obsession. Regrettably, racial distinctions

have been reinscribed in the post-1994 period in ways similar to the way they were pre-1994.

The Employment Equity Act, for example, requires employers to itemize their workers by racial category in order to assess how far they have progressed in meeting affirmative action targets. Being "black," long a social liability, carries obvious political and economic advantages today. But one's claims rest on more than the actual shade of one's skin; it is as much a historical and social distinction as it is a racial one. And as during the days of apartheid, peculiar decisions can be rendered.

In legal terms, "black" is defined as African, coloured, and Indian. But in a case reported in 2003, an aspiring flight attendant was rejected by South African Airways [SAA] because she was "not African enough." As a "coloured" person, she would not help SAA reach its objective of making its employee pool reflect the demographics of the country. But someone can even appear to be "too black." In a lamentable episode in 2004, police detained a 15-year-old boy and threatened him with deportation because he appeared "too dark" to be South African. In this case, the xenophobic fear of *makwerekwere* [illegal aliens] singled out its prey in much the same way that apartheid regulations once did.[38]

Race thus continues to be highly politicized, and the question of who is and who isn't "African" is vigorously argued. "Shall we bring back the race board?" one letter to the editor asks in dismay. One more declares "My sweat has earned me a piece [of this country]," whereas another asserts, "My skin may be slightly pink, but the blood that runs in my veins is red, like the African sunset, like the mud that can be found in certain places in Africa."[39] Not surprisingly, all these writers carry non-black African names, and their sentiments reflect their sense of being edged aside in the present day. As long as being black is given preference with respect to opportunities in the "New South Africa," race will retain its (controversial) salience.

Evolutionary biologist Stephen Jay Gould demonstrated the power of racial ideologies in *The mismeasure of man* (1981). He persuasively argued that nineteenth-century scientists *unconsciously* biased their studies on race and intelligence: they skewed presumably objective data by under-measuring the interior skull capacities of African specimens, while packing European samples to their maximum volume. Those investigators erroneously took their results to be evidence that Europeans were naturally more intelligent than Africans.

For Gould, racist fallacies led investigators to generate data that confirmed their preconceived ideas; to this modern-day scientist, a more insidious state of affairs than if his predecessors had purposely set out to do so. In his opinion, they were so steeped in the bigoted, imperialist thinking of their era that it thoroughly and woefully tainted their research.

Whether or not South African curators deliberately encoded the supposed evolutionary sequence and intellectual hierarchy of apes, Bushmen, black Africans and Europeans into their exhibits eludes a definitive answer. What is clear, however, is that this was the message that was persistently

communicated within museum after museum, throughout the greater part of the last century.

This chapter has primarily focused on meanings of race during the apartheid period, implemented in 1948, and during the postapartheid era, beginning in 1994. The ways in which today's curators address that much lengthier legacy of exhibiting race and difference is the subject of chapter 3.

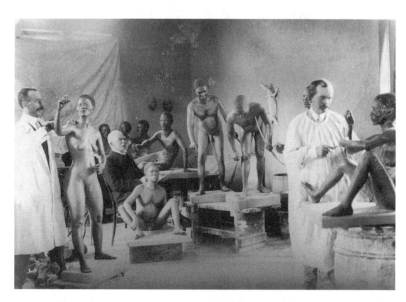

Figure 4 James Drury (left) working on body casts of Bushmen in the South African Museum studio. Dr. Péringuey is seated in the center

Source: South African Museum Photographic Collection, courtesy of Iziko Museums of Cape Town.

CHAPTER 3

The First Shall Be Last:
Picturing Indigenous Peoples
and the Sins of Long Ago

The African soul is a blank slate on which anything can be written; onto which any fantasy can be transposed.

Naipaul, 1980

Childhood ruminations often contain fond memories of museums. These places may house the grotesque, the mysterious, the monumental, the creepy, the unimaginable, the beautiful, the thrilling, and—giggle/titter/shhh!—the lurid.[1] Museums offer insights into how the world works, what it means to be human in all of its manifestations, how people are related to other species, and what they have achieved through the ages. And museums help kids develop their distinctive sense of self, both by seeing their own reflections in certain respects, and by judging themselves against other stuff that is there on offer. Museums supply excitement, wonderment, instruction, forbidden pleasures, enchantment, and escape, all in one extraordinary spot.

A memoir of growing up in Cape Town in the 1950s and 1960s includes this passing allusion to a favorite Sunday afternoon past time: "Sometimes we would go into the museum to look at the Bushmen and amuse ourselves with the big, stuffed gorilla."[2] This visit typically triggered mutual teasing, comparing one another to apes, calling their mates "ugly," and, not surprisingly, lots of laughter.

The place in question is the South African Museum [SAM]. And the life casts displayed within the Bushman diorama made it the best known and the most popular attraction there. In fact, this particular author's voice stands for incalculable others, generation upon generation of South African children. But the writer in this instance is somewhat unexpected: a black woman reminiscing about her early life in District Six, a multiethnic, working-class enclave near the city center that was demolished by apartheid decree in the 1970s and 1980s (to be discussed in chapter 5).

She describes her band of happy-go-lucky youngsters as "[a] crazy mixture of a lot of Coloured and a few African children."[3] And that's what causes a reader to take pause. When the *coloured* [mixed race] children gawked at the display of diminutive people with a yellow tint to their skin, some of the real-life models could have been related to them, molded in plaster early in the twentieth century. And the black African children, themselves members of a reviled group, were similarly mesmerized by what they saw.

It's likely that this bunch of kids made the trek to SAM regularly. And it's also probable that they sniggered at these peculiar human/creatures, just as they carried on in front of the nearby gorilla display. Museums do entertain, after all, and children can hardly be expected to bring a politicized or deconstructive eye to their casual viewing.

But as beloved as the Bushman diorama has been, it has also been deeply despised. And as such, it has sparked a great deal of conversation, controversy, and ongoing revision.

CAST OF CHARACTER(S)

The public trekked to SAM's Bushman diorama over many, many years—for nearly a century, in fact. The exhibit featured body casts produced by the museum's own collecting project between 1907 and 1924. The undertaking was initiated by museum director Dr. Louis Péringuey and carried out by modeler James Drury. Sixty-eight casts were made during that time; years later, additional molds were cast for the first time.[4]

The title of a book that recounts Drury's 40-year affiliation with SAM, *Bushman, whale and dinosaur*, highlights the centrality of these body casts to the museum's reputation, while at the same time it reduces the human models to the status of animals, both living and extinct. Published in 1961, it subscribes to the same racist point of view that motivated the expedition in the first place. The text describes Bushmen as "inconsequential as children," "inquisitive as monkeys," and "primitive and superstitious savages." In Drury's own words, "what we restless Europeans call laziness is an inherent racial trait with Busmen [*sic*]."[5] He rewarded his subjects with a white shirt and tobacco for their compliance.

Part of this collection has been on view since the early twentieth century (1911–1919), with early photographs showing them bunched together much like a herd of eland or a pride of lions. These figures became "[t]he main attraction of the gallery," when a new display was mounted in 1941—"undoubtedly."[6] At that time, three glass cases highlighted three "types" of Bushmen, differentiated by geographic location: the Cape, South West Africa, and the Transvaal. The majority of the figures were undressed because "they are considered to be mainly of anthropological rather than ethnographical importance."[7] They were bodily specimens, stripped of their individual histories and devoid of personal psychologies.

At this stage, the curators also presented a selection of African weapons, art, and other items. But they realized that these played like a B-movie to the

main feature in the public's mind. A museum staff member condescendingly explained, "This is to cater for a certain section of the public which likes to dabble gently in what one might call 'the popular highbrow.' "[8]

SAM's galleries were redone once again, beginning in 1959. The diorama that the little girl from District Six recalled visiting replaced the basic glass display cabinets at that time. The same 13 Bushman figures continued to be displayed: male and female, clothed in loin-coverings and aprons. But now they were regrouped into a "natural setting," reflecting "a day in the life" of such people in the early nineteenth century in the Karoo [a vast semidesert that sprawls throughout the Cape provinces].[9]

It's important to realize that SAM's successive modes of presenting these exhibits represented normative museum practice at the time, not something irregular. The museum also endorsed and reproduced broader social attitudes. Throughout the last century, as change occurred in either respect, the Bushman display was correspondingly altered.

SAM added another dimension to the diorama in 1989, reflecting greater self-consciousness on the part of the museum world, a more critical discourse on the ethics and unequal power dimensions of displaying human beings, and a growing respect for indigenous peoples and their cultures. Curators pulled together an adjoining display that explored the original rationale for the casting project, and they examined the background and identities of the people whose bodies had been used. Years after the fact, a sense of personhood was thus restored to people whose material bodies had been in effect frozen in time. This supplemental information literally "fleshed out" what had long been considered as inert objects.

The task of continuing revision became evident again in 1993 when curators added "dilemma labels" to the diorama. These printed texts analyzed the suppositions, omissions, and obfuscations of the exhibit. "We had great fun pointing out why the exhibitions were flawed," curator Dr. Patricia Davison recalls. This was, to her mind, "an auto-critique of what was there."

Davison judged these interventions to be stopgap measures, signaling that the SAM understood the Bushman exhibition raised significant, critical questions for many contemporary viewers. She and her colleagues thought it important to make clear that the diorama had a particular history and to reveal the mindset that had generated it. "What we tried to do is to explain to students and others that all exhibitions are constructed, no matter how realistic you make them look," Davison argues. "In fact, probably the most realistic ones are the most constructed ones," she continues, "in that you are trying to efface that this is a museum, and this is in fact something that has been designed and scripted, and selections have been made."[10]

The curators superimposed images upon the display cases to complement these dilemma labels, imagery that contrasted with the exhibits themselves.[11] "They destabilized the narrative," Davison asserts. In some instances they filled in historical blanks, in order to propel the people represented by the casts from a hypothetically pristine hunter-gatherer existence to the modern-day farms and mines where many of their descendants eventually toiled. In

others, they counterpoised seemingly strange local customs to their equivalents elsewhere, laying emphasis upon the conceit and dominance of the Western perspective.

Davison also remembers that she and other museum personnel wrote papers on these matters, and they presented talks at professional conferences. But Davison readily admits that the populace at large was for the most part excluded from these discussions. She understands as well that "more" was not necessarily "better": adding text and visuals to the diorama was a strategy as likely to confuse or bore the average visitor as it was to engage or enlighten her. As artist and professor Pippa Skotnes remarks, these supplemental gestures were unequal to "the theatre of the actual diorama."

Split Decision

One of the most serious objections raised against the diorama was that the museum relegated Bushmen to the status of animals by featuring them in what the general public considered to be a natural history museum. This was certainly the perspective that President Mandela voiced in 1997 when he condemned museums for being narrowly focused and degrading. And on the face of it, the charge seems to fit.

But the actual story is more complex. The SAM dates back to 1825. After 125 years of collecting, accessioning, and receiving gifts, its holdings exceeded its storage capacity. So something had to be done to relieve the strain.

The SAM had always been a general museum but remade itself in the early 1960s. The colonial history collections were transferred to another location, forming the basis of the South African Cultural History Museum. The SAM, meanwhile, now featured anthropology and natural history. And it held tight to its popular Bushman diorama.

To anyone outside the museum, it appeared as if "culture" had been whisked away and cordoned off from "nature"; European culture, that is. This meant the Bushmen were being lumped together with other species of the animal world. Thereafter nature, so broadly defined that it included casts of additional native Africans as specimens as well, occupied SAM in its entirety. It's not difficult, therefore, to understand the public's perception of the museum's mission.

But had curators intended to inscribe such an essential division? Once again, the most parsimonious explanation goes back to mid-twentieth century *habitus*: curators likely organized material in the way that looked and felt "right" at that moment. They were blind to the extent to which they were confirming racial stereotypes that retain significant authority today, and that, in the real world, had in fact had devastating consequences for actual Bushmen. Only in hindsight are the implications and costs of putting these beliefs on view so transparent.

It would be expedient to believe that SAM's curators were outliers in the museum realm in doing what they did, malevolent handmaidens of a repressive

ideology. That would make it possible to reserve a special type of condemnation for them. But on the contrary, people in comparable positions throughout the world have erected the same figurative partitions in their institutions. One scholar observes that displays in natural history museums "often show how the foraging strategies of animal species and human groups are similar. As a result, hunters and gatherers are assimilated to our ideas about nature at the same time as we exempt our own forms of culture and technology from the same examination."[12] Recognizing this does not absolve SAM's curators of culpability; it merely acknowledges that many others, in various locales, can be indicted for similar offenses.

Patricia Davison reflects, "I do not think that curators that are currently working are responsible for decisions taken a hundred, eighty years prior. But I think you have a responsibility to know that what you do now is something that you *are* accountable for." She retrospectively acknowledges, "Perhaps we kept the diorama open longer than [some] people thought we should." However, she stresses, "We were not yet sure what the appropriate way forward was."

CASTING A JAUNDICED EYE

These Bushman casts always had produced a strong impact upon viewers, ranging from adoration to condemnation. They were repellent to artist Sue Williamson, for example, who intensely describes them as "flesh-crawlingly exploitative." But they exuded "a beautiful, ethereal quality" for Pippa Skotnes; she found them to be "beautiful," "remarkable."

Human rights worker and diversity management trainer Shifra Jacobson remembers that they "dismayed" and "unnerved" her, a reaction that remains so strong to this day that she can't verbalize it any more concisely. And for history professor Dr. Julia Wells, the manner in which they were displayed implied an evolutionary sequence with the Bushmen wedged between apes and Europeans; the diorama, in her view, was "as bad as it gets." But to Patricia Davison, on the other hand, they are "so lifelike and seductive."

In 2000, SAM and over a dozen other cultural institutions in the Cape Town vicinity were consolidated into a single entity, Iziko Museums. It is a jumble of historic houses and buildings, art collections, conventional museums, a planetarium, and even a fossil park. *Iziko* means "hearth" or "hub of cultural activities" in isiXhosa, those being the guiding ideals for the member organizations of this new entity. This reorganization created three broad divisions: art, social history, and natural history, and with specialized curatorial posts within each. The rationale was to facilitate discussions across disciplines and beyond former organizational barriers; to generate exhibitions that draw upon Iziko's collective holdings; and to eliminate duplication of support services in areas such as public communications and libraries.

Iziko's first CEO took the bold decision at the beginning of April 2001 to close the diorama, in order to reconsider how the Bushman casts might be presented in the future. In the run-up to this announcement, criticism of the

display had intensified, including political pressure being applied by government ministers. In effect, they were taking up the gauntlet that Mandela had thrown down four years earlier.

The fever pitch of the discussion can be gauged by the fact that several newspaper accounts reported that some of the models had died during the original casting process. The extreme cruelty of the venture was thereby "authenticated" as scandalous from its inception.[13] As it turns out, those stories were mistaken, although it in fact took some time for John Drury to perfect his technique so that he successfully secured a complete life cast without suffocating his model.

His very first attempt ended in panic when he could not remove the "plaster cocoon": "Disturbing thoughts of having to stand trial on a charge of 'premature burial,' with a large mass of plaster appearing as principal witness for the Crown, probably passed through his mind as he struggled with the refractory plaster, which got harder and harder, and, as one of the concomita of setting, hotter and hotter." Significantly, this is imagined from Drury's point of view, not the model's. For whom, after all, was it getting "hotter and hotter"? In due course Drury's biographer grudgingly acknowledges how frightening it would feel to submit to this: "Such a prospect might well intimidate more civilized persons, but to their [the Bushmen's] simple minds the operation must have seemed disconcertingly like sepulture."[14]

Curator/scientist Donald Klinghardt describes Iziko's gambit of shutting down the diorama as a way "to give us breathing space, and to show the public that we are serious about what we do, that we are serious in talking to them [about the exhibition's possible future design.] Closing it was symbolic." This was intended to send a signal that SAM was aware of the problems inherent in the diorama, and was sincere in trying to address them.

Some critics condemned the action as "politically correct," or "politically expedient." Others thought it was insufficient: "Instead of hiding the diorama behind a plywood screen," one person suggested, "they should have either blown it up or put it in the middle of a traffic circle on Adderley Street."[15]

"NO ONE WAS TALKING ABOUT VERMEER"

The most ballyhooed art exhibition anywhere in the world during the 1995–1996 season was *Johannes Vermeer* at the National Gallery of Art in Washington, DC. The National Gallery assembled the largest number of paintings attributed to Vermeer ever shown in one place. Critics effusively praised this historic show, and the long lines and repeatedly extended museum hours confirmed the show's status as a megahit.

But Marilyn Martin, director of the South African National Gallery [SANG], recalls that Vermeer did not dominate the news in South Africa, nor did he monopolize conversations in local circles of artists and intellectuals, as

was the case elsewhere. This seventeenth-century Dutch master even failed to engage his own countrymen when Martin visited the Netherlands in 1996. In both places, people instead argued with her over *Miscast: Negotiating Khoisan history and material culture*, an exhibition curated by University of Cape Town art professor Pippa Skotnes at SANG that year.

The neglected tradition was a watershed for addressing the Eurocentric bias in South African art museums. *Miscast* likewise tackled problems inherent to natural history and cultural history museums. *Miscast* was also the most divisive exhibition mounted in this country and raised weighty questions about the way that all types of museums conduct their business.

Miscast was a contemporary, creative "answer" to the Bushman diorama. The passions that this exhibition had aroused were still supercharging the air a year later when Nelson Mandela took to the podium for his 1997 Heritage Day speech. And the reverberations continue to this day.

TRACKING THE BUSHMAN

Pippa Skotnes adored seeing the Bushman diorama when she was growing up. Even now, she describes the "exquisitely cast and painted figures," its "finely painted background," and the "dramatic," "fantastic glimpse" into a world and time far different from her own.[16] She could not foresee that this commonplace South African experience would so profoundly shape her life's work.

As an art professor, Skotnes had become interested in South Africa's extensive array of rock art and the lively debate between contemporary theories explaining the meaning and significance that this work held for their Bushman creators. She also read extensively in the Wilhelm Bleek/Lucy Lloyd archive, a massive project begun in Cape Town in the 1870s to document Bushman languages from the dwindling numbers of native speakers, to record their mythology and indigenous knowledge, and to collect drawings regarding Bushman life and cosmology.

Not only did this deepen her awareness and understanding of indigenous people and their culture, but it also led to a controversy and court battle that seasoned her for the storm yet to appear over *Miscast*. Specifically, Skotnes produced a limited edition "artist's book" based upon what she'd read and seen in the Bleek/Lloyd archive. She considered *Sound from the thinking strings* to be a work of art, a perception confirmed for her when the SANG purchased one of the 50 limited edition copies of it. So when the South African Library demanded that a copy be deposited there, as is required for all books published in South Africa, Skotnes balked.

The library sued her, and she lost. But Skotnes then mobilized other artists and fought through the appeals process. The final legal judgment: her work was both art *and* a book. This blurring of categorical boundaries would characterize her larger undertaking, *Miscast*, as well.[17]

Miscast contested SAM's Bushman diorama in fundamental ways. Whereas the diorama was a static depiction of an idealized traditional life, *Miscast* was

dynamic. It incorporated multiple perspectives, involved a variety of media and sensory experiences, and required the audience to interact with its various components.

Whilst the diorama disregarded the reprehensible treatment the Bushmen received at the hands of European settlers and their descendants, *Miscast* interrogated that history. It was legal to hunt and kill these people well into the twentieth century.[18] Dutch settlers once shot and ate a Bushman, "assuming that he was the African equivalent of the Malay orang."[19] And some whites were so indifferent to the Bushman's essential humanity that they created tobacco pouches from the breasts of murdered Bushman women, a macabre, sadistic practice graphically highlighted in the movie *Proteus* (2003, Jack Lewis, director).

Europeans considered them "varmints," maltreated them as unwelcome "intruders" upon what was their own ancestral land—territory that Europeans now coveted. Anthropologist Robert Gordon sees a relationship between groups that have been subjected to genocide at different times and places: "vagabond Bushmen," "Wandering Jews," and "roaming Gypsies."[20] Each characterization underscores being rootless, the antithesis of a settler, and the binary correspondent of savage to civilized.

Because many people felt that the diorama confirmed and perpetuated archaic racial stereotypes, a primary aim of *Miscast* was to challenge such ideas. Skotnes re-presented a people who had been characterized persistently as sideshow curiosities at best, subhuman or "living fossils" at worst, in a nuanced and personal manner instead.[21] She restored them to the human family, as possessors of distinctive languages and culture.

Furthermore, prior to this exhibition, museum goers in South Africa (as well as elsewhere) could generally only be aware of what curators consciously decided to show them. But *Miscast* went behind the scenes and "put the archive and storeroom on display" as well.[22] And significantly, *Miscast* was presented in the National [Art] Gallery, not at the South African Museum, thus troubling entrenched notions of where nature and culture "belong." In several respects, *Miscast* shared a great deal with the landmark *Harlem on my mind*, whose documentary quality, reliance on wall-sized enlarged photographs and sound projections, absence of art per se, and uncharacteristic subject matter all jarred the conventions and expectations associated with New York City's venerable Metropolitan Museum of Art more than a generation earlier.[23]

Miscast brought to the fore issues of cultural ownership: who has the right to speak for whom? Can a person from one group legitimately represent the experiences of another? *Miscast* also brought to light the deficiencies of time-honored cultural institutions by addressing questions that these places had largely ignored and by examining lives that had long been overlooked or narrowly pigeonholed.

Miscast had tangible consequences for the people whose heritage it presented: the exhibition became the focal point for Khoisan individuals (see below) holding divergent points of view to come together, solidify and affirm

a collective, precolonial (and thus pre-apartheid) identity, and contemplate future political action such as pressing land claims. The exhibition thereby became the catalyst for mobilizing a wretchedly pariah group.

And *Miscast* forced many people to expand their thinking about what museums are and what they might become. Its impact was virtually unprecedented, and it was felt both within and beyond their institutional boundaries.

A Note on Terminology

"Khoisan" (or Khoesan or Khoi-san) is a widely used, yet highly disputed term. It reflects a linguistic amalgamation of Khoi or Khoikhoi or Khoekhoe (Hottentot) pastoralists/herders with San (Bushman) hunter/gatherers. These are purportedly distinct groups. Skotnes notes that her original title for the exhibition was *Miscast: Negotiating the presence of the Bushmen*, but that the National Gallery nixed using "Bushmen" because of its pejorative associations. "Khoisan" was substituted in its place.[24]

"Khoisan" reflects the desire on the part of many contemporary scholars, journalists, government officials, and others to move forward from terms that had acquired a great deal of emotional baggage over the years. It also acknowledges that few, if any, "pure" exemplars of the Khoi or the San survive, due to the deliberate decimation of these populations by colonists/settlers, and intermarriage and assimilation both between these indigenous groups and with other groups as well. Parallel debates rage on about who is who: between academics, and between groups of indigenes themselves. In either case, the stakes, in terms of prestige and resources, are considerable.

Varied sources agree on one point: the San have lived in Southern Africa for 20,000–40,000 years. Many references peg their origins at 30,000 years ago, thereby representing the late Stone Age. Academics and the general public have long assumed that the San and Khoi people are distinctive from one another: ethnically, economically, and linguistically. But more recently scholars have argued that these distinctions may be largely illusory, artifacts of the status quo at the point of contact with European frontier and settler cultures, when these foreign arrivals were first establishing dominance in their African colonies.

The academic "revisionists" argue two main points. First, the San may have been primarily hunters *or* pastoralists at different periods in their history, but they were not different groups. They were simply at different points of an economic cycle that allowed them to hold livestock at one time, whereas insufficient resources necessitated that they rely upon hunting at other moments. Second, these different lifestyles were probably *never* exclusive: hunters likely kept some stock, and pastoralists probably did some hunting.[25]

Representatives of these groups also bicker amongst themselves over what's "correct." A 1995 conference of Bushman bands in Namibia opted to call themselves "Bushman," rather than San or Khoikhoi. "San," they felt, was a derogatory name denoting thief or scoundrel; "Khoikhoi" blurred important group differences; and "Bushman," although derived from

the Dutch for bandit or outlaw, now positively marks them as resisting colonial rule.[26]

A meeting of various San groups in 2001, also in Namibia, likewise rejected the blanket term of Khoisan, and those attending unequivocally distanced themselves from the Khoi. But they referred to themselves as San, not Bushmen. The headline of a newspaper article reporting the story is blunt: "The Khoi don't share our culture, say San."[27] Yet other groups explicitly refer to themselves as San Bushmen.

A 2003 article in *New African* used specific tribal group names such as Basarwa, Gana, and Gwi to sidestep some of these difficulties and characterized the broader expression "Bushman" as an "unflattering colonial term."[28] That same year, Rick Nuttall, director of the National Museum in Bloemfontein, planned to relabel a Bushman display because that term is "no longer used."

It should be obvious, then, that each expression can offend someone, challenging or undermining some aspect of how they'd like to be publicly perceived. Until now, I have almost uniformly used "Bushman" because that has been the most common way of referring to SAM's diorama. From this point forward, I will also use "San" and "Khoisan," as warranted by the way individuals or groups label themselves. In an age of heightened identity politics and intensified nationalisms, each name has its strategic advantages and drawbacks.

NEITHER FISH NOR FOWL

Even today, *Miscast* confounds people. At Columbia University you will find the exhibition catalogue in the largest general library on campus, shelved alongside social science and historical studies of South Africa's indigenous peoples. This is not the case with *The neglected tradition*, located instead in the Avery Architectural and Fine Arts Library. Even so, both shows were mounted in art museums.

Skotnes envisioned an exhibition that would engage a number of distinct issues and employ diverse visual and textual display strategies. It was an ambitious brief. Building upon her long-standing personal interest in Bushmen, Skotnes wished to reconcile what she saw as a glaring discrepancy: Bushmen had been slaughtered in horrific actuality and symbolically victimized in the vast majority of depictions of them. But the image of ignorant, subhuman, and passive creatures did not square with what Skotnes uncovered when she consulted the archive.

Here Bushmen revealed a multifaceted and highly resourceful culture. Bushmen had resisted the incursions of Europeans and Bantu peoples the best they could, but they were besieged and devastated by greater numbers and superior weaponry. Skotnes proposed to let the archive counter the slender perspective that had largely shaped the modern view of these people. She would facilitate the Bushman in speaking truth to the power of established stereotypes, and she would do this via voices that were recorded over 100 years ago.

To this end, Skotnes wished to disconnect *Miscast* from the ethnographic discourse that had dominated the standard characterization of the Bushman in museums. She therefore rejected the South African Museum as an appropriate venue, opting for an art milieu rather than a natural history setting. She reports that her motives coincided with those of the South African National Gallery's director Marilyn Martin. SANG could shed some of its elitist character by hosting *Miscast*, [29] while Skotnes could take a fresh look at very time-worn representations without being weighed down by the traditional conventions of place.[30]

In Donna Haraway's memorable discussion of "teddy bear patriarchy," she argues that natural history museums were established by elites as sacred spaces, offering a sense of communion between man and other mammals, a return to innocence, resurrection through taxidermy, spiritual regeneration, a symbolic test of manhood, and a redoubt from urban masses and urban ills. Established hierarchies of class, race, and gender were assiduously expressed there. "African human life had the status of wildlife in the Age of Mammals," Haraway states.[31] That legacy is precisely what Skotnes wanted to distance herself and her exhibition from.

MISCOMPREHENSION

Skotnes also chose an innovative aesthetic strategy, namely installation art. Largely developed in the 1970s and 1980s, installation art breaks through established cultural conventions. It is generally site-specific, multidimensional, and audience interactive: audiences move through and around the work. While it allows a tremendous degree of freedom for artists, installation art places an increased burden of interpretation on the audience; it is forced to intuit associations and draw conclusions about what is commonly a vast array of disparate objects. In a basic respect, each viewing of the work merges the plastic and performing arts. "Curatorship is the creative act" in this instance, Marilyn Martin declared.[32] And indeed, one visitor groused, "Isn't this all self-promotion?"[33]

Because installation art is more open to varied interpretations than painting or sculpture generally would be, the likelihood of misinterpretation of the artist's intended message is correspondingly increased. Installation art was a relatively novel form of expression when *Miscast* appeared in 1996, and it was neither well known nor widely practiced in South Africa. The cultural boycott, of course, had retarded the diffusion of art world trends.

Moreover, Skotnes had a difficult time imagining the audience for this show. She realized that it was likely to attract her peers from art and academia. But it was also apt to bring in people who had never visited a museum and who were not clued into the standards and customs of this rarified world.

To illustrate the kind of challenge this presented, *Miscast* used juxtaposition and irony to make its points. But while this was recognized and appreciated by some segments of visitors, others interpreted it as an unembellished replay

of what was annoyingly familiar, quashing Skotnes's aim to critique the past. And *Miscast* was highly symbolic: its structure represented the Last Supper, a complex and subtle imagery that was probably lost upon the bulk of the audience. As Skotnes describes it, she built in "all sorts of little codes" that referred to particular Catholic traditions.

Miscast sprawled over three rooms. Within each, visitors were engulfed by a huge assortment of objects and bombarded with a visual overload. In the first space, 13 cases mounted on the wall featured mostly objects made by the Khoisan. Opposite that were 13 resin casts of headless body sections that had been made in the 1980s. In each domain, Skotnes was alluding to the communion of Jesus and his disciples, just before he made the ultimate sacrifice. But for many contemporary viewers, drawing an association between the heaps of bodies shown in photographs of Nazi concentration camps and what they were seeing at SANG was perhaps more probable than catching the understated religious reference she was making.

In Skotne's version, the 13 partial casts represented the largely unexplored martyrdom of the Bushmen as subjects of scientific investigation, but here it was balanced by personal expressions of their productivity. Skotnes in essence recreated the cenacle, the room where the original Last Supper was staged. She thereby reinvested the museum with a sense of sacredness that *Miscast* was largely designed to puncture. Her impulse was unintentionally similar to the displays Donna Haraway describes at New York City's American Museum of Natural History, designed in the early twentieth century: "[E]ach diorama presents itself as a side altar, a stage, an unspoiled garden in nature. . . . As an altar, each diorama tells a part of the story of salvation history . . . Eachs [*sic*] offers a vision. Each is a window onto knowledge."[34]

One of the features that most unsettled visitors was the entrance to the second room. Skotnes "carpeted" the floor entirely with enlarged reproductions of newspaper articles, official documents, and photographs of Bushmen, transferred and printed on vinyl tiles. Included among the many papers that Skotnes amassed was an auctioneer's list of mammal hides, and catalogued in the inventory was the skin of a "Buschmann frau." Like it or not, anyone entering this space was forced to step on these representations of native faces and bodies. All thus became complicit with oppressing the Bushman, deeply dismaying many of the visitors.[35]

For that very reason, Sue Williams thought it was a bad exhibit. She found this aspect "extremely insensitive." As an artist herself, she did not know where the documentation stopped and the logic of the installation began. And Patricia Davison adds, "Although it was a metaphor for the trampling of a culture, it was taken absolutely literally."

Additional resin casts of body parts were piled up elsewhere, as well as fiberglass models of "trophy heads." And cabinets of scientific paraphernalia from the nineteenth and early twentieth centuries—locating the Khoisan as specimens—shared space with contemporary photos of the Khoisan, examples of their material culture, and tracings of rock art. Skotnes thereby presented these people as both object and subject.

WHAT'S WRONG WITH
THIS PICTURE?

Skotnes was stunned by the intensity and duration of the controversy that *Miscast* spawned. But she was not completely caught by surprise.

As noted, Skotnes had had to explain and defend her work in a public manner prior to *Miscast*. In the episode where the National Library demanded she give them a copy of the artist's book she'd produced, Skotnes could precisely pinpoint the moment when the matter turned grave: a bailiff nailed a court order to her door. And during the year leading up to the opening of *Miscast*, Skotnes made the news when she sparred with the British Museum (Natural History) over possibly including Khoisan trophy heads in her exhibition. These heads had been taken back to England, stuffed, preserved, and stored as "souvenirs" of nineteenth-century warfare or executions in Southern Africa.[36]

Skotnes was denied permission to borrow the heads, or to sketch or photograph them. And she was not sure whether or not she would have included them even if she had obtained authorization. But once the news media picked up the story, it publicized the fact that Skotnes was dealing with highly sensationalistic material. She compares this with watching a movie trailer, previewing the spectacle to come, and ratcheting up the anticipation of a curious public.

Skotnes did not intentionally court controversy. Her primary interest was to confront issues that had never been fully addressed before. And the exhibition could not have been timelier: the Truth and Reconciliation Commission [TRC] was about to commence its hearings, although the TRC's inquiries would focus exclusively on crimes committed during the apartheid regime from 1948 onward, well after the actions that had nearly wiped out South Africa's indigenous peoples.

The TRC was examining more contemporary "blacks" and "whites"; the Bushman would once again be "disappeared." According to Khoisan activist Jean Burgess, "The new democracy is built on a lie. Until people know the truth, there can't be healing in the land. . . . The pillars of apartheid have been destroyed, but no one has ever said 'Sorry' to the Khoisan." Because Skotnes was not soft pedaling her presentation of material that's fraught with strong emotions and important political implications, controversy in fact erupted.

Skotnes does admit some degree of responsibility in the matter, however. "I was very aware of how a [visitor's] body would move through that space," she says. "And I played it quite strongly and almost shamelessly." Skotnes is speaking of the fact that she was conscious of setting up extreme, and jarring, contrasts. She complemented her display of the dismembered body casts (which she found to have that previously mentioned "ethereal beauty") with brutal accounts of the massacre of Bushman bands. It was harsh comparisons such as these, she believes, that intensified visitors' emotions and caused many of them to react with horror and anger.

But no matter what Skotnes did or did not do, much of the material she uti-lized was incendiary by its nature; she provided the place, and the opportunity, to spark the conflagration. And as it turned out, certain viewers claimed to see things in *Miscast* that didn't even exist.

Some people insisted that there were genitals connected to certain body casts,[37] and bottles filled with them. But while Europeans have had a long-standing fascination with the organs and sexuality of indigenous people, no genitals were included in this show. This was a chimera. Even so, one critic of the show, writing about it five years after the fact, held fast to the claim about genitals.[38]

Someone else claimed to have seen a life-sized photograph of Saartje (or Sarah) Bartmann, the so-called Hottentot Venus (see chapter 4). But Bartmann died in 1815, some years before the development of photography. This person undoubtedly had a mental image of Bartmann—drawings of her do indeed exist—but it did not come from any photo that was displayed in *Miscast*.

Such misapprehensions are not unprecedented, once the atmosphere around an exhibition has heated up. In 1993, for example, the Library of Congress [LOC] in Washington, DC, hosted *Back of the Big House: The cultural landscape of the plantation*. The show had been well received in other cities, but refueled a long-simmering dispute at this venue. Some black employees, it turned out, had referred to the LOC as "the Big House" because they felt they were discriminated against due to their race. And a few of them furiously assailed the exhibit, including one person who was especially disturbed by the photo of a white overseer, on horseback, brandish-ing a gun.[39] It simply had too much contemporary resonance. The only hitch was there was no such photo.

When audience members project their concerns and fears onto an exhibi-tion, they can magically tailor what they are seeing to conform to their presuppositions and current needs. The specific vision and efforts of Skotnes aside, *Miscast* could be read in a variety of ways, to satisfy a range of desires: to reconfigure identities, certify the historical continuity of groups, and validate histories of systematic abuse.

MISREADINGS

Beyond the discomfort of walking over Bushmen, audience objections included the fact that the display of the naked body casts in this public man-ner violated the Khoisan taboo against men and women jointly viewing human nudity (although, reflecting the diversity of the Khoisan, some guests arrived at the opening topless, or clothed in skins). One Griqua leader lamented the "recolonisation of our material culture,"[40] while another Khoisan faction reportedly declaimed it was "sick and tired of naked brown people being exposed to the curious glances of rich whites in search of din-ner-party conversation."[41]

Skotnes's intent might have been to expose the colonial mindset and thereby critically assess its major assumptions and its grave consequences. But

from the perspective of these particular critics, *Miscast* perpetuated rather than reduced their sense of oppression.

Not all indigenous viewers concurred. A member of the Khoisan Representative Council from the Northern Province declared, "We may be endangered, but we're not yet extinct. . . . This is the beginning of the Khoisan wake-up call."[42] In toto these responses simultaneously highlight the politics of representation and the politics of reception, in other words, the point where curatorial vision collides head on with audience under-standings and reactions. Who was entitled to make particular curatorial choices, and what those choices meant, was thus loudly disputed at public forums and throughout the media.

Miscast and the responses it garnered raised increasingly familiar questions of cultural ownership and cultural spokesmanship. *Miscast* brought people together as well as drove them apart.

The obvious comparison to make is between *Miscast* and an earlier exhibi-tion, *Into the heart of Africa* (Royal Ontario Museum, Toronto, 1989). Like the controversy over the Library of Congress's *Back of the Big House*, this controversy took place against a backdrop of tension: the police shooting of a black youth had stirred racial animosity in the city. In both instances, the controversies that sprung up were about the exhibitions, to be sure, but they also became opportunities to air issues that were both preexisting and more broad-based.

Into the heart of Africa addressed Canada's role in the colonization of the continent and questioned the roles played by all of those who participated: fortune hunters, missionaries, Western collectors, and one of the ultimate beneficiaries, museums themselves. Two contrasting readings of the exhibition were possible: it either attempted to pointedly deconstruct nineteenth-century conduct and its costs, or it sustained stereotypes by displaying unflat-tering depictions of Africans and the racist comments of white "explorers" of the continent.

According to the director of the museum, the organizers held focus groups with African-Canadians, hashed out some sensitive points, and did some fine-tuning before the show opened. But this did not avert intense criticism. Some local blacks demanded that the exhibition be shut down and that the museum issue a public apology.[43] Emotions escalated, leading to skirmishes between demonstrators and police. And eventually, other muse-ums that were scheduled to host *Into the heart of Africa* withdrew it from their exhibition schedules.[44]

Like *Miscast*, *Into the heart of Africa* incorporated a mélange of exhibi-tion strategies. Colonial objects and images were "counterbalanced" by others made by Africans. Moreover, a diorama and other antiquated types of displays seemed to be supported by texts reflecting the sentiments of nineteenth-century white adventurers, rather than critiquing them. The museum had expected these elements to "speak for themselves." Instead, people were confused about whether or not to take what they were viewing at face value.

The major miscalculation of *Into the heart of Africa* was to expect audience members to do more interpretive work than they were equipped to handle, and more than they should have been required to do. Irony, mixed messages, and missing information and links stymied, frustrated, and angered visitors. As anthropologist Enid Schildkrout notes, "[P]eople still look for narrative stories." She concludes, "[W]hat was meant as critique was seen as a nostalgic memorialization."[45]

COMING APART AND COMING TOGETHER

South Africa's history is punctuated by the Boers, the Brits, and the Bantu peoples facing off one another in bloody engagements. The only interest they have shared is a common contempt for the Khoisan, and their various campaigns to drive them from their ancestral lands. To some of its critics, *Miscast* joined this ignoble roster of enemies: "How can you speak 'for' a people you know so little about?" one person demanded. "How can you speak 'for' a people you do not respect?"[46]

Skotnes replied that this was a serious misunderstanding of her intent; she was primarily examining the impact of European contact with the Khoisan, not attempting to speak on their behalf. But in an exhibition with such a "strong visual bang,"[47] and one that transferred so much interpretive responsibility to the viewer, it is easy to see why such a significant breach would develop between Skotnes's desired messages and the audience's actual understanding.

Discrepancies such as these are common with postmodern forms of expression such as installation and performance art. When audiences are expected to complete the meaning of a piece, they do so the best they can, and in whatever way they can. A study of American artist Karen Finley, for example, discovered that audience members seldom grasped her intentions to explore women's oppression through performance. More often than not, regardless of their own sex, viewers were as likely to be in attendance to be shocked or enticed—due to Finley's notorious reputation for nudity and foul language—as they were to have their feminist consciousnesses raised.[48]

The claim that Skotnes could not speak for or about people she "did not understand" addresses once again the politics of representation. To be candid, indigenous people did not have the specialized training, resources, professional connections, or knowledge and access to relevant materials that would have enabled them to stage a museum exhibition in 1996. Their long history of oppression had guaranteed that they were unequal players in virtually any public discussion or decision taken in relation to them.

Pippa Skotnes made the effort to consult with the Khoisan. But "official" groups were just forming, few in number; were spread throughout several countries; represented a wide range of opinion; and were, understandably, cautious in their dealings with a white female artist/academic. *Miscast* reflects a particular moment in South Africa's political and cultural history that is forever gone: "I think there was something sort of politically incorrect about that exhibition," she reflects.

Skotnes recalls that at a public forum she organized for the day after *Miscast* opened, one man shouted "Who is this whitey? Who are you as a white woman to be representing our past?" She now understands, "That was almost the last moment that it could have been done. . . . [One year later] I couldn't have done a similar exhibition. It was no longer possible for someone like me to ignore the fact that I was a white person."

That public forum brought together Bushman, Khoisan, San, and other constituencies in an unprecedented dialogue about identity, representation, and self-determination. Over 700 people of all sorts attended the gathering, many of them at the invitation of Skotnes, who had contacted whatever groups she could locate that had any visibility. What stays with Sandra Prosalendis, who cochaired the meeting, was the enormous anger, the shock, the trauma, the pain that people felt after viewing the exhibition. Marilyn Martin also remembers the audience members being extremely angry and critical, and likens it to a political rally. *Miscast* brought divergent groups face to face, tweaked the growth of a heretofore embryonic desire on the part of indigenes to project a self-generated, proactive, modern view of themselves, and forced the rest of South African society to listen up.[49]

There was hardly unanimity in the room. Skotnes recalls audience members publicly and proudly declaring their Khoisan blood for the first time, a "coming out" process of sorts. And yet there were others stating flatly that they did not wish to be lumped with such-and-such others. All the rivalries and grudges that had simmered for years, and the seemingly minute differences that had marked the boundaries between the various indigenous groups, were brought into the open.

In due course, *Miscast* became the event that crystallized inchoate yearnings into group mobilization. In an earlier dispute in 1991, a white man had been labeled a "cultural trophy hunter" when he published a volume of Bushman poetry from the Bleek/Lloyd archive.[50] But while the issue of tribal and ancestral sovereignty may have been defined at that moment, people were not yet sufficiently stimulated to directly act upon it. As Skotnes appraises the situation, "I think it [Miscast] did initiate a debate. Maybe it didn't really initiate it, but gave impetus to a debate that was not being heard. So I suppose in a sense if it has a legacy, its legacy was in raising issues in a public forum and facilitating a debate that otherwise might have only happened differently and later."

WILL IT PLAY IN P.E. [POST ELIZABETH]
(OR EAST LONDON OR BLOEMFONTEIN)?

Was the Bushman diorama *inherently* offensive to the modern eye? The criticism that both it and *Miscast* generated would lead one to think so. The display of early human groups, whether as "noble savages," or simply savages, cannot be taken for granted. Or can it?

The East London Museum has a San diorama, as well as a Xhosa kraal, and other native displays. But in the years since *Miscast* appeared, and SAM's Bushman diorama was closed ("archived" in official parlance),[51] there has not been any local outcry against these depictions. Nor have there been demands

for removal. The situation is the same at the National Museum in Bloemfontein: no complaints and no bother. Although director Rick Nuttall is changing the label on the Bushman cast, the impetus has come from within the museum and is not the result of external pressure.

East London and Bloemfontein are much smaller communities than Cape Town, and less cosmopolitan. In communities such as these, locals are more likely to accept the authority of museums. And while Bloemfontein is home to a number of museums, neither place has a concentration of universities where critical discourse is all the rage.

Conversely, interest groups of various sorts are easier to mobilize where there is a density of population. And the media regularly trawls for stories in an urban center like Cape Town. In other words, the "Mother City" is a much bigger oyster than these other locales. News is made there, and the rest of the country hears about it.

These comparisons illuminate the *social construction of acceptability*, the premise that material that pushes peoples' buttons in one area or instance will not automatically have the same impact elsewhere.[52] Museum director Kevin Cole compares East London to Cape Town: "[In Cape Town] you are going to have people that have an understanding of museums that would be able to intellectualize about interpretation more. That in itself is going to raise internal conflict within individuals." And Rick Nuttall adds, "Perhaps the folks who visit this museum are not as militant, if I can put it that way, as they would be in a sense in Cape Town."

It is also worth noting that the Bushman diorama is but one place where SAM has displayed body casts within the museum, but the others have survived without negative comment. And at the same time that *Miscast* appeared at SANG, an exhibit in an adjacent gallery by acclaimed South African artist Jane Alexander featured a naked white woman. That elicited no adverse response, which most probably reflects the fact that visitors to that part of the museum would likely be more accustomed to the unclothed body displayed within a museum context.

At the end of the day, there is the issue of how people are mobilized to protest, and how representative they are of more widespread sentiments. As General John Keene, chief curator of the South African National Museum of Military History cautions, "The trouble with controversies is, one or two people raise it, and then they convince other people about their point of view. That is where the controversy was."

Miscast provided the ideal conditions of time and place to foment heated debate.

BLACKS AGAINST BLOODS

What has come with the mobilization of indigenous groups, boosted to an extent by coming together against the "common enemy" of a controversial museum exhibition?

New political possibilities mushroomed with the change to a democratic government in 1994. After nearly half a century of apartheid oppression, and compounded by the injustices committed by previous regimes as well, people could now make claims regarding what had been done to themselves and past generations of their families. And for once they had a reasonable expectation that they would be heard, and thoughtfully considered.

Social transformation begets personal transformation. And sometimes that transformation can be head-spinning. Before the 1990s, South Africa's indigenes were secretive about their origins, embarrassed and frightened to reveal who they were. The reasons were not difficult to fathom: they had been dispossessed, abused, exploited, and hunted down—not much of a legacy to embrace. And the apartheid classification of "coloured," where they'd been placed under the Population Registration Act of 1950, had been sufficiently broad to allow the Khoisan to meld into a much larger entity.

According to Bokka de Toit, designer/developer of the Kouga Culutral Center in Humansdorp, "Five years ago it would have been very difficult to find any so-called coloured person to acknowledge their identity or link to the Khoisan. It has become very popular since." Moreover, a heritage that was once clearly a social liability could promptly bring rewards. An elderly San woman interviewed in 1997 urged President Mandela to openly acknowledge his "San roots";[53] many people have noted that as he has aged, Mandela's skin color and facial bone structure seem more and more to indicate some indigenous ancestry.

Such resurgent identity is a global phenomenon. In the United States, American Indian tribes are granted tax exemptions that give them a competitive business advantage and also entitle them to open gambling casinos. Groups of people who have been scattered geographically, ethnically blended, and culturally assimilated now attempt to reconstitute themselves. But they must convince the Bureau of Indian Affairs that they represent a tribe with biological and social continuity.

Traditions are therefore revived; sometimes they are conjured up. Unscrupulous individuals may circle round when such lucrative economic opportunities arise. Tempted by the promise of financial gain, some impostors have fraudulently pieced together a common heritage that cannot be corroborated or authenticated. In several instances their quests have been backed by wealthy investors wishing to turn a big profit. And some of them have gone to jail.

Moreover, once a tribe has been officially recognized, internecine battles may erupt over who is a legitimate beneficiary of the group's good fortune. Such is the case with the Seminole Nation of Oklahoma, an Indian tribe that has coexisted and intermarried with former African slaves since at least the early nineteenth century. They were driven en masse from Florida in the 1840s. But now the Seminoles are divided over who qualifies for a share of a $56 million government settlement over land claims. "Blood Seminoles" are trying to edge "Black Seminoles" out, although these distinctions have not

been that relevant in the past. Now "cousins of different colors, who still live side by side, accuse each other of racism, opportunism and betrayal."[54]

Descendants of fugitive slaves in Brazil have also disguised their heritage for generations, even though their language and customs betray West African roots. But that has changed. Recently they have sought government recognition; their land, once disregarded by others, has become attractive for ranching and mining.[55] And numerous Indian tribes in Canada, including the Haida, are reasserting their ancestral rights over territory rich in oil, timber, and diamonds.

In the case of South Africa, land, mineral rights, knowledge of plants that may have commercial value,[56] and control of lucrative tourist sites and game reserves are at stake. Scholars have written of "episodes of new ethnogenesis," whereby groups reassert identities that were once despised.[57] Nama-speaking Khoikhoi pastoralists in the Northern Cape, for example, "perform" their "Namaness" when it is in their collective interest to do so. It is a style of role playing that is mobilized when advantageous and then deactivated.[58] In front of one audience, they look and act like their ancestors once did. But they revert to their contemporary selves in other situations—as impoverished wage laborers trying to eke out a living.

This "sudden reinvention of Nama culture"[59] in the 1990s has paid off: the Constitutional Court upheld their historical claims to ownership of diamond-rich land in Richtersfeld, a desert area south of the Namibian border. Like the Khomani San people of Botswana, they are *potentially* among the richest people in Southern Africa. Pushed to its logical conclusion, some Khoisan argue for "internal territorial self-determination," envisioning a type of federation of autonomous districts.[60] For anyone familiar with South Africa's history, this vision is uncomfortably akin to the apartheid-era "homelands."

But role playing ancient identities does not miraculously neutralize the impact of decades of abuse upon these people. Khoisan communities, for the most part, are wracked by high unemployment, drug abuse, alcoholism, violence, tuberculosis, and HIV/AIDS—another unfortunate parallel with their American Indian counterparts.

Despite their success in the courts, the Khoisan have reaped few tangible rewards. Understandably, they are nearly bereft of the necessary skills to manage their windfalls. And the level of social dysfunction leads one commentator to grimly predict, "[T]he chances of the [Khomani San] community surviving another generation are remote."[61] As satirist Pieter-Dirk Uys (a.k.a. Evita Bezuidenhout) repeatedly quips, the ANC government's failure to address the AIDS crisis head-on may achieve what apartheid never could: wiping out South Africa's nonwhite population.

THE PRICE OF THE TICKET

The response to *Miscast* was exhausting, draining, and traumatic for Pippa Skotnes. "My phone rang off the hook for five months," she grumbles, "five months of complete barrage." Skotnes received phone threats against herself

and her daughter, and she enlisted a security guard to escort her from her office when she left after dark. *Miscast* thus broadens the meaning of James Clifford's discussion of museums as "contact zones."[62] Even today, she routinely fields inquiries from people who are interested in this show.

Skotnes also felt she took a battering from intellectuals discussing the show: "There was lot of scholarship around it, many people writing things, many of them for me were just like leeches." Although she concedes that "there were some people who engaged in interesting intellectual ways," in general Skotnes was appalled at the way *Miscast* became an academic feeding frenzy. "There is a grouping of academics in South Africa, quite a lot of academics who, you know, anything that happens they've got this one piece of software that is programmed to accept a sort of knee-jerk response," she laments. "And so immediately it doesn't matter what the exhibition was, or what is going on, or where it is, they have to respond in that deconstructive, negative, knee-jerk way."

Moreover, "They made assumptions about what I thought and did: 'Pippa Skotnes thinks, blah, blah, blah.' But they never asked me. Even where they were responding positively it was this sloppy, shoddy scholarship." The cumulative effect of this battering was disappointment and cynicism. "There was a point at the end of that," Skotnes recalls, "when I thought, 'I won't believe another thing an anthropologist ever writes because I can believe they go off there to their island or to this community and they make it up.' It was really quite a shocking experience, the shabbiness of some aspects of scholarship, but there was also very interesting debate which I found fascinating, interesting."

For all the uproar that *Miscast* provoked, SANG's Marilyn Martin does not regret the museum's sponsorship of the show: "I am still very happy that we did that exhibition. It also really put the South African National Gallery on the international map." What's more, it boosted SANG's attendance figures: over 1,200 people showed up on opening night, and an unprecedented average of 500 people visited daily.

For Patricia Davison, the legacy of *Miscast* has been to reconsider what museums ought to be doing in fundamental and inventive ways. "I just think nobody would exhibit in this way again," she remarks. To her mind, it provides a reference point regarding key boundary issues: who speaks for a community, and whose voices will be heard in an exhibition. She recaps by saying, "I think that that exhibition made us aware, unintentionally, that you can evoke a lot of negative response, that irony is something that is very difficult to deal with within a museum."

And for Skotnes, "There was affirmation and there were a lot of people who sort of felt that so much of their lives were changed by that exhibition."

In the Wake

One of the best examples of an exhibition reflecting a "post-*Miscast* mentality" was *TRANCEsending time and space: Sacred symbols of the San* (SANG,

2000). This exhibition of San rock art emphasized the aesthetic features of such work, rather than its usual ethnographic aspects. Labels were largely based upon quotes from San individuals; when academics weighed in, it was only with the endorsement of the San. "In the prevailing climate of political correctness," wrote one reviewer, "it is thought that for a white scholar to speak for indigenous people is a piece of neo-colonialist presumptuousness."[63] Another exhibition strategy was to incorporate large-scale, wide-angle lens photography of rock art paintings in situ; this technique mimicked the curvature of the earth and contextualized the material in a particularly dramatic way. The overall effect was to liven up material that had been previously rendered inert because of the way it was put on view.

It is notable that the end of the exhibition was commemorated by a First Nations Healing Ceremony conducted at SANG on Easter Sunday, linking it to the theme of rebirth. Indigenes used a sacred peace pipe and presented traditional song and dance. They also burned eight intertwined sticks to symbolize the burning of boundaries that separate people from one another.[64] It was a ceremony of cleansing, celebration, and closure, much like the throwing of the bones by a sangoma at the Johannesburg Art Gallery just a few months earlier.

And the South African Museum subsequently mounted *Opening of lQe— the power of rock art* (2003), featuring a replica of a cave, with its interior coated by a giant photo of a real cave. By design, as was the case with *TRANCEsending time and space*, this strategy was conceived to allow the viewer to experience something approximating what the Bushmen might have felt originally. It was, therefore, regarded as an "answer" to the deficiencies in the various Bushman displays that the SAM had presented in the past.

The motive is unmistakable, as evidenced by these words by Iziko director Jatti Bredekamp that are inscribed on the wall at the entrance to the exhibition: "The tragic history of dispossession, brutality and cultural loss that befell the San people at the hands of the colonial settlers was overlooked [previously in SAM] in favour of idealized displays that reinforced stereotypes." Characterizing the "old" SAM, Bredekamp argues, "it was better known for displays of plaster body casts that emphasized the physical features of San people rather than their history or culture."

Also exhibited in *Opening of lQe* are three large stone slabs embossed with rock paintings, removed from their site in 1917, and the Blombos rock, a newly discovered stone with cross hatchings dating back 80,000 years. In both these shows, what was paramount in the curators' minds was providing an environment for *experiencing* this work so that viewing it could lead to a fuller understanding of the San and their culture than was possible with earlier exhibitions of similar material.

SANG also presented *The moon as shoe—drawings of the San* (2003), built around the work of six San who stayed in the Bleek/Lloyd household from 1875 to 1881. And among the many shows that private galleries have presented in the past few years was *The Bushmen experience* at the Art of Africa Gallery in Cape Town (2004). These artists, who opt to be called "Bushmen," make

"body maps," life-sized outlines of their own bodies around which they relate their personal stories. A reviewer wrote, "The simple greens and pinks tell a tale that should by rights be written in blood red and purple shame."[65]

As the dust kicked up by *Miscast* has settled, artists of all types are once again turning to the culture of the San for inspiration. In 2004 acclaimed South African writer Antjie Krog edited and published a volume of Bushman poetry from the Bleek/Lloyd archive. But this author was not denounced as a "cultural trophy hunter," as was the case in 1991 when another non-San person, Stephen Watson, produced a similar volume. And when the Jazzart Dance Theatre presented *Rain in a dead man's footprints* in 2004, it was, oddly enough, partly based upon Watson's work, *The sun, the moon, and the knife*. This piece is also directly connected to Pippa Skotnes: she solicited drama professor Mark Fleishman to add a performance component to work-shops she had been conducting with children.

The raw material came from the archive. Fleishman restates an issue that was so central to the controversy over *Miscast*: "I was very conscious of the fact that there are huge ethical and political questions at stake here. The San can't speak for themselves because our cultural forebears, whether African or European, have basically taken away that right [or ability, or access to a public platform] to speak."[66] In this instance, the politics of representation did not prevent an artist from one racial group from interpreting the culture of another.

But Fleishman and company's work was not merely a reiteration of the words of the San. This piece tried to re-create an important component of the San cosmology, the melding of time frames: past, present, and future can be experienced simultaneously. *Rain in a dead man's footprints* may be the only work to ever mix together San culture with the techniques of a hip-hop deejay and the theatrical legacy of Gertrude Stein. As one commentator sees it, "They had a choice: either they could stay silent, because they have no right to represent the San, or they could shout through their art."[67]

MAGIC BULLET, OR MISFIRE?

These imaginative reflections upon the legacy of South Africa's indigenous peoples denote one possible response to how their culture and their experi-ences can be presented in a contemporary museum context at a time and place where collective human rights are a dominant theme. But we need to reflect on the closing of the Bushman diorama in 2000 once again. The debate a propos that exhibition is ongoing.

General John Keene anchors one side of the argument by stating, "I think that was a very good exhibition. There was nothing offensive as far as I am concerned. I mean that is heresy, an emotional statement to make." And indeed, it is rare for a museum administrator to candidly reveal such unfash-ionable sentiments. But when Makgolo Makgolo, CEO of the Northern Flagship Institution based in Pretoria was asked what he would do if one of his member museums had an exhibition that reflected an earlier period of

thought, and was now objectionable, he countered, "If it is really offensive, we will definitely have to discard it."

Between these two extremes, most museum professionals advocate contextualizing and historicizing the Bushman diorama. From this perspective, the diorama provides an invaluable glimpse into what were once conventional scientific beliefs and museum practices. Destroy the diorama, and you erase an immeasurably important artifact. Destroy the diorama, and you make it more difficult for future generations to reconstruct traces of the past. Destroy the diorama, but you are not in fact wiping out the behavior that these layers of prejudicial social attitudes sanctioned, and that have an impact to the present day. Destroy the diorama, and you've settled for a magic bullet "solution" to the very real problem of enduring racism within South African society.

Khoisan groups are split as well. Some have vocally opposed the diorama for years, finding it racist and very hurtful. But other constituencies are grateful for it; they feel it confirms their indigenous status. As archaeologist David Morris of the McGregor Museum in Kimberley points out, "What I have heard is quite a strong feeling from the Khoisan people that they want it back."

Compare these two outlooks, published in different Cape Town papers at the time of the closure. A Bushman representative in Namibia asserted, "We have lost a lot of our history. That exhibition must stay there [in SAM]." He continued, "That which happened in the past must be preserved, even the wrong things that happened. We really want the public to see how it was." Another Bushman representative in Botswana concurred, saying,"That exhibition is about our old people and it is important that people know how our old people lived."[68] Should SAM have no more use for the diorama, they wanted to procure it for their San Cultural Centre. But a Khoisan spokesperson was delighted over the closure: "The Khoisan are shown as animals to Europeans and their children, who laugh at the depiction."[69]

Iziko CEO Henry (Jatti) Bredekamp is proud of his Khoisan heritage; his outspokenness, and the vintage photographs on his office wall of his own ancestors, leaves no doubts about that. And it was under Bredekamp's direction that the Bushman diorama was shuttered. His approach to the future disposition of the Bushmen is to consult with relevant stakeholders. Bredekamp's personal background will be an obvious asset in gaining the trust of a wide range of people who would like to have their say in the matter.

But while consultation is admirable in theory, it can be messy in practice. Pippa Skotnes made the effort to do so in regards to *Miscast* but soon discovered important limitations. "You can consult 'til the cows come home," she remarks, "but at the end, your vision is the kind of exhibition you are going to get. . . . I spoke to dozens of people from all sectors and from many different [academic] disciplines, but the sort of creative decisions I made were my own creative decisions." And, she cautions, "You can't consult on how people are going to respond to something."

Consultation encourages people to feel a sense of ownership because they have contributed something to the process of creating an exhibition. But

those feelings can quickly change to a sense of betrayal if they believe their counsel has not been followed. Moreover, there is a striking disparity between people who have been engaged in debates over identity and representation in a professional sense, and those for whom these issues are lived daily.

Facility with language, basic matters of Western etiquette, and styles of self-presentation make encounters between artists, academics, the media, and more tradition-based people inherently imbalanced. In a 2004 hearing in the Botswana High Court, a San Bushman explained to the magistrates why he should not be forced to leave what he considered to be ancestral land. "I do not need a piece of paper to show that the land was given to me by God," he testified. And while this simple and guileless declaration does carry an emotional impact, anyone living in a modern African state is subject to the laws of that place, regardless of their personal beliefs.[70]

A special predicament is that the Bushman notion of leader does not always concur with Western ideas. In the main, elders are accorded great respect, of course, but in some instances "spokesperson" might be more accurate than "leader," indicating a transitory rather than fixed role. In those instances where there are unmistakable traditional leaders, it is a point of contention that the South African government has not granted them comparable status to the traditional leaders of other groups (which brings with it, among other perks, a government allotment). Those people who politicians and the media acknowledge are at times a twenty-first-century necessity fashioned out of age-old traditions. But the very process of being singled out—or putting oneself forward—may nullify that person's continuing credibility within the group.[71]

"Transformation" includes bold, sweeping actions such as closing a well-known and popular attraction like the Bushman diorama. But it is more than that. Regrettably, such audacious gestures draw an inordinate amount of attention: from the media, from politicians, from interest groups, from the public at large.

The McGregor Museum in Kimberley, on the other hand, is conducting research into San ethnomusicology and medicinal plants. These topics would have never become part of their research agenda previously, but to the dismay of director Colin Fortune, this is not generally seen as transformation. How do you gauge results in these pursuits? How do you know when something's been "accomplished"?

In an increasingly outcomes-based society, where value is calibrated by how much political capital can be generated, the sometimes tedious, sometimes turgid process of conducting research is neither eye-catching nor generally deemed constructive. Fortune reflects, "Well, when you see government and politicians build twenty houses for black people, they are 'transforming.' Twenty houses are visible. But when I say that we are doing research into medicinal plants, it is not tangible."

"Real" Bushmen

Post-*Miscast*, and since Iziko's closing of the Bushman diorama, how are the San, the Bushman, the Khoisan—all of South Africa's indigenous people, for that matter—viewed today?

When you now enter the South African Museum, you are greeted by wall text executed in large type, "Welcome to Iziko: SAM/Where knowledge is presented from African perspectives." And under the title "Out of Touch?" the following overview alludes to the past history of SAM's practices as well as its current approach:

> This gallery was constructed in the 1970s and since that time approaches to exhibiting African culture have changed.
>
> *Do* these exhibits create the impression that all black South Africans live in rural villages, wear traditional dress and use only hand-made utensils?
>
> *What* about those people who live and work in towns, travel abroad and become industrialists? *Do* they not challenge conventional ethnic stereotypes?
>
> African culture is not static. *Why*, then, are many labels in the gallery written in the *present* tense, as if time had stood still?
>
> New images have been introduced into the gallery to create awareness of these issues.

South Africa's national coat of arms includes two Bushmen whose likenesses derive from rock art. And the national motto comes from an indigenous language: *!ke e: /xarra//ke*, "diverse people unite." These are signals of recognition of a new, significant respect for South Africa's first peoples. But for the most part, the dominant narratives are regrettably much the same.

Indigenes remain indistinguishable, interchangeable one to the other: the same photo of a family group trekking across the Kalahari appeared twice within four months as the cover image for a Johannesburg newspaper's travel section in 2003. One of the two articles christens a Khoi San girl, "Nature's child." And a photo caption in the other reads, "In the Heart of the Kalahari: Where the lion kings mate in marathons, the Bushmen make fire as their ancestors did and the birds proliferate on the plains."[72] The familiar comingling of Bushmen with animals is obviously still pertinent.

The popular writings and films of Laurens van der Post about the Bushmen, it has been argued, supplied a psychic sanctuary for Westerners from the stresses of the cold war in the 1950s and 1960s. At a time when it seemed that the world was poised on the brink of destruction, here was an inspiring society: at one with nature, a people who had survived enormous adversity, with their humanity intact.[73] Now in an era when "terrorism" is the enemy, the Bushman has become a pop-cult figure personifying a enviable mystical essence.

Diva Yvonne Chaka Chaka, for example, has featured San people in one of her music videos. And a connection has been made with the disaffected kids

of today's rave culture via the release of the cd's *Sanscapes*. These mix traditional Bushman healing songs with contemporary dance beats, including the music that they use to enter a state of "kia" [trance] in order to access the spiritual realm. A record executive observes, "It is an almost perfect junction with modern youth, youth who feel that they belong nowhere."[74]

Furthermore, a newspaper article describing a performance by Bushmen at a nightclub in trendy Newtown, Johannesburg, showed an elder wrapped in an antelope hide, playing the *goa goa* [an empty tin can with strings], and sporting a hands-free microphone around his head.[75] In each of these cases, the Bushman satisfies some present-day need that contemporary Western culture fails to meet. It is not solely a one-sided transaction, of course; Bushmen profit as well. But the uneasy feeling remains that indigenous people remain "on show," as they have for centuries.

Kagga Kamma, a "living museum" in the Western Cape where a band of Bushmen has taken up residence on a white South African's farm, provides an alternative to their harsh, impoverished life in the Kalahari. Visitors can watch them conduct their daily round here, billed as a glimpse at an ancient culture. But this sort of setup leaves some people uneasy, even outraged. One critic has characterized this as an "unholy business": "demeaning," "paternalistic," "exploitative," "criminal"; it "reinforces colonialism" and is "a human zoo."[76]

In a basic respect, the Bushman remains trapped between two equally simplistic depictions, roughly paralleling the predicament of the Maoris of New Zealand, the Aborigines of Australia, and American Indians. On the one hand is the prelapsarian trope: these are gentle people, deeply spiritual, communalistic, living in sync with nature, environmentalists at heart, not squandering their natural legacy. It is a form of idealization that was prevalent in America after the release of the film *Dances with wolves* in 1990, a tale of cultural boundary crossings that provided an obvious contrast to the militaristic mindset that spawned Operation Desert Storm shortly thereafter. But on the other hand, the Bushman is also seen as savage, backward, out of step with the modern world.

Both perspectives are regularly voiced. "San, a gentle people of thrift and kindness," reads the headline of a contemporary newspaper article, for example.[77] Quite the opposite, the title of a letter-to-the editor declares, "The Khoisan were not perfect," thereby rejecting the romanticized representation: "[T]o impute to Khoisan civilisation a nature entirely different to that of any other known civilisation—free of human foibles—is not just wishful thinking, it is a form of reverse racism."[78]

Nearly a century has passed since the South African Museum sponsored its casting project, nearly a century since it first sent its staff out to mold the archetypical bodies of a "vanishing race." Nearly a century has passed, and yet we are still trying to sort out what this project says about "the other," and what it reveals about "us": the nonindigenous, the museologist, the academic, the museum goer, member of the interested public; or, "coloured," "African," and "European" children of every imaginable hue

and background who stood in wonder in front of SAM's Bushman displays over the years.

As curator Patricia Davison persuasively argues, the casts had been preformed mentally, well before they materialized.[79] They were essentially "made to order" embodiments of the conventional European image of the Bushman; researchers only chose to cast those people who conformed to their preconceived notions of what the Bushman was "inherently like." Such practices have long distinguished encounters between Westerners and natives of other lands. The president of the National Geographic Society, for example, recounted how the photo of a Polynesian woman once published in its well-known magazine was altered to conform to the expectations of its readers, especially of someone appearing partially nude: "We darkened her down, to make her look more native—more valid, you might say." And a *National Geographic* editor noted, "If [the photographer] didn't find any happy people, I'd tell him to go back and find them."[80]

For all the debate about exploitation, misrepresentation, and "authenticity," Davison realizes that whatever way the casts were displayed throughout the 1900s, the constructed nature of this entire venture was apparent all the time, hidden in plain sight, an impression I have alluded to before. It turns out that in their quest for unconditional mimesis, researchers meticulously painted lighter and darker skin tones on the casts to demarcate the areas of these real bodies that had been wearing clothes, from those that were fully exposed to the sun. Bona fide twentieth-century Bushmen had tan lines, in other words.[81]

In the end, the allegiance that these scientists professed to the standards of their craft sabotages the claims of their mission. The evidence was always—well, evident—to debunk the argument that these were timeless depictions of children of nature. But it took nearly 100 years before anyone publicly pointed it out.

RELICS AND VESTIGES

In New York City's Harlem, a stairway linking St. Nicholas and Edgecombe avenues at 157th Street is called the Bushman Steps. Today the name is enigmatic, its meaning lost over time, just as so much of the Bushman population as well as information about them have also vanished.

On a visit I made to the Eastern Cape in July 2003, I met a young black man at a tourist information center. He was enthusiastic about his job and eager to please visitors. He informed me with great confidence, "The Khoi are dinosaurs. The Khoi died out centuries ago." Then he took off his cap and ran his hand over his head to dramatize the point: "Khoi should have strong hair like mine," he said, "strong short hair that you can't put a comb through. People that claim that they are Khoi have hair like white people."

His point was this: it's bogus nowadays for people to claim ancient origins in South Africa, first people status. And attempting to do so is putting people

like himself at a disadvantage. Now is the time for blacks to flourish in this country—black Africans, that is. All else is posturing and self-serving and a mockery.

From "living fossils" to "dinosaurs": there are stubborn similarities in the ways that South Africa's indigenous groups and their descendants have been characterized over the years. And for the most part, they have been nameless victims of incalculable callousness and brutality. If they are indeed "dinosaurs," historical records make it clear why that's the case.

Figure 5 Willie Bester's sculpture of Sarah Bartmann on display at the University of Cape Town's science and engineering library, 2001

Source: Used by permission, Cape Argus/Trace Images.

Prisoners to Science: Sarah Bartmann and "Others"

Often referred to as "a freak of nature," the freak, it must be emphasized, is a freak of culture.

Stewart, quoted in Strother, 1999

Hankey is a speck of a town. In Khoikhoi, it originally meant "place of fertile earth"; today it's known as the "pantry of the Eastern Cape." Citrus and vegetable farming is profitable, yet poverty is rife. The largest sundial in Africa greets visitors as they drive in, and the local golf course is "the pride of the town."[1]

The (extremely) modest Hankey Hotel, a few small general merchandise and farm supply stores, a market or two, and that's about all. Travel more than a couple of blocks in any direction away from the main crossroads, and you have left it.

Nonetheless, people around the world were fixed on an event unfolding there in the lush Gamtoos River Valley during 2002. A high-profile funeral was infusing this rural community in the Eastern Cape Province with new life. Hankey's most famous daughter was returning to receive a proper burial at long last.

Her name is Saartjie, Saartje, or Sarah Bartmann, and the array of tags that have been conferred upon her is dizzying: slave, heroine, prostitute; sideshow freak, opportunist, alcoholic; prisoner of science, role model, syphilitic, and tubercular; Grandma, Mama, Sister, *Ouma* [Aunt], Queen, Mother/ Grandmother of the Nation; grotesque, savior, lascivious; pauper, Sister ancestor, compatriot; icon, sex object, museum exhibit; fortune seeker, missing link, ultimate victim of racism and sexism. But her place in history has most commonly been marked by the epithet "Hottentot Venus."

Sarah Bartmann's return to South Africa in 2002, and the very public funeral accorded her, provoked many feelings: anger over the drawn-out negotiations for the release of her remains from a French museum, where they had been kept for nearly two centuries; grief concerning the ill treatment

she'd received while living, and the disrespect she'd received after death; pride and empowerment sensed by the people who most likely share her lineage, the Khoisan; relief that her protracted exile had at last come to an end; common cause, in restoring her dignity, but also exclusive assertions of ownership over her legacy and her physical vestiges by various constituencies; and even hopeful anticipation that this could become a unique and valuable marketing ploy for Hankey's economic future.

Although the basic outline of Sarah Bartmann's plight has become more or less well known, some important questions beg to be answered. How is it that from the multitudes of human remains held in museums and universities throughout the West, Sarah Bartmann emerged as one of the foremost exemplars of the cruelties of colonialism? How common was Sarah Bartmann's predicament: her open display, both while she was alive, as well as after her death? What was the significance of her funeral to indigenous people whose public portrayals in museums and other domains have been consistently negative? What do the dead and the treatment we accord them reveal about the living? And what is Sarah Bartmann's significance in the New South Africa?

Venus: A Work of Art

By christening Sarah Bartmann the "Hottentot Venus," one senses sarcasm, scorn, a sneer on the part of nineteenth-century Europeans. Undoubtedly because of this, along with the fact that Bartmann embodied subaltern status in the extreme, contemporary artists have avidly embraced her as a subject for their work.

Well-known South African artist Penny Siopis created "Dora and the other woman" in 1988. In a canvas executed in her typical style, densely packed with scores of images, she links Bartmann's story with Freud's famous case of Dora. Each woman was maligned for what she did or thought, or simply for who she was (in Dora's case, she was labeled "hysteric"). And both were degraded by the treatment they received at the hands of a male-dominated medical establishment. Another South African artist, Tracey Rose, was photographed in the veld as "Venus Baartman" [2001], her naked body warily tensed in a half-crouching position, her eyes fixed on something in the distance, beyond the scope of the lens.

Conceptual artist Renee Green created the mixed-media installation "Sa main charmante" in 1989. One part is set up like an arcade peep-show contraption, and when the viewer looks inside, s/he sees a copy of a nineteenth-century caricature of Bartmann's public display. Echoing the way *Miscast* made visitors complicit in debasing South Africa's indigenous people, here viewers succumbed to, and were forced to ponder, their own voyeuristic impulses.[2]

And Renee Valerie Cox, working with Lyle Ashton Harris, has used her own body as an example of "postcolonial performance art." In Cox's different

interpretations of "Venus Hottentot" in the 1990s, she has been photographed with metallic breasts and butt extensions superimposed over her own nude body, or with plastic parts from a Halloween costume. Her look is confrontational; her purpose, reclamation; her aim, revisionist.

Cox's work addresses one of the chief reasons that Bartmann's body captivated Europeans: it was steatopygic, featuring characteristically large hips and buttocks. Bartmann has, therefore, provided special inspiration for feminist artists whose works explore body image. The exhibition *Fat* in Atlanta (1999), featured "Girdle in progress," presenting contemporary women's self-portraits juxtaposed with prints of Sarah Bartmann. In 1990–1991, writer and artist Carla Williams exhibited a large photograph of her own buttocks, mimicking ethnographic material produced a hundred years earlier. She paired this with a photocopied patchwork of images of the Hottentot Venus as part of her series "How to read character." And Deborah Willis's three-section quilt "Hottentot/Bustle," exhibited in 2000, incorporated a lithograph of the naked Sarah Bartmann; an antique dress with a bustle (a nineteenth-century fabricated steatopygia for under-endowed European ladies); and a modern dress design emphasizing the derriere.[3]

The wry message is that when a large butt belongs to a black woman, it is derided—outside of her own community. But when such voluptuousness is assimilated as mainstream fashion, it is stylish. This principle was superbly illustrated by a photo promoting South African Fashion Week, appearing in a South African newspaper just a month after Sarah Bartmann's funeral. A white model is posed against the backdrop of an industrial rooftop in a dress meant to emulate Bartmann's figure: the top is a corset-like, European skin-toned contrivance, while gauzy white fabric is generously bunched just below her back to form an enlarged, bee-stung butt.[4]

When contemporary artists address the subject of Sarah Bartmann, however, they run the risk of unintentionally carrying on her humiliation. This is a question that arose when a play about her life was produced in South Africa. *Venus*, by Pulitzer Prize-winning American author Suzan-Lori Parks, was staged in New York City in 1996. Producers later brought the play to South Africa as part of a world tour, where they presented it using local actors and an American director in 2002.

During rehearsals, however, the South African actor tapped to play Sarah Bartmann refused to play the role nude. From her perspective, with the "art scene" being rather limited in the country and audiences being relatively unfamiliar with nudity on stage, she anticipated feeling extremely vulnerable and imagined that the situation could be quite unsettling for viewers as well. In Cape Town, therefore, an American actor who had come over with the production company assumed the role.

But the troupe continued to debate the issue. According to Phillippa de Villiers, a member of the cast, when they shifted to Johannesburg, "The producers came to the realization, they said, 'Actually if she goes naked now, it will be like re-exploiting Saartje Bartmann, re-exposing her, and we don't want to do that. We want to give her dignity.'" In this second venue

Bartmann's character was assumed by a local performer clad in a snug body suit that may have been similar to what the real Bartmann wore.

A life-sized sculpture of Bartmann by Willie Bester also generated controversy in 2001. Made in the artist's signature style of welding together bits and pieces of various materials, this galvanized steel work makes her look robotic, dynamic, exposed, and fragile at the same time. Bester was inspired to make the sculpture after he visited the Musée de l'Homme, where Bartmann's remains were housed since 1816. Critics were not dismissive of the work per se, but they were vexed at its particular placement at the University of Cape Town: the fact that it was put on show in the science and engineering library seemed inappropriate to some viewers.[5]

Novels have been written about her (*Hottentot Venus*, by Barbara Chase-Riboud, 2003); documentary films have been made (among them, *The life and times of Sara Baartman* [1998] and *The return of Sara Baartman* [2003], both by Zola Maseko); plays (the aforementioned *Venus*); and plans for a feature film and a musical with puppets have been discussed. But by far the most influential artistic work has been a poem, "Tribute to Sarah Bartmann" (1998), by self-declared cultural activist Diana Ferrus.

Ferrus, of Khoisan descent, recalls that she composed the poem in Holland on the first anniversary of own mother's death. "I felt her loneliness," Ferrus wrote of Bartmann. "She was far away from home, from her mother, her people and her country. I felt her pain and I wanted to take her home."[6] As the story goes, a French senator read the poem, felt moved by it, and then rallied the support of his colleagues for releasing her remains.

Reflecting the South African obsession with competitive sport, one observer noted, "There have been many players [in the campaign to return Bartmann], but one good South African woman scored the goal for our country."[7] Her poem catapulted Ferrus into a central role in the repatriation of Sarah Bartmann's remains, including becoming part of the delegation sent to Paris to accompany Bartmann home, and being included as a visible participant in the various ceremonies that welcomed her after she arrived.

A NOTE ON TERMINOLOGY, II

Different versions of Sarah Bartmann's given name reflect how perceptions of her have changed over the past decade, and they also show the shift in power amongst various interested parties. As one participant in the debate floridly argued, "[The reclamation of indigenous] names deal[s] a blow to the cultural supremacy of our erstwhile colonisers who arrogated to themselves the right to name, rename and mispronounce the indigenous names of people and places."[8]

Through the mid-1990s, she was generally known as Saartjie (or Sartjee) Baartmann, Baartman, or Bartmann. As the campaign to have her returned to South Africa intensified after 1994, she was more often referred to as Saartje, dropping the "i." Saartjie with the "i" is Afrikaans for "little Sarah," a diminutive form more commonly used for children than adults.[9]

Moreover, a letter-to-the-editor writer recollected that when he was a schoolboy in Limpopo province, "About 60% of the female donkeys were named Saartjie. And when we drove them into the veld [open grassy country], we used to beat them repeatedly, saying, 'Saartjie!', 'Saartjie!' So it is clear that this name was given to this woman by whites, because they could drive her around like a donkey."[10]

Once her remains arrived back home in 2002, "Sara" or "Sarah" was more frequently used. According to Jatti Bredekamp, at that time director of the Institute for Historical Research at the University of the Western Cape, her birth certificate read "Sarah Bartmann."[11] Its use has become accepted practice. The printed program for the enrobement/*aantrek*/dressing ceremony that occurred in Cape Town some days before the actual burial was entitled "Flowers for Sarah Bartmann," and Deputy Minister for Arts, Culture, Science and Technology[12] Brigitte Mabandla, in her public address at the burial, argued that "Saartjie" must be dropped because of its negative connotations. I shall also use "Sarah Bartmann," while preserving an author's original language within any direct quotes about her.[13]

Sarah's Odyssey

Some facts about Sarah Bartmann's life have been well established. Others are subject to debate.

She was born in 1789. Given the maltreatment she received before and after her death in France at the end of 1815, or the beginning of 1816,[14] more than one commentator has noted the irony of her birth occurring in the same year as the French Revolution, supposedly heralding the establishment of liberté, egalité, and fraternité. Her life situation in 1810 has been variously characterized as that of a nursery maid, domestic worker, farm girl, or servant (indentured or otherwise). But others believe she was a slave, kidnapped and marched with her clan to Cape Town,[15] while still others claim she "migrated to the Cape Flats," and was living there in a small shack.[16]

The year 1810 was a momentous one for Bartmann. Merely 21 years old, she sailed to England where she was publicly displayed on various stages as a freak of nature. Was she sold to Alexander Dunlop, a British ship's doctor who noticed her when he visited a Boer farm in the Cape? Was she tricked into going? Persuaded? Lured? Coerced? Or did she have a sense of adventure and a desire to become wealthy? Each possibility has its advocates, with radically different implications for Bartmann's agency in the matter, and the degree of complicity she exercised in her own fate.

Bartmann was "managed" in England by Hendrik Cezar, brother of the farmer on whose property she apparently worked. She appeared in shows at Piccadilly, Haymarket, and Bartholomew Fair in London and later circuited through the countryside. She toured Ireland, and at least one source put her in Scotland.[17] Bartmann commonly wore a skintight costume matching her skin color that gave the appearance of her being nude, and she was subjected to audience members gawking, poking, prodding, and hurtling catcalls at

her—and, reportedly, physical and verbal abuse from Cezar, if she resisted performing as expected.

And what was it that turned Sarah Bartmann into such a public sensation? As noted, like Hottentot women in general, and other indigenous women from Southern Africa as well, Bartmann's body shape exemplified steatopygia. This distinctive physical trait features hips and buttocks formed by large deposits of fat, which can seem exaggerated by European standards. Scientific "knowledge" and common "wisdom" at the time also assumed that the sex organs of these people were more developed than in Europeans. Of special interest was the so-called Hottentot apron, a hypertrophy of the labia. Many people also assumed that Hottentots represented a "missing link" between humans and animals; Bartmann offered a tawdry glimpse into the mysteries of the past.

Spectators flocked to view this curiosity, displayed not because of any *uniqueness* amongst her own people, but precisely because of her *representativeness*.[18] The attraction she held for European audiences calls to mind two contradictory elements of the so-called Miller test that American courts use to determine whether something is legally obscene or not: suspect material must both appeal to the "prurient interest" and be "patently offensive."[19] A gag that circulated during the "culture wars" of the late twentieth century in America construed this to mean it must turn you on and gross you out at the same time. The Hottentot Venus was alluring and disgusting in equal measure.[20]

Accounts differ in some respects, but all agree that Bartmann's remains were on public view in the Musée de l'Homme until the mid-1970s; a few even push the date up to the mid-1980s. Two important articles helped revive general interest in her at about the same time. Stephen Jay Gould recalled her story in 1985, exploring the boundary between human and animal that Bartmann seemed to call into question for people in the early nineteenth century. That same year, Sander Gilman investigated how a combination of nineteenth-century ideas about prostitution, atavism, deviant sexuality, and blackness converged in the body of the Hottentot Venus.[21] Citing Havelock Ellis, Gilman stated, "Only people 'in a low state of culture' perceive the 'naked sexual organs as objects of attraction.' " The avid interest in the butts of indigenous African women was, therefore, "a displacement."[22]

A few years later, Robert Gordon argued that white male anxiety exaggerated their reports of colossally sized female Hottentot anatomy and sexual appetite, because these women were reportedly strong, independent, and extremely lustful within their local settings. He further noted that historical accounts symbolically emasculated Hottentot men by describing them as near eunuchs. These characterizations, Gordon reasoned, derived from fear of these Others, and not from rigorous observation of them.[23]

But what we might assume are antiquated attitudes still creep into contemporary discourse. A contributor to a compilation of scholarly articles on the public display of humans notes on the first page of the main text that Sarah Bartmann "*suffered* from steatopygia, enlargement of the behind."[24] But why invoke "suffered," rather than "illustrated" or "exhibited" or "demonstrated"—something less judgmental? Sarah Bartmann continues to

be the misplaced focus of other peoples' curiosity, pity, and overactive imaginations.

She was taken to Paris in 1814 and displayed at theaters and museums; on the dinner-party circuit, and at high-society balls, dressed with only a few feathers; and at the Jardin des Plantes, "in the company of exotic birds, plants and animals brought back to France by colonial adventurers in Africa."[25] Bartmann also caught the attention of the renowned Baron Georges Couvier, Napoleon's surgeon-general.

Couvier hankered to study Bartmann, and after she died at the end of 1815—disputably a penniless prostitute, from syphilis or tuberculosis[26]—he cast her body in wax and then had a plaster model made of it. He also dissected the corpse, separated her skeleton, articulated and placed it in a glass display cabinet, and had her brain and genitals conserved in preserving fluid. His findings were later published with highly questionable speculations about the relation between indigenous Africans and various simians.

Jean Burgess, a Khoisan community activist, recoils at what was done with Bartmann's body: "This woman's spirit couldn't rest because of her remains [being unburied], and the fact that it was her private parts that gives birth that was kept in a bottle, the fact that it was her brain that made her who she is, it was kept in a bottle. It wasn't the heart or the lungs or the liver, it was those specific body parts."

A newspaper article in 1995 expressed bewilderment that "[Bartmann] has become the *bizarre focus* of a cultural campaign in the new South Africa demanding her return." The reporter in question characterized officials at the Musée de l'Homme in Paris as "baffled" by a request for the return of Bartmann's remains. And she quoted the South African researcher who had presented the appeal as saying, "They couldn't imagine anyone could see her as a heroine."[27]

In the years following, it would become readily apparent how seriously the museum miscalculated the amount of energy and determination that South Africa's indigenous peoples would deploy to bring Sarah back. That passion is explained by Jean Burgess: "Scientists [have] refused to look at the spiritual side of it, [but] there was this pain carried over from generation to generation. And we were born into a spiritual pain that we couldn't comprehend." She continues, "It is that spiritual pain that we, I personally, could never comprehend until I touched Saartje Bartmann's remains. There was a spiritual dawning on me, 'This is why we are who we are.' "

THE HOTTENTOT VENUS:
VICTIM OR ADVENTURER?

One of the most sensitive and hotly contested questions arising in this case is whether or not Sarah Bartmann consented to become a human spectacle. Did she at least partially author her own destiny? The question of agency goes to the heart of how contemporary commentators evaluate her story, and try to engineer what she might represent to people today.

If she were sold to the doctor who took her back to England,[28] or if she was simply a "poor naïve young woman,"[29] she could not be held responsible for her fate. Ditto if she were a slave, or as one writer states in rather overwrought language, "[S]he was pushed into depravity by Western opportunists who saw in her a chance to take advantage of Africa's innocence."[30] Broadly speaking, those who cast Sarah Bartmann as a victim—who may, indeed, strongly wish to cultivate a sympathetic response to her—may unintentionally render her a passive witness to her eventual fate.

Many others prefer to view her differently. Anthropologist James Clifford assesses the type of situation that non-Westerners in general faced when they made contact with agents of colonialism: "people lent themselves to the projects of explorers and entrepreneurs for a range of reasons, including fear, economic need, curiosity, a desire for adventure, a quest for power."[31] And Dr. Willa Boezak, national chaplain for the Khoisan community, has a foot in either camp, viewing what happened to Sarah Bartmann as an instance of a good prospect gone sour: " 'She was taken, not against her will, but under false pretenses, by unscrupulous men.' "[32]

Phillippa de Villiers reflects, "I found it more satisfying [to consider] 'Yes, she thought about the money.' " De Villiers, one of whose characters ordered Bartmann around the stage in the play *Venus*, draws this conclusion: "In that whole first scene when she was asking about money, 'How much money am I going to get?' 'Okay, okay, I could dance, I could dance, I could go and do that. Ja, sure, I will do it for the money.' We do that all the time; it is a very human thing to do."

Pippa Skotnes also appraises this as an economic gamble: "There is the argument that she was a showgirl, and she was out to make her fortune, and like many showgirls, she of course didn't. She got ill and died a miserable death." So this might have been an instance of fiscal collusion, or possibly the case of a young woman pursuing her dreams of living in a manner that would not normally be available to someone of her station. "There must have been something in it for this lady, otherwise she wouldn't have done it," reasons Dr. Manton Hirst, of the Amathole Museum.

But what dismays Skotnes is the manner in which Bartmann has been valorized into an icon, and her life magnified to personify grand, abstract concepts: "I think in the interests of her becoming a symbol for all sorts of struggles, indigenous peoples' struggles, feminist struggles, the historical veracity was shoved out the window. There was very little accuracy in what was written at the time of her repatriation."

INJUSTICE ON TRIAL

Despite her celebrity at the time, not everyone was keen about the display of Sarah Bartmann. London papers began to receive letters of protest over her treatment soon after she first appeared there. Many complainants felt obliged to write because England had outlawed the slave trade with its colonies by

the 1807 Abolition Act, and they regarded this public attraction as seeming uncomfortably close to enforced servitude.[33]

An advocacy/pressure group called the African Association took the lead to protect Bartmann if she were, indeed, being forced to appear against her will. The African Association worked closely with abolitionist groups, and it could potentially arrange for Bartmann's repatriation, if that seemed warranted. As part of their investigation, three of its members attended Bartmann's show. Based upon what they had observed, the group prodded the Court of the King's Bench to take up the matter.

After the magistrates examined the papers filed in the case, they resolved to hear directly from Sarah Bartmann herself. And so she was questioned in front of witnesses concerning what she understood about her present circumstances, to what degree she had consented to be displayed in the way that she was, and how she felt about it.

Bartmann's testimony surprised and disappointed the representatives from the African Association. After three hours of questioning, she revealed that she had voluntarily chosen to leave South Africa for Europe; her treatment had been satisfactory, and she was not subject to physical violence or threats; she was content with her situation and did not desire to return home. As a result of this testimony, the case brought by the activists collapsed, and their attempt to "rescue" her was thereby derailed. But at least one commentator believes that a moral victory *was* achieved, and that Bartmann's treatment likely improved after the hearing.[34]

Bartmann had become a popular sensation. She was the subject of caricaturists; a comic opera was written about her; and a satirical ballad of the time read, in part,

> [I]n this land of libertie,
> Where freedom groweth still,
> No one can show another's tail
> Against the owner's will.[35]

Of the modern-day accounts that have been written about Sarah Bartmann, one in particular aimed to get beyond the details of the case, to get inside her head, and to try to imagine how Bartmann actually felt. When historian Yvette Abrahams contemplated this long-ago episode in a London court, the verdict she reached diverged significantly from the official one.

Abrahams argues that Bartmann was in fact a slave in South Africa, and that her status was roughly equivalent when she appeared in Europe. She rejects the conclusion that Bartmann was "greedy for money,"[36] and she insists that the official interview with Bartmann cannot be accepted at face value. On the contrary, she insists that the words that Bartmann exchanged with her interrogators must be closely studied in order to extract the interpersonal dynamics of the encounter.

From Abrahams's perspective, the power differential between Bartmann and all the others involved in this episode—even those who advocated for

her—must have critically shaped both how and what she answered. Would a black woman's accusations against a white man be taken seriously? And if she had accused her "owner" of maltreatment, what would be the consequences if she were then released back into his custody? In all probability, Bartmann would have carefully gauged whatever she said, settling on a strategy that she felt would bring her the least trouble. Bartmann's mental calculus must have concluded with the decision to play it safe, for survival's sake; the devil you know, as the maxim goes, is better than the one you don't.

"[W]e may be certain," Abrahams wraps up, "that she [Bartmann] wore the 'mask that grins and lies' in court not because she had no desire to be free, but because she considered it necessary for the sake of survival. It would have been highly unreasonable to expect her to accept the goodwill and sincerity of strangers who looked too much like the slave masters back home."[37]

DIANA DIED FOR YOUR SINS

As noted, when Pippa Skotnes was researching *Miscast*, she discovered a collection of nineteenth-century stuffed Khoisan heads in London's British Museum (Natural History). The practice of turning the heads of vanquished enemies into trophies was once widespread, by Europeans and Africans alike. But the quest to repatriate fallen heroes is a much more contemporary phenomenon. The chronicles of other high-profile cases leading up to the return of Sarah Bartmann's remains from her museum confinement puts this distinctive story into perspective.

Approximately 70 miles outside of Barcelona, in Banyoles, Spain, the Darder Museum of Natural History features all manner of oddities. The museum has featured mummies, human skulls, and the splayed skins of a human male and female, their faces cut down the middle, thereby grotesquely forcing the two halves to stare at one another. And from 1916 until 1997 it exhibited the stuffed corpse of a southern African hunter, stolen from a grave by a French taxidermist in the late nineteenth century. The man's exact origins are unclear: although widely reported during recent years to be a member of a Khoisan tribe, he is just as likely a Tswana from South Africa. Dubbed "The Black" or "El Negro," he became a point of contention in the run-up to the Barcelona Olympic Games in 1992, with some African countries threatening a boycott.

South African writer Breyten Breytenbach describes El Negro in meticulous detail, down to his toenails and skin ("very dark and leathery—perhaps it had been varnished"). When he chats with the museum attendant she relates the story of a woman who regularly "visited" the exhibit: " 'She sits in there for hours talking softly to the hunter and then she always leaves food behind.' " But as peculiar as that sounds, the worker's interpretation of this offering is equally strange: " 'Stupid, of course, as if the African would eat Catalan fare! Blonde woman. Must be a foreigner. We don't show her away, we just remove the food afterwards.' "[38]

El Negro was welcomed with a festive homecoming in Botswana in 2000, even though that may not be where he came from. Scores of people had a

look at him through a windowed casket as he lay in state in the civic center in the capital of Gaborone, and his remains were then buried with state honors. The museum in Spain had removed them from the public a few years earlier "to prevent a diplomatic incident," and "out of 'respect to the thousands of African immigrants who live in this town.' "[39]

To cite another example, Brett Bailey's play *iMumbo Jumbo* revolved around South African Chief Nicholas Gcaleka's modern-day journey to Scotland seeking the skull of Xhosa Chief Hintsa, reportedly beheaded during the frontier wars of the nineteenth century. Gcaleka asserted kinship with Hintsa, and he claimed that he was instructed in a dream to reclaim the chief's head. Flamboyant, and an accomplished media spinner, Gcaleka generated a great deal of buzz about his activities, and he rallied the necessary corporate financing to underwrite his overseas mission.

But when he and his entourage returned with a skull in 1996, they were met with skepticism rather than acclamation: the stories of Hintsa's beheading, it turned out, were contradicted by an official inquiry authorized in 1835. Cognizant of this, a group of Xhosa elders turned the skull over to scientists for inspection. Their conclusion? It had belonged to a middle-aged European woman, not a native South African.

A strikingly parallel story springs from Australia, with the search for the skull of aboriginal leader Yagan. Both these men were liaisons between their people and the Brits, who later became victims of their former associates (Yagan was murdered in 1833; Hintsa, in 1835). Each of the groups seeking the remains of their martyred leader believed that his spirit would not be at peace until the body and head were reunited in a proper burial. (Advocates of Sarah Bartmann believed her to be suspended in a similar sort of psychic limbo.) And the drama of these quests peaked within a year of one another.[40]

Yagan was born around 1810, the year that Sarah Bartmann left South Africa. As a young man, Yagan resisted colonial authority and white incursions into tribal land, just as various indigenous groups were doing in South Africa. After he was murdered by two young men seeking to collect a government bounty, Yagan's head was cut off and smoked for weeks in a hollow tree; thus preserved, it was taken to England. (Hinsta's body was reportedly stuffed into an antbear's hole.)

The skull was donated to the Liverpool Royal Institution in 1835, where it was displayed in the Insect Room; in 1894, it was permanently loaned to Liverpool City Museum. Officials buried it in a pauper's grave in 1964, alongside stillborn infants and the remains of additional "exotic" people who had been captured and stored in the museum. Yagan's aboriginal descendants searched for the whereabouts of his skull for many years.

The arrival of Yagan's skull back in Australia in 1997 triggered a bizarre cycle of symbolic payback. One of the aboriginal activists claimed that Princess Diana's fatal car accident signified karmic reparations for what her countrymen had done to *their* leader more than a century and a half earlier. "Because the Poms [Australian slang for the English] did the wrong thing, they now have to suffer," he declared.[41]

In retaliation, an Australian fan of Lady Di claimed responsibility for decapitating a statue of Yagan near downtown Perth, on the day of Diana's funeral in September; the same thing occurred again, a few months later. This was followed by a film, *Confessions of a headhunter*, released in 2000. It recounts the fictional adventures of two young aborigines who cross the country, decapitating white colonial statues.[42]

Shortly after return of the skull, unsuccessful attempts were made to steal it from a government facility, although the identity of the culprits was unclear. More than five years after its repatriation, the skull remained unburied. Locating the original burial site proved to be more challenging than expected, prompting a sense of extreme disquiet that Yagan's spirit was still roaming the land, and generating conflict between different aboriginal factions over how to proceed. One elder decried, "The delay in burying Yagan's head has brought sickness to our community. They have got to get rid of that head."

As if to prove the point, a member of the delegation who had retrieved the skull suffered a heart attack later the same month that he returned home. And another leader perished in a road accident. The heart attack victim declared, "I believe this is spiritual badness through this messing around with Yagan."[43]

By 2003, elders had accepted the fact that it was futile to continue the search for Yagan's remains. The quest had become quite expensive in monetary terms, and internally damaging to group spirit and cohesion. In order to restore equilibrium to the community, they decided to bury Yagan's head, and they turned their attentions to planning a cultural center at the site as the most meaningful memorial to his legacy.

What Becomes a Legend Most?

Yagan's head represents a vast and long-standing interest in the West in the remains of indigenous human beings. A London antiquarian once used Yagan's head at a "conversazione," "a Victorian dinner party where scientific oddities were shown off."[44] Such items were cherished as mantelpiece ornaments and valued as scientific curios.[45]

Phrenologists sought them for study, and the distinctive tattooing and body scarification common to the Australasian indigenes intensified European curiosity about their remains in particular. Yagan's skin was flayed and kept as a souvenir; Maori tattooed heads were also deemed desirable (the largest collection is held by the American Museum of Natural History in New York City).[46] Estimates of aboriginal remains in museums today reach into the thousands.

Moreover, the display of live "specimens" of different "races" was commonplace throughout the nineteenth century, and through the pre–World War II era, particularly at expositions, fairs, dime museums, and carnival sideshows. In South Africa, Bushmen were included as attractions during the

1952 van Riebeeck Festival, celebrating 300 years of European settlement in Southern Africa.[47] Some authors compare these presentations to "cabinets of curiosities,"[48] except that in these instances the exhibits were living and breathing. Such displays were both ubiquitous and constructed.

Moreover, G.A. Farini presented South African Bushmen as "Earthmen" (they supposedly burrowed underground) or "Yellow Dwarfs"; "Clicko," "The Wild Dancing South African Bushman," and "Bain's Bushmen" were also crowd pleasers. And another nude South African woman, also dubbed the Hottentot Venus, was displayed at a Paris ball in 1829. A wide range of human attractions, in addition to the insane, the misshapen, and other novelties, once drew the stares of hordes of viewers. In fact, "exotics" have fascinated rulers since Greek and Roman times, and they have enlivened European courts since at least the period when Columbus and Cortés brought back Indians and Aztecs.[49]

In basic respects, audiences conflated the attributes of race, low intelligence, physical abnormality, and presumably animalistic qualities when they inspected these sights. As one author explains, "Persons from tribal cultures, on show in the West, were commodified, labeled, scripted, objectified, essentialized, decontextualized, aestheticized, and fetishized. They were cast in the role of backward, allochronic contemporary ancestors."[50]

Authenticity was not a strict requirement; wonderment and crowd appeal most certainly were. In Chicago's (ironically named) "Century of Progress" World's Fair in 1933–1934, two microcephalic black men from the American South were misrepresented as supposed "African headhunters." And the bulk of the "natives" in the African Village were conscripted from Chicago pool halls.[51] Just as we saw in the case of the Bushmen body casting project by the South African Museum, the examples that were chosen (or conjured up) for public view confirmed preexisting stereotypes. And, significantly, some world's fairs left an enduring legacy: many ethnological museums evolved from them. Among these is the Musée de l'Homme, the place where Sarah Bartmann was kept for so many years, originating from the 1878 Paris World's Fair.[52]

All these humans who were exhibited, Sarah Bartmann included, would have had to foster ways of coping with the minute scrutiny and deep derision directed toward them. For Chicago's South Siders, separated from their actual homes by a matter of blocks, it might not have been so difficult to maintain their psychic equilibrium. And besides, they were probably street-smart, well accustomed to "putting on the Man," and they were making money through expending very little effort.

Clicko the Dancing Bushman might have "saved" himself by entering into an ecstatic trance state while he was on show, thus distancing himself from the distress of the immediate situation.[53] But Sarah Bartmann did not have these advantages: as a woman, marooned far from her home, subject to harsh treatment and humiliating self-exposure, how was she able to survive, day in and day out? In a court affidavit filed by the African Association on her behalf, the deponents described what they observed when they saw Bartmann on display: "said female gave evident signs of mortification and misery at her degraded situation," and the men characterized her as being "very morose and sullen."[54]

In *Venus*, the character of Sarah reminisces about her former home by grumbling, "It was a shitty, shitty life, but I miss it."

So the question remains: from the multitude of people who were once put on public display, how has Sarah Bartmann attained such iconic status in South Africa?

"BECAUSE WE LOST OUR NAMES"

The handbills designed for *Venus* at the Windybrow Arts Centre in Hillbrow, Johannesburg, read, "For 188 years, she was a prisoner to science. She's come home." Why did actress Phillippa de Villiers feel it was important for her to be part of this play? And what significance does Sarah Bartmann hold for people today?

"Because she is one of our few ancestors that has a name," de Villiers answers, simply, "and that has a history that can be traced in books." That fact, as much as anything else, separates Bartmann from the crowd. De Villiers continues, "I think that for a long time Saartje Bartmann was the only person, the only woman anyway, besides Mrs. Shaka [*sic*] and Mrs. Dingane [*sic*][55] that had a kind of presence, and seemed to have made a couple of choices in her life, or had something, had a life." Performing in *Venus* was therefore a way for her to explore both personal and social issues.

From de Villiers's perspective, many South Africans now face the daunting challenge of imagining, or even inventing, the lives of their forbears. This is especially imperative for someone like herself, who was raised by a white family but later discovered she had in fact been born "coloured."

Once de Villiers located her African father, she believed she had finally "come home." But as she has since learned, this can be a very knotty, frustrating, and potentially disappointing journey: "I think in a way we are a little bit naïve about, you know, you'll just get your name, you will get the right clothes, you will start eating the right food, you will learn the language, and then you will fit in. And it is actually so much more complex than that. But it is also very interesting, that complexity, and sometimes frustrating, because the ancestors are not really what you think they are going to be."[56]

Sarah Bartmann may have died nearly two centuries ago and thousands of miles from the country of her birth, but her name survived her. This enables contemporary South Africans to personalize, to individualize the pain and injustices of the past. In a statement that captures the emotional void and uncertainty that many South Africans feel because of the ways in which colonization and apartheid divided people, stripped them of their histories, and destroyed their identities de Villiers movingly declares, "Because we lost our names, we lost a lot of meaning from our lives."

Sarah Bartmann, though exiled, sullied, and exploited, was never completely lost to popular memory. Yagan's significance to the Australian aboriginals works along similar lines: "It wasn't a hierarchical society with a permanent military leadership," we are told.[57] Hence, few resistance fighters

were known, or remembered, by name. Bartmann and Yagan are thus two people who have come to represent entire (decimated) communities.

Inevitably, however, Bartmann's official image was carefully constructed in particular ways in years past. Jean Burgess, the Khoisan community activist, remembers, "In government schools, what we were taught was the negative side of Sarah Bartmann. The educational system ensured that we divorced ourselves from this woman. She was portrayed as an ugly woman with big bums, a prostitute, who deserved to die. [That] ensured the ruler that we would never claim the remains because we could not identify with the woman." But the discourse shifted in the 1990s, the exhibition *Miscast* being one of the noteworthy forces behind rethinking this aspect of South African history.[58]

The increased attention being devoted at present to reconsidering the fetishistic collection, hoarding, and customary exhibition of human body parts by Western museums compels us to ask, "What signified 'savage' and what constituted 'civilized' behavior, following European encounters with the inhabitants of faraway lands?"

FUNEREAL RIGHTS

The American artist Barbara Kruger famously stated, "Your body is a battle-ground." That was in 1989, as part of a layered photographic print that she designed for an abortion rights march in Washington, DC, executed in her customarily bold, sloganeering, poster style. But while this motto had a specific focus, it was prescient in regards to recognizing the body as an important locus of struggle over the construction of identities and the exercise of social power.

This general principle extends to bodies whether dead or alive. It is a mistake to suppose that once a person has passed on, her body would no longer hold meaning.[59] On the contrary, it can be invested with great significance and multiple connotations. The body is a site of conflicting claims, whatever its social location, gender, or state of being.

The deceased have a specific historical resonance in South Africa: during the struggle against apartheid, people who died at the hands of the government were hurtled into martyrdom at very public funerals, sometimes attracting thousands of people. The loss of an individual life was being honored, to be sure, but funerals were also an expression of unity, a moment of revitalization of shared identity, and a form of collective resistance, a particular moment that plaited together the personal and the political.[60] Funerals visibly and defiantly challenged the political status quo; they bore enormous symbolic value because other sorts of public gatherings were banned.[61]

Afrikaners on the extreme right, who were once the object of contempt by black mourners, now realize for themselves the potential publicity value of funerals. In 2001 the Herstigte Nasionale Party [HNP] issued a call to convert the funerals of white crime victims into rallies. Arguing that crime is not random, but that blacks intentionally target Afrikaner farmers, a HNP document appropriated the term "genocide" to characterize what was

happening to their brethren. Seeking recognition of their cause, the text boldly declared, "Whites will have to defend themselves with all means at their disposal"[62] (whether consciously or not, echoing Malcolm X's defiant pronouncement of many years earlier).

In account after account, African scholars have highlighted how funerals expose social fault lines and bring unresolved conflicts to the fore. The focal point of one study is the death of a wealthy Ghanaian man who had converted to Christianity and adopted a contemporary lifestyle. Different groups vied to bury him: his life was a contradiction between the traditional and the modern, a conflict that had to be resolved in some manner once he had died.[63]

In the case of the death of a man who was a successful lawyer in Kenya, the protracted and well-publicized battle over where he should be buried gripped the country for five months. The points of conflict were manifold: between metropolitan/cosmopolitan and rural/birthplace identities; between customary, localized law, and contemporary, national law; between Christianity and traditional beliefs; between the rights of the deceased's clan and those of his widow. The anxiety over the proper disposition of a body is obviously great for those like this man, who are "recently arrived": betwixt and between their point of origin and where they have ultimately put down new social roots. These are individuals who, in the authors' words, "carr[y] a double consciousness."[64]

They argue that contestation over funerals crosses scores of eras and national boundaries, especially in the case of royalty.[65] And heavily symbolic battles can even brew over the rightful possession and disposition of a deceased animal. These writers also discuss Omieri, a beloved python who had been taken from her rural Kenyan village to Nairobi for medical care, after being badly burned in an accident. Villagers successfully battled the National Museums of Kenya to return her home for further treatment at the local Kisumu Museum. But Omieri died two years later, and the debate thereafter centered on either honoring her corpse with a "clan burial" or preserving her as a museum specimen. This dispute intersected with the one raging over the distinguished lawyer, each one informing the other.[66]

In the South African situation, the reburial of the remains of an early twentieth-century female prophet in the Eastern Cape helped negate how she was treated while alive, at the same time dramatizing the conflict between native beliefs and governmental authority. Like Sarah Bartmann, Nontetha had been a victim of racial science. She had the bad fortune to be preaching at a time when the government felt great apprehension concerning the possible eruption of popular uprisings, captained by charismatic religious leaders: a disastrous military response against a sect called the Israelites had resulted in the Bulhoek Massacre of 1921.

To neutralize any threat, Nontetha was committed to a mental hospital in 1922, where she remained until her death in 1935. She was then buried in a pauper's grave. But her remains were joyously laid to rest within the dictates of the Church of the Prophetess Nontetha in 1998, after her followers were successful in recovering and gaining control over them.[67]

An additional situation emerged during the apartheid era, when the central government funneled blacks into desolate homelands and exclusively endorsed black leaders loyal to the racist regime. Many people considered those who displaced the traditional leaders to be sham rulers.

The paramount chief of the Thembus was one of those ousted from power, and he later died in exile. The apartheid-appointed homeland chief minister ordered him buried in the women's section of a pauper's burial ground. This shocking breach of custom may have demonstrated this official's power, but it undercut any sense of authority he could claim among the general population, and also undermined any declarations to ethnic legitimacy that he might make.

The initial burial took place in 1986. But when this minister was deposed the next year, supporters of the deceased paramount chief mobilized to bury him according to custom. As one author argues, the defenders of traditional beliefs thereby championed social change and resistance. The reburial ceremony prominently featured antiapartheid songs and *toyi-toying* [mass high-stepping dancing and singing, popularized during the struggle against apartheid to demonstrate collective strength and to unnerve the authorities].[68]

In the case of Sarah Bartmann, the story that government officials and indigenous leaders wished to construct was to be one of unity and healing. But to what degree was that successfully achieved?

"A Duty of Memory"

The Griqua National Conference approached President Mandela in 1995 about lobbying the French government to release Bartmann's remains; Mandela subsequently spoke with his French counterpart, President Miiterrand, about the matter. The Griquas, present-day descendants of Hottentot and European pairings, also sent a "Protest Note" to the French government. One noteworthy passage makes it clear that they were advancing themselves as the exclusive heirs to Bartmann's legacy, describing their stewardship role as "the autochthonous, aboriginal and indigenous Griqua, in their capacity as a First National of SA and as guardians and custodians of continuous, uninterrupted Cape original Khoikhoi heritage language and identity."[69]

As with the Bushmen pressing land claims, this was a forthright effort by the Griquas to stride into public consciousness and to legitimize themselves. One news article refers to "[t]he intriguing Griqua renaissance,"[70] stemming from the group's attempt to have the ANC recognize the group's traditional leaders. Rallying around Sarah Bartmann was vital to their reunification, and to enhance their potential political muscle, thereby prevailing over the many forces that had scattered and subjugated them in the past. Even though the Griquas enlisted the support of Mandela and the ANC, their long-standing sense of exclusion, and suspicion of government, was obvious. One Griqua leader lamented, "we're again sucking at the hind teat."[71]

Later on, a coalition of ethnic interest groups formed the National Khoi-San Consultative Conference of South Africa to generate additional interest in

the cause. And Dr. Phillip Tobias, distinguished emeritus professor of Anatomy and Human Biology at the University of the Witwatersrand in Johannesburg, eventually entered into negotiations with the Musée de l'Homme, making the most of his professional contacts. According to Dr. Ben Ngubane, minister of Arts, Culture, Science and Technology, the negotiations "raised tempers on both sides."[72]

At one stage South African envoys were told that Bartmann's remains had somehow been lost or destroyed. The matter dragged on and on. A large part of the resistance on the part of the French was due to their fears that releasing Bartmann's remains could open the floodgates to similar demands. They were especially concerned about requests originating from their former colonies and the prospect of ex-subjects seeking the return of relics of various sorts that were plundered during France's reign.

Museum officials were alarmed over setting such a precedent. They therefore raised the defense that Bartmann represented part of the French national patrimony, was thus legal property of the state and could not be deaccessioned, save for a specific order of the French parliament. As late as 2000, a French curator was quoted as saying, "for us she remains a very important treasure."[73] And the press officer for the French Embassy in South Africa declared, "If you hand back everything to the people, we will have nothing in our museums."[74]

As symbolically important as the return of Bartmann's remains became, it did irritate some indigenous people that so much effort was being expended on this matter, thereby deflecting attention from the critical real-world problems that their communities continue to face. "How is it possible to be so concerned about a skeleton, but not at all concerned about her people suffering and dying every day?" asked the chaplain of the National Council of Khoi chiefs. "We are growing sick and tired of empty, political talk-shops. As long as the Khoi-san are not recognised as South Africa's first indigenous nation, Saartjie will still not be free!"[75] And the media officer of the National Khoisan Council declared that the return of Bartmann's remains was merely a token gesture that must be followed up with an official apology from the French government, and even reparations. He bolstered his claim by citing similar claims made by Canadian Inuits, American Indians, Holocaust survivors, and the Herero in Namibia.[76]

As mentioned, an influential factor in changing the sentiments of French lawmakers was the moving "Tribute to Sarah Bartmann," a poem by Diana Ferrus. The proposal to return Bartmann eventually mustered unanimous support in both assemblies, doing so as "a duty of memory."[77]

"Your Brother's Blood Cries Out to Me"[78]

One of the oddest yet most intriguing moments of the nationally televised funeral service for Sarah Bartmann was the spectacle of two women of East Indian descent, draped in customary garb, swaying across the stage while

performing traditional dance movements. It is not that what they were doing was so strange, but the surrounding scene most certainly was: they were encircled by scores of Nama (descendants of Hottentots occupying Southern Nambia) and Khoisan women bedecked in their own traditional attire, many of their outfits embellished with the beaded red AIDS ribbons that are seen throughout this part of the world.

These Africans were ample women, women whom the best-selling novelist Alexander McCall Smith would likely characterize as being "traditionally built."[79] And when the Indians inevitably collided with the robustness of the African ladies, they were flung in every direction, careening from corner to corner in some bizarre human version of bumper cars. If this were a vision of "The New South Africa," it was a madcap choreography mixed with friction, persistence, and comic absurdity.

One of the voice-over commentators described the scene as follows: "There are a couple of Indian dancers who are refusing also to be submerged by the other people, which is very interesting, because they don't stand aside and say 'Ah, well, we'll get our own turn and do our own thing [later]' But they form part of the whole thing and they are doing their part out there."

Was this an occasion that all South Africans could, and should, identify with? Or did it belong to the Griquas, who successfully campaigned to claim her as one of their own, and have her buried in Hankey? Furthermore, was this Sarah Bartmann's day? Or was it an occasion for politicians?

As noted, from the time democracy was established in South Africa in 1994, various people acted to have Bartmann returned. Moreover the South African Museums Association [SAMA] passed a resolution in 1996 supporting the repatriation of her remains. It also organized a meeting in Cape Town to discuss what should happen to them once they arrived back home.

The following year, the South African National Gallery hosted an international forum on Human Rights Day that drew nearly 1,000 people. The invitation demands, in bold letters, "Free Saartje Baartman! Give Back Our Dead!" It also insists upon the release of "other Khoesan remains detained in a kind of custody in museums." At this juncture, associations of Nama, Baster (a mixed-race group centered in Rehoboth, Namibia), and Griqua people[80] united in a common cause to sponsor the event: "This will be the first time ever that representative Khoesan groups will come together to express solidarity as Khoesan First Nations."[81]

This forum promoted the idea of burying Sarah Bartmann on Robben Island. While in recent times it is primarily remembered as a place of imprisonment for political prisoners during the apartheid years, it had also been a place where the Dutch banished Khoikhoi leaders in the late 1600s. But once the return of Bartmann's remains became inevitable in 2002, the contest was on for where she "belonged."

A number of other sites were put forward as possible alternatives. The town of Paarl, 60 kilometers outside of Cape Town, was proposed as a place where she likely grew up. And Oudtshoorn was mentioned as perhaps being her birthplace, and also where her modern-day descendants could be concentrated,

rather than in the Gamtoos River Valley. Meanwhile, the closer that Bartmann's release actually became, Robben Island became more noticeably absent from the discussion.

When Robben Island was initially brought up, the museum there was just being inaugurated (see chapter 6). And although the island confined many groups of prisoners over several hundred years, the museum's primary focus was the story of the ANC and the recent struggle against apartheid. Sarah Bartmann's story was rather extraneous to the narrative that officials were then developing.

Others championed the Company's Garden as the best site. Laid out in 1652, this verdant space once provided fresh produce for sailors and settlers dispatched by the Dutch East India Company. Its tree-lined pathways now offer a pleasant respite from the hectic Cape Town streets that form its perimeter. And it provides a gateway for the South African Library, the South African National Gallery, and the South African Museum, while also skirting the back of the Parliament buildings. It is the one of the symbolic centers of the city.

This proposal garnered a broad array of support. When Bartmann's remains arrived in Cape Town in May 2002, the Western Cape provincial minister of Cultural Affairs declared, "We would like her to be buried here in Cape Town in the Company's Garden. She has become a national symbol and she should be buried where there is access to a wide range of people."[82] And a Griqua spokesperson concurred, "We would like to share Ms. Baartman with the rest of the country. Having her buried in the Company's Garden will also change the character of the Garden, created by colonists."[83]

The National Khoi-San Consultative Conference endorsed this option as well. Earlier on, a Khoisan rights activist had elevated the discussion of funeral arrangements from a parochial concern to a nationwide one: "It will not be a Cape Town thing," she stated flatly, "it will not be a Griqua thing, it will be a national thing."[84]

But discontent was apparent underneath this seemingly harmonious surface. From the very day of the handover of Bartmann's remains by the French to the South African delegation, the potential for rivalry between different indigenous factions was apparent; the provincial minister for Cultural Affairs "has appealed for calm," according to one report.[85] Moreover, some groups angrily denounced the Consultative Conference as not representing them or their interests, and refused to recognize them as legitimate negotiators.[86] And Nama activist Maggie Oewies-Shongwe, who advocated Paarl in the Western Cape for the burial, threatened drastic action if this choice did not prevail: "she warned that 'her people' were likely to dig them [the remains] up and rebury them in the town."[87]

The decision was ultimately taken by a "reference group" set up by the aforementioned provincial minister of Cultural Affairs. And it chose Hankey.[88] A primary consideration was to honor a practice common among many groups of South Africans: returning an individual's remains to their point of origin (for some, this also means where the placenta was buried). Because the movement

for Sarah Bartmann's return had been spearheaded by the Griqua National Conference in March 1995, and that group most effectively prevailed in staking their claim as Bartmann's legitimate heirs, Hankey was the plausible choice.

In May, when the pressure was on to come up with a decision, the Nama activist quoted above declared, "She [Bartmann] went through enough pain and suffering. We do not want her to become a political football."[89] And when the reference group ultimately announced its decision, it insisted that it was unanimous and in accord with the wishes of the Khoi-San Consultative Conference.[90] But despite this subsequent talk of accord, the article entitled "Tug-of-war over Saartjie Baartman" indicates that conflict had in fact developed; the opening line reads, "Khoi-San groups in the Western Cape are heading for a showdown as to where the remains of Saartjie Baartman, the so-called Hottentot Venus, should be buried."[91]

DISSATISFACTION AND DISINGENUOUSNESS

Moreover, there was some lingering dissatisfaction regarding specific aspects of the funeral, and what it represented. The government scheduled the event for August 9, 2002, to coincide with National Women's Day, commemorating the event in 1956 when an estimated 20,000 women marched to the Union Buildings in Pretoria to specifically protest extension of the despised pass laws to women, and to condemn gender oppression more generally. August 9 overlapped as well with the International Day for Indigenous Peoples.

Jean Burgess reports that some people were afraid that the memory of Sarah Bartmann would be diluted by linking the funeral to these larger commemorations. And she states that some Khoisan strongly wished to have the funeral correspond with the full moon, which would have endowed it with greater significance to them.

All in all, the funeral did not turn out the way that Jean Burgess would have preferred. She reflects, "The impression that I got was that Sarah Bartmann was used as a political tool to promote the policies of the ANC. It was a political funeral. I was disgusted that there were ANC flags there throughout the funeral. To me, it was a bit too much." She continues, "If it were the South African flag, then that would have been another story."

And while Burgess felt it was a positive sign that the deputy minister for Arts, Culture, Science and Technology had been tapped to formally represent her department—thereby recognizing the energy that this woman had devoted to successfully securing the release of Bartmann's remains from France—Burgess believes that an all-too-familiar sexism permeated the proceedings: "The majority of the speakers were male [and yet] males do not experience the same trauma that women experience when it comes to abuse. [Couldn't they] forget about protocol for just that one day?" she asks.

In fact, at every stage of Bartmann's repatriation, some journalists gave the story a universalistic spin, and some politicians attempted to hijack the events for their own ends. When she was welcomed back to Cape Town, for

instance, one writer claimed, "she returns to the Cape as a symbol of the success of the struggle."[92] But many indigenous people feel that "the struggle," a commonplace reference to the movement to overturn apartheid, largely ignored their own distinctive and extensive history of oppression, which significantly predated the imposition of apartheid.

In covering the ceremony where Bartmann's remains were readied for burial, another journalist claimed that Bartmann "became a symbol of the humiliation and subjugation endured by the Khoisan and blacks under colonialism and then apartheid."[93] Once again, the particular features of the oppression that the Khoisan have borne were subsumed into a larger pattern. And at the funeral itself, President Thabo Mbeki solemnly honored Bartmann, while at the same time converting the meaning of her hardships and suffering into a communal narrative: "The story of Sarah Baartman is the story of all the African people of our country," he alleged.[94]

Such statements signaled nothing less than bad faith to Bartmann's own kinsfolk. The moment when their uniqueness should have been paramount was instead diminished to the status of a small (but significant) entry in a much larger chronicle of oppression and abuse in this part of the world.

Not everyone was convinced that this very public burial, and its expected contribution to bringing people together, would in fact play out as expected. A historian and social worker, writing in a lengthy guest newspaper piece, opined that the consequences could instead be deleterious and divisive: "Breast beating and belly aching about perceived and real human rights abuses of the past contribute not one iota to the difficult process of unifying all South Africans into one nation today. In fact, much of it is based on myopic or cock-eyed interpretations, half-truths and exaggerations and is causing new grievances and misconceptions for the future."[95]

Rites, At Last

Sarah Bartmann was feted at every step of her journey back to her native soil. As soon as the French turned over her bottled remains and skeleton to a South African delegation that had come to fetch her in Paris, they adorned the crate with a flag, performed a "purification ceremony," and Diana Ferrus sang and also recited her celebrated poem. Then when the plane carrying Baartman arrived back on South African soil, her casket was accompanied by six Khoisan children to a hall at the Cape Town airport, where she was honored with a welcoming ceremony.[96]

An enrobement/aantrek ritual was held in Cape Town the Sunday before she was buried, approximately three months later. The traditional Khoisan herb mixture *Khoi-goed* (including *buchu* and other aromatics) was burned; the national anthem was sung; Muslim, Jewish, Christian, Hindu, and African prayers were offered; and other tributes were also presented. While a group of Khoisan women went off to prepare Sarah Bartmann's recovered remains for their long-delayed burial, the crowd that had gathered at the Civic Centre watched performers put on a varied cultural program.

With the private rites completed, the coffin was again brought out to the crowd. Blood, water, and burnt herbs were placed around it. As one woman explained, "The blood from the sheep signifies life, the herbs show what she suffered and the water is for cleansing because her body was so badly ruined by men."[97]

Jean Burgess was one of the women who readied the remains. And like most adult Khoisan women, she has helped to prepare bodies for burial on previous occasions. But this instance was unparalleled. Jarringly so: "Looking at a corpse and working with a corpse is something different than working with skeletal remains and [with] part of that person's body in bottles," she says. While it was an honor and duty for her to participate, it was also a profoundly unsettling situation: "I was the one who put the remains in the coffin. It was a moment that I had never experienced, and I never want to experience again. It was very traumatic."

As she helped open the antique bottles, Burgess describes a memorable instant when raw emotions clashed with the prudence and rationality of the bureaucrat: "We realized that the glue was so tight that it couldn't open, and so I asked for a knife from somebody. And the lady, I'm not sure if she was the funeral services or the government [representative], she said to me 'Just make sure that you don't break the bottles because the bottles have to go back to France.' "

Burgess was stunned: "And I looked at her in amazement. How can somebody at this juncture tell me not to break the bottles? I actually felt like smashing the bottles. And for days on end that woman's words echoed in my ears."[98]

Unfinished Business

Estimates of between five and ten thousand people gathered on the sports field of a school in Hankey for the burial. As the cameras panned the area, the cobbled-together shacks of many of the locals were clearly evident and clashed dramatically with the grandeur of the proceedings. President Thabo Mbeki (preceded, naturally, by a praise singer) offered a powerful and dramatic oratory.

A significant portion of his speech incorporated actual quotations from nineteenth-century European political theorists. The president unleashed a torrent of condemnation toward Enlightenment thinkers such as Montaigne and Diderot, whose ideas buttressed the scientific racism that mistreated Sarah Bartmann with "barbaric brutality." He spoke of the "rabid racism" of Baron Couvier, who had compared "the Negro race" to monkeys. And turning the tables on those who perpetrated such offenses, he stated, "It was not the abused human being who was monstrous, but those who abused her."

Mbeki shocked the crowd. One newspaper account reported that some of these quotes were "so brutal that they drew cries of outrage and disbelief from the audience."[99]

When Jatti Bredekamp addressed those who had gathered, he remarked that South Africans were "still caught in a cage of identity denial." He had been personally involved in Sarah Bartmann's return, and cited John Donne's famous adage, "No man is an island unto himself." Bredekamp's hope was that indigenous South Africans would now be able to proudly embrace their heritage, and that others would concede their responsibility toward people who had been so cruelly oppressed during the country's history. And Cecil le Fleur, head of a coalition of Khoikhoi groups, cautioned, "It's the first time the government has promised to take care of the Khoisan people. We now want them to turn their words into deeds."[100]

Sarah Bartmann was laid to rest in a pine coffin, conveyed by a white Mercedes hearse. Her remains were wrapped in cloths. According to Jean Burgess, the Khoisan women wanted them to decompose as quickly as possible. The ceremony combined Christian and traditional religious elements, with one observer noting "the presence of true and fake leopard skin belts, hats and fur coats."[101]

Khoi-goed was once again burnt to purify her spirit. It is commonly used by traditional healers in encounters to exorcise evil spirits, communicate with the ancestors, or to celebrate occasions such as the birth of a baby. A bow was broken and its parts scattered, fleshy aloe leaves were placed atop the coffin, and a procession of mourners/ celebrants individually placed ceremonially washed stones around her grave, with President Mbeki offering the first one. The funeral oration implored, "Let her rest in peace. Let the ancestors of old accept her, now and forever, amen."

"AN EXERCISE IN SOCIAL HERITAGE IMAGINATION"?

Recall the young African chap quoted at the end of the last chapter who declared, "The Khoi are dinosaurs. The Khoi died out centuries ago."

He works out of the Hankey tourist information office, and despite all the attention given to Sarah Bartmann and the oppression of South Africa's indigenous population, he believes that the burial episode was, at its core, a charade. To his mind, Bartmann's so-called kin or descendants were all fakes and opportunists. And this, take note, comes from a person who guides sightseers through the local area. The official storyline that so many others have endorsed obviously remains immaterial to him.

Moreover, he reports that he hears local students regularly tease one another about their "big bums" and recite a silly song about Sarah Bartmann. They too have failed to be moved by her story. One's arse, after all, is commonly a subject of guilty delight to kids.

But Jean Burgess affirms witnessing firsthand that Sarah Bartmann's return has had a profound spiritual impact upon Khoisan women. "It was the beginning of a process of decolonising of spirituality," she claims. "We never would have ever talked freely about spiritual damage before. We would always go around it, but you would never address the issue." Since the burial, however,

"it was like you don't even doubt it, you don't even think about it, you just speak. It came so easily after that."

Burgess describes what she believes will be the long-term legacy of this event: "Mothers could now begin to understand their children and where they are coming from. So it opened up a total new dimension in thinking and seeing things. The burial of Sarah Bartmann definitely did that."

But when nonindigenous observers weigh in, their summing up is not as enthusiastic. Dr. Julia Wells describes a campaign to name a residence hall after Bartmann at Rhodes University in Grahamstown, that she watched fall to defeat: "You know, most residence halls are named after people who are glamorous or glorious or had great achievements in their lives, and for her to be dissected isn't the kind of achievement we usually celebrate."

Wells personally attended the burial ceremony. She says she has observed the public perception of Sarah Bartmann metamorphose from ultimate victim, to mother of the nation, to purported royalty. "Every person that had ever been, felt oppressed by racism, was saying, 'We turned it off.' You know, by making her a mother they were breaking a certain kind of mental chain."

But Wells holds doubts about this being such an uncomplicated process and believes, "Turning Sarah Bartmann into a mother and now princess is really an exercise in social heritage imagination." Pippa Skotnes shares this stance. "You know," she says, "the Sarah Bartmann thing was very fascinating for the amount of absolute rubbish that was written about it. Invention. Nonsense. There was a kind of [blanket] bad-mouthing of science and medicine."

Colin Abrahams, director of the South End Museum in Port Elizabeth, also attended the funeral. But he has felt disillusioned with the outcome: "After having the burial, everything has died away. So yes, quite a bit of money was spent there, and it was a posh affair, and the government came. My personal view is that I would put a museum there or something to develop the history of the Khoi."

And that is precisely the dream of Margaret Coetzee, local *Khoekhoesess* [KhoeKhoe chief]. The ANC's celebration of Sarah Bartmann's life does not simply erase the feelings of anger, doubt, disappointment, and, yes, even paranoia that the Khoisan have accrued toward *any* administration over the years. "The government's word doesn't mean to them what our word means to us," Jean Burgess charges.

Standing alongside Bartmann's grave, high above Hankey, Coetzee and her entourage pointed out to me an old building that they believe would be ideal to convert into a museum. It is suitably spacious, it is a historic structure, and of critical importance, it is right there in Hankey and not located far away in some metropole.

This place would differ from all previous ones in a notable way: within the museum walls that Coetzee imagines, the Khoisan would be narrating their own story this time around. Coetzee knows of artifacts, now held in private hands, that a museum collection could be built upon. But she has advised

their owners to hold tight. Their museum, whenever it materializes, will incorporate a distinctly intimate vision and voice.

Interviewed nearly a year after the funeral, Jean Burgess was annoyed that the government had not consulted the Khoisan about anything since the burial. Jean Burgess was impatient because this place cannot be declared a national heritage site until telecommunication mast heads are removed,[102] and that had not happened. And Jean Burgess was distressed because the grave did not yet have a marker. This was unacceptable, given the amount of time that had passed.

After consulting with other Khoisan, Burgess believes they are not keen to accept the government's proposal for a marble headstone. Their collective desire is that three boulders be placed at the site, representing the past, present, and future. Says Burgess, "We want real rock boulders. [And] we said explicitly that in our culture, when you visit the grave of an ancestor you must put a rock on the grave. So they must make sure that there is enough space over ten years for 40,000,000 stones."

Bokka de Toit also laments about what he sees there: "There's a little natural cave, a cavity really, right underneath her burial." He believes that this would have been a more appropriate place for the grave. Furthermore, he is troubled that an unadorned chain-link fence surrounds the plot: "The fencing—I mean, she spent all her life in cages, and now she's back into the same little cage there again, you know. People [generally] respect their dead, but that immediate environment around her burial site is sad, this is extremely sad."

DeToit reflects, "The day [of the funeral] itself was extremely beautiful in the sense that it brought together all the people along with the Khoisan, linked in this common issue, but subsequently, no, there's not been much impact." He continues, "It is more like a seed that was planted in the people in terms of their [Khoisan] identity and heritage and culture, but it needs new impetus now to make that grow. It's not what I personally hoped for, that one catalyst that would unite and bring together the people."

Any vision of locals working in partnership runs squarely into counterpoised belief systems. The "natural cave" to which de Toit alludes reflects his holistic understanding of people and the physical environment bound within an ecosystem of mutual interdependence. Margaret Coetzee acknowledges that same cavity, but she attributes it to a vast system of ancient human excavations underlying the area. For her this validates the primeval Khosian presence in the valley. And an employee of the Hankey tourist office explains this same system of channels as representing a modern-day water management scheme. These competing visions illuminate reality for their proponents but also blind them to other perspectives.

Coda

Recognizing that violence toward women continues at alarming rates—domestic and sexual violence of all types, involving kids as well—the Saartjie

Baartman Centre for Women and Children has been established in the Cape Town area. The immensity of this problem was tragically highlighted when the body of an abducted boy was found near Bartmann's relatively freshly dug grave in 2003. The "Hottentot Venus" returned to a place where those who hold little social or political power, and those who continue to be marginalized because of poverty or race or gender, remain painfully vulnerable.

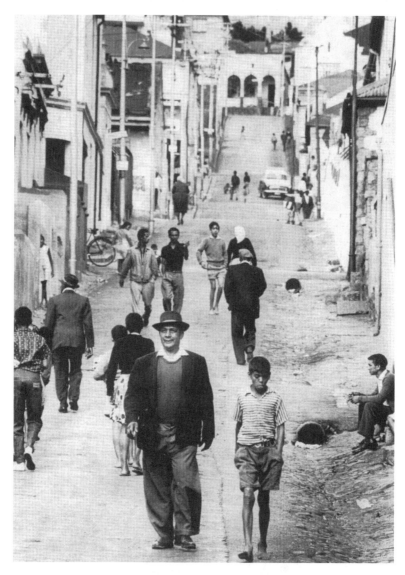

Figure 6 Pedestrians in Richmond Street, District Six

Source: Photo by Cloete Breytenbach, courtesy of District Six Museum.

"A Pustular Sore on a Queen's Forehead": District Six and the Politics of the Past

Those who knew
What was going on here
Must give way to
Those who know little.
And less than little.
And finally as little as nothing.

<div align="right">

Szymborska, 1998

</div>

Imagining "what if" is fraught with dangers. And yet we do it all the same.

It's impossible to speculate with much precision about what Sarah Bartmann's life would have been like had she remained in South Africa, in large part because there are such varied accounts of what her situation actually was when she set sail from Cape Town in 1810. But, *what if* she had lived out her life in the so-called Mother City?

It is highly probable that she would have resided in an area called District Twelve, or Kanaladorp (derived from the Malay *kanala* [to help one another]).[1]

Kanaladorp started to burgeon in the 1850s and 1860s, just when Bartmann would have been entering old age. Much of the area's growth could be attributed to the booming trade on the waterfront, at its foot.

After an initial stage of economic diversity, it became a working-class enclave in the 1870s and 1880s. Given Bartmann's background, she would have fit in comfortably: what Kanaladorp lost in the way of economic mix, it gained in ethnic multiplicity. Like many urban precincts that spring up near harbors, and adjacent to a city's core, it became a place of first settlement as people arrived in Cape Town. The district housed all types: black Africans as well as freed slaves of Malay origin; Jews, Muslims, Hindus, and Christians; artisans and common working folk; and additional immigrants of various sorts. Its streets became conduits for housing, feeding, and entertaining a wide variety of people passing through the busy ocean docks.

Different groups continued to intermingle for almost 100 years, until the idea of a racially diverse area such as Kanaladorp—which become known as District Six in 1867—ran smack up against one of the most despised pieces of apartheid legislation, the Group Areas Act [GAA, 1950]. Under its jurisdiction, District Six was methodically flattened by government bulldozers, beginning in 1966, and peaking in the mid-1970s. By the early 1980s, almost all of District Six was gone, and its residents scattered. Estimates place the number removed at between 55,000 and 65,000 people.

Many of them were resettled in government estates on the windy, desolate Cape Flats, torn from their roots, their neighbors, their extended families, their neighborhood shops, their churches and mosques,[2] and as had been the case for many of them, from close-at-hand, working-class jobs. The housing schemes they were consigned to were imperfect substitutes for what people had been forced to leave behind. In some instances, the new communities were embellished with direct references to places in the original District Six, like Lavender Hill and Hanover Park. But this was a fundamentally shallow gesture, for these were communities in name only.

Such developments featured new, albeit shoddy construction; they were little more than ghettos dispersed across this wasteland, far from the city's nucleus. The consequences, sadly, have been predictable: a huge upswing in all types of antisocial and self-destructive behavior among the people who were relocated. This has been especially noticeable in their offspring—the so-called bulldozer kids, who witnessed the actual demolition of their homes[3]—as well as in those who have never experienced the embrace of extended families and a close-knit community. Violent gangs have taken deep root in this sandy soil, and unrelentingly terrorize the Cape Flats. The area has become a textbook example of wrong-headed social engineering creating anomie.

If Memory Serves

Should you publicly mention "District Six," South Africans will experience instantaneous recognition, as well as a mixture of feelings: joyfulness, nostalgia, anger, and intense sadness. This area of Cape Town retains far more symbolic weight than its one and a half square kilometers would lead an outsider to imagine.

As was the case with Sarah Bartmann, the memory of District Six did not fade away. In fact, it has been actively nourished by scores and scores of former residents, and through the efforts of a dedicated cadre of cultural and social activists.

Bartmann and District Six, despite the obvious differences between being an actual individual and an urban landscape, share a great number of attributes. Both were victimized and destroyed by racism. Both would primarily be considered "coloured" in apartheid terms. Both have inspired a remarkable volume of artistic responses. Both have become rallying points for postapartheid identities. And both have attained mythic status.

Both are also linked in critical ways to museums: Sarah Bartmann became a specimen in one; the District Six Museum preserves some of the local ephemera and, equally as importantly, sustains the acute sense of loss for what was once a vibrant body politic. But its purpose is not to enable former residents to remain mired in the past, however. It has rather become a center of advocacy for restoring, to whatever degree that is possible, what vanished through government fiat. The District Six Museum is known not so much for what it possesses, as for what it *does*.

The ultimate fates of Sarah Bartmann and District Six are separated by a century and a half. Even so, the memory work spawned by their two sagas has become integral to how people are confronting the turbulent past of their country, and to how they are constructing the "New South Africa."

There is no dearth of articles and books about District Six. But I would like to raise some issues that I have never seen addressed before. How does a modest community initiative solidify into a "museum of conscience"? What happens when the success of such a venture forces it to comply with standards of performance and accountability like other institutions? Will it be possible for the museum to maintain its organic relationship to the community over the long haul?

Moreover, non-South Africans are likely to be struck by the manifold ways in which District Six has been remembered, and the depth of feeling it evokes. How unique was the social fabric and social dynamic of District Six, within South Africa and beyond its borders? How exceptional was its eventual fate, and how did it come to represent experiences elsewhere in South Africa? Can parallels with the American experience tell us something about the cycle of growth/decay/regeneration that conspicuously characterizes particular areas of cities throughout the Western world?

The forced removals were extremely dramatic and perpetrated by agents of the notorious National Party government. Significantly, P.W. Botha ("Die Groot Krokodil" [the big crocodile]) was the minister of Coloured Affairs and Community Development when he declared District Six to be a white area in 1966; later on, he rose through the ranks to become the country's prime minister. The idea of spatial apartheid emanates directly from the concept of apartheid itself, meaning "separateness."

The conjunction of autocratic power with the creation and reconstruction of memory is vitally important to understanding the significance of District Six. The immense political muscle of the apartheid regime, and the very public nature of its actions, has bred an unexpected consequence: the panoply of oppressive measures that this government enacted in order to crush its victims has paradoxically bound them tightly into a fraternity of suffering. This alliance, forged under duress, now heightens the ability of people to sustain a sense of unending identity even in the face of strong countervailing forces. This thereby strengthens their demand for compensation for the losses that they incurred.

District Six was both unique and generic. Its distinctive "vibe" has attracted an abundance of attention. In one person's estimation, "District Six has become a cult."[4] Its commonality remains significantly under-addressed.

THE INFINITE ACHE OF THE
PHANTOM LIMB

Doctors and scientists have been aware of phantom limb syndrome since at least the American Civil War. In essence, whenever a person loses an arm or leg they continue to feel sensations radiating from where that extremity once was. Such feelings are common, and they are physiologically based: the part of the brain that once received signals from the now missing limb reorganizes itself and continues to function. However, the brain misattributes sensations it receives to a part of the body that no longer exists.

Phantom limb syndrome is a phenomenon that can be explained but not explained away: it is haunting, fantastic, uncanny. It can also be understood metaphorically. People who experience other types of catastrophic loss can be profoundly unsettled by something that is no longer there as well—the loss of a home, say, or a beloved, all-encompassing community. Those memories can pulsate with longing, throb with yearning.

Skim the literature about District Six and you will quickly fathom what an enormously ruinous experience it was for people to be ripped from a place they adored, and a way of life they wholeheartedly endorsed. The trope of gross bodily injury recurs: "A scar that has cut deeply into the flesh of the mountain" now marks the area, writes one observer.[5] "A huge bleeding wound had been slashed across the face of the city," says another.[6] The "urban tissue" has been rent apart.[7]

District Six was raped. It was murdered. It fell victim to "a genocide . . . to destroy people's souls."[8]

Once the demolitions began, those who were still there became residents of a radically altered streetscape: "Physically their world was manifesting advanced signs of a form of social gangrene."[9] The barrenness that resulted "defiles the landscape like a pustular sore on a queen's forehead."[10] And, revealingly, those who lost their houses were also in danger of "losing their manhood."[11]

Those houses are anthropomorphized into sentient victims, heavy equipment operators become their "executioners," their "hired killers." As pillars are yanked down, it is "like bones breaking"; houses "breathed their last."[12] And most commonly, the heart is invoked: Cape Town "has lost its beating heart," it was "ripped out."[13] Calling up a phrase of great poignancy that South Africans regularly invoke to describe emotional pain, it made people "heart sore."

The sound of the bulldozers was "apocalyptic."[14] The destruction was "arguably the single greatest act of cultural terrorism of the apartheid era."[15] "Jackboots"[16] bowed to the orders of the Group Areas Act, a law that one displaced Cape Town resident described being "as evil as Nazism."[17] In the words of Donald Parenzee, head of exhibitions at the District Six Museum, "District Six has got the drama, it has got the suffering, and people come here and they talk in terms of a 'holocaust.' "

The government's destruction of District Six has also been compared to the burning of Troy and the overrunning of Jerusalem by infidels.[18] An absentee

landlord who sold his properties to the government is likened to Pontius Pilate.[19] And a young woman crying over the destruction of her house fears that the memory "will be like having a Nessus shirt on my back."[20] The prelapsarian paradise thus has been lost. Its people have been driven into exile, the diaspora has commenced.

The denuded landscape became an open sore, festering with anger, pain, melancholy. It's a "wasteland,"[21] "salted earth,"[22] a "desolate moonscape."[23] It was changed into "a gigantic urban desert."[24] It became "South Africa's Hiroshima."[25] And tellingly, a memoir of growing up in District Six is prefaced with the phrase "once upon a time . . . ," the prime signifier of a tale about happenings in a land long ago and far away.[26]

District Six is prime real estate, nestled between the slopes of Devil's Peak and the Cape Town waterfront. The old Moravian Hill Church, a rare vestige of the community that was spared the wholesale destruction, has become "a headstone to the ravages of forced removals."[27]

The Improvised Museum

The origins of so many museums reveal deliberate efforts to glorify their founders, enhance their power, amplify their social cachet, assert knowledge, advance ideologies, or elevate the masses. But from its inception, the motivation behind the District Six Museum was different. It is a museum by name, sure enough, but it did not arise from some grand vision. The District Six Museum has evolved according to its own logic, and it has become a venture that turns many of the central assumptions of such places on their heads.

It grew directly from the activities of the Hands Off District Six campaign [HODS], a grassroots movement that began in 1988 in order to challenge the proposal by a major petroleum company to redevelop the land that was once occupied by District Sixers. HODS was ultimately successful in defeating that plan. The next year, one of the group's projects was to establish the District Six Museum Foundation, in order to set up a museum.

Among its first activities was a small photographic exhibition in 1992 in a building that was formerly home to the Methodist Mission Church in Buitenkant Street. The site itself bore an interesting history: the congregation was founded for descendants of slaves, it was a hub of antiapartheid activities in the twentieth century, and it is situated on the perimeter of the old quarter. It is nicknamed the "Freedom Church."

The inaugural show was a tremendous success: what the organizers projected to be a temporary, two-week installation obviously tapped a collective nerve, an unfulfilled desire to reexperience a lost landscape. Shortly thereafter, a group of former residents began to work toward creating another exhibition. The show, *Streets: Retracing District Six*, went up at the church in December, 1994 which since that time has been the museum's home. Once again, organizers did not anticipate how popular their efforts would become, or how much they would be supported.

Ex-resident Linda Fortune was asked to assist with the show, and she has never left the museum. And Sandra Prosalendis, the original director, discloses that "it was only in 1997, 1998—three years, four years after that—we started thinking about planning ahead, having a real vision for the museum." As she states elsewhere, the museum did not spring from a core assortment of objects: "What had to be collected was, in fact, this intangible spirit of community."[28]

Several elements in the museum hold pride of place. One, a centerpiece of the *Streets* exhibition, is a set of original street signs that was destined to become landfill in Table Bay but was instead squirreled away by a former government apparatchik. They have been strung together and cascade from floor to ceiling in front of the original pulpit. As literal signposts of the community, they have become aide-mémoires, tangibly recapturing a network of lost places. This "ladder" has been described as being "simultaneously skeletal and a soaring tree of life."[29]

The street signs may be simple markers, but they are evocative symbols. And the tale of how the museum came to acquire them is an important part of its institutional lore.[30] They were collected by a man named David Elrick, who was prompted to some degree to save them because of reading about the significance of items saved from the bombing of London during the blitz. Beyond that, his motives were not clear, and he had no specific plans for them.

The collection was widely rumored to exist but hidden away for years. After they had tracked down a number of leads, director Sandra Prosalendis, accompanied by trustee Stan Abrahams, paid the man a visit at his home. They were met by a very nervous guy, speaking to them through a door that was barely cracked open. His wife was particularly anxious, imploring them, " 'We don't want trouble. We aren't going to be tried for 'war crimes' or anything?' " Interestingly, she once worked as a midwife in District Six.

Prosalendis and her partner gradually won over the couple's confidence through several visits, allaying the Elricks' apprehensions by reaching them through religion and sport. Prosalendis accentuated the fact that the museum was based at the Methodist Church. The couple was devoutly religious, and after praying over the matter, they decided that it was good that the signs would end up in such a setting. But it was a mutual interest in rugby that closed the deal, overriding cultural differences between the two men.

Prosalendis reports that some people affiliated with the museum were not so patient: "Others felt that they should march in and take the signs and go [because] he was just a 'racist,' 'evil,' 'fundamentalist,' a 'white supremacist.' My thought was more, 'I think we can pay for them.' "

She was geared up for tough negotiations with Elrick. But then he revealed that he had paid local kids a trifle to scoot around and retrieve the signs from the countless piles of rubble in District Six. Prosalendis was astonished when he told her that he wanted merely the equivalent of R2 a sign, in order to recoup his outlay to the kids. She recalls, "I would have given him all the money that we had to get them. I just thought that it [his offer] was

an extraordinary thing." Elrick's only stipulations were that the signs remain intact as a collection, and that they never be sold at a profit.

Prominent too is a "map painting" that dominates the central floor area of the museum. The old District Six is plotted here. Covered by transparent plastic, visitors may walk over it, pinpoint places of significance to themselves with a *koki-pen* [marking pen], and record their feelings and thoughts. As time has passed, former residents have thereby "fleshed out" the diagram and animated it. Included as well is a "namecloth," a record of visitors' signatures and remarks that have been embroidered onto fabric. In some sections the work has been done by imprisoned women. Initiated at a temporary exhibition in 1992, and later incorporated into the museum, the namecloth has expanded to more than a kilometer in length.

Whereas *Streets* focused on public lives and public spaces, *Digging deeper* (2000) turned to more private, interior spaces. And, once again, the displays that were set up have become continuing features of the museum. Rod's Room presents the reflections of Rod Sauls, a contemporary artist and another former District Six resident, on issues of memory, visually and aurally. Nomvuyo's Room reconstructs the multifunction space of a black African former resident, Nomvuyo Ngcelwane bringing to life the words from her published autobiography; an old radiogram transmits stories that add another dimension to the experience. And the Memory Room is a recording studio with a comfy feel, where oral testimony can be collected, and where visitors can also sample the entire range of the archive.

THE POLITICS OF PLACE

The District Six Museum is populist at its core. It aims to construct a space where memory and community can be reactivated, confronted, and explored. It is a place to reconnect. This museum's focus is more therapeutic than acquisitive, more activist than aloof or separated from peoples' lives and experiences. It prioritizes human interaction, therapy, and catharsis over amassing an enviable collection of rarified objects.

Donald Parenzee characterizes the place as a "forward-looking, development-oriented, community-engaged organization." He sees it as the opposite of a conventional museum: "The term 'museum' is actually a misnomer because it is so dynamically engaged with this community's desires and unity and demands and things like that."

Director Valmont Layne believes that the District Six Museum allows people to "self-articulate," that is, it provides a setting that draws out memories and encourages reflection. Beyond that, he believes this institution raises fundamental questions about museum practice itself: "Some visitors come in here and have talked about the way they see this museum as a museum about other museums, as a museum about representation, because there is this refusal to settle on one narrative."

And Haajirah Esau, head of the archives and resource center, observes, "It is not a static environment. Our projects are always mushrooming into something else." She offered the museum's exhibition on Protea Village, another Cape Town site from which residents were removed, as an example.

The museum staff had not thought beyond mounting the show. But relationships were formed in the process: the museum occasionally provided space for former community members to meet together, and museum personnel held workshops to assist them in getting a museum up and running. District Six Museum staff also helped these other people pull together what they needed to file land claims for what they had lost by the removals. As Esau remarks, "Things just don't stop."

As one of the trustees of the District Six Museum Foundation argues, "The content of the Museum is located not in what is seen but in what happens within the space. Once the Museum stops being a live, *generative* space and becomes an object, to be consumed, merely looked at and left behind untouched, its function as a living space will end."

She concludes, "It is our responsibility as caretakers and constructors of this space to protect the kind of reflective, unhurried ambience that facilitates the *generative* human acts that occur within."[31]

The Strongest Link

As should be clear, the District Six Museum has been a political beast from the outset. So too are many of its staff members. By design, it embraces an activist stance.

Sandra Prosalendis, the museum's original director, was aiming for a career in dance or the film industry. Then Soweto exploded in 1976. As a white South African, she was unexpectedly confronted with choices: to leave the country or to stay; to pursue her career ambitions as if the moral ground had not shifted, or to become involved in facilitating change.

Prosalendis altered her life course. She worked for the Witwatersrand Council of Churches during the struggle, in a project set up to instruct young people whose education had been disrupted by the continuing turmoil in the black townships. She did this for about a dozen years, eventually leaving the job, and Johannesburg, but only after "I had buried 21 of our students or colleagues. It was too violent," she recalls.

Prosalendis moved to Cape Town, where her past followed her: a minister who knew of her work approached her to oversee what was initially intended to be a small, short-term community project. But after former District Six residents demonstrated their enthusiasm for the 1992 exhibition, she tapped into the network of contacts that she had made while raising money for victims of apartheid in order to secure support for what later became the District Six Museum. One of these connections alerted her to funding possibilities for cultural projects offered by the government of the Netherlands, which became an important initial source of financial support for the institution.

Her successor, Valmont Layne, never intended to work in a museum either, nor did he receive any training specific to the job. He came of age in the years after 1976. Layne locates himself as a member of a radicalized generation that focused on political freedom and overthrowing the apartheid regime, rejected its invented and wide-ranging classification of people such as himself as "coloured," and very consciously endorsed an inclusive interpretation of South African identity and culture.

As a musician, Layne was particularly attentive to the ways people in the liberation movement used music that they had drawn from different linguistic or cultural experiences; he even cites the influence of songs from the American civil rights movement.[32] Layne was stirred by performers such as Abdullah Ibrahim (Adolphe "Dollar" Brand), and the fact that he and others were forced into exile alerted Layne to the need for people of his generation to reconnect with these artists.

He later completed a master's dissertation on the history and cultural politics of the dance band and jazz traditions in South Africa. And that became his link to the museum: he was tapped to set up an audiovisual archive to collect and preserve the area's history, through such media as oral histories and period sound recordings.

And Donald Parenzee considers himself part of "a larger fraternity of people" who have been politically and socially engaged since the 1960s and 1970s—artists and educators, among others—to whom the label of cultural activist also fits. In fact, he was invited to participate as a poet at an event associated with the initial exhibition, the success of which eventually provided the basis for an actual museum. Parenzee was later drawn in as a full-time employee, an organic process that bridged the community and a nascent institution, and channeled the vitality of activism into an ongoing organization.

Furthermore, a majority of the people associated with the District Six Museum, from the staff to volunteer tour guides and the trustees, have personal ties to the area. Valmont Layne grew up there, moving away when he was 11 years old; his family's connection reaches back to his paternal great-grandfather. Linda Fortune and Noor Ebrahim, education officers at the museum, lived there as well. Fortune left when she was 22, and Ebrahim left at age 29, "when they kicked me out." He notes that his father, and the father's 19 brothers and 10 sisters, were all born in the same house in District Six.

Noor Ebrahim was a prolific hobbyist photographer, and he had published newspaper articles about the neighborhood. His work was thus publicly known, so that the people organizing the two-week exhibition in 1992 included a sampling of his photos. He has been involved in the museum ever since.

Linda Fortune attended that show, and she was profoundly moved by it. She bought a number of postcard reproductions of Ebrahim's photos, and then asked him if she could use his work to illustrate a memoir she that she had written about her childhood in District Six. When *The house in Tyne*

Street was published in 1996, expedited by Sandra Prosalendis, Ebrahim was one of several photographers who contributed to it. And Fortune has worked in tandem with him as an education officer from that point forward.

Donald Parenzee's father worked in District Six, and his grandparents lived just beyond its borders. Prosalendis also has a family link: it turns out that her maternal grandfather had once lived there, although she did not discover that fact until after she became involved with the museum. And Haajirah Esau is connected through her mother's lineage, and observes, "You look at our mission and our objectives, it [*sic*] is very personal. It is more a personal vision for a city, and how a museum should be."

THE SCENE OF THE CRIME

When travelers visit South Africa for the first time, many of them will undoubtedly be struck by the fact that in so many places they will repeatedly hear wistful references to communities that no longer exist. What these spots share in common is that the apartheid government destroyed them. In Johannesburg, it was not only Sophiatown, but also Vrededorp/Pageview/Fietas and Doornfontein. In the Pretoria area, it was Marabastad and Lady Selborne. In Port Elizabeth, Fairview, Salisbury Park, and the South End. In East London, the North End. And in Cape Town, District Six, of course, but also Tramway Road, Protea Village, Simon's Town, and at least three dozen additional sites.[33]

Residents of these areas had few ways to effectively forestall the inevitable, and the personal toll was great. But District Sixers did not surrender their sense of irony: they dubbed the dreaded official notices of termination of occupancy "love letters."[34] Mockery, unfortunately, did not blunt the disorienting impact of such a massive upheaval.

Account after account mentions people who committed suicide rather than move. Others simply lost interest in their continuing survival, and they let their lives ebb away, "dying of broken hearts." Most of these reports are short on details, but some are quite specific. One book includes at least eight such references, and concludes that in many instances, "the eviction notice was a death notice."[35]

At times, these removals were of the "scorched earth" variety: nothing, or virtually nothing, was left standing. This is what happened in District Six and South End. In others, owners were forced to abandon their properties and received only token compensation, at best.[36] New residents, typically white, were then permitted to move in.

According to one estimate, after the GAA had ordered coloured residents out of the nearby community of Mowbray in Cape Town, property values more than doubled in less than a decade. Moreover, a few white real estate companies made profits of as much as 372 percent in a very short time.[37] A former resident of the same general locality remarked, "Apartheid was not based on colour, it was based on greed."[38] But although that observation holds some merit, the ceaseless quest for material advantage fits the American model of urban renewal and gentrification more closely than it does the

South African approach, where strict spatial separation of the races was an obsession of the central government.

Absentee owners controlled about three-quarters of District Six,[39] with whites and Indians owning property at a rate highly disproportionate to their part of the local population. The fictional landlord of the five "mouldy cottages" that are the locus of Richard Rive's autobiographical novel *"Buckingham Palace," District Six* (1987) is a Jewish man named Katzen, who also ran a general shop in Hanover Street, a major commercial thoroughfare. Some of his tenants refer to him as a "miser," "skinflint," "Midas," and "stingy," even though they had not paid any rent to him in 15 years.

When the government starts to collect the names of occupants prior to their removal, Katzen refuses to cooperate: he had escaped from Nazi Germany, and reflects, "So now I cannot do to your people what was done to my people. . . . my heart is with all the *untermenshen* [supposedly subhuman], whoever and wherever they are."[40] At his death, however, his son in Johannesburg is only too eager to cash in all this property, even at the government's cut-rate price.

The government's vision for District Six was that a neighborhood of new, middle-class housing reserved for "Europeans" would spring up. But one anecdote alleges that residents spit on the ground when they left, "cursing it to remain fallow until apartheid's inevitable demise."[41] If one puts faith in such matters, the hex has been partially successful: several plans for large-scale redevelopment foundered over the years in the face of community opposition. Renaming the area Zonnebloem [sunflower], after one of the early farms that once stood there, could not remove the taint of the forced removals.

The government broke the stalemate when it established the Cape Technikon (a technical college, originally restricted to white students) in 1982, and a police barrack. Moreover, a few thousand whites, many of them state employees, live in buildings that had been refurbished or newly constructed. The Bloemhof Flats, for example, were emptied of coloured residents by 1980 and "modernized" into the Kaapse Huis [Cape House]. These particular buildings were relatively new by District Six standards, originally built in 1939–1940 as council housing, after an earlier round of slum clearance.[42] The cumulative impact of the various new developments has left only 35 percent of the land vacant, a surprisingly low figure when you consider that even that portion seems so sizable when you view it today.

South Africa now guarantees the right to restitution for any citizen dispossessed of property because of racial discrimination since 1913. Former property owners as well as renters are entitled to reasonable financial compensation for their losses, including the choice of a one-off payment; reclamation of the lost property, if possible; or the occupancy of newly built homes, as is the case in District Six, commencing in 2004.

There are a number of reasons why the memory of District Six has persisted to the extent it has. Most obviously, the section of the district that has remained vacant is a telltale reminder of what was wiped out. De Waal

Drive, a major Cape Town roadway, brushes alongside, so that thousands of people catch sight of it daily. It remains a mocking indictment of the obsessive lunacy of the Group Areas Act's policies. And in a city that prides itself on the beauty of both the natural and built environments, it has become an obvious blot on the landscape.

Rival city Johannesburg relentlessly expands into the veld, meaning that a majority of its population never comes into contact with areas that the GAA altered within that city. Cape Town has spread out, too yet its streets are still crowded with pedestrians throughout the city center, at least during the day-time. Its more compact, urban mode of life, and the nearby presence of important government buildings and cultural attractions, also make the site of the old District Six more noticeable.

In addition, the area has continued to be a source of inspiration for artists in various fields, who have made certain that even people who did not have firsthand experience of the "Die Ses" urban ecosystem, where a distinctive geography bred an equally distinctive sociability, are able to encounter it to some degree through a broad range of depictions. Highly significant too is that for the so-called coloured population, which has always been socially suspended somewhere in between whites and black Africans, this was a place that was peculiarly their own, and where indigenous traditions such as the annual Coon Carnival emerged.[43] The land, although eerily empty, is still profoundly inscribed with that history.

LIQUORICE ALL-SORTS

Gazing about at his fellow denizens, a bar patron in District Six reportedly remarked, "They're just liquorice all-sorts," thereby comparing them to a popular assortment of candy.[44] Many people today feel that the hybrid and cosmopolitan soul of this area prefigured Bishop Desmond Tutu's much-touted concept of a "Rainbow Nation," a nonracialist South Africa. This place was "multicultural" before the concept held much currency. In musician Dollar Brand's characterization, it was a "sixth-sensed district,"[45] containing an inexplicable outlook that perceived the world in a conspicuously different way. And that very feature may have proven decisive in sealing the fate of areas like District Six.

A statement by a spokesperson of Port Elizabeth's Department of Community Development in 1965 exposes the government's dual agenda in razing certain areas. When the first sections of its version of District Six were earmarked to be knocked down, he viewed them as "the worst part of South End, the most depressed and *the most mixed*."[46] Slum clearance was a smoke screen, a rather thin one at best. It was used to obliterate instances of diversity in living together, a situation that contravened what the law generally allowed in apartheid-era South Africa.

A fictional character declares, "It's only in the District that I feel safe. District Six is like an island, if you follow me, an island in a sea of apartheid."[47] In the name of "uplifting" people, the government forced them

apart. Such logic is equivalent to the supposition of American military strategists in Vietnam who insisted, in some instances, that a village must be destroyed in order to "save it."

Whenever middle-class, do-gooder investigators and political functionaries turn their sights on poor neighborhoods their judgments are typically clouded by moral indignation and fear of contagion, be it spiritual or physical. The removals sanctioned by the Group Areas Act were not the first to target District Six. The area had been considered a slum since the late nineteenth century, a literal and figurative cesspool.

A smallpox epidemic terrified the city in 1882, and an outbreak of bubonic plague in 1901 led to large-scale demolitions, as well as the relocation of black Africans outside the city, the consequence of what one scholar describes as "the sanitation syndrome."[48] That is why the District Six that was destroyed by GAA is primarily remembered as a "coloured" area, an overgeneralization according to memoirist Nomvuyo Ngcelwane, who writes about the continuing, albeit small, presence of Africans in the area.[49] But, in the main, the GAA targeted those racial groups considered to be "in the middle": Indians and coloureds.[50]

A number of official inquiries from 1919 onward characterized conditions in District Six as a "menace to society." The situation continued to deteriorate due to landlords' neglect of their properties, so that in the postwar era it was considered to be either a "moral or sanitary challenge to the health of Cape Town."[51] The South African pattern of public health emergencies resulted in demonizing slums and slum dwellers as the source of the contamination, and tearing down working-class precincts of cities as a result. And that precisely fits the American experience, at precisely the same times.

The way that former residents describe life in such areas contrasts sharply with the official perspective. The idioms of quotidian existence, in other words, are far different from the rhetoric of containment and control. "We were really a League of nations in South End," one man declared.[52] And another portrayal reads, "In District Six no one—neither the *moffie* [gay man; sometimes an effeminate man, or transvestite] nor the gangster—is seen as the outsider. District Six is the microcosm of the ideal world, a richly human place where everyone is welcome if he or she will only share."[53] This meant that cross-dressing and flaunting the law were not considered aberrant, but they were an expected part of the local scene.

If you can push aside the specifics of the apartheid system for a moment, you will appreciate how, at the deepest level, places like District Six, South End, and Sophiatown were unsettling to outsiders: boundaries were fluid, not fixed. Residents of District Six "were able to cross religious, class and social boundaries,"[54] we are told, a situation that intrinsically runs counter to the way people order the world most of the time.

Don Mattera said of his life in Sophiatown (or "Kofifi" or "Sof'town" as it was known to locals), "[I]t was preparing the people for a new frontier. And then it was just wiped out."[55] Writer Es'kia Mphahlele described the people of Sophiatown in the following way: "They didn't feel constrained by

any boundaries and it showed in their easy-going lifestyle. . . . One never had a sense of being cramped."[56] And Jakes, a character in the play *Sophiatown* who is a journalist at the legendary *Drum* magazine, characterized the atmosphere of the place as "[t]oo much freedom, too much meeting, too much fantasy, too much easy access. White bohemians and black intellectuals—that meant trouble for the Boere's dream of a whites-only world."[57]

The intellectual and artistic ferment in the area, and its popular reputation as a place for wicked behavior, earned Sophiatown such titles as "little Paris of the Transvaal," "the Chicago of South Africa," and "Little Harlem."[58] One writer captures its essence with the effectiveness of one well-placed punch: "There's a tang about it."[59] Jazz was an important feature of the smart life in Sophiatown, just as it was in Chicago's Hyde Park neighborhood (see below), yet is much less frequently mentioned regarding District Six. But one journalist has noted, "the jazz clubs and street life of District Six— including a gay scene that would never have been permitted in most of Cape Town—drew people from across the city."[60] It is a heritage that the District Six Museum is actively excavating.[61]

Frontiers. Crossing boundaries. Easy access. Transcending boundaries. These ideas all speak to transgression, liminality, and categorical meltdown. By definition these are all destabilizing social situations, unless they are tightly regulated by specific time constraints and spatial limits.[62] District Six, Sophiatown, and a few additional multiracial enclaves in South Africa put the lie to apartheid, negating the notions that the races were inherently different, and that groups were the most contented, and felt most comfortable, "amongst their own kind." These areas were "free zones" of social exploration, experimentation, and egalitarianism. As such, it was vital for the apartheid government to destroy them.

SHOULDER TO SHOULDER

In the United States as well, many communities were radically reconfigured in the post World War II period: Boston's West End, Chicago's Near West Side and Hyde Park-Kenwood neighborhoods, Manhattan's Lincoln Square, San Francisco's Western Addition, Los Angeles's Bunker Hill. And while the events in many of these precincts generated a disproportionate number of social science studies, it would be highly unusual today for a tourist to be regaled with stories of "how it used to be" in any of those places.

These histories are privately sustained, if at all. Who remembers? And who cares? For the most part they have simply faded from public memory. In South Africa, on the contrary, stories such as these pulse with life.

In spite of their differences, the South African and American experiences also display many similarities. Labor shortages during the war attracted rural blacks into the cities in both places, changing their local character and making whites nervous.[63] Cities developed in much the same way throughout the twentieth century: as transportation systems expanded, such as the web of

freeways that sprang up from the 1950s onward, the middle classes and the wealthy left the urban core for outlying suburbs, where residential areas were distinctly separate from commercial shopping centers.[64] Meanwhile, the working classes largely remained behind, concentrated in the central city. Whether you analyze Kansas City or Kaapstad [Cape Town], the same model applies.

In both societies, the communities that were targeted for redevelopment were primarily comprised of the poor and the working class. Moreover, a majority of the people living there experienced discrimination because of their race or ethnicity. And in some (but not all) cases, these were neighborhoods where a unique blend of different cultures coexisted, in sharp contrast to surrounding areas. How, then, can we account for the dogged persistence of memory in one society, and its notable decay in the other?

Renewal and All that Jazz

The Group Areas Act [GAA], enacted in 1950, empowered the apartheid government to declare areas to be the exclusive domain of certain racial groups (but note: this was not the first legislation of this type, nor does it apply to all examples, which will be discussed below). This regulation allowed local officials to clear areas for redevelopment, or to "turf out" existing residents and thereafter control transfers of property, thus guaranteeing that it would not pass from members of one racial group to another. The scale of the forced removals was massive: by the time the GAA was repealed in 1991, it had displaced nearly 900,000 people in the period from 1960 to 1983.[65]

In the United States, urban renewal began with the Federal Housing Act of 1949, and the program ended in 1974. In some American cities such as Chicago, local ordinances set the stage for demolishing so-called blighted areas as early as 1947. In these instances, the federal laws simply added more muscle to the enterprise. The designations of "blighted" or "slum" have always been politically driven and controversial in regards to where and when they have been applied. Where officials saw a "slum," local residents, along with more objective observers, often saw communities that were thriving in the social sense. Admittedly, however, they were places that were often grungy and in need of refurbishing.

The American approach was generally to flatten an area and begin anew. In many cases this meant welcoming whites into areas that were once predominately occupied by minorities. According to one scholar, at other times sites were cleared and left fallow for a time. In St. Louis, one such tract was known as Hiroshima Flats; Detroit contained "ragweed acres."[66]

Hyde Park-Kenwood offers an interesting case in point, a neighborhood that cultivated an ambiance analogous to that of District Six in certain respects, and that resembled Sophiatown to an even more remarkable degree. This area surrounds and borders the University of Chicago on the South Side of the city.

A major artery, Fifty-fifth Street, boasted about two dozen taverns in the early 1950s,[67] including the Compass, where a group of actors who would later

form the renowned Second City ensemble first tried out comic improvisation. The other attraction in generous supply was jazz; Charlie Parker reportedly played his last Chicago gig on this strip.[68]

After urban renewal targeted the area, the effects were dramatic: it "virtually closes after sundown . . . an important part of the neighborhood has been buried in concrete," one report testified, looking back 20 years after the makeover began.[69] This writer further recalled, "Time was a body could . . . listen to fine modern jazz, blues, and hip satire amid the amiably mixed audiences that patronized the clubs on 55th."[70] But no longer: Jimmy's Woodlawn Tap is the sole survivor from that fabled time.

The bureaucrats who sanctioned the changes worked closely with university officials who desired that the neighborhood become "classier" and its sidewalks be cleared of much of the foot traffic that might make residents feel uneasy. The irony of such schemes, as urbanologist Jane Jacobs has pointed out, is that relatively empty city thoroughfares are in fact *more*, not less dangerous.[71]

A remark attributed to writer and humorist Mike Nichols, a central figure in the Second City troupe, mordantly addresses the distinctive interface between race and social class that dictated who would stay in Hyde Park, and who would be forced to leave. In one of its many versions it hails "Negroes and whites, working shoulder to shoulder, against the lower classes."

The text that accompanies a photo documentary book about District Six addresses the issue of the relaxed atmosphere of racial mixing there as well. The author refers to a primitive sort of gendered democracy that prevailed in the most essential of places: "The public lavatory, euphemistically called a chalet . . . suddenly became quite full with black men, brown men and white men all standing close in and shoulder to shoulder." Such casualness boldly negated the norms of social interaction honored throughout most of South African society at that time. The attendant, one Abubaker Jaffa, gloats, "Here there is racial peace and harmony."[72]

In an important respect, the Hyde Park example differs from the chief American paradigm: its naughty past *has* entered the lore of generations of University of Chicago students, especially those bemoaning the relative paucity of nightlife that exists in the community at present. Moreover, the university is the one easily identified source of that changeover, and readily villainized.

But in truth, what happened was more complex and much more furtively planned and executed than the public realized. A coalition of interests conspired to write the script for what unfolded. And those who publicly sustain the memory of the Hyde Park of old are more likely to be individuals who have heard the stories of what previously existed, rather than those who were on the losing end during the social upheaval of that time and place. They are now widely and anonymously scattered, who knows where?

The Play's the Thing

Audiences throughout the West are familiar with Tony, Maria, Anita, and Officer Krupke as some of the main characters in *West Side story*. Gang

warfare has seldom been so carefully choreographed or slum life so idealized. But as these rival groups of teenagers sang and danced their way across a backdrop of crowded and dilapidated tenements, they were unwittingly performing a farewell tribute to a neighborhood that was about to be destroyed. The turf that the Sharks and the Jets feuded over was soon razed to build New York City's West Side cultural hub, Lincoln Center for the Performing Arts.

West Side story is a rather unique paean to a lost, mid-twentieth century American way of life.[73] But in South Africa, tributes of this sort comprise a distinctive body of work, broadly spanning different genres. Within them a cavalcade of relatively innocuous gangsters preen and pose, good-hearted merchants ply their trades, and the warp and weave of urban life creates a vibrant, multihued tapestry of peoples, languages, and customs.[74]

Bad things can happen, to be sure, but most of the neighborhood denizens prove to be more comic than threatening, eccentric but relatively harmless. Perhaps the most significant potential peril that residents may face in these fabricated scenes is becoming the target of the sharp tongues of meddling neighbors. Americans, in contrast, have not generated a storehouse of tributes anywhere comparable to the variety and passion of South African reminiscences of communities destroyed by apartheid.

District Six, the musical (1987) looks like *Guys and dolls* meets Catfish Row. *Fairyland* (1991) and *Kat and the kings* (1995), produced by the same creative team of David Kramer and Taliep Petersen, cover similar ground, as does *Kings of District Six* (2003) and the musical *"Buckingham Palace,"* *District Six* (1989), based upon the book by Richard Rive, a writer born, you guessed it, in District Six. The latter work features a madam with a heart of gold who oversees the Casbah, a local brothel. Its stable of girls provides sexual comfort to men, motherly advice to neighborhood children, and even staffs a booth at the annual church bazaar. Local sports called Zoot and Pretty-Boy Vermeulen add local color. (The play *Mkbumbane* [1960] is a musical treatment of life in a similar locale, Durban's Cato Manor.)

Poems "Blues for District Six" by Dollar Brand and "Springtime in District Six (Zonnebloem)" by Mavis Smallberg; the films *Last supper at Horstley Street* by Lindy Wilson (1983) and *Dear grandfather, your right foot is missing* (1984) by Yunus Ahmed; a 13-part television history, *O'se Distrik Ses* (*Our District Six*, 2001); and *District Six: Image and representation* (South African National Gallery, 1995), and the photographic exhibition *District Six in Mitchells Plain* (Alliance Française Centre, Mitchells Plain, 1999) demonstrate the diversity of artistic interpretations of this terrain.

Furthermore, Sue Williamson's installations "The Last Supper" (1981) and "The Last Supper revisited" (1993) incorporated debris leftover in District Six from which she built a dining table; photos taken at one family's final celebration of the Muslim holiday of Eid al-Fitr in the neighborhood; and an audio background, featuring the sound of bulldozers and a muzzein calling his people to prayer.

Painter George Pemba's "Eviction: Woman and child" (1992) was based on forced removals he witnessed in another part of the country, Port Elizabeth, and Pamela Jooste's novel *Dance with a poor man's daughter* (1999) relays the story of a 11-year-old year girl and her family, dislocated from a fictitious community in the Cape. Sheila Gordon's novel *The middle of somewhere* (1990) also uses a child's perspective to address the ways that the GAA tore apart families and wrecked relationships between friends.

Fictional depictions by writers who lived in District Six comprise a genre in themselves: the aforementioned *Buckingham Palace*; Alex LaGuma's *A walk in the night* (1986); Achmat Dangor's *Waiting for Leila* (1978 [1995]); and Andrina Dashwood Forbes's *Birds on a ledge* (1992) are simply a sampling. Memoirs are also prevalent. And one of the most touching allusions to District Six is when it's mentioned on *Takalani* [Tshivenda for "be happy"] *Sesame*, where children are not only encouraged to accept an HIV+ Muppet character, but discover that a diverse world, where mutual understanding once prevailed, was destroyed by evil-minded people. Come to think of it, this description fits a place very much like the idyllic Sesame Street, which kids now watch on television.

Johannesburg's legendary freehold area of Sophiatown has likewise generated a bounty of artistic representations, including Junction Avenue Theatre's *Sophiatown* (1986); a 2002 production of *A streetcar named desire*, transposed to Sophiatown, with a minibus taxi named "Desire"; documentaries by artist William Kentridge, *Freedom Square and Back of the Moon* (collaboration with Angus Gibson, 1988), *Have you seen "Drum" lately?* (1989, photographer Jürgen Schadeberg, director), and *Sophiatown* (2003, Pascal Lamche, director); the feature film *Drum* (2005, Zola Maseko, director) and the celebrated work by Lionel Rogosin, *Come back Africa* (1957), which was shot against the backdrop of the actual destruction of the district; memoirs *Memory is the weapon* (1987) by Don Mattera and *Blame me on history* (1986) by Bloke Modisane; "Requiem for Sophiatown" by writer Can Themba (n.d.), *Tsotsi* [a petty thief, a corruption of "zoot suit"] by Athol Fugard (1983), and *A world of strangers* by Nobel prize-winning author Nadine Gordimer (1958). In the novel *Triomf* (1999), the Afrikaans writer Marlene van Niekerk takes a wickedly comic look at a pitiable family who live in the white Johannesburg suburb built upon the land where Sophiatown once stood. The title is Afrikaans for "triumph," the spiteful name that officials gave the area after it had been leveled.[75]

The photographic exhibition *Reawakening the spirit of Sophiatown— Images of life, loss, laughter and love* (MuseuMAfricA, 2002) recaptures how the place, and its denizens, looked. Musically, *Bye bye Sophiatown*, by the Sun Valley Sisters, and *Meadowlands* (about one of the places where dislocated Africans were relocated to in Soweto), stand out ("Do you hear what the white man says?/He says we must move to Meadowlands./And we are not moving!/We are staying!").[76] And Paul "Rudeboy" Mnisi's 2003 debut album infuses this music with new life: it incorporates remixes of Sophiatown-era hits into his Afro-house style music.

A measure of the degree to which Sophiatown has entered the collective consciousness was the 2003 racially mixed student production of the musical revue *Sof'town—A celebration!* at Rand Afrikaans University [RAU], a formerly all-white school in Johannesburg. On the one hand, it signals increased acceptance of the country's shared culture: "[A]ll will be touched by this creative contribution to the healing of relationships between communities characterised by separation and alienation in the past," the official program asserts. On the other, it represents a co-optation of primarily black African idioms of expression from music, language, dress, and dance. The Back of the Moon restaurant at the casino at Johannesburg's Gold Reef City similarly appropriates an authentic period name and then tries to cadge the unique atmosphere of a celebrated Sophiatown *shebeen* [illegal drinking establishment, a speakeasy].[77]

Taken together, these representations comprise a formidable reservoir of remembrances. As such, they have made a major contribution to ensuring that the memory of these devastating South African experiences would not fade away. Richard Rive said of Cape Town's Baxter Theatre, where *District Six, the musical* was first staged, "is no longer a blue-rinse preserve," as a result.[78] Moreover, the play's impact on the audience was immense: "more than entertainment . . . [attending] [i]t becomes a psychological, cultural and political act."[79] In comparison, the American cultural archive is noticeably scant in this regard, and its contribution to keeping such memories alive is thereby negligible.

ROTTEN AT THE CORE?

A distinctive pattern of urban transformation is familiar to any student of post–World War II politics and geography: in instance after instance, American cities were remade through the behind-the-scenes collusion between politicians, businessmen, and other local movers and shakers. The capitalist desire for profits provided a motive. Frequently, but not always, racism did, too. New draconian laws provided the means.

According to historian Arnold R. Hirsch, the "first ghetto" was formed and maintained in Chicago through private means; restrictive covenants that prohibited transferring property to members of certain minority groups were key. Such covenants were legal until 1948.[80] Residential segregation was extreme and strictly enforced.

What he calls the "second ghetto" became a post–World War ll phenomenon. Local governments, allied with both business interests and establishments such as schools and hospitals, pushed minorities out into areas previously prohibited to them, repossessed the land, and constructed middle-class housing or used it for institutional expansion. One scholar notes, "[S]ome African Americans regarded urban renewal as 'Negro removal.' "[81]

The Illinois Institute of Technology, for example, justified its desire to push into its neighboring South Side residential area as "an act of self-preservation."[82] And in Hartford, Connecticut, after the race riots of the late

1960s, a syndicate of the heads of insurance companies, the city's principal industry, devised a secret plan that projected moving the city's blacks and Puerto Ricans out to the rural suburbs.[83]

A variation on this pattern emerges in the classic study *The urban villagers* by Herbert Gans (1962), which is based upon his extensive observation of "West End." This was an area in Boston that was officially declared a slum in 1953, and then it was razed between 1958 and 1960 through the use of the doctrine of eminent domain.[84] Only a few institutional buildings were saved.

Gans argues that this was not a slum, but an independent, working-class, immigrant-inflected subculture; he focuses in particular on the Italians. He describes the area's energetic street culture, its "European feel," and what he calls a "peer group society," with people "living mainly in the group, [and who] have an insatiable appetite for group experience."[85] Extended families commonly lived within the area, and it was possible for many people to walk to work.

Despite the vitality and cultural richness of the West End, there was profit to be made, and the neighborhood was replaced with luxury housing. And no wonder: part of the district bordered on prime riverfront property; the Massachusetts General Hospital gained more exclusive neighbors; downtown retailers acquired a new pool of potential shoppers, quite close by; and the city received increased tax revenues. Everyone benefited, it seems, except those who were "in the way." Families were torn apart, and small businesses folded, many of them unable to start up elsewhere.

Most residents found replacement housing on their own: as "whites," they did not face the territorial restrictions that African-Americans or South African coloureds or blacks did. Old-time residents reportedly came back to wander over the rubble of the West End, and the emotional toll was high. Deaths were attributed to the social disruption: an 84-year-old barber reportedly died shortly after he closed down his shop. And one man remarked, "It pulls the heart out of a guy to lose all his friends."[86]

To cite another example, *The social order of the slum* by Gerald D. Suttles (1968) examined an area of Chicago's Near West Side, home to a mix of people: Negroes, Puerto Ricans, Greeks, Italians, and Mexicans.[87] Although some of the residents organized to resist the encroachment of a major university, hospitals, and expressways, many residents were forced out.

And Elijah Anderson's *Streetwise* (1990) focuses on a part of Philadelphia he calls the "Village." There had been a history of diversity and tolerance in the area, but the destruction wrought by eminent domain "amounted to a wholesale amputation of a major portion of the Village's black community."[88] New businesses and organizations filled in this void, and the remaining housing was renovated for wealthier residents. Like Hyde Park, the Village remained racially mixed, but it became more homogeneous by class, more middle and upper middle class to be precise.

A number of factors link these places. In all these areas, just as in District Six, the streets were the place to be. Children "belonged to the community": no kid could act out without many sets of eyes monitoring them. Homes and

businesses were jumbled together, generating a high degree of familiarity between merchants and their customers. Jewish shopkeepers were commonplace in every one of these locales. After the bulldozers destroyed the area, extended families were fractured into smaller units. And dislocating old-timers from familiar ground exacted a tremendous toll; many believe it amounts to a murderous one.

Beyond the GAA and urban renewal laws, the dynamism intrinsic to neighborhoods such as these was undercut in the post–World War II era by a number of large-scale trends, affecting the United States, South Africa, and elsewhere. As mentioned, people shifted away from the city core due to an increased dependence upon cars, and the proliferation of new networks of highways. Local industries, upon which the working class depended for a decent living wage, relocated further away. And disinvestment from the city transferred capital to other parts of the metropole. These city centers, once bustling with residents, workers, and shoppers, were left to deteriorate and wither. The coalescence of all these factors was lethal to the way of life to which so many people had been accustomed.

It is startling to realize how closely the American experience parallels the South African one, but with a significant difference: the forces behind "renewal" were typically more opaque in the United States than they were in South Africa. The process in South Africa was draconian, politically transparent, and racist at its heart. But in the United States, both race and class played defining roles: whatever the color of a community's residents, they were vulnerable to removal if real estate developers, businessmen, politicians, and others had a different vision for the property they occupied.

American decision makers operated with more stealth, sealing backroom deals, thereby making it difficult to point fingers at those who were directly responsible for displacing large numbers of people. In the American case, "natural" economic and social forces of expansion, "progress," and change appeared to play the dominant role—not simply barefaced racism, as was obviously the case in South Africa, and frequently a factor in the United States, too.

FAIRYLAND OR NEVERLAND?

The gift shop of the District Six Museum sells an oversized photo postcard, shot by Cloete Breytenbach, that captured a graffito at one of the entrances to the precinct: "You are now in fairyland," it proclaims.

Its precise meaning is somewhat elusive, but it is an allusion that surfaces with regularity. This catchphrase became the epigraph for Rive's "*Buckingham Palace," District Six*, and it is shown twice in the catalogue accompanying the exhibition *District Six: Image and representation*.[89]

"This *is* Fairyland," declared a resident as she looked out from her home, at a moment when District Six was nearing the end of its existence. An artist who was her companion that evening was struck by the enchanting visual effect of "the sweep of shimmering city lights across the bay,"[90] fairy lights in

essence. And the text that accompanies a collection of photos that chronicled District Six while it still stood described it as follows: "The fairyland where love, happiness, kindness, tolerance, and squalor existed side by side."[91] Whatever way this expression is interpreted, District Six retains a magical, if contradictory, quality.

The sepia tint of nostalgia highlights some elements of the past while it masks others.[92] Most commonly, District Six is dreamily recalled through a gauzy veil that accentuates the live-and-let-live attitude of the place, its sense of harmony, tolerance, equality, personal security, and *helpmekaar* [sharing]. As Linda Fortune puts it, "What have we got left? Only our sweet memories. So people tend to romanticize about District Six; we don't want to think about the pain. We don't want to think about the suffering, only the juicy bits, the sweet memories."

A black African woman explains how multiple families shared kitchen facilities, an outside toilet, and other amenities when she was growing up in District Six. But because their use was regulated by group-generated rules, she brashly claims, "This resulted in perfect harmony and tolerance."[93] "Everyone was one," declares a former resident of Tramway Road, another Cape Town area destroyed by GAA; "We were close-knitted," states another.[94] Linda Fortune writes, "You never needed to starve; all you had to do was ask."[95] And in outlying Simon's Town, one man recalled, "Most people were poor to very poor; however, 'there was nobody who would starve or go begging.' "[96] Using a very broad brush to paint the distinctive social landscape of District Six, another observer notes, "Everything there seemed to end in laughter, even tragedy."[97]

There is undoubtedly truth in the impressions each of these people share. But there is obviously a strong measure of idealization and denial as well. These rival elements provide a challenge for any museum engaging with this material. And it is obviously something with which the District Six Museum must grapple. Much less frequently addressed are the gangsterism and dire poverty and domestic violence that also directly affected many of the inhabitants there. District Six Museum staffer Haajirah Esau reveals that when she once compiled a pamphlet describing the vibrancy and hodgepodge of people in the area, and mentioned prostitutes as one of many local types, a fellow employee "got furious." She continues, "He said, 'No, no, no. We didn't have those sorts of people working in District Six.' " The person who objected had obviously not read Richard Rive's *Buckingham Palace.* Or, he had selectively edited out all the scandalous activity buzzing around the Casbah.

The inherent contradictions of this, or just about any poor or working-class neighborhood anywhere, are unmistakably embodied in one of its most celebrated sons, author Richard Rive. Rive could wax poetic over his home terrain: "There were times in spite of its sordidness, the District seemed like poetry. It effervesced and bubbled over," he reveals. Yet in another breath he could bluntly confront the unrefined facts of life. "It was a ripe, raw and rotten slum. It was drab, dingy, squalid and overcrowded," he openly declares. "A slum is

never romantic especially for those forced to live in it,"[98] he adroitly observes, and he also admits that the area was suitable for slum clearance.

Linda Fortune presents a similarly incongruous depiction. She notes in her memoir *The house in Tyne Street* that people seldom locked their doors. Nevertheless, she and her brother took judo lessons to learn to protect themselves. And the documentary film *A normal daughter* (2000, Jack Lewis, director) celebrates the coloured *moffie* subculture that flourished in District Six: scores of flamboyant hairdressers, young chaps who regularly assumed feminine personas (Kewpie Doll, most famously, and others such as Piper Laurie, Jean Shrimpton, Hayley Mills, Yvonne de Carlo, and Capucine), and popular drag shows. These were in-your-face queens, who were reportedly not simply tolerated, but affectionately embraced as part of the social landscape, and even "adopted" by local families as daughters or sisters or *tannies* [aunties]. Even so, the film alludes to the fact that in spite of all this love and acceptance, these gay men sometimes suffered serious physical assaults, including castration.

Astonishingly, while reading through the literature about communities displaced by the GAA, I have encountered only a single reference to brutal behavior within families while they were living in areas such as these: "There was a lot of domestic violence, men abused their wives and children," one observer reports. "People today fantasize about their youth. But it wasn't only pretty stories."[99]

On another level, gangs were a familiar presence in District Six, among them the Killers, Jesters, Rangers, Mongrels, Starbucks, Red Cats, Hungry Hills, and the most infamous of all, the Globe Gang. Gang activity escalated within the area post–World War II, into the 1960s.[100] And although gang members were capable of crimes ranging from petty theft to murder for hire, they are remembered as being "[not] merely ignorant criminals," but as also having served the community by sponsoring social and sports clubs; they "did much good among the underprivileged."[101]

Gang members are more often respectfully remembered as fitting the mold of Damon Runyanesque characters, than as the real threats they could in fact be. Faced with the violence that has become endemic to communities on the Cape Flats such as Mitchells Plain, one lady wistfully remarks, "In District Six we had decent *skollies* [thugs/street hustlers] and I was not frightened of them."[102]

Perhaps the most concise, candid and contradictory characterization of District Six is that it was "a paradox . . . of respectability and rascality."[103]

What If? Redux

One memoirist concludes her book by reflecting, "The struggle of my life goes on and on, and I think: None of this would have happened if I still lived in William Street."[104] This is a poignant statement, undeniably, but probably naïve. For who knows what would have happened to District Six, had it not been deliberately destroyed? Without being able to answer for certain, we can infer from experiences elsewhere that are highly suggestive.

The obvious place to begin to look is Cape Town's Bo-Kaap district, the neighborhood that bears the closest resemblance to the old District Six. Located across town, its torturously steep streets advance steadily up Signal Hill. The Bo-Kaap has traditionally been known as the Cape Malay Quarter, home to descendants of the early slaves brought to South Africa. Hundreds of their graves are scattered along the upper slopes above the neighborhood.

It boosts modest attached houses, numerous mosques, panoramic vistas, and enviable proximity to the central business district, museums, and the waterfront. The Bo-Kaap Museum re-creates daily life in a successful Malay household of the nineteenth century, in a building erected there in 1763.

This area of the city dropped below the radar during the apartheid years, remaining largely intact both architecturally and ethnically. In 1994, only one or two whites lived there, and they had to secure special permission from the government to do so. But in the decade since, the ratio of white to Muslim or coloured residents has become 1:3. Community meetings and marches cannot stem the tide of gentrification, or halt what some activists call the "bargain basement handing off of a heritage."[105]

Stroll the narrow lanes here, and you will see rows of small homes awash in sundry, vivid hues. It is not unusual to catch sight of salmon, mustard, burnt orange, blue-gray or pink facades within the same block. Haajirah Esau lives in the Bo-Kaap and has witnessed the changes firsthand. She dubs these "smartie colors." In the past, she claims, "all those houses were white, I promise you."

According to one source, residents were prohibited from decorating their homes in this way under apartheid. But with Nelson Mandela's release from prison in 1991, color erupted as a sign of resistance and a symbol of a new future.[106] This trend has both accelerated and mutated: newer residents are quite design conscious. Older ones have realized how alluring these streetscapes can be to tourists. Esau reports that someone bought a whole block of houses in this area for R300,000, jazzed them up, and then offered them for sale at R800,000 apiece. For property-hungry South Africans, and deep-pocketed foreign investors, the Bo-Kaap is sizzling.[107] In 2005, concern within the local Islamic community intensified to such an extent that the Muslim Judicial Council issued a fatwa banning any development that might encroach upon burial sites at the topmost sections of the district.[108]

Colin Abrahams, director of the South End Museum in Port Elizabeth, suspects that something similar might have happened where his institution is located, had the GAA not enabled the government to level most of the buildings there, and had developers not subsequently erected up-market, if stylistically monotonous town houses. He believes that the South End would have probably become commercialized because of its proximity to the city, a transformation he sees as a "natural pattern" of working people moving out and other activities moving in.

Valmont Layne also believes that gentrification, stimulated by speculators buying up property and kicking people out, "might have been the natural flow of events anyway" in District Six. From his perspective, the cadence of

life and work carried out in District Six represented a "particular industrial and post-slave economy." District Six was likely the final manifestation of a way of life that has obviously been eclipsed in a postindustrial, globalized world, particularly in a city like Cape Town whose international appeal has rocketed over the past few years. Real estate prices have soared commensurately, and tourism has become a major industry.

Donald Parenzee believes it was "insane" to break down the buildings in District Six. Not only did that destroy individual homes, but it also wrecked the "European feel" of the area, disrupted the integration of living and shopping, and obliterated the organic feeling of community that flowed from people living chockablock next to one another, within a maze of peculiarly configured streets.

Observers of the American experience cite the same sort of losses when they have examined the fate of jam-packed, pedestrian friendly, ethnically mixed or minority neighborhoods during the same period. Is it possible to recapture even a bit of the unique atmosphere that imbued all these areas?

BACK TO THE FUTURE

Architects and planners who are proponents of the so-called New Urbanism aspire to recover certain aspects of the built environment that have either fallen out of vogue, or been consciously destroyed, and they hope to recapture a spirit of community life that was once commonplace. They favor mixed land-use areas where homes, businesses, and public spaces coexist; areas that are people-centered and not car-centered; and the reintroduction of such structural design features as streets equipped with sidewalks, which are human-scaled and not precisely aligned on a grid, and the reintroduction of porches (verandahs, or *stoeps*, to South Africans) to mitigate the boundary between private and public. "We were an outdoor people, then,"[109] one man recalled, a fact mirrored in the prevalence of lively street scenes among the art that has depicted life in the old District Six. One critic fittingly describes the people in such paintings as "verbs."[110]

The best-known examples of actualizing the principles of the New Urbanism in the United States have been the Disney Corporation's Celebration, Florida, and Seaside, Florida, the town that was featured in the movie *The Truman show* (1998). But these places have been criticized widely as being synthetic, inorganic, and experientially totalitarian, in essence dictating community according to strict codes. Their planners have tried to impose sociability from the top down, not permit it to bud and then flower according to its own tempo. The question becomes, "Can you manufacture neighborliness by design?"

In 2000 President Mbeki released the land where District Six once stood to be used for redevelopment, a week before elections were scheduled. But it was not until 2003 that foundations were finally laid for the first cluster of town houses, earmarked especially for elderly returnees. Political filibustering and bureaucratic snafus repeatedly set back the rebuilding.

In February 2004, former president Nelson Mandela presided over a "Homecoming of the Elders" ceremony at the site, where he handed over symbolic keys to two of the as-yet unfinished set of nine semidetached, double-storied homes. However, some people saw it as a cynical, political gesture: months later, the other seven dwellings remained unfinished.

Eventually, about 4,000 households will be moving back to District Six. To do so, returning residents must accrue a significant nest egg to supplement the modest subsidy the government is providing them. Valmont Layne hopes that planners "draw a few living principles" concerning architecture and lay-out from the former District Six, but re-creating archaic flourishes is pricey, and even the most basic construction costs have soared since redevelopment plans were first approved.

The District Six Museum has been surprisingly successful in providing a site where people can keep memory alive. It remains to be seen, however, whether or not peoples' memories of day-to-day life in the old neighborhood can be revived to a degree that is satisfying to them. South Africa is now a different place in manifold ways, and the District Six returnees have had varied life experiences since they were forced to leave. Will a community, in the fullest sense of the word, once again sprout there?

A palm tree that had been used for set decoration on a film shot in Cape Town in 2004 was planted behind the first row of houses as a living symbol of hope.[111] Time will tell whether or not the celebrated spirit of District Six can be rekindled.

THE END OF THE INNOCENCE

The District Six Museum was born in conjunction with the new South African democracy. Throughout 2004, the country's major museums took this decennial milestone as the occasion to assess the changes that they had undergone in the interim. And for the trustees and staff of the District Six Museum, the run-up to this anniversary was a time to reflect upon the threshold of major change now facing the institution.

According to Sandra Prosalendis, it was "a critical moment" for the museum. Haajirah Esau experienced it as "a difficult, hectic time." And for director Valmont Layne, it was "a dangerous moment." What, exactly, do such grave descriptions signify?

For one thing, the museum's core audience is shifting. In the early days it attracted a preponderance of ex-residents from District Six. But by 2004, tourists, especially foreigners, were clearly outnumbering the original constituency. Several staff members recall times past when they routinely shared intense feelings with visiting former residents, but this has become ever rarer: many District Sixers have already touched base with the place, and others have passed on.

Sandra Prosalendis remembers, "Every person who came through that door had an extraordinary encounter, and for four, five, six years I remember I couldn't be in the museum without feeling every day, I felt the pathos of

that space. It would bring millions of tears just [about] every day." But the staff went beyond simply providing the occasion for catharsis: "There was a lot of counseling we were doing, and there was lots of highly felt emotion."

According to Haajirah Esau, when former residents show up nowadays, it is commonly regarding restitution claims, for which they are referred to the District Six Beneficiary Trust. Their confusion is understandable: in 1997 the museum was the site of a historic hearing of the Land Claims Court. Competing factions came to a agreement to establish the Trust, ex-residents were assured that they would be given a significant part to play in the redevelopment, and that they would be granted the right to file individual claims.[112] Convening this tribunal in the museum simply underscored the central role it has played in expediting the claims process since it came into being.

Valmont Layne characterizes the museum's responsibilities in the following way: "It is not our job to build the houses, but it is our job to look at the human issues, the people issues, and then at the symbolic and cultural issues and memory issues. That is going to be our primary work in the next two years." He concludes, "Parallel with that is advocacy and lobbying work."

Layne clearly illustrates a dilemma that pops up at present: "If you have 20 tourists in the museum, and an old man from the district walks in, and you have one tour guide on the floor, who do you serve first?" Whichever decision is taken yields different consequences for the museum: "Do you run to the old man and leave the tourists to do what they will? Or do you get tourists to buy your books so you can keep the doors open?"

Sentiment and fiscal needs pull the staff in opposite directions. Layne continues, "It doesn't have to be an either-or [situation], but that is the way it plays [out] at the moment, and we have to think of creative ways of making sure that we don't ignore the reason why we are here in the first place."

Tourism is a mixed bag: "it is a danger and an opportunity," says Layne. The metamorphosis of the audience has meant that people who now show up bring different social, cultural, educational, and economic backgrounds to bear on their viewing; different needs, expectations, and different desires, too. The museum's continued viability turns upon how well it satisfies this new clientele. Layne reflects, "We were lucky that we were set up before the big tourism [boom], we were set up out of a local need. We have been fortunate that we weren't defined in terms of the tourism market."

"Part of the success of this institution is that it responds to a real need, in a real community that is locally based," he says. But that was then; this is now. Within the span of ten years the District Six Museum has become an internationally acclaimed site and a must-stop for culturally minded sightseers.

Moreover, Haajirah Esau reflects that early on, the museum operated on an ad hoc basis. Many people worked as volunteers, and "[i]t was a very close-knit setup." As she recaps the museum's history, in 1994 the director was the only employee with an ongoing appointment, as opposed to term

contract. It was not until 1997 that another permanent staff member was brought on board.

Sandra Prosalendis candidly reveals the insecurities of those inaugural days. In 1994 she fretted to her mother that the only objects she and her collaborators had to show the public that were "museum-like" were the recovered street signs and a few framed photos. But the older woman insisted that they push forward: "She said, 'Sandra just open the doors. You don't need anything more than this. Just open the doors.' And I said, 'We can't. What can we show people?' And she said, 'You don't need anything else. Open the doors.' "

Furthermore, never underestimate the importance of serendipity: "We had lots of important people coming through the museum," Prosalendis recollects, "because we were in the right place at the right time. We were the postapartheid symbol of love and triumph and 'let's be together' and all of those things." A hit among the locals, the District Six Museum also zoomed to international acclaim. Among the dignitaries who made highly publicized visits in those early days were U.S. Vice President Al Gore, Irish President Mary Robinson, and royalty from Spain, Sweden, Norway, and the Netherlands.

GOODBYE TO ALL THAT

The museum's success has forced it to adopt new organizational arrangements, which also threaten its original character. "We used to have a completely flat organization [where] no one had authority over anyone else," Haajirah Esau points out. "But that has changed very recently. Now we have some sort of hierarchy."

How does that translate to everyday work routines? There is a great deal of uncertainty and insecurity, as one would expect in any transitional period. "It is very different when you are a small staff and everyone is used to being equal," Esau laments, "and suddenly you get told, 'Actually, no, you need to ask so-and-so' if you can do this, or you have to clear it with this person." As a result, not everyone feels clued into what decisions are being taken, what will become of their particular positions, or where the museum is headed.

One of the main issues is heightened accountability. In the past, the museum was rather autonomous, answerable to its board of trustees, whereas the trustees represented the broader community of former District Six residents, its primary constituency. But as the museum becomes better known, and undertakes larger projects, other stakeholders come into the picture. The District Six Museum is feeling the pressure to act "more rationally," more like a "typical" bureaucracy.

The museum competes with other cultural institutions for recognition and support and must adhere to nettlesome government regulations. As the external environment with which it deals intrudes in more ways, and becomes increasingly complex, the museum is forced to develop what organizational theorists call "isomorphic structures." In other words, government officials

and foundation grants officers expect a high measure of predictability: they must be able to easily identify which staff members with whom they should deal, and they must be assured that conventional administrative procedures are in place. There is an inexorable tendency, therefore, for organizations to grow to resemble one another, in order to function as reputable, established entities.[113]

All this comes into focus over an opportunity the museum had to initiate a major expansion in 2003: it leapt at the offer to buy a warehouse nearby the Methodist Church building, at a giveaway price. But even though this was a singular opportunity, major costs are involved beyond the initial outlay: plans for the new facility's use will turn it into a community center catering for former residents and others, including a theater, a library, and additional exhibition space. Whatever burden the museum felt in the past to chase after funding is therefore increasingly weighty.[114]

In 2003, the directorship of the museum passed from the original incumbent to a new appointee. Since then the executive's manifold responsibilities need to be shared with a financial director, and a professional fundraiser, new positions that by their very nature are attuned to different principles and procedures than simply community oversight. Above all, those posts typically lay emphasis on financial stability, growth and financial integrity, whereas the trustees have prioritized their extremely deep-seated personal investment in the humane and participatory values the museum stands for, and what the organization does to promote them. By incorporating increasingly specialized positions into the museum's structure, the center of gravity may likely shift away from the founders and their fundamental philosophy.

For example, the South African lottery provides generous funds to cultural endeavors. But is such money "tainted" by nature? Many trustees feel strongly negative about accepting such support, but in an environment where so many worthy projects go begging, refusing assistance from any source seems imprudent. Director Valmont Layne is at the center of these crosshairs: "I am sort of the watchdog the trustees have asked to make sure that as we grow and as we expand that we retain our core values and our core mission," he says. "It is going to be hard because we are bringing on new people, and there needs to be a transfer of that [original] vision to the new people and a re-negotiation of that arena, but ultimately [we must] be answerable to a community."[115]

As mentioned, one of the central values of the District Six Museum is its independence: from government bureaucracies and from the potentially manipulative demands of funders. The museum's insistent adherence to this ideal explains why it has earned such high esteem from the people whose experiences it represents. One of the main reasons it has been possible for the museum to stick to its principles thus far is that it has received generous funding from foreign sources such as the Spanish, British, Dutch, Swedes, and Norwegians; the Ford Foundation; and a significant award from the Prince Claus Fund for Culture and Development (the Netherlands) in 2003,

honoring projects that promote "interculturality."[116] These donations have confirmed the legitimacy of what the District Six has done, and they have allowed it to develop in line with the mandate it has established for itself. "We live on the goodwill of the international community," Valmont Layne states succinctly.

The museum is eager to contribute to nation building in South Africa, but is leery of becoming entangled with officialdom. "We have seen what it does to other institutions, it just destroys creativity. And part of our core and identity is that we are a community institution," asserts Valmont Layne.

Promoting the values of community loyalty, political advocacy, egalitarianism, and accessibility has served the District Six Museum well. This bundle of attributes defines what the museum is. But how far it will take the museum in the future is part of the unfolding history of this unconventional institution.

A MODEL MUSEUM

The GAA sent the first eviction notices to residents of Port Elizabeth's South End in 1965. Unlike District Six, however, this area was immediately rebuilt as a white enclave. Visit there today and you will see upscale modern housing developments and extremely lush, tropical foliage. But if you are a little more observant you can also spot several brightly painted mosques dotting the landscape, remnants from an earlier time. And you may also discover an 1897 architectural folly of a structure, the former Seamen's Institute Building, which now houses the South End Museum.

Another sort of institutional isomorphism is demonstrated here. Like the District Six Museum, this organization has an organic relationship with former community residents: its director, and members of the board, once lived in the area. The South End Museum also features a "map painting" on the floor, retracing the local geography as it once was. And the museum is collecting peoples' memories and their material belongings to re-create in some small measure what was lost when the bulldozers came.

District Six is the model for this type of museum of remembrance, and it is likely that other dispossessed communities will develop similar places in the future. The will to do so is there; the resources generally are not. But there are some notable, budding efforts in Sophiatown and other locations. For example, the Sophiatown Heart and Soul cultural revival project is compiling an archive of material documenting the glory days of that Johannesburg neighborhood, and it has sponsored exhibitions and cultural events, such as a "shebeen evening." It featured live entertainment in a recreation center decorated to replicate a famous jazz and drinking joint, tables named after area streets, and party-goers talking in Tsotsitaal.[117] And in 2005, a memorial march from Sophiatown to Meadowlands and a reenactment of a forced removal marked the fiftieth anniversary of the destruction of the area. Those spearheading these efforts hope that this will provide the foundation for a future museum.

The Hector Pieterson Museum in Soweto (see Chapter 7) has already duplicated the growth cycle of the District Six Museum. It developed from what was supposed to be a one-off exhibition, in this case, a display of photos to commemorate the twentieth anniversary of the Soweto uprising of 1976. From its meager beginnings in shipping containers adapted into gallery space, a groundswell of community interest led to building an architecturally cutting-edge facility that opened in 2002.

The District Six Museum is also a founder member of the International Coalition of Historical Site Museums of Conscience, an alliance that now includes 13 locations worldwide. It is an eclectic grouping of institutions, including Memoria Abierta (Argentina), the Terezin Memorial (Czech Republic), Gulag Museum at Perm-36 (Russia), Liberation War Museum (Bangladesh), Maison des Esclaves (Île de Gorée, Senegal), The Workhouse (England), and several places in the United States, among them the Lower East Side Tenement Museum and the Japanese American National Museum.

Common interests in a variety of forms of oppression bind these sites together, including slavery, forced labor, dictatorship and state-sponsored terror, atrocities of war, genocide, poverty, and racism. In their own way, each insures that memory resides in actual places, and not just in individuals' hearts and minds.[118]

And significantly, the activism that spawned the District Six Museum is still very much in evidence. In 2003, workmen excavating a site for commercial redevelopment in Greenpoint, a trendy part of Cape Town, were surprised to discover human remains. They had stumbled upon an eighteenth-century cemetery, holding perhaps as many as a thousand burials. Most were probably slaves, nonbelievers in the Dutch Reformed Church, and other members of the colonial underclass.

Community concern about the ultimate fate of both the site and its remains coalesced in the Hands Off Prestwich Street Committee, purposively echoing the name of the Hands Off District Six campaign from the late 1980s—the group that opposed redevelopment of the district, and was also key to establishing the museum. Moreover, the two movements included some of the same activists, and District Six Museum staff and trustees added their voices to the public debate as well. The spirit of kanala endures.

Monument or Tombstone?

A full-page analysis of alternative future prospects for District Six appeared in a Cape Town newspaper article published in 1969, after the demolitions had begun. The writer, a local industrial designer, put forward a detailed blueprint for a true renewal of the area. His plan called for dividing the area into four quarters. The residents of one quarter could be relocated to temporary accommodations while their section was demolished and rebuilt. Afterward, residents from another quarter would duplicate the same process. When followed through to completion, the original residents would have new homes,

and by concentrating them in a smaller proportion of the overall area, part of District Six would also become available for whites to move in.

But that would have only been acceptable to a government that was sincerely interested in slum clearance in order to improve peoples' lives. Its actual motives, however, were different. Furthermore, the Department of Community Development had commissioned a study of buildings of historical and architectural interest in District Six that merited preservation.[119] Neither of the plans was heeded and the demolition moved forward.

By shunting thousands of people primarily to the Cape Flats, and thereby multiplying their misery, the government inadvertently created the social conditions that strengthened the hands of its opponents and eventually helped bring down apartheid. For, as Marx predicted a century earlier, the concentration of these oppressed people enabled them to act in concert with one another: the Cape Flats became a scene of uncontrollable turmoil, particularly after the student uprising in Soweto. The compression of anger, despair, and a keen sense of comradeship also nourished the memory of District Six that retains such power today.

The author of the above mentioned proposal for redevelopment, in an amazingly prophetic statement, remarked, "The new District Six might well be a monument to apartheid, but it could just as easily be its tombstone."[120]

* * *

The enormous sense of disruption that District Six residents felt after their neighborhood was destroyed is captured by a story that sounds apocryphal, but is narrated by the man who experienced it firsthand. When District Six Museum employee Noor Ebrahim was 17, a neighbor presented him with 50 racing pigeons. Reflecting that invariable "spirit of kanala," he and his friends collected wood from local Jewish merchants and built a backyard loft to house them in. Raising and competitively racing pigeons was a popular pastime during Ebrahim's younger days in District Six.

A little more than a decade later he was living in an outlying coloured area, after he was forced from his home in District Six. Once he had been in the new place for three months, Ebrahim decided he should release his birds to see whether or not they would return. He tried it one Sunday morning. But by that evening, only one bird had found its way back.

The next day he drove to his old street in District Six. And there, on the land where his house had once stood, he discovered his beloved flock of birds. Ebrahim recounted the story to me saying, "Strangely, some of them actually turned around and they looked at me, as if to ask me, 'Where is our home? This wasn't your home only, this was our home also.' I went down on my knees and I cried, and that was my saddest moment in my life."

Two weeks passed, and by then all but one of the birds had returned to their new location. When kids asked Ebrahim what he thought had happened to the missing bird, he replied, "Maybe the other one committed suicide."

Ebrahim regularly repeats this story to museum visitors. For him, it is emblematic of the emotional costs of such a massive dislocation: "Imagine, that was a pigeon," he points out. "Imagine how we felt, after we were kicked out of our homes."[121]

Noor Ebrahim dismantled the loft once again after a move to another house. But he intends to reconstruct it after he relocates one last time in his life—back to District Six.[122]

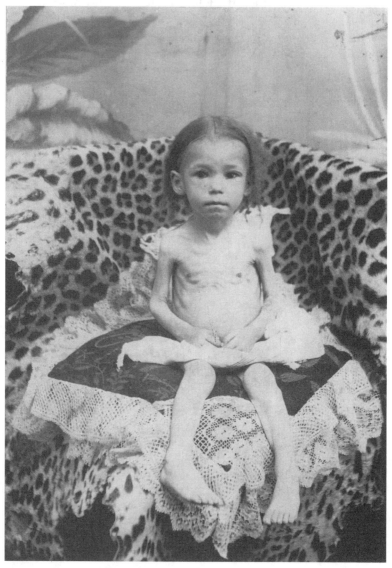

Figure 7 A victim of malnutrition in the Bloemfontein concentration camp, Anglo-Boer War

Source: Photo courtesy of War Museum of the Boer Republics, Bloemfontein.

CHAPTER 6

"The History of Our Future": Revamping Edifices of a Bygone Era

It's only history if you steal something really large—like a country. Then it's history.

<div align="right">

Purkey and Stein, 1993

</div>

Visitors to the National Cultural History Museum in Pretoria might opt to linger over a meal in the African Window Restaurant, located on its main floor. The bill of fare on a warm spring day in 2003 offered two options: a "Western meal" featuring chicken á la king with rice, or the "ethnic meal" consisting of tripe with pap.

On the face of it, here is a menu in sync with its social time and place. But while it is an obvious gesture toward inclusion, and an expansion of what would normally be offered in such settings—it certainly expands the genteel notion of "ladies who lunch" that distinguishes so many comparable places in the West—just how progressive is it? Does this reflect a well-intentioned, yet in essence "separate but equal" accommodation?

I know this must sound like a harsh and dismissive reaction. After all, it represents a sincere nod on the part of the museum to the multicultural nature of South African society. But let's consider some alternatives. The restaurant might present a smorgasbord, allowing the patron to be a bit more adventurous, mixing selections at will. Or else the chef could experiment with culinary fusion, or nouvelle cuisine Afrique, combining contrasting elements to synergistically produce unanticipated enjoyment. But as it stands, while the choices for diners have undeniably been enlarged, they are forced to remain within one gastronomic camp or the other, fashioned along venerable racial and cultural lines.

And that characterizes a central predicament for contemporary South African museums, in whatever they do. How do you integrate elements that never coexisted before? How do you introduce ingredients that were previously unfamiliar to local palates, or intentionally left out? How do you

expand the repertoire of recipes and preparations in order to rustle up new fare for the public, fresh ways for them to savor and experience the world?

Such is the dilemma, and challenge, of transformation.

DEALING WITH TERRORISTS

The revolution in South Africa in the 1990s was not bloodless. Nor was it a bloodbath, as many had feared it might be.

The change in government has caused an upheaval in beliefs and everyday ways of doing things, prompting individuals as well as institutions to critically rethink basic assumptions. And one site where that is conspicuously apparent is within South Africa's numerous military and war museums. For what could require a more fundamental cognitive turnabout than reconsidering what was once legally judged to be "terrorism"?

Umkhonto we-Sizwe [MK] was the armed wing of the African National Congress. As sworn combatants against the racist National Party regime, its cohorts were officially deemed terrorists and enemies of the state, and they were treated as such. A brief notice about an exhibition of "terrorist weapons" at the South African National Museum of Military History in Johannesburg [NMMH], appearing in 1979 in *Paratus*, the army's official magazine, reflects this perspective:

"Met die uitstalling word 'n beld gegee van aktiwiteite in die Operasionale Gebied. Dit bestaan uit 'n groot verskeidenheld wapens en toerusting van Russiese en Tsjeggiese oorsprong. Die uitsalling word aangebied op versoek van besoekers aan die mueum. Dit voorsein in 'n lank gevoelde behoefie omdat min mense bekend is met terrorsitewapons." (With this exhibition a picture is being portrayed of activities in the operational area [Northern Namibia/Southern Angola]. It consists of a great variety of weapons of Russian and Czech origin. The exhibition is being presented on request of visitors to the museum. It satisfies a long-existing need because few people are familiar with terrorist weapons.)[1]

Official power has since shifted directly into the hands of many former MK members and supporters. For a museum to characterize these men and women as ex-terrorists today would be questionable, indeed. Curators and directors have been forced to become alchemists, hastily making over former foes into freedom fighters, patriots, and visionaries. MK is now a resistance movement.

In places such as the Military Museum at Fort Bloemfontein and the NMMH, curators have been quite keen to reframe their exhibits about Southern African political struggles. Posters, uniforms, weapons, and other paraphernalia from such insurgent movements as MK, FNLA (Angola), and SWAPO (Namibia) are now highlighted in such venues.

The change is personified by Joe Modise, who was once commander in chief of Umkhonto we-Sizwe, but then from 1994 to 1999 served as South Africa's minister of Defence. The National Museum of Military History now features the uniform he wore while a member of MK. Allan Sinclair,

NMMH's curator of art and aviation, notes that "terrorist" has become out-moded, arcane; "We can't say that now," he explains. "In the old South Africa," he continues, "we would have a display on terrorist weapons. Now, obviously, you cannot. So things have to change, you have to take into account [altered] sensibilities."

According to Fort Bloemfontein's Johan van Zyl, "In the past, in the old military museum, the exhibitions were meant to support a certain political idea. [It was] a government fighting against what they then called terrorists, but today's [there's] a big change. It's important to us [now] to get the two sides balanced."

Moreover, resistance to military service swelled during the apartheid years, particularly because of soldiers being dispatched to quell disturbances in black and coloured townships, and being posted to fight the border wars in neighboring countries. The End Conscription Campaign [ECC], launched in 1983, publicly challenged the legitimacy of the actions the National Party government was taking. With its distinctive shattered chain logo—once solidly joined elliptical links are falling away from one another, with the "E" and "C's" of ECC floating free—this organization believed that sending the South African Defence Force against South African citizens in effect constituted civil war.

By supplementing direct action tactics with the extensive use of political posters and stickers (one paired Picasso's *Guernica* with the slogan "A Civil War Is Not Very Relaxing," while another featured Bart Simpson posed with a slingshot rebelliously decrying, "F.W. [de Klerk] Eat My Call-Up"), and events such as the art exhibition *PoW* [*Prisoners of war*, Market Theatre, 1987], the ECC earned the wrath of the government. It became a banned organization. But men who defied the government by protesting, going into exile, or being imprisoned, are now viewed as part of a righteous, centuries-long opposition to what some people viewed as a string of illegitimate wars, during their own times.[2]

The exhibition *Rebels and objectors* at the NMMH, for example, employs strongly sympathetic language to highlight their heroic and altruistic qualities, rather than any traitorous ones. Moreover, Italian prisoners of war from World War II are likewise remembered for their resourcefulness, and the distinctive culture they generated within the camps in which they were detained in South Africa, rather than for potential treachery or probable danger to the general public. But the exhibition's inclusiveness also generates some strange bedfellows: protests by the extreme right-wing Ossewa-Brandwag movement at the Union Buildings in Pretoria and at the Voortrekker Monument against South Africa's participation on the Allied side during World War ll are shown as well.

TAKING THE HATE OUT

Not surprisingly, the scars left from apartheid remain fresh. But those inflicted during the Anglo-Boer War (1899–1902), a South African conflict that occurred over a hundred years ago, have not completely healed either.

That, in itself, is not remarkable. The chasm between North and South that marked the American Civil War also continues to be salient in certain respects, a century and a half later. And symbols from that conflict such as the Confederate flag and war memorials still generate furious debate on occasion.

Even now, traveling through South Africa you can catch sight of the remnants of the vast network of blockhouses that the British strategically set up alongside railroad bridges to thwart guerilla attacks by the Boere. But these signposts are easily overlooked, or seem like bewildering heaps of stone to many passersby. At particular moments, however, historic artifacts such as these may swell with significance.

In the mid-1990s, planning began for centennial commemorations of the Anglo-Boer War. But with a black African-dominated government in place, this was hardly a priority. One ANC official declared, "To celebrate a colonial war is an affront to the new democratic dispensation. . . . we have just got back our dignity. We oppose this event—it has nothing that unites our people." And another reacted to an invitation to participate in commemorative events by remarking that it "might as well have said 'Conservatives of the world unite.' "[3]

In a different part of the country, a news story noted the following: "The battle to darken the artefacts and exhibitions of the country's museums and historic festivals received another boost this week." A provincial minister "issue[d] a thinly veiled warning to the organisers, local historians, and tour guides to effectively stop aggrandising white-only conflicts, thereby perpetuating apartheid," it said.[4]

In spite of government interest and backing that ranged from lackluster to nonexistent, museums understood that this was the opportunity to expand long-standing perspectives on this conflict. The Anglo-Boer War is notable for a number of reasons. It was the first mass-mediated war, with broad coverage by journalists, photographers, artists, and even filmmakers, a theme explored in the 2000 exhibition *Visual reports: Artists in the Anglo–Boer War (1899–1902)* at MuseuMAfricA in Johannesburg. The publicity surrounding this conflict generated a great deal of attention throughout Europe, drawing international brigades of volunteers to the side of the Boere.

Furthermore, the British "scorched earth" policy destroyed or displaced almost everything in sight. And the Brits introduced a new concept into the world's lexicon at this time: the concentration camp. Over 25,000 Boer women and children perished in them, under conditions of extreme deprivation and rampant disease. More than anything else, this sticks in the craw of Afrikaners.

Colonel (retired) Frik Jacobs, director of the War Museum of the Boer Republics in Bloemfontein, understood that the centennial could be the occasion to revisit time-honored depictions. The Anglo-Boer War Women's Memorial stands just outside the museum, and it commemorates the white civilian casualties of that war. But no mention is made of what happened to blacks during the same period.

While he was sympathetic to presenting a more racially inclusive view of the war, Colonel Jacobs found himself constrained by a relative lack of

documentation showing how blacks actually participated in, and were affected by, that conflict. At the time it occurred, no one particularly cared to record or represent this aspect of the hostilities. Colonel Jacobs could not manufacture evidence. But he discovered that the existing record had not yet been thoroughly mined.

Blacks fought in large numbers in this conflict; they worked in various supportive capacities as well. Moreover, like the Boere, they were also forced from their homes and became refugees. They too were incarcerated in British concentration camps, primarily as a precautionary measure so that they could not support their Boer employers. And they perished in great numbers: of an estimated 116,000 detainees, 14,000–20,000 died in custody.[5]

This information has become more broadly known, through such means as the exhibition and accompanying booklet *Not only a white man's war*, mounted by the Voortrekker Museum in Pietermaritzburg in 1999. It shows black and Indian participation on both sides as *agterryers* ["after-riders," or horse tenders and general assistants], scouts, wagon drivers, stretcher bearers (including Gandhi, in support of the British), suppliers, builders, cooks, and servants. By closely reexamining the War Museum's extensive photo archive, Jacobs and his researchers detected traces of activities of this sort that previously had been overlooked.

After enlarging certain pictures, blacks emerged in finer resolution than ever before. Using this "new" material, and others, the War Museum presented *Suffering of war* in 2003, to demonstrate the manifold types of destruction that warfare inflicts on all levels: on combatants and noncombatants, on agriculture, ecology, the economy, and on the infrastructure.[6] According to Jacobs, "I think this project is supportive of the ideal of transformation because we show how black people had their huts blown to pieces by dynamite. You see black people bound to a wagon wheel and being flogged."

Pictures of emaciated Boer children, which make up part of the museum's more permanent displays, were also featured: one shows a skeletal young child posed in a delicate white dress, sitting primly on a chair that threatens to envelope her wasted body. Her piercing stare indicts the viewer. One critic discovered that the exhibition prompted a profound bit of soul-searching: "My reaction to the photographs was a bit like some Germans' reaction to the Nazi camps: why did I not know? One knew, of course, abstractly."[7]

This particular exhibition culminates a protracted process of reassessing the museum's exhibitions and its objectives. Colonel Jacobs echoes the sentiments of other former military men I interviewed who have entered museum work: having experienced combat firsthand, their personal goal is now to inculcate an antiwar, while not necessarily pacifist, mentality into upcoming generations. He draws an interesting contrast between his institution and an art museum, where you can bring children in and teach them to draw. "I can't jolly well let guys come in at the age of nine and shoot a gun," Jacobs advises. "They might fall in love with it."[8]

Jacobs is committed to reorienting what the war museum stands for. Just as he refuses to invent a version of history purposely tailored to the needs and interests of the present government, he is equally resistant to the museum being a site where extremists can rally their troops. In the past, he notes, it had served as a place where "the real right-wing Afrikaners come and look at things and so to speak *charge their batteries of hate* again, you know." But for over a dozen years Jacobs has tried to "take the hate out [of the permanent exhibitions] and put the history into it." He has discovered that after chucking out certain bits of the alleged record, some of his constituents have become infuriated.

Jacobs offers one example of such revisionism. "You know, there were stories of ground pieces of glass in bully beef [potted meat] cans, fish hooks in bully beef cans. But if they were specifically put there for the suffering of [Afrikaner] women and children in the concentration camps, you've got to prove to me that 105 years ago people were able to form a conspiracy in New York and Chicago with the meat packers, to determine which cans are going to the British soldiers, and which are going to the camps."

He concludes, "It is impossible. That sort of rubbish I've taken out because nobody's proven a conspiracy theory to me." Colonel Jacobs is adamant that the museum retain its singular focus on the Boer War, and yet he is equally committed to presenting that history in the most inclusive and least biased manner possible.

The Anglo-Boer War is now called the South African War.[9] The "Kaffir Wars" are now labeled the Frontier Wars, or the wars of dispossession, depending upon your perspective. Other historical episodes are being reconsidered as well. For example, a bloody confrontation between a millenarian Christian group and the police outside Queenstown in the Eastern Cape in 1921 resulted in the deaths of 183 Israelites. Called the Bulhoek Massacre, it pitted an Old Testament-inspired battalion of about 500 men against modern-day firepower. On the one side, the weapons of choice were *knobkerries* [clubs], sheep shears, and swords made from car springs and files, with hilts of wood and sheaths fashioned from tin cans. On the other side, 800 men were equipped with rifles, handguns, and even machine guns.[10]

According to an article in *Militaria*, the military history journal of the South African Defence Force, prior to the 1980s, the incident was blamed on religious fanatics. But with the rise of the "popular" or "people's history movement," the Israelites have become political heroes resisting an authoritarian state.[11] Their radicalism is now seen in light of a combination of factors that forced impoverished black Africans from the land: drought, animal diseases, and the 1913 Land Act.[12]

Of particular interest is the fact that the police seized many of the sacred artifacts that belonged to the Israelites, including their Ark of the Covenant, which "found its way" to the Albany Museum in Grahamstown, under circumstances "unknown."[13] In 1995, church elders pressured the museum for its return; within months, it had been deaccessioned and turned over to the descendants of the 1921 massacre. They then agreed to allow the museum

to repossess the oilcloth scroll from its consecrated box, which contains the ten commandants written in isiXhosa, for conservation purposes. In the future, the group may commission a replica to use for regular worship.[14]

And in 2003, during the annual Grahamstown Arts Festival, the Albany Museum sponsored a historical walkabout of the town, whereas a young resident of the local township led an alternative tour, "Through Makana's eyes," presenting an African perspective on pivotal local events. Makana, considered to be a prophet, a diviner, a counselor to chiefs and "the Black Christ," led a force of 10,000 Xhosa warriors against 350 British soldiers in 1819. Legend has it that Makana told his men that the British bullets would turn to water when they struck, and that they would be protected by the ancestors. In the end, the Xhosa were badly defeated.

Since 1994, the Xhosa have turned this rout into a source of pride, celebrating the bravery of resisting the British invaders. Throughout the tour, Sivento Ntleki repeatedly remarked, "The [written] texts say [such and such], but what I can tell you is that the oral knowledge says [such and such instead]." His version of events, based upon conferring with the elders of his tribe, contradicts what recorded accounts and museums have to say. Ntleki disputes the claim that Makana announced the prophecy regarding the bullets, for example. And Makanaskop, the ridge from where the attack was launched, has long been identified at one location, but the Xhosa now insist it must have been elsewhere. Their point of view is incorporated into a battle memorial dedicated in 2001.

While these adjustments are important and overdue, a related type of revisionism has emerged in postapartheid South Africa. This represents a more comprehensive form of makeover, transforming sites of state terrorism, or bastions of extremely myopic, official ideology, into places of reinterpretation, reconciliation, and multiculturalism.

HEALING PAST WOUNDS

Several sites in Grahamstown have been radically transformed. The nineteenth-century battlefield where the British and Xhosa once fought one another later became a sports field built for Africans, and a corner of it now holds the memorial, which is intended to be a site of reconciliation between the parties. The site of the military fort became a mental hospital, and in the township, what was previously the headquarters of the South African security forces is now a community art center, the Egazini Outreach Project. *Makana remembered*, an exhibit of prints retelling the story of the Xhosa leader and reinterpreting the local history, was mounted there in 2000.

Analogous projects have proliferated throughout the country. The former Bourke's Luck Military Base once trained police dogs to sniff out dissidents. In the future, students will prepare for careers in tourism and related hospitality industries there. And in 2001, traditional healers gathered at Vlakplaas, near Pretoria. It was once home to a brutal South African government death squad, formerly a place of torture and death. Artist Jo Ratcliffe captured the banal

ordinariness of the place in a series of photos, *Vlakplaas: 2 July 1999 (drive-by shooting)*, revealing a mundane surface that disguised the cruelties that had taken place within. The aim of the healers was to cleanse the site of the horrors committed in the name of "state security" and to refresh the land through prayer, song, and dance. Their ultimate goal is to transform it into a national center for reconciliation and healing, along with a government-run museum highlighting political violence.[15]

In Durban, an important site transformation was set into motion in 1991, when a man sent a letter to the mayor urging him to preserve a building that had been central to the administration of "native affairs" in years past. The "Durban System" of racial segregation that originated there became the model for apartheid's separation of the races throughout the country. The man wrote, "I have been to America and I visited Alice [*sic*] Island in New York. This is where immigrants were 'processed.' My earnest wishes [*sic*] for KwaMuhle to be preserved the way the buildings in Alice Island have been."[16]

KwaMuhle is isiZulu for "the place of the Good-One," named after a Zulu prince, uMuhle, who worked with the first manager of Native Administration in Durban. It became the name of the head office of that government division, which was the nerve center for anything having to do with the local black African population: matters of housing and health, as well as the management of government-controlled beer halls, whose revenues subsidized the department. Of critical importance, KwaMuhle was where Africans sought the precious *dompas* [identification book carried by nonwhites] that entitled them to work within the city. "Simply put," the formal proposal to convert the place into a museum argued, "Kwa Muhle was the pulse of urban life in Durban."[17]

The process of preserving and reoccupying the building began before the end of apartheid; it had been empty, and plans were going forward to turn it into a dance hall. The explicit aim of the museum was to counterbalance the Eurocentric perspective that dominated Durban's existing exhibitions and to foster racial reconciliation. Today it is a museum that focuses on the urban African experience and features a reconstruction of a beer hall and a living compound for black men, and a diorama depicting the Cato Manor 1959 Beer Hall Riot. This consists of mannequins of three enraged African women, representing protesters during an incident that challenged the government's monopoly; brewing beer has traditionally been a source of income for African women. Blown-up copies of newspaper reportage at the time from the *Natal mercury* and *Ilanga lase Natal* make up the background, re-creating a noteworthy instance of popular resistance to official policy. When black Africans pass through KwaMuhle's doors today, they do so as fully enfranchised citizens.

Parallel Universes

Seal Island lies in Cape Town's Table Bay. It was a supply depot for early European sailors and settlers, and it has been a strategic part of the defense of

the city. In the runup to World War II it became a military installation guarding against the incursion of German U-boats, for instance.

But the natural beauty and advantageous location of Seal Island belie the miseries of a succession of groups of people detained there. It has accommodated, at various junctures, a leper colony, an insane asylum, a hospital, and a prison.

In other words, it has long served as a dumping ground for whomever mainstream society has deemed objectionable, either because of the way they looked, thought, or acted, or who were considered dangerous, contagious—or, simply Other. Since the 1600s, whichever political regime held sway in the region used the island to detain its enemies, in most instances people who were already members of oppressed and disenfranchised groups. Among those expelled there have been slaves from Sumatra and Java who disobeyed the Dutch; Xhosa chiefs (including Makana) who opposed the British;[18] and nonwhites who seriously challenged or dissented from the apartheid government. It was even the site of an interracial, same-sex affair between a Khoi and a Dutch inmate. Both men were executed, an episode that has been immortalized in the film *Proteus* (2004, Jack Lewis, director).

Located merely a few kilometers from Cape Town, this was a place of exile positioned tantalizingly close to the bustling city just across the bay. According to one historical account of the place, "For the most part the Island protected colonists from having a guilty conscience."[19] Nelson Mandela spent 18 of the 27 years of his political imprisonment here, and the roster of names of other major figures from the contemporary liberation movement includes Sobukwe, Sisulu, and Mbeki.[20] This was a key outpost where the apartheid establishment defended itself from what it perceived to be the *swart gevaar* [the black threat].

In 1997 a Khoisan chief was unsuccessful in his bid to file an indigenous land claim for this area, and many eyed it as the final resting spot for Sarah Bartmann, after the return of her remains from France. Seal Island is known throughout the world, but generally by another name—Robben Island.

Hart Island, its American counterpart cordon sanitaire, lies between The Bronx and Great Neck in Long Island Sound. Since the Civil War, it has also been a place where people deemed to be undesirable, for whatever reasons, have been segregated from the general population. That has included Confederate prisoners of war, victims of yellow fever, and delinquents.

At various times the place has accommodated a women's hospital, a boys' workhouse, a tubercularium, and alcohol and drug rehab centers. A NIKE missile installation once stood there as well. But the main activity for years has been the burial of tens of thousands of unidentified, unclaimed, or simply impoverished bodies. Hart Island is a vast Potter's Field.

Whereas Robben Island is presently a museum, national monument, and World Heritage Site, virtually no one is aware of Hart Island regionally, let alone globally. As is the case with District Six and American neighborhoods similarly destroyed by urban renewal, South Africa and the United States boast sites with comparable histories of banishment, and yet their public

recognition and significance could hardly be more dissimilar. So the challenge once again is to explain how one place captures the public's imagination, whereas the other fails to register in its consciousness at all.

BEING THERE

The last political prisoners were released from Robben Island in 1991. The Department of Correctional Services subsequently transferred it to the Department of Arts, Culture, Science and Technology in 1997. The keys were handed over to ex-prisoners, literally putting the inmates in charge of the establishment. This turned the buildings and grounds of Robben Island into an open-air museum, with an emphasis upon the experiential.[21]

From the outset, this site was deliberately designed to be different from other institutions. Remember that when Nelson Mandela inaugurated Robben Island as a museum, he spoke about how unrepresentative such South African places had been in the past, labeling them "alien spaces" where people had been narrowly stereotyped, and history had been edited with a heavy hand. It becomes clear to anyone who disembarks from the half-hour ferry ride onto Robben Island that this is not a museum in the traditional sense.

Instead of unnamed curatorial authority shaping the visitor's experience, for example, everyone who comes here is steered through the buildings and grounds by ex-prisoners. These former inmates explain the daily routine, everything from the mundane (work, diet, sleeping arrangements), to some particularly onerous restrictions (the censoring of mail and the severe regulation of visitors), to the unrelenting cruelty and dangers. They relate not only the ways in which sadistic warders pitted groups of prisoners against one another, but also how prisoners united to educate one another and to sketch out future plans for a nonracial South Africa. A video that is screened on the ferry ride calls the prison "a nursery for the new democracy."

Enlarged photographs and printed labels placed in strategic locations convey information, to be sure. But the didactic element has been addressed in the most complete manner in the Nelson Mandela Gateway to Robben Island that opened in 2001, the building from which visitors board the ferries to depart from the mainland. Here the visitor encounters all manner of items, from prisoner garb and dinnerware, to posters from the liberation movement, and multimedia presentations drawn from an extensive archive of material. It is as high-tech and slick as any contemporary museum. On the island itself, the guides enlarge the encounter, adding the crucial dimension of bona fide memories and feelings.

These are the men who *lived* it, and these are the men who can directly answer questions a visitor might have about any aspect of life there. It is one thing to be told that the sun reflecting off the walls of the rock lime quarries where inmates were forced to work was so intense that many of them suffered permanent eye damage. It is quite another to be taken to these mines, briefly subjected to these conditions one's self, and receive a first-person account of what it was like to work there, day after numbing day.

But while the experiential packs quite a punch—it is dynamic, participatory, and potentially quite memorable—it also has a significant built-in limitation: this type of presentation is only as good or bad, effective or unsuccessful, as the performance of a particular ex-prisoner on a particular day. The content of the "text" potentially changes with every encounter; the style of the presenter dictates how it is delivered, as well as how it is taken in.

In a basic respect, the guides "are the primary 'objects' on display."[22] But precisely because these "exhibits" are not inert, visitors receive broadly varied experiences. The writers of one account allege that a 1999 tour was "sanitized," unlike another two years prior; reconciliation had become the major trope, and guides eliminated tough details so as not to disturb the visitors.[23] Another analyst also contrasts two visits, made in 1997 and 2000, and concludes that the dehumanizing aspects of imprisonment had been culled, and that the museum's administrators had apparently been responsive to criticism that the ANC and political "stars" such as Mandela were overly emphasized, to the exclusion of other parties.[24]

And one additional observer reaches a similar conclusion. She is impressed by the guide "integrating a personal element into his narrative of the prison's history and conditions in a moving and understated way." She further notes, "Indeed, one of the most moving experiences of the tour was to hear the former political prisoner guides speak in such gentle tones, without bitterness, about their hopes for reconciliation . . . The idea, the guide said, is to remember the past yet also move past it."[25]

I, too, have had contrasting experiences on the island, in 2000 and 2003. But my conclusions diverge sharply from these others. The ex-prisoner who conducted the tour I took in 2000 was forthright in his presentation of life on the island. As a South African of Indian ancestry, he made a point of speaking about the multiethnic character of the liberation struggle and about reconciliation. The visit was emotionally moving, informative, and quite frankly unforgettable.

But when I visited again in 2003, the excursion was broken up: a young man directed the bus tour of the island, whereas only the site visit to the prison was led by an ex-prisoner. Both of them were black Africans.

The comments the young man made throughout his portion of the circuit were exceptionally flippant, thereby diminishing the gravity of what had occurred there. As he pointed out a shipwreck, for example, he referred to it as "The Titanic." When we later spotted a herd of grazing springbok, he quipped they "were preparing for the next World Cup" (the Springboks being the South African rugby team). And while passing by some ruins of stone structures, he referred to them as "time shares with sun roofs" that—sorry for the disappointment, folks—"were fully booked through the next month."

After we were handed over to the ex-prisoner, his conduct was ill-suited to the situation as well: aggressive, confrontational, intimidating, and hostile, irrespective of a visitor's race or age. He made it clear that this was *his* prison and he was in complete control of the situation. We were told that as visitors

we had no freedom, and he openly challenged anyone to reclaim their admission fee and come back another time if they did not agree with his style.

Because this took place a short time after the United States initiated the war in Iraq, he singled out Americans for particular humiliation, as he did British visitors because of their country's backing of this military action. At the same time, he neglected to include some features of the tour that I saw the first time I took it, such as pointing out Nelson Mandela's cell, or unrolling the meager mats that prisoners slept upon, to demonstrate the austerity of prison conditions.

The guide's verbally abusive behavior—there is no other way to suitably characterize it—turned many people off, as evidenced by the amount of grumbling by members of the group throughout the tour. And his conduct was even more regrettable because many visitors were taking advantage of a half-price tariff (reduced from R150 to R75) for the first ferry load of the day, a bid to making the site more accessible to a broader range of the community. Contradicting the general pattern, locals and their families outnumbered foreign tourists; many of the attendees were nonwhite, and they looked as if they were poor.[26] For them, this was undoubtedly a significant occasion, a rare opportunity to personally connect with what was once a negative, but ultimately inspiring, facet of their nation's history.

This sort of unconstructive attitude undermines rather than facilitates reconciliation or education. It kept old wounds open, perhaps even created new ones, rather than helped heal them.

The mandate of the Robben Island Museum is in part to create a living institution that recounts a history that was long hidden from the general public. According to Deputy Director Denmark Tungwana, "Robben Island is all about reconciliation, it is about bringing nationalities together. . . . As a people we can look at things and say 'Let bygones be bygones.' We cannot forget about the past but we can take lessons from that and go forward." But the same license that allows the guides to potentially make this a positively memorable experience also grants them the freedom to abuse their power and weaken the message of empathetic understanding that is potentially inherent in the encounter.

No Society of Saints

Sometimes the prominence accorded "being there" can border on the bizarre. At one point administrators proposed renting out cells overnight for the "prison experience."[27] And among the higher-profile activities that have taken root here are annual group weddings held in a chapel built in 1841, and an elaborately staged opera. In 2004, 24 couples became the fifth group to solemnize their vows on Valentine's Day, an event that has attracted local couples and even some from abroad. One excited groom burbled, "We really want to bring love to Robben Island."[28]

And in the gift shop, managed by a former warder (others skipper the ferry boats), you can purchase soft cloth dolls with the likeness of Mandela on them,

complete with a head of crocheted white yarn and sporting different versions of his signature, boldly designed shirts (R280, approximately $37, in mid-2003). Or you can buy a necklace depicting the bars of a prison cell, with the insignia R[obben] I[sland] #5 where Mandela was held (chain not included, for R805, a little more than $100). And nothing quite duplicates the weird feeling you have back on the mainland when you lug your purchases around in a stylish Robben Island bag, bearing its distinctive logo of cell bars morphing into a human figure of liberation, against a splashy bright blue backdrop.

But beyond the glossy packaging, Robben Island has not completely shaken its controversial reputation. Ex-prisoners have clashed with administrators, accusing them of financial mismanagement, corruption, and even fraud. At one point a group locked themselves in their old cells and conducted a hunger strike, demanding the suspension of the director and his deputy. It was an exceptionally compelling form of protest, and extremely embarrassing to the island's administrators.

Various parties have leveled charges of racism regarding personnel matters, highlighting feelings of preferential treatment and inequality at the museum. And there have been rape and sexual harassment allegations lodged against workers, even as a dozen or so employees were disciplined for allegedly viewing Internet porn. Transforming a place so imbued with pain and bigotry into an exemplar of reconciliation is obviously a process fraught with missteps and setbacks.

I sent a long letter of complaint to the Robben Island Museum in 2003, detailing my charges about the guided tour. In fact, I sent it twice. But I received no response either time.

When I confronted Denmark Tungwana about the matter some months later, he responded that the guides are uniformly trained, but "talk within the limits of their own experience." And although he admits that some are very good while others are "slack," by in large he discounts the legitimacy of visitors' complaints: the same guide, he explains, can elicit completely opposite evaluations. Satisfying the public, to Tungwana's mind, is no easy task.[29]

Of everything I have read about the tours at Robben Island, none matches the aptly named "Jaundiced eye" feature in a major Cape Town paper, a year after the public visits were initiated. The writer found the guides to be "unctuous but stupid," and felt that the experience "trivialized" and "mummified" the experiences of those who had been imprisoned there. "[I]t is tatty, tasteless and little more than an employment project for some of the riffraff of Umkhonto weSizwe who are unable to sustain themselves by robbing banks," he boldly declared.[30]

Deputy Director Tungwana brushes aside troubles at Robben Island as being predictable, intrinsic to any work environment: "The same things happen at Pick 'n Pay [supermarket] and ABSA [bank]," he insists. Tungwana normalizes problems as being endemic to human relations; simply because a place is sanctified does not mean that everyone who works there is saintly. "Unless you live in 'cloud cuckoo land,' " he claims, "you will get antagonisms between workers and management in any environment, in any

country, anywhere." Because of its iconic status, Tungwana insists that prob-
lems at Robben Island attract a disproportionate amount of attention. It is a
defensive strategy that absolves him, and other parts of the museum's admin-
istration, from addressing specific charges.

Tungwana also alleges that biased reporting has blown up difficulties
there. He contends that those working in the media are not neutral,
that they are in fact on the prowl for the sensational story, in particular
anything that reflects negatively on the ANC, in order to discredit it. "The
media is not [composed of] people who live on another planet, they live
here," he asserts.

Moreover, some journalists "will have their own agendas, and write for
different reasons, and to prove that any black government cannot produce,
and that they're all the same, and so on. So you will get those Afro-
pessimists." Such claims thereby chalk up alleged deficiencies as the result of
racist interpretation and embittered dismissiveness on the part of whites, and
not as genuine shortcomings.

Under Surveillance

Where do you establish the line between verisimilitude and slick museum
practice in a place such as Robben Island?

In 1998, the museum sponsored *Thirty minutes: Installations by nine
artists*. The concept was simple: allow artists to "reoccupy" the narrow
cubicles in the visitors' block, where prisoners enjoyed infrequent, carefully
regulated meetings with loved ones. Their brief was to design site-specific
artworks that would address the intensity and heartrending quality of these
half-hour encounters.

The artists chose to install their works on the prisoners' side of the glass
partitions. This placed viewers in the actual position of former visitors; they
sat down and looked through to the installations in the spaces opposite. Sue
Williamson, for example, entitled her piece "Is anybody . . .?" A strikingly
austere setup, it featured a television monitor that captured visitors as they
approached the space, confronting them with their own faces and dramatiz-
ing the idea of being under continuous official surveillance.[31] Sound was
transmitted through the old intercom system—at first a faint beat, like a
heart—growing more incessant and louder the longer one spent there. Once
again, the emphasis was on the experiential.

When the artists were first shown the building, Williamson was particu-
larly stirred by the old acoustic tiles lining the booths, etched with the
accumulated telephone numbers, drawings, and miscellaneous scratchings
left behind by inmates over the years. For her, these were direct, tangible
marks of the real-life moments passed there.

Williamson was stunned to receive a call one day telling her that the tiles
were being ripped down and the walls repainted. When she checked further
she was told by someone at the former prison that the tiles were old and dirty,
and that the policy was to refurbish the spaces on a revolving cycle.

Williamson called the director to protest, "This is a museum." But she was met with the unsympathetic response, "We have got to keep it looking nice."

She arranged a meeting with him on-site, and sure enough, they discovered piles of wet tiles strewn behind the building. She put as many of them back in place the best she could, but felt dismayed that "[t]here was no kind of feeling that the actual little residue of things that people left behind was of interest."

As the museum has matured, a respect for authentic objects, and for the ordinary prisoner, has deepened. *Cell stories*, inaugurated in 1999, draws upon a two-year collection of the reminiscences and belongings of former inmates. Co-curators Ashwell Adriaan and Roger Meintjies have staged it in the A-section, formally used as an isolation unit for newly arrived inmates. In the eloquent language of bureaucratize, it was a place for "attitude assessment."[32]

A poster announcing the project and soliciting public input referenced Nelson Mandela, but in a pointedly atypical manner: "We've all heard his story. We'd like to hear yours," it read.[33] It thereby resists further encouraging the cult of personality that has developed around the former president, and it incorporates a broader range of individuals and political perspectives than is standard whenever the liberation movement is presented in a public venue.

Cell stories consists of pictures of ex-prisoners, their dates of incarceration, and a single memento or possession, the significance of which the person describes. The installation exploits the old intercom system to transmit their stories in some instances, or written texts in others. In one case a trio sings a collection of freedom songs; the sound comes from three separate cells, "singing in harmony," as would be the situation there in everyday life. It has the advantage of communicating straightforwardly to its audience, relatively unmediated by an authoritarian curatorial voice.

JUSTICE PREVAILS

The title of this chapter, "The History of Our Future,"[34] is the motto of Constitution Hill, and the name of an exhibit on the ramparts there. Standing on the ramparts and looking east, you see the high-rise buildings of flats that make up the Johannesburg neighborhood of Hillbrow, now a teeming slum and home to thousands of immigrants from throughout Africa, seeking asylum or their dreams of fortune.[35] Westward the city evolves from the business, educational, and cultural institutions of Braamfontein to working-class and then more affluent suburbs. To the south lie the mine dumps, the ubiquitous heaps of pale yellow residue from the extraction of gold, upon which the wealth of Johannesburg was built. And the view northward takes in prosperous, predominantly white suburbs, whose residents have benefited from the myriad of industries that have followed in the wake of that initial mineral bonanza.

This place holds the dubious distinction of being where Mahatma Gandhi and Nelson Mandela, two of the prime movers and principal symbols of

South African liberation movements—and inspiration for the struggle against oppression worldwide, for that matter—were incarcerated at different times. Gandhi was imprisoned as a leader of the passive resistance movement (*satya-graha*) against the pass law for Asians, and this was the first of his jail experiences. Mandela, of course, was held as a member of the ANC.

Afrikaner leader Paul Kruger erected the prison at the beginning of the Anglo-Boer War in anticipation of a British raid to take over the gold mines of the Witwatersrand. But in a reversal of political fortunes, the British captured the position and then jailed Boer soldiers there in the early twentieth century. Later on, the Boere used it, in the main, to confine blacks. Until it was closed in 1983, The Fort held conventional criminals, as well as political detainees awaiting trial, whatever their race.

If a black man went missing during the nightmarish years of apartheid, friends and family would search for him at hospitals and in the morgue, and they would most certainly check at "Number Four," also known as the Native Prison or Ekhulukhuthu ["the deep hole" or "isolation cell"].[36] Robert Sobukwe, Chief Albert Luthuli, the Treason trialists of 1956, participants in the 1960 Sharpeville anti-pass protests, and students from the Soweto uprising in 1976 were all held there.[37] More generally, it was the place where pass offenders were detained, deemed guilty on the basis of their race of not "belonging" in the city.

One man reminisced, "Number Four has always been a part of black life in Johannesburg. As children, many of us knew a brother, an uncle or even a father who had been inside. . . . When a person came out of Number Four, their family would bathe them in water mixed with the crushed leaves of an aloe plant." He concludes, "Thinking about it today, going to Number Four was like an urban rite of passage for the thousands of young, black men growing up in a sick society."[38]

Convicted African men remained at the Native Prison, and a Women's Gaol held both black and white women, but in separate divisions. In its time, it locked away serial poisoner Daisy de Melker (notorious for murdering two husbands and a son), as well as political activists such as Winnie Madikizela-Mandela, Albertina Sisulu, Helen Joseph, and Ruth First.[39]

The Fort fell derelict for nearly two decades; one portion of it became the site of a gay pride dance in the 1990s, after the annual parade through the streets. Savor the quirk of fate: this place once held people who had violated the so-called immorality laws that forbade sex across the legally mandated racial categories, and between men. But Constitution Hill is an ambitious project that is, in the words of Judge Albie Sachs, "transforming a place of hell, suffering and resistance into a precinct of hope."[40]

Some of the buildings have been taken apart; others radically refashioned. The old holding gaol or awaiting trial block has been mostly disassembled and the bricks have become the walls for South Africa's first Constitutional Court, housing the highest tribunal in the land.[41] The initial case it heard was in 1995. It forbade capital punishment, a decision that was heavily informed by the excessive violations of human rights during South Africa's past history. And this

is the body that ruled on behalf of the indigenous people of the Richtersfeld region in 2003, recognizing the discrimination that they had experienced in the past and honoring their claim to diamond-rich land (chapter 3).

Nelson Mandela's papers will be housed in a former cell. The courtyard that was once an exercise ground for white prisoners has been named for Joe Slovo, a South African Communist Party leader. And a woman's healing center and the Commission on Gender Equality has occupied the Women's Gaol; its chairperson was once imprisoned there. Exhibitions addressing human rights and other social and historical issues will occupy some of the areas that have been retained. For example, in 2004 *The f word*, "f" standing for forgiveness, featured the testimonies of people from South Africa, Romania, Israel, Palestine, Northern Ireland, and England on the subject of reconciliation. Other sections, like Number Four, will remain as they are, comprising an architecture of personal degradation and confinement evocatively reminiscent of other places of infamy such as Auschwitz.

Constitution Hill is a pivotal place where South African democracy has put down its roots. As is the case with both Robben Island and the District Six Museum, this place expands the definition of a museum in significant ways. In the inaugural exhibitions in 2002, coinciding with the World Summit on Sustainable Development, one interior space in the former prison became the backdrop for portraits of former female inmates, imprinted upon translucent material (the same technique is used to great effect at the District Six Museum). The images were suspended from the ceilings, complemented by the recorded whispered testimony of former inmates, and presented along with some personal belongings. They became a haunting presence, reinhabiting these spaces in both a bittersweet and triumphant manner.

Didactic displays offer historical insights, in situ. And part of the court building itself is an enormous gallery. A major collection of South African art, significant portions of which incorporate a human rights theme, graces the most prominent public corridor of the building. Consisting of approximately 200 pieces, it was assembled using a shoestring budget, through donations of work, and with money raised from foreign sources; if the judges and curators had appealed to locals for funds, those same people might be litigants some day, a potential conflict of interests.

South African artists have also designed architectural accents ranging from door panels to drinking fountains, incorporating many indigenous themes. The expansive lobby is propped up by columns that tilt on an angle from one another, for example. They are meant to evoke the traditional African custom of *kgotla* [community justice] determined in a public courtyard or forum under a tree, a concept heightened by the way light is filtered through the space. And the Bill of Rights is engraved upon the atrium windows. The two words that are repeatedly invoked in describing the building are "accessibility" and "transparency." According to Judge Sachs, this zeal for openness has generated an unforeseen challenge: "There is too much light. The very transparency of the building—the inside/outside effect—which is marvelous for the ambiance, is deadly for artwork."[42]

If the public responds as the designers hope it will, Constitutional Hill will do a great deal to convert the horrors once contained within these walls into the basis for healing. Clive van den Berg, who worked on both the Northern Cape Legislature buildings and Constitution Hill, reflected on those experiences by saying that they had "made my notion of making, of materializing [the fact] that democracy was working, come true."

CULTURE AND MAMMON

Competing parties and objectives vie for shaping what Constitution Hill becomes, and what it signifies. For urban visionaries, Constitution Hill is seen as the anchor of a "cultural arc" that will stretch across a wide span of central Johannesburg, symbolically linking schools, museums, theaters, and music venues. Shopping, residential, and hotel space will eventually fill the remainder of the expansive area. Moreover, city planners are hoping it will spur the revitalization of some neighboring, down-at-the-heels precincts that are currently disconnected from one another in the public's mind.

For a cadre of artists, historians, and other cultural workers, and the former internees they have consulted for information and guidance, the revamped Constitution Hill provides the opportunity to inform the broad community about how this prison once operated. For Clive van den Berg, how to represent their experiences posed significant questions. How do you animate places of confinement to recapture what real people once endured there, without exploiting them once again?

He recalls, "We had an American consultant say, 'Oh, just toss a whole bunch of bodies in there [the cells].' That would have been the corniest thing in the world, in my opinion." Underlying van den Berg's negative response was the weight of South Africa's past experiences in symbolizing native peoples, as demonstrated by the controversy over the Bushman diorama in Cape Town, for instance.

Van den Berg feels that museum practices used in the past and representational strategies in various media that contributed to the subjugation, marginalization, and negative stereotyping of black Africans had seriously shrunk his options: "In my opinion, it's insulting; you can't cast a black body. If I did that, I'd be lynched! I just wouldn't do it." He continues, "I would not think that I am the right guy to do it. If I were a black artist doing this project, maybe; though none of the black artists working with me are going to, either."

Lastly, marketers perceive an opportunity to trade on the site's past notoriety to make a buck. According to an account of a special evening tour, what was once evil is now glamorous: "In a place that used to resound with prisoner songs and the lash of the whip," it reports, "the chatter and laughter of visitors now fills the air."[43] In my own experience this tour evokes feelings of intrigue, privilege, and trespass. While the article advises against wearing high heels—that could make coming down from the ramparts in the dark after a glass or two of champagne a little awkward—a Constitution Hill

spokesperson sums up the experience, "The prisons are more eerie [at night] and everyone half hopes they will see the ghost that is said to walk number four prison. Visitors find the architecture remarkable."[44]

That restless spirit supposedly belongs to serial murderer Daisy de Melker, although the name of the author of the above-cited news story remains a mystery. One cannot help but wonder if its trivializing style would have been tempered if s/he had had to sign their writing.

CELL STORIES

Working out an approach to constructing displays in the former cell areas of The Fort entailed, in essence, constructing a new grammar of expression. The planning team eventually developed three main themes: cell geography (how inmate status determined one's location and comfort level within the space); power and punishment; and resistance and resilience. But having rejected the idea of placing models of bodies within these surroundings, the problem facing the team was how to *suggest* human habitation, misery, and mortification.

As Clive van den Berg describes his role, "Mainly my job was to take all the historical research the team had conducted and to materialize it. They [the inmates] range[d] from mass murderers—at one end of a kind of moral scale—to political prisoners at the other end, with a big slide in between." After much deliberation, van den Berg "was not crazy about" giving an equal voice to the murderer and the so-called freedom fighter.

However, as a man quoted earlier noted, young black men during the apartheid years were "growing up in a sick society." That made, and still makes, it difficult to draw absolute ethical lines. And those boundaries remain tricky to gauge in retrospect. Van den Berg reflects that it was up to him "to take those experiences and to find ways in which they can be materialized, with some discretion."

Through sensitively listening to the people who actually experienced life in this setting, the exhibition designers were able to honor a unique form of creative expression known as blanket sculpture. In its time, and in a milieu virtually devoid of resources, this pursuit provided an ingenious outlet for the inmates, and a way for them to assert a degree of freedom and individuality that was otherwise fundamentally absent.

Ex-prisoners have re-created impressive and oddly compelling sculptures of a sofa and a military tank within the old cell blocks, for example. Written text explains that they honed their skills through weekly competitions, encouraged by the prison administration. Furthermore, various images are fleetingly projected onto the walls that disarm the visitor; one cannot predict when and where they will appear, or automatically understand what they mean, for that matter. And the hulking presence of an original flogging frame mutely hints at some of the horrors experienced within these walls.

Van den Berg is neither wedded to the notion that these exhibits are necessarily definitive, nor is he convinced that they should be permanent. "We're

at a time in our democracy where all these languages are provisional," he argues. And in a statement that sounds surprising, coming as it does from someone who invested quite a lot of effort and creative thought into engineering these displays, he concludes, "This notion that we can even be designing modern representations of democracy now, I think it's vanity."

One thing *is* certain, at least for the time being. By placing an emphasis upon liberation movements, the directors of this civic site cum memorial cum museum elide the past differences between groups to a degree unimaginable in earlier times. In a multimedia show that orients visitors to what they will see on a tour of this compound, the Boer General Jan Christiaan de Wet is considered the leader of a struggle against unjust domination by the British, just as leaders of the African National Congress or the Pan African Congress are against the Boere who became ascendant later in the twentieth century.

In other words, Constitution Hill has been designed so that the rainbow ecumenically covers a broad range of groups of freedom fighters. The test will be whether or not that grammar of expression remains the lingua franca of this place.

High Upon Another Hill

The most sacred date for Afrikaners is December 16, known as the Day of the Covenant or the Day of the Vow. It marks the 1838 victory by a band of nearly 500 Voortrekkers over thousands of their Zulu enemies.[45] This decisive confrontation was written into twentieth-century history textbooks as the Battle of Blood River ("the river flowed with the blood of the natives"), and it reinvigorated the trekkers on their march across South Africa's interior. A week earlier these men had pledged to God that they would forever consecrate the day of battle if they were victorious. And their descendants did just that, in a very imposing manner.

One hundred years later, a symbolic reenactment of the Great Trek by ox wagon across the country culminated in a ceremony on December 16, 1938, with an estimated 200,000 celebrants in attendance. The cornerstone was laid that day on a hilltop outside Pretoria for an immense monument and museum, built to last "a thousand years and more," in the words of its architect, Dr. Gerard Moerdijk.[46] It eventually opened on December 16, 1949, at a key political moment, coinciding with the ascendance of the National Party's control of the government.

True believers return to the monument annually on that date for a solemn service to reaffirm the commitment to their tribe, and to resanctify the blessed relationship between Afrikanerdom and God. Seating is provided for 2,500 people, but that usually does not fully accommodate the crowds. At the climax of the ritual, after the re-reading of the covenant, people jostle one another for prime positions to watch the sun stream down from an aperture punched through the peak of the building's domed roof. It shines onto a granite cenotaph (from the Greek, *kenos* [empty] and *taphos* [grave]), the symbolic tomb of the martyred leader Piet Retief and his followers.

As noontime nears, the sun inexorably ascends the stairs leading up to the unoccupied crypt. Precisely on the hour, as if by divine plan, it illuminates an inscription borrowed from "Die Stem": *Ons vir jou Suid Afrika*, ["We for thee, South Africa"]. (A flashing beacon on top of the structure sends out this slogan nightly in Morse Code as well.)

Devotees hold babies aloft in the sunbeams to bless their young lives. To this day, it is an astonishing and emotionally charged scene.

The monument continues to fill to capacity on December 16, a decade after the downfall of the Afrikaner regime. And yes, the old Transvaal and Free State anthems are still sung during the ceremony. But these days December 16 appears on the official calendar as the Day of Reconciliation. (Earlier in the twentieth century, it was known as Dingane's Day, named after the Zulu leader who faced off the Voortrekkers.)[47] Now a small number of young people in the audience sport trendy haircuts, designer label clothes— even earrings can be spotted on a few young men, or purple hair on a woman. "We have thrown away our *'kappies'* [traditional bonnets] a long time ago," one hipster remarked in 2002.[48]

In 2003, the minister leading the service was positioned in front of the epic marble frieze that cuts across the monument's interior so that to his one side was the image of Zulu warriors beating Piet Retief's men to death, and to the other, Retief being forced to watch the slaughter, his hands and legs bound. A few black people sat in the first row during the service, directly facing the reverend. The women were flamboyantly attired, their heads and bodies swathed in vibrantly patterned African fabric, and sporting beaded earrings and kente-cloth chokers.

In startling contrast, and seated immediately behind them, was a scattering of people decked out in customary Voortrekker garb: for the women, *kappies* and long-sleeved, high-collared frocks with accompanying neckerchiefs and aprons, while for the men, waistcoats, flap breeches, and wide-brimmed hats (one wore a neck scarf bearing the caption "1838–1988 Groot Trek 150"). At one of the collection points for donations after the service, Afrikaners dropped their rands into a *potjie* [three-legged metal cooking pot commonly used for stews].

Change is slowly permeating the culture of the monument, a place where only a few years ago right-wing rallies took place, blacks would not be expected or welcomed, and beliefs, garb, personal appearance, and behavior would all heavily favor the traditional.[49]

White Elephant or Pink Palace?

Many people compare the Voortrekker Monument to a gigantic, vintage radio; others detect a resemblance to fascist architecture. It is reportedly the largest monument in Africa, after the pyramids.[50] But one need not view it by oneself to form an impression of the place. The ways that others have described the site are suitably vivid.

It is a "monolith," a "mausoleum-like edifice, a "shrine", and" "[o]nce an inspirational ode to apartheid."[51]The building is "an Afrikaner holy

sepulchre,"[52] a "massive monolith,"[53] "once [an] Afrikaans holy-of-holies,"[54] "a temple to apartheid."[55] It "remains a place of pilgrimage."[56]

"It looks like a pop-up toaster, a precisely moulded *jelly* [gelatin], a 1940s wireless, a salt cellar and even, according to one tourist, a crematorium." It is "the country's most visible symbol of apartheid," "a big lie" about the past, of "chauvinistic height."[57] The monument is a "monstrosity," "an empty shell—all smoke and mirrors,"[58] imposing on the outside perhaps, but empty within, sort of like the revelation at the end of *The Wizard of Oz.* "It is a massive monument to conquest," "The official version of the old order."[59]

One observer reads the design of the Voortrekker Monument as addressing two distinct issues. The first is a response to the stateliness of the Union Buildings in Pretoria, designed by the renowned Sir Herbert Baker, one of the foremost architects of colonial style throughout the British Empire, and completed in 1913.[60] The other is the message encoded throughout the structure of Europeans triumphing over natives. This is evident from the massive historical bas-relief wall frieze carved in Italian marble inside the Hall of Heroes section of the monument—reputedly the largest in the world—to the *laager* (a circular, self-protective wagon formation; also refers to a self-imposed, narrow *laager* mentality) of 64 wagons embossed upon the terrazzo wall surrounding the building.[61] It "serves as a symbolic document showing the Afrikaner's proprietary right to South Africa."[62]

With the demise of apartheid, the Voortrekker Monument obviously endures in many minds as a reviled relic of the past. There were rumors in 1994 that the monument would be demolished, and the bricks either thrown away or used to build housing for the poor. Another alternative, having the ring of an urban legend to it, was that the building might be turned into a public toilet for black use only.[63] An eleventh hour, sleight-of-hand transfer helped prevent any of these schemes from being carried out: in 1994, in the waning days of its official power, the National Party government shifted control of the buildings and grounds to an independent Afrikaner cultural organization, guaranteeing it would not fall directly into the hands of the ANC. (Although the monument had been built with taxpayer funds, and it receives government funds to this day, it is not under the control of the Department of Arts and Culture.)

Yet another suggestion was that it should be painted pink and turned into a gay nightclub where rave parties could be held. That proposal, launched in jest by journalist Barry Ronge, drew an avalanche of criticism: he was called "a colonial Anglo-racist" by an enraged letter-to- the-editor writer,[64] and an Afrikaner group filed a formal protest with the Broadcasting Complaints Commission claiming that he had demeaned them as "backward and narrow minded" [*agterlik en bekrompe*] and their beliefs as "laughable" [*belaglik*] (the commission rejected any claims of fanning race hatred, however).[65]

According to General (Retired) Gert Opperman, CEO of the Voortrekker Monument and Museum, "Now he said it tongue-in-cheek. [But] I think those remarks infuriated people tremendously, and he in fact in the process played into the hands of the more conservative elements [of the Afrikaner

community]." Ronge's quip, and others, crystallized many things: the fears held by Afrikaners of potentially losing a sacred space; the contempt that people who were newly empowered projected onto this conspicuous symbol of their despised enemy; and the sense of relief (and delight) that some non-Afrikaner whites felt over the downfall of a group with whom they shared little more than skin color.

Those currently in charge of the monument are faced with turning an edifice that was once so tightly entwined with a specific brand of politics into a site celebrating a particular cultural history. Its mandate now is to celebrate the overall accomplishments of the Afrikaner, and to publicly disentangle the identity of the group from a narrow focus upon the apartheid system that its members once sustained.

Fresh Perspectives

The monument itself may not have been dismantled. But its ideological foundations have been profoundly deconstructed. Academics have succeeded where demolition crews have been held at bay. And that has prompted the more welcoming atmosphere at the monument today.

The "new historians" of the American West have thoroughly reconsidered the standard depictions of the exodus of people of European stock across the continent, and have bared the previously under-explored themes of the exploitation of women and ethnic minorities; the role of capitalist greed in fueling the fervor to expand into new territory; the callous disregard for ecological matters; and the belief that this was land free for the taking, without prior claims by other people.[66] Historians of Southern Africa have accomplished something similar in their own studies.

The foundation myth of Afrikaner nationhood is the Great Trek, a saga of taking leave from the Cape Colony during the mid-1830s in order to escape the oppressive rule of the British. This decision demonstrated the Afrikaners' wish to pursue their lifestyle freely, including the right to keep slaves. This quest for self-determination and its visual portrayal—pioneer families transporting their households overland by covered wagon, indomitably struggling (and triumphing) against both nature and menacing savages, with God securely on their side—have their analogue in the familiar depictions of the resettling of the western United States. In the words, once again, of the Voortrekker Mounument's architect, "The Voortrekkers were the first white people to succeed in taming the interior of Africa. . . . It is nonsensical to suppose that the interior of Southern Africa belonged to the Bantu and that the white man took it away from him."[67]

And yet the Great Trek was not so great after all, it turns out, but a bunch of smaller migrations that Afrikaner mythmakers retrospectively amalgamated to create the illusion of a grand mission, supposedly mounted intentionally to establish a Voortrekker state. And Europeans did not hold a monopoly on journeying en masse: blacks were also on the move during the same period, fleeing colonial expansion, other warring tribes, or marauding slavers. But

these facts have been relatively overlooked. The so-called *mfecane*—large-scale internal migration stimulated by intertribal fighting that had cleared the midsection of the country of much of its population around the time the Voortrekkers arrived, especially due to Shaka's territorial wars—is now seen as a simultaneous "great trek."

Moreover, the Voortrekkers may have felt the push of increasingly intolerable living conditions in the Western Cape, but they were pulled by what they envisioned as profitable economic opportunities as well. These would-be settlers can be as accurately described as land speculators as cultural purists. Furthermore, the notion of Afrikaner nationalism developed only *after* the events of the mid-nineteenth century: the trauma of losing the Anglo-Boer War to the British compelled them to construct a sense of collective identity to help counteract their sense of dispossession and political weakness, until the National Party victory of 1948 propelled them into power. The ideological underpinnings of Afrikaner nationalism have been fundamentally ground down, and changing social conditions have disrupted the sense of philosophical and cultural unanimity that Afrikaners once felt.[68]

The monument gives form to the Afrikaner presence, and Afrikaner might, in South Africa. But its genesis thus reflects a particular cultural moment, rather than some transcendent, enduring existence. In the same manner that various Khoisan factions have amplified their collective identities and promoted their distinctive historical legacies for the benefit of enhancing group solidarity, building the monument was the culmination of Afrikaner dreams, desires and fears, setbacks and victories, political fits and starts.

Travel across South Africa and you will find prominent stone markers commemorating that 1938 symbolic trek across the country, oftentimes complemented with impressions made from the wheels of one of the ox wagons and preserved in cement. And in many communities, as well, Voortrekker Street remains a prominent thoroughfare. The centenary celebration demonstrated an acute example of "ethnic mobilization," "mass cultural theater," and a supreme expression of Benedict Anderson's well-known concept of an "imagined community," whereby people share a sense of "deep, horizontal comradeship."[69]

The trek generated "near euphoria" across the country, and the masses of people who gathered outside Pretoria for the December 16 laying of the cornerstone exhibited "something akin to mass hysteria."[70] Because the project was so revered from the beginning, the monument was constructed by South Africa's "first (and last) whites-only building force."[71]

However, a reenactment of the Great Trek on the 150th anniversary in 1988 exposed significant rifts among Afrikaners: different groups set out from the Cape, each espousing a distinct political viewpoint. The ethnic unity and cross-class alliances that were once so evident had disintegrated over the preceding half century; the factions seriously clashed over what it meant to be an Afrikaner, and who "owned" the monument.[72] A 1977 article appearing in *National Geographic* that proclaimed that "[m]ore than three hundred years of history have laminated [the Afrikaner] soul to soil" may have been poetic, but it was no longer descriptive of an increasingly diversifying population.[73]

Out of the Trenches

General Gert Opperman took control of a highly contested space when he became CEO at the Voortrekker Monument in 2000. As Opperman explains by similar language in nearly every interview he grants, "My approach is, let us get out of the trenches of cultural isolation. Let us be hospitable and invite people to come and get to know us so we can explain to them exactly what, where we come from." To that end, Opperman has initiated many changes at the monument to make it more welcoming to a broad spectrum of people. African languages now supplement the wall texts in English and Afrikaans, and five black African tour guides have been hired. One was formerly a cleaner there.

Echoing the setup at Robben Island, Opperman says, "We do not from our side control our guides on a day-to-day basis. They tell [the history of the events pertinent to the monument] as we taught them, but we have also given them other exposure [to additional sources of information]." As a result, he states, "I am satisfied that they have the necessary freedom of movement and speech to tell the black scholars [students], when they come here, their version of history as well." But as we have discovered, such autonomy can lead to highly variable visitor experiences.

One of the boldest gestures of reconciliation taken thus far, and reaching beyond the monument's tried-and-true constituency, occurred in 2002 when Opperman invited former president Nelson Mandela to a wreath-laying ceremony. The occasion was the dedication of a statue of a Boer War hero that had been recently transferred to the monument's control.[74] Opperman understood that this invitation could raise the ire of certain segments of the Afrikaner community, yet was still amazed by the degree of negative emotion the event stirred up. "I was called a traitor, an arch-traitor, and all sort of bad names," he recalls.

The oratory against the event was prolonged and heated, particularly on Radio Pretoria, a media bulwark against the changes in South African society that mixes racial politics and farm news with the oompah beats of traditional Afrikaner music. Some young extremists even paid Opperman a visit and tried to intimidate him into canceling the event. But he would not budge: "We just said, 'Listen, we invited him and we are good hosts, and we will take care of his safety and his dignity. We are not going to cancel.' "

The antagonism intensified to the point where, in Opperman's retelling of the story, "[t]here was a young chap who [threatened] 'We will get you out [kill you].' " But he and his cronies had seriously miscalculated their opponent in the person of Opperman, a career military man: "I told them that I have been through wars, I know what the responsibility is to take people's lives in your hands." Once again, he successfully faced them down. In the end, Opperman considered them "mischievous," not dangerous.

As it played out, there was no disruption of the event, although the monument's staff kept their eyes peeled for any potential trouble. Mandela bridged the distance between himself and the overwhelmingly white audience at the

event by speaking in Afrikaans, and declaring, "My own shaping as a freedom fighter was deeply influenced by my introduction to the work and lives of Afrikaner freedom fighters."[75]

Nelson Mandela has an unequaled degree of moral authority to draw such an analogy without risk of incurring much public censure, even though the leader of the Afrikaner Unity movement dismissed his appearance there as "black comedy."[76] The president was striking the same rhetorical chord as the exhibition designers at Constitution Hill have, stringing together conflicts from different eras as instances of righteous struggle against oppression, an advantageous way for groups to frame their experience in the present political climate.

Lessons were obviously learned from taking this gambit, lessons about how much change a site's core constituency can tolerate, and the pace at which change can be instituted. The staff has discussed inviting President Mbeki to a future December 16 service but has backed away. "I think we must not overdo this," Opperman cautions. "Why didn't we rather spread this [out]," he told his colleagues, "[instead of risking] possibly having a very damaging after-effect?"

An Afrikaner heritage center is under construction on site, and Opperman knows that controversy is inherent there as well. Do they aim to be as inclusive as possible, or whitewash history? He is acutely aware that choosing to highlight certain members of the community such as Bram Fischer, who was a leader in the South African Communist Party, or Beyers Naudé, a churchman who vocally opposed apartheid, will provoke outrage among those people who consider these men to be traitors to their race.[77]

But because they were born as Afrikaners, Opperman insists that their lives must be represented. Opperman concludes, "We have to be sensitive, and I think we [also] have to make courageous decisions. We will be criticized, but I don't think that we can shrink away from our responsibility, a very historic responsibility. We have to be willing to be the front-runners in this situation."

When General Opperman assumed the helm of the Voortrekker Monument and Museum, it was a stagnant remnant of a discredited culture. He recalls that there was a completely despondent air around the place. But today, the four Voortrekker leaders whose colossal likenesses anchor the perimeter of the building look upon activities that are completely at odds with their own nineteenth-century lifestyle. Skateboarders whoosh down the inclines. Mountain bikers speed over the surrounding rocky terrain. Horseback riders enjoy full moon jaunts, with complementary wine and biltong. And people stargaze, enjoy the wildlife that has been introduced to the grounds, celebrate New Year's, get married, and rock out to the sounds of contemporary bands. It has become the backdrop for fashion shoots; pornography, an issue of a local gay magazine; and in 2004, the monument hosted a pan-African fashion show.

At the same time, Opperman has launched plans for features and activities that are more heritage-, memorial-, training- and conservation-oriented. A cultural village is envisioned, along the lines of scores of others around the

country that celebrate various indigenous cultures. In this case, however, it will take the shape of a model pioneer community with people demonstrating traditional skills such as bread baking; butter, soap, and candle making; and wagon building.

A garden of remembrance is also being developed, a place to inter human remains. This reflects certain contemporary realities: Opperman reports that widows come to the monument with stories of their husbands having been buried in places where informal housing settlements now stand. Or they have lost the family farm and hence no longer have access to the graves of loved ones. They would prefer their family members be relocated to a more familiar laager setting.[78]

Moreover, a bush camp will offer leadership, adventure, and nature conservation training on this site. It will include accommodation for backpackers and youth groups; chalets; and a farmstead-like environment where tourists can overnight in "semi-luxury conditions." At present, the Voortrekker Monument is one of the most important tourist destinations in South Africa. And paralleling the situation at Robben Island, foreigners outnumber locals; in this case, at a ratio of more than three to one.

A traditional museum is located in the basement of the monument, a place that features scenes from the trek, period costumes, furnishings, displays of skills, and a model of a Voortrekker camp. The exhibition space it once occupied in an adjacent building now hosts art shows, a venue that has not been immune to controversy. In 2001, for example, a painting of the naked torsos of a couple in embrace, included within an exhibit whose proceeds would aid needy children, sparked considerable interest.

As the headline of an article in an Afrikaans-language newspaper declared, " 'Kaal paartjie' laat die fone sing" [" 'Naked couple' has the phones ringing"]. The text explained that after the same weekly had published a photo of the work, the gallery was flooded with calls: "Die stemtoon van mense wat navraag doen, wissel van opgewondenheid om die skildery van die 'twee kaal mans' te koop, tot die onpretensieuse 'hoeveel kos die skildery van die kaal paartjie?' tot die versigtige 'is dit 'n man en 'n vrou, of is dit twee mans?' " ["The tone of people inquiring ranges from excitement to buy the painting of the 'two naked/nude men,' to the unpretentious [straightforward] 'how much does the painting of the nude couple cost?' to the cautious 'is it a man and a woman, or is it two men?' "][79] For the record, the artist was not forthcoming with a definitive answer.

Has the Bleeding Abated?

An index of both the movement toward racial reconciliation, and the immense power of the past that retards its pace, is an incident I observed in November 2003. General Opperman's assistant had accompanied four black guides from the Voortrekker Monument on a trip to KwaZulu-Natal, with a twofold purpose. For one thing, they were picking up the materials for a traditional Zulu beehive hut that they planned to erect on the monument's

grounds, with the aid of a cadre of Zulu workers they were also carting back to Pretoria. Moreover, this was the opportunity to allow the guides to visit the actual historical sites they had been lecturing visitors about, but which they had not personally seen for themselves.

I joined the group for an evening braai at the Battle of Blood River Heritage Site, a national monument that is managed by the Voortrekker Monument. I had arranged to rendezvous with the group in hopes of hearing about what they had seen on the tour, and their reactions to these landmarks of Voortrekker history. But as soon as the cooked meats were brought into the dining hall (the "Trekker Kitchen"), the group split exclusively along racial lines: blacks seated at one long table, whites at another. To my disappointment, I was carefully ushered to a place within the white enclave, quickly sabotaging any plans I had for a cross-racial dialogue.

Were the whites being racist by segregating themselves in this way? Were the blacks? Or, was it simply a matter of groups of people typically gravitating toward other people with whom they believed they share the most in common?

While many of the whites did indeed have prior relationships with one another, they also shared what were clearly cordial working relationships with some of the blacks. Moreover, the blacks were hardly a homogeneous group: two of the guides were Venda in origin, one was Northern Sotho, and the other was Zulu. And they had just met the Zulu craftsmen earlier that day. The same food was served to both tables, so that could not be a deciding factor. Race, therefore, trumped everything else, including past familiarity with one another, and cultural differences and similarities.

After overnighting in the Andres Pretorius room, the next morning I accompanied the guides on a walking tour of the Blood River site, where they were lectured about events that had unfolded there over the past century and a half. It was only within this less formal situation that I got my opportunity to interact interracially. Even so, neither I nor the guides could find much common ground. There was both a stilted and awkward quality to our encounter.

The only point at which that social clumsiness briefly dissolved was when one of the guides spotted a puff adder, coiled and prepared to strike, and he physically halted us all from stepping forward. But once we had circumvented the danger of being bitten by the snake, the impromptu sense of relief and camaraderie dissipated; we split along the same racial lines from the previous evening to take our breakfasts at separate tables. None of the South Africans, or myself, felt sufficiently comfortable to switch sides.

INSIDE THE LAAGER

The Battle of Blood River National Monument is a remote outpost reached via gravel road, over 20 kilometers off the main highway between the towns of Dundee and Vryheid. The modern world intersects this place in minute ways. Rooms furnished for overnight guests feature animal hides on the floor, vintage prints of the cruelties the Voortrekkers endured at the hands of their Zulu enemies, and kerosene lamps, albeit converted to electricity.

Cell phone reception is iffy in this out-of-the-way place. The best tactic to insure that a connection is made is to stand within the Kakebeenwa Monument, a granite replica of a Voortrekker "jawbone" wagon by Coert Steynberg. It's located at the entrance to the visitor center that houses an interpretive exhibition, *smouswa* [giftshop], and restaurant. The site retains such a sense of sacredness that manager Dawie Viljoen reports that many Afrikaner visitors resent paying the entrance fee. They believe that this place is an inherent part of their cultural heritage, and that you cannot attach a monetary amount to that.

An orientation video incorporates vintage film clips that underscore the savage/civilized, Zulu/Voortrekker partition, just as scores of movies reinforced the Indian/cowboy, malicious/virtuous division that captivated generations of Americans. Zulu king Dingane is described as "a sly, suspicious man who had murdered his own family"; his reneging on the deal to transfer land to the Voortrekkers, and the brutal slaughter of Piet Retief and all of his followers, was "a treacherous deed."

But explanatory wall panels introduced in 2003 back away from such moral certainty. The text recognizes that contradictory renditions of the events of 1838 exist, based upon different kinds of sources and conflicting group interests. "Some historians even question the fact that the Battle of Blood River took place whilst others regard the Voortrekkers' victory as a miracle," it reads. "Somewhere between these poles," it argues, lies "the truth." In the spirit of reconciliation, it notes that the site of the dead warriors in the river was "one of the most tragic scenes in the history of Africa."

WHY DID "DIE GROOT KROKODIL" CROSS THE RIVER?

Not everyone is willing to cede such interpretive ground, however. At present, December 16 commemorations stretch over three days at Blood River, and they are drawing increasingly larger crowds every year. The bulk of attendees are commonly drawn from the right-wing extremist end of the political continuum. And many are attracted by the preaching of a charismatic clergyman from a Dutch Reformed church in Pretoria.

In 2002, police evicted seven men, members of the religious order Dogters van Sion (Daughters of Zion), from the grounds. During a three-month standoff, commencing after the December 16 service, they camped out, prayed, and sang at Blood River. All claimed direct descent from people who died in the nineteenth-century battle there. They believed that their ongoing physical presence was preventing the site's governing body from doing the "work of the devil," that is, "turning the grounds into a market place" selling out their legacy.[80]

And in 2003, about 1000 Afrikaners attended a revival-type ceremony where references to "kaffirs" were heard. The reverend in charge bluntly stated, "On 27 April 1994 we lost our right to self-determination and

freedom when we became part of the same authority that governs all the citizens of South Africa."[81]

Local Zulus also held a celebration, on the opposite side of the river. But their ululating, drumming, and dancing could not have provided a more vivid contrast of cultural expression and belief systems. Separated by a distance that can be calculated in yards, the two groups were detached and generally oblivious to one another.

To some, Blood River is a cherished historical redoubt, heavily endowed with the blood and sweat of their Voortrekker predecessors. For them, no bridge can be extended to the other side. But in defiance of this last-stand attitude, a frail former president P.W. Botha, "Die Groot Krokodil," crossed over the river in a gesture of goodwill. Some diehard ideologues—even those who may *seem* to be antediluvian—*can* change with the times.

WHITHER THE VOW?

A sense of Afrikaner sanctity resides not only in the Voortrekker Monument. Approximately 350 miles to the south stands the Church of the Vow in Pietermaritzburg, built in 1841. Significantly, the building served as a church for only 20 years. It was subsequently put to a variety of uses: as a school, a blacksmith, or chemist shop, and a tea room. It became the Voortrekker Museum on Dingane's Day, December 16, 1912.

Notably, a guide to the museum first published in 1952 states that the dedication four decades earlier had attracted "Natalians of *both* language groups,"[82] thereby erasing black Africans, those of Indian descent, and anyone else from any consideration. Today, along with the reconstructed farmhouse of Andres Pretorius, and buildings acquired from a former girls' school, the church is now simply part of a larger complex.

December 16 was not renamed the Day of the Covenant until 1952. This, along with the fact that the Church of the Vow did not achieve its current significance until after the Anglo-Boer War, demonstrates that the centrality of the vow to Afrikaner identity was established long after the actual event.

Once again, change is embodied within an individual's biography, in this case a stylish and self-confident employee of the Voortrekker Museum, a young woman of Indian descent. In her mid- to late twenties, Ms. N. Govender staffs the front desk and greets visitors. She candidly recounts her own history with this museum: she first saw it on a school trip. Her second visit occurred years later, when she went for a job interview in 1996. And her third visit came on her first day of work there. This was not a place that she felt was very "welcoming" for people such as herself before 1994, and she is convinced that she would not have had a reasonable prospect to be hired until after the fall of apartheid.

When queried further about her experiences, she said that one of her initial concerns was what language she would be expected to use on the job. She can speak Afrikaans, although she hates to. She was relieved to hear that she could use any language she was comfortable with. And she relates that meetings

within the museum are generally conducted in English, although with a simultaneous isiZulu translation: many of the newer employees are not fully adept in both tongues.

Retired director Ivor Pols, however, reports a less harmonious use of language. Pols claims that just before he left, members of his council "became very nasty." Asked to explain, he says, "They decided to speak Zulu, and somebody had to translate it into English, and somebody had to translate it into Afrikaans. So a meeting lasted hours and hours." He concludes that " 'things' will not work out well" if they persist in this manner.[83]

Significant administrative change occurred when the first black director, Sibongiseni Mkhize, assumed the helm in 2002. A journalist chose to invoke militaristic imagery to describe this noteworthy event, depicting Mkhize as "the first black South African ever to seize control of one of Afrikanerdom's most sacred places."[84] Mkhize laughs at the characterization that he "seized control." In fact, he emphasizes repeatedly that he had to summon up his courage to even apply for the position: "I think really that I was quite strong to say, 'No matter what, I will go to the Voortrekker Museum,' although it is a bit scary, and there are all sorts of rightwing elements all around the place. 'I will go to the Voortrekker Museum and work hard and try by all means to take it into the twenty-first century.' "[85]

A native of Pietermaritzburg, Mkhize never visited the museum until the 1990s. It was "not catering for" people like himself; "it was really a sort of white people's domain." He continues, "I did not see myself represented in this museum in any way."

What had traditionally been all-white museum councils gained the first non-Afrikaans-speaking chairperson in 1996. After that, change became apparent in many ways. Louis Eksteen worked at the Voortrekker Museum until he assumed the position of curator at the Fort Amiel Museum in 2003. He characterizes the transformation of the staff and the exhibitions that he witnessed there as "very drastic," with "a lot of tension" and "accusations of racism."

Eksteen explains that when he began working at the Voortrekker Museum almost all the staff was white. But within the space of one year, eight positions opened up for various reasons, and they were all filled with black people. The Afrikaner director, for example, retired after holding the job for 25 years. Sibongiseni Mkhize believes that in the case of two of the vacated positions, people left because they "couldn't cope with the change." He adds that the fact they were white "makes me a bit uncomfortable, but I didn't do anything to them."

"That was quite traumatic," Eksteen relates. "Just over night the whole structure changed." He repudiates some other people's perception of racism at the museum, however, emanating from any direction. "It is actually more in-fighting and [a] clash of personalities," he claims. Nevertheless, he candidly confesses that he is glad he is not there anymore.

Assistant Director Henriette Ridley has come through the transformation. "It is not an easy time to work in museums because of now having to

accommodate multiculturalism," she admits. She cites the present day confrontation of perspectives in staff discussions, differences of opinion that would have been rarer when the team all shared common cultural credentials.

Take the fateful (and fatal) encounter between Dingane and Piet Retief. The very same Zulu king who is described as "a sly, suspicious man," guilty of "a treacherous deed" in the orientation video at the Battle of Blood River site, is seen in a vastly different light by this museum's Zulu employees. From their standpoint, Retief had raised considerable suspicions about himself by walking around a restricted area of the king's homestead at night. The Voortrekkers' motives were, consequently, questionable, and Dingane acted defensively when he wiped them out.

"Initially you sometimes think, 'My goodness. I don't agree with this.' [But] it is actually good to get those other interpretations," Ridley recognizes. The museum's description of this episode now concedes that there is a difference of opinion regarding why Retief and his men were killed. Debates such as these amongst the staff, Ridley acknowledges, are not always pleasant. "You would much easier stay in your comfort zone," she notes. But in the end, she understands that it is productive to air differing interpretations; the test is maintaining mutual respect for one another's opinions.

By making these observations, Ridley realizes that cultural history museums face challenges that sister institutions do not, or if they do it is only to a lesser degree. Just as Colonel Jacobs drew a distinction between a museum featuring military matters and one presenting art, Ridley notes, "Working with cultural history is much more difficult than working, for instance, at the Natal Museum [down the road], which is [heavily] natural science [oriented], where you work with animals or insects or archaeology, which is more, it is less emotional." She is correct in her assessment, except of course when these museums decide how to present humans in evolution and history.

INSIDE, AND OUTSIDE, THE LAAGER

A visit to the Voortrekker Museum's gift shop also jars expectations. Posters depict the Voortrekkers crossing the Drakensberg Mountains, the Battle at Blood River, and feature the diagram of an ox wagon. But these days old Zulu dolls are also offered for sale.

The museum has transformed itself from a single-themed museum (the old apartheid-era distinction of "Own affairs") to a place that surveys the histories and customs of all the people within the province. "The main idea," retired director Ivor Pols says, "was to make this the National Cultural Museum of KwaZulu-Natal." Pols expresses relief that after 1994 "we had got rid of this single theme business that they [the government-appointed council] pushed down on me and we could really broaden out."

Employing the same strategy that General Opperman has activated at the Voortrekker Monument, Pols argues that the museum stems from an event

that took place more than 150 years in the past. Attempting to distance it as much as possible from the 50-year reign of the National Party, Pols asserts, "the place has nothing to do with apartheid." While literally correct, not everyone believes that that distinction can be so clearly drawn. Both the monument and the museum were important repositories of meaning, reinforcing Afrikaner pride and dominance during the reign of an extremely repressive government.

Barry Marshall, director of the South African Heritage Resources Agency, brashly declares, "Ivor Pols was a right-wing Afrikaner. There's really no question about it, though nobody wants to say he is. That was why he was director of the Voortrekker Museum in the first place." Henriette Ridley disagrees. "I don't think that it [the museum] was meant to be politically motivated and ideologically based," she says. "Dr. Pols was totally antipolitical. So he certainly would not have allowed any political party to sort of use the museum to its benefit."

Visit there today and a painted signboard at the entrance to the main exhibition building confronts the visitor with grotesque human skulls, displaying red eyes, bloody mouths, and the logo

<div align="center">

AIDS KILLS
INGCULAZA IYABULALA

</div>

KwaZulu-Natal Province, where the museum is located, has the highest HIV infection rate in the country; more than one in three residents carries the virus.[86]

On the grounds stand a replica of a Hindu Shiva temple and a traditional Zulu hut. Inside the museum, a collection of horse-drawn carriages stands next to a display on how African beer is brewed. Sarah Bartmann's life is celebrated, as is Mahatma Gandhi's ("A Man for all Seasons"). *Not only a white man's war*, the revisionist history of the Anglo-Boer conflict, is counterpoised to a collection of Voortrekker footwear and musical instruments of East Indian origin.

Across the treed campus stands the quaint, whitewashed Church of the Vow, gabled in the distinctive Cape Dutch style fore and aft. Displays on Voortrekker customs pack the interior: marriage, christening, funerals, a day at school, and music, duly represented by vintage hymnbooks. All explanatory labels are now in English, Afrikaans, and isiZulu.

Unfortunately, the museum has not conducted audience surveys. It is impossible to gauge, therefore, who its audience is, where they come from, or what they focus upon.[87] Anecdotally, however, staffers admit that both the history and name of the museum attract many South Africans and foreigners specifically to the Church of the Vow, in order to explore Voortrekker life. Passengers from tour buses, according to Assistant Director Henriette Ridley, "automatically walk directly to the church, and if they have only 20 minutes, often that is basically all they see." For the majority, their interest is likely not

as keen, and their endurance not sufficient, for them to take in the multicul-
tural displays in the main building as well.

My own very limited observations confirm this: I have sat near the recep-
tion area on a couple of occasions, and I have heard the receptionists describe
the broad range of the museum's offerings. Once they have gotten that
overview, however, white visitors commonly inquire about the specific loca-
tion of the Voortrekker exhibits, and then turn heel to walk over to the
Church of the Vow.

Ridley relates an interesting example wherein a journalist wrote that the
Voortrekker Museum had become a "struggle museum." She explains the
misconception as follows: "They probably walked around here, and they did-
n't ask too many questions, they saw the *Birth of democracy* [about the anti-
apartheid liberation movement], and they couldn't see any Voortrekker
things, and they probably thought, 'It has all been done away with, and is
now a 'struggle' museum.' "

Even in the absence of "hard data," it can be noted that the switchover
from a particular to a more wide-ranging focus is superficial in execution and
befuddling. By attempting to cover so many cultural bases, the Voortrekker
Museum now offers a mishmash of experiences, with no overriding sense of
order or rationale. Too many ideas are contained within too little space. It
might represent that hypothetical smorgasbord mentioned at the beginning
of this chapter, but in this case the portions are all so tiny that they hardly sate
one's hunger for knowledge. The situation calls to mind the memorable reac-
tion of a visitor to the State Museum in Windhoek, Namibia, where curators,
in the spirit of independence, have interspersed African objects among its
holdings of German and Afrikaner colonial artifacts. That person was heard
to say, "it looks as though a group of Bushmen have moved into a German
house."[88]

Many observers are dismissive of what the Voortrekker Museum has done.
Colonel Frik Jacobs notes, "I think the previous director was trying to be 'p.c.'
to the extent of making a fool of himself." Barry Marshall echoes that sentiment,
remarking, "There is an element of rushing out to very quickly get as politically
correct as you can." And Vusi Ndima, chief director of Heritage at the
Department of Arts and Culture, concurs: "The kind of arrangement could have
been a little bit haphazard."

Ndima envisions a way to address the situation, however: "If they could
solicit some professional expertise, it could be done in such a way that you
have the whole experience well packaged, and the whole narrative well out-
lined." As it stands, "The blurring of the boundaries might even make one
not necessarily see the theme. What then is the theme now? But I don't think
that problem is insurmountable."

In the museum's defense, Henriette Ridley sees the changes as a judicious
response to an altered political environment: "I think the museum realized,
quite honestly, that if it doesn't change, it is going to be very difficult to get
funding. If you don't change, pressure will be put on you. You *have* to

change." Although she admits that there was some right-wing resistance to the transformation, it was "the right thing to do."

TRUTH IN ADVERTISING

One of the largest sources of confusion at the museum is that its name no longer adequately reflects its mission. An important symbolic indicator of the transformation of the Voortrekker Museum is that its traditional entrance was shifted from where the Church of the Vow stands, to around the corner, after the campus of the girls' school was annexed in about 1989. Rather than being directly shunted into the part of the museum that most directly refers to the Voortrekker experience, visitors now must chose where they will go and what they will see within a cluster of buildings.

In mid-2003, the museum's advisory council decided that a name change was essential. They solicited suggestions from the public but allowed little more than a month for replies. According to Henriette Ridley, about 50 submissions were received, although the majority weighed in that the name should *not* be altered. Only one name was forwarded to the minister of Arts and Culture, a suggestion that Ridley believed was too local in nature, and not reflective of the province as a whole.

Overall she believes that the process was too hasty for such a momentous decision. But when she suggested to colleagues that the name ought to refer to "heritage" or to KwaZulu-Natal, she was told that even that name is contentious. As mentioned in chapter 1, it is an amalgamation of the apartheid homeland of KwaZulu and the colonial province of Natal. "Good gracious," she thought; it was deemed "politically incorrect," even a decade into the new dispensation.

The determined campaign to change the museum's name bothers Ivor Pols as well. He cautions that "one must be careful." "When you lose your brand," he warns, "it is like taking Coke and call[ing] it 'Black Water.' Nobody is going to drink it."

This took place against the backdrop of another proposal: in 2002, a great deal of concern had been expressed over the projected renaming of a significant number of streets and buildings in Pietermartizburg. The suggestions spanned a broad range of individuals with historical ties to the province, including blacks, whites, and Indians; women and men; and people who lived during the nineteenth and the twentieth centuries. But one letter to the editor slyly suggested that the revision did not go far enough, and recommended that East Street and West Street be switched, and offered additional possibilities such as "Hijack, Mugging, Litter, Brothel and Shebeen streets."[89]

Despite concerns, the name of the Voortrekker Museum was slated to officially change to the Msunduzi Museum on April 7, 2006, after a river that runs through Pietermaritzburg. The Voortrekker legacy may no longer monopolize its public identity. But now, *everything* within the place will be equally obscured by the new tag.

CREATING THE ENEMIES
YOU DESERVE

In the discussion of Robben Island, I mentioned the fact that its wide renown contrasts sharply with a comparable location in New York, a site that remains virtually unknown. Once again, the resolution of the question "Why?" rests upon the exceptionally repressive nature of the apartheid regime.

Unlike individuals who are detained because they have committed an ordinary criminal offence, or due to the fact that they have contracted a disease, the final cohort of detainees at Robben Island was united by its mutual opposition to a racist government. That sense of solidarity was further incubated and nourished when they experienced the extremely authoritarian circumstances of being imprisoned in common.[90]

It was perfectly clear who their enemies were, as were the advantages of working in concert with one another. Thus when the "outlaws" became the elected leaders of the country, it was inevitable that their successful joint struggle against injustice would become the dominant narrative of the last half of the twentieth century in South Africa.

Incarcerated political prisoners were seldom left to deal with an individual sense of stigma and shame bearing upon their sense of self—unlike, say, lepers, patients with tuberculosis, or "common criminals." This contrast brings to mind sociologist C. Wright Mills's classic formulation of individual troubles versus social problems.[91] Jailed South African freedom fighters defined their mutual fate as a social issue; other types of inmates, and medical patients, much less frequently reach that sense of shared circumstance. And while projects such as *Cell stories* recover the bits and pieces of what may be individual accounts, it is with an eye toward reconstructing the universal Robben Island experience.

Apartheid created the enemies it deserved. Memories of life in District Six and on Robben Island remain so vivid because the government and some of their particular policies were so clearly responsible for the wretched destiny of large numbers of people. Former residents of District Six have dutifully cultivated the past as a way of retaining their dignity in the face of government fiat that rendered them relatively powerless. Former political prisoners retain and publicize the memory of the past as insurance against such large-scale human rights violations happening again. The recent character of South Africans has been forged through such extreme conditions, unlike other places in the world where relative political and economic stability shields many sectors of the public from experiencing catastrophic changes in their way of life.

Furthermore, places such as the Voortrekker Monument, the interpretive center at the Blood River site, and the Voortrekker [Msunduzi] Museum have all changed, to be sure. But they will never completely erase or neutralize their institutional histories and public identities. Nor should they, necessarily. Beyond what their curators and other personnel have done of their

own accord, a new breed of museum has appeared that addresses issues that these older establishments either ignored in the past, or presented through a narrowly focused lens. These more recently founded institutions have thereby opened a significant new dialogue amongst the public, as well as with those places that preceded them.

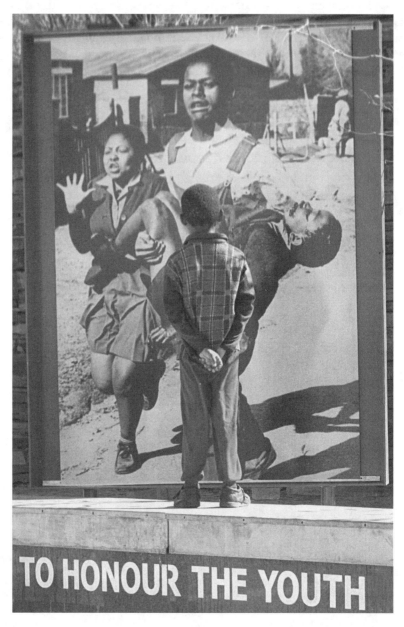

Figure 8 A young boy contemplates an enlarged version of the renowned Sam Nzima photograph of the fatally wounded Hector Pieterson at the start of the 1976 Soweto student uprising, at the memorial in Soweto

Source: Photo by Kim Ludbrook, courtesy of *The Star*, Johannesburg.

Tête-à-tête: Museums and Monuments, Conversations and Soliloquies

It's a moot point whether either younger or future generations will need, as their elders do, to return to the site of public pain, to wear the barbed outlines smooth by repeated viewing.

Greig, 2002

With a thunderous commotion and behind a wall of smoke, former prime minister J.G. Strijdom (the "Lion of the North") inexplicably collapsed into an underground parking garage in Pretoria in 2001.

More precisely, a colossal facsimile of his head split in two and disappeared from a public square, although a neighboring pedestal bearing the sculpture of three galloping horses remained erect. It was an eerie and baffling finale to a much despised symbol of the former regime, on a site where seven black people had been murdered in a notorious racially motivated attack in 1988. The timing of the cave-in was serendipitous: May 31 was once dubbed Republic Day. In the New South Africa it is simply another date on the calendar.

For anyone seeking confirmation that the old system was defunct, the demise of this apartheid icon was heavily imbued with meaning. But symbols are seldom so inexplicably and speedily dispatched. In most instances human intervention both establishes and demolishes them, after much debate.

Discussions have opened up at every level of public and private life in South Africa since 1994, exchanges of opinion that would have been unimaginable under National Party rule. Before then, apartheid had been the proverbial elephant in the South African lounge that was repeatedly disregarded or talked around in public venues such as museums. When it was ignored, it seriously befouled the environment nonetheless. And to now acknowledge and dissect this metaphoric creature entails moving out the old furniture and reconfiguring rooms, passageways, entrances, and exits.

Those individuals who deliberately create lapses and omissions from collective memory are the ones who dictate the prevailing myths. In his book *1984* George Orwell christened the resultant "memory holes," the dystopian mechanism Big Brother devised to purge dangerous ideas by dropping any trace of them into a furnace. But the emancipatory events of 1994 created a broad-based desire in many South Africans, especially among those working within the heritage sector, to excavate such holes, dredge up the contents, and then insure that the general public can witness what was once hidden away.

New museums are now confronting national secrets and gaps in the historical record. Just as *Miscast* took issue with the South African Museum's Bushman exhibition, these places give voice to previously unstated perspectives, and engage established institutions in a fresh dialogue about the past.

Breaking New Ground

The Blood River site, where the fateful confrontation between the Voortrekkers and Zulus occurred in 1838, has been memorialized by Afrikaners since 1866. On December 16 of that year, celebrants placed rocks where the original wagon laager had reportedly been assembled. That stone mound survives, as do additional monuments, on the same property, that have followed in its wake. Most impressive is the laager that was erected in 1971, consisting of 64 full-sized cast-iron replicas of Voortrekker wagons, coated with bronze, silently encircled in perpetuity in commemorative self-defense.

The wagons may be mute, but their presence bears testimony to the triumph of Europeans over the Africans. Since its installation, the laager has helped comprise the final word about that confrontation. Until 1999, that is. On the opposite embankment of the shallow Ncome River [isiZulu for "praised" or "welcome"], the Ncome Museum and Monument complex provides a different, native perspective.

That message commences with the physical structure of the building itself: the curvilinear shape alludes to the renowned Zulu-fighting strategy initiated by Shaka, the war horn formation. Two groups of younger fighters making up the "horns" surrounded the enemy from either side in a pinscher maneuver, while the more experienced warriors comprising the "head" or "chest" ruthlessly charged forward with their *assegais* [spears]. Now, through two distinct interpretive sites, these forces face off one another yet again, across the water and across history.

As a gauge of the self-assurance black Africans have attained, and the degree of self-assertion that they have expressed since the coming of democracy, consider this statement by the chief minister of KwaZulu-Natal, Dr. Mangosuthu Buthelezi. Speaking at the inauguration of a historical reserve and visitor's center near Isandlwana, the place where Zulus crushed the British in 1879, he declared, "There was no new South Africa before the 19th century without having to deal with the Zulu reality. There will be no

new South Africa in this last decade of the 20th century without dealing with the Zulu reality."[1]

The Ncome Museum directly owes its existence to President Mandela's 1997 critique of museums. A consequence of Mandela's remarks was an initiative by the national government to establish and fund "legacy projects" to honor those who were overlooked in the past, and to air perspectives that had previously been unexpressed. The Ncome Museum is one of the beneficiaries of this initiative, and is administered by the Voortrekker Museum in Pietermaritzburg.

Ncome's 2001 information flyer states, "The museum offers positive re-interpretation of the 1838 war and Zulu culture in general." It further notes that the Blood River Museum is "in the neighbourhood," a startling understatement given the fact that the two sites face one another, and the "neighbourhood" offers a broad vista over miles of sparsely occupied terrain. Despite their propinquity, one must drive a roundabout road that connects the places.

The day I visited the Ncome Museum for the first time in early 2003, I encountered the rather startling scene of a group of as many of 50 young people toyi-toying down the road toward my car. At the last possible moment they split apart to allow me to pass. I later discovered that they were accompanying a young man about to pay *lobolo* [bride wealth], to his future in-laws. However new the museum may be, it is nonetheless enveloped by centuries-old traditions.[2]

Dual(ing) Perspectives

When the first on-site celebration of the new project occurred in 1998, with the requisite dignitaries and fanfare, the as-yet-to-be-erected building was called a Monument of Reconciliation. No mention was made of it becoming a museum, or housing an interpretive exhibit of even the most elementary type. Professor Jabulani Maphalala, head of the Department of History at the University of Zululand, was less than enthusiastic regarding the venture, saying, "monuments of this type were not really a part of Zulu culture . . . [but] a concession to the westernizing influences that had affected Zulu culture in recent years."

He argued, however, that "Zulu culture has had to change—or we would still be wearing animal skins." From his perspective, "Zulu traditionalists would not have built a monument on a battle site from which the spirits of the dead had long departed."[3]

But another commentator could hardly contain his enthusiasm at the kick-off or subdue his sense of optimism: "A culture of reconciliation was being forged in the heat of the day. The occasion was congenial, musical, and devout," he gushed. The muddy fields played host to diverse people who had "a shared heritage," "a common future," and "a spirit of oneness." And in what sounds like a promotional campaign for the rainbow nation, he declared, "Liberation from group thinking and tolerance of otherness were tangibly

present. . . . The people present defied simplistic racial, tribal and occupa-
tional classification."[4] Subsequent events have proven him to be wildly naïve
and radically off the mark.

Barry Marshall, director of the South African Heritage Resources Agency,
also rejects the very concept of there being a Ncome Museum. He argues, "I
think you are dealing with a horrific situation; you have a classic case of
apartheid because you've got a white museum, and a black museum on the
other side of the river." He recalls remarking to those in charge when he
visited the site, "You guys are mad; you've got separate development here,"
invoking one of the now discredited apartheid concepts used to justify keep-
ing different racial groups apart from one another.[5]

Marshall argues, "The white museum is funded and run by a rightwing
Afrikaner organization, and although they'll tell you that they are trying [to
change], and you can see that, it still only represents one side of the conflict.
What has been created on the other side of the river, which they are calling a
museum, I wouldn't. I don't think it [Ncome] deserves to be a museum."
The place features only a small assortment of items representing Zulu material
culture, with brief explanations of some essential historical points. Far and
away what has provoked controversy, and much consternation, is the Zulu
perspective regarding the Battle of Blood River that the Ncome Museum
presents.

To put the issue into perspective, I cite an information sheet distributed at
the December 16 ceremony at the Voortrekker Monument in 2003.
According to this account, 464 Voortrekkers, backed up by their drivers and
helpers, defied the odds and roundly beat back the attack of between 12,000
and 15,000 Zulus. Three thousand Zulus were killed; amazingly, only three
Voortrekkers were wounded.[6]

The information panels at the Blood River Battle Heritage Site echo this
version. But in the spirit of reconciliation, and reflecting recent revisionism,
the curatorial voice replaces smugness with a tentativeness that would have
been absent pre-1994. "Historical events are often interpreted in different
ways," they say. There are "divergent interpretations": the panels reflect
research based upon primary and other written sources, whereas oral tradition
shapes the Zulu interpretation. "Somewhere between these poles," they note,
"lies the truth." The text cautions, "The search for the truth should never be
complete."

Moreover, at the Church of the Vow extension in Pietermartizburg, an
exhibit asserts that "many" Zulus were killed at Blood River and a diorama
there featuring Dingane's kraal now sits across from the Re-creation of a
Voortrekker campsite. These examples represent sincere attempts on the part
of established sites to broaden their perspectives.

In contrast, the guide taking visitors around the Ncome Museum often
characterizes the essence of Zulu beliefs about the subject by saying that they
infer "many were killed, as many as the hairs on an elephant." The point is
precise tallies and body counts are not as important to Zulus as they are to
Westerners. But after the collection of traditional artifacts was introduced at

the Ncome Museum, an accompanying pamphlet boldly asserted that merely ten Zulus died in the battle, thus invalidating the image of a river of blood.

One heavily ideological and propagandistic rendition of history was thereby offered up to counter another that has been significantly moderated in the recent past. And the reaction has been predictably dismissive. Ivor Pols, retired director of the Voortrekker Museum, reasons, "Ten Zulus were killed that day? You can argue about a few thousand this way or that way, but not ten. That is impossible." General Gert Opperman reports, "They [Ncome] give a completely biased interpretation of what happened. It is, in fact, so biased that the current manager of the Ncome Museum admitted to me he is embarrassed by the inaccuracies. They admit that it is nonsense."

But for Barry Marshall, this is not a particularly surprising development: "They are angry people that have set this up, and they have a kind of agenda to tell things from their perspective, and there are some very ridiculous things that have been said. You know: 'four [*sic*] Zulus killed at Blood River.' We know that is nonsense, and most Zulus know it is nonsense. But it's because it is still the [apartheid] boxes [of racial classification] that are operating." The tribalism that the journalist in 1998 so strongly felt was waning, in fact retains enormous influence.

Some critics point the finger of blame for the biased account directly at a man they believe to be of dubious reputation, Professor Jabulani Maphalala. And so long as contemporary feelings of relative group stature hinge upon interpretations of key historical events—whether based upon eye-witness accounts, oral tradition, ideological manifestoes, or "legend"—disputes such as these will continue. A posting on a white nationalist website on December 16, 2002 makes that clear. It bluntly announces that Zulu warriors "got a giant mud hole stomp in their butts" on that date, many years before, at Blood River. "The whole Zulu nation got spanked so bad that the Zulu cry about it too [*sic*] this DAY!"[7]

At the inauguration of the Ncome Museum, the provincial premier articulated the sense of rivalry and antagonism, too: "Dié museum is hier om ons te herinner dat dit ons plig is om vrede en versoening te bewerkstellig. . . . Anders as die Ncome-museum het die museum aan die 'Voortrekkerkant ' van die slagveld buiten 'n paar verlepte poskaarte en tekeninge bitter min wat aan die slag van Bloedrivier herinner." ["The museum is here to remind us that it is our duty to facilitate peace and reconciliation. [But] it is not a collection of dusty artifacts. . . . In contrast to the Ncome Museum the museum at the 'Voortrekker site' of the battlefield has very little except for a few wilted post-cards and drawings that recall the Battle of Blood River."][8]

Around the nearby village of Wakkerstroom, descendants of the original combatants continue to struggle against one another as well: black farm-workers claim that white landowners are intimidating them to leave, thereby nullifying any claims they might make to ancestral lands. Each side accuses the other of resorting to violence to eliminate them from the area.[9] Moreover, whatever dreams of reconciliation that underlay the establishment of the Ncome Museum to amend or counterbalance the view from the

opposite side of the river have yet to be fully realized: someone attempted to scratch out the word "reconciliation" on a bronze plaque at the new museum's entrance. The mismatch that remains between the white and black African perspectives is, to invoke a distinctive South African expression adopted from the British, like putting together chalk and cheese.

The Other Side of the Mountain

For years, the Afrikaner perspective dominated another site as well, the Voortrekker Monument outside Pretoria. But a substantial commitment of public funds is changing that.

Freedom Park is an additional "legacy project," generated to redress the one-sided message that the monument and its museum long represented. It is ambitious: Freedom Park will include a garden of remembrance, a memorial to honor a broad range of victims of human rights abuses, a museum, a library, a conference center, and an amphitheater for special events. It is costly: the ANC-led government pledged R350 at its outset; by 2004, two years later, that amount had soared to R560. Its construction will be protracted: begun in 2002, the completion is estimated to take until 2010.

Many aspects of Freedom Park have yet to be finalized; it is envisaged as something of a continuous work in progress, "The Hill of a Thousand Designers."[10] It will sit across from the Voortrekker Monument on a ridge called Salvokop—the name refers to the barrage of gunshots fired from there during the Anglo-Boer War—and has clearly become a pet project of the ANC. One of Freedom Park's board members is former president Mandela, dubbed "patriot-in-chief."[11]

Freedom Park owes its existence in large part to the example of the Truth and Reconciliation Commission, as a place that will allow the ongoing quest for reconciliation between South Africa's many groups to be sustained. For Dr. Ben Ngubane, the minister of Arts, Culture, Science and Technology at the time of the project's inauguration, it represented "the physical manifestation of reparation."[12] Soon thereafter, President Thabo Mbeki unveiled the site, declaring, "We are coming out of a period of invisibility."[13] One of the hallmarks of Freedom Park is its projected inclusiveness, addressing seven distinct circumstances and events where large-scale human rights violations have occurred: genocide, slavery, wars of resistance, the Anglo-Boer War, the two world wars, and the struggle against apartheid.

The concept is grandiose: "a visionary undertaking," offering a "one-stop heritage precinct,"[14] as if historical legacies can be packaged and peddled in the same way that "big-box" stores wholesale household necessities to a clientele prioritizing economy. The goal is to become no less than "the leading national and international icon of humanity and freedom," the "centre for indigenous culture and heritage in the world," and "to accommodate and chronicle all of the [sic] humanity's experiences."[15] That means that the narrative Freedom Park

develops will span some 3.6 billion years, from the initial emergence of life forms to dinosaurs roaming the Karoo. It will highlight Southern Africa as the "cradle of mankind" and the home to indigenous peoples with distinctive cultures. And the site will address the dialectic between oppression and resistance that has marked the relationship between Europeans and native Africans for more than 300 years. This mandate is so broad that it seems virtually unparalleled by any existing institution anywhere.

The advice of traditional leaders was solicited throughout the planning, and cleansing and healing ceremonies were conducted in each of South Africa's provinces in the run-up to the dedication of the Garden of Remembrance. In early 2004 a national healing and reparation ceremony was held on the hilltop itself. Since that time, cleansing ceremonies have also been staged to honor neighboring countries that have provided asylum to South Africans (Botswana, Mozambique, Lesotho, and Swaziland), and more far-flung places as well (the United Kingdom, Russia, and the United States). Boulders, soil, and indigenous plants from each of the eight provinces and three neighboring countries have been placed there, and a spiral path leads pilgrims to a shrine and fountain. It was consecrated with the smell of incense, the taste of traditional beer, and the sound of choirs. Visitors are already finding it to be a deeply spiritual place.

CASTING A WARY EYE

The promise of Freedom Park is that it will not just be an antiapartheid museum, but it will cover "everyone." But some people are monitoring the development with suspicion. And certain small details fuel their concern. The headline of a newspaper article reads "In memory of a struggle for humanity," for example.[16] The use of the singular can trigger anxiety that the recent liberation effort will overshadow everything else.

Moreover, in a comprehensive description of the project published in a special color fold-out newspaper supplement, Freedom Park's location is touted for offering a panoramic view of the national capital (listed as "Pretoria"), and it notes the time-honored symbolic importance of such high points for communal gatherings and making contact with the spirit world. However, the text fails to mention the Voortrekker Monument, its obvious neighbor, as if it is entering previously pristine veld.[17] And at the dedication of the garden of remembrance in 2003, Freedom Park CEO Dr. Wally Serote remarked that "the garden was something bigger than the Voortrekker Monument, since it was in memory of all the fallen heroes and heroines of South Africa, whatever their race."[18] Freedom Park's sister institution across the valley, and some of the most fervent constituents of that place, are feeling apprehensive.

Ever pragmatic, General Opperman recognizes that "[o]pposing them will only estrange us from the other people on the government side. We have to co-exist on these two hills here." To that end, Opperman has

directly facilitated the new construction process as much as possible, including making certain service roads accessible to the builders for greater convenience.

But more importantly, Opperman and members of his staff have become conspicuous in attending events relating to Freedom Park, and have encouraged reciprocity. The black people seated prominently during the December 16 ceremony at the Voortrekker Monument in 2003 (chapter 6) were invited representatives from Freedom Park. That afternoon, Opperman and his colleagues attended Day of Reconciliation events sponsored by Freedom Park.

Opperman, his staff, and board members have also attended commemorations of the Sharpeville massacre, an activity that he characterizes as "unthought of before." He explains it this way: "The whole idea is that we can start reaching out to each other and then get past bad times and move into a new frame of reference." However, this is not a straightforward process: "Obviously not everybody will always agree with us," he says. "There will be people who will consider us to be traitors. [But] we cannot afford to sit back and to let our progress be retarded by people who don't want to move at all. So there are risks involved in terms of nation building, and getting to know one another."

In fact, Opperman reports that callers have pleaded with him to actively oppose Freedom Park. These are people who are not comfortable with alternative narratives being put forward. A spokesperson for the Kloof Covenant festival committee, for example, condemned the project as a "blatant provocation of the Afrikaner people," one that was literally too close for comfort. "While the ANC makes out that SA is a non-racial, rainbow nation," he continued, "the project is nothing other than the unilateral, racist honouring of ANC terrorists against the whites of SA."[19]

Anton Pelser, an archaeologist at Pretoria's National Cultural History Museum, is also concerned that a project the size of Freedom Park could capsize his own institution's bids for money from the government, and possibly even poach its holdings. He worries, "They've got no collection, so where do they get their objects? I think, obviously, from our museum. So what is going to happen to us, are we going to be dispatched for a place like Freedom Park? So that is a great threat."

All in all, Opperman welcomes Freedom Park, and he is hopeful that the inevitable increase in visitors to the area can have a positive impact on the Voortrekker Monument as well. He is concerned, however, that tour groups might bypass it because there is an entrance fee, and Freedom Park will quite possibly be free of charge. He asserts, "I have enough faith in people that it is going to be fairly representative. But on the other hand, I must accept that there is going to be an element of 'drum beating' out there. So I think it is going to be sort of a 'struggle museum' in a way."

That does not cause General Opperman to fret. As he relates the fraught history of the Afrikaner and the Englishman, he underscores the importance of intergroup struggle. In pure reconciliatory rhetoric, he says, "So the Afrikaners, we [too] understand the desire to be liberated, to be free.

LET A THOUSAND VIDEO
SCREENS BLOOM

If the Ncome Museum has engaged the Blood River Battle Heritage Site, and Freedom Park is entering into dialogue with the Voortrekker Monument in various respects, Johannesburg's Apartheid Museum offers an alternative version of history to that presented by its neighbor, Gold Reef City.

Located between Johannesburg (eGoli, city of gold) and the sprawling black township of Soweto, the Apartheid Museum opened its doors in 2001. The museum is adjacent to Gold Reef City, built upon the defunct Crown Mines, which closed in 1975. It is an amusement park cum casino cum historical theme park, with a re-created mine village and tours of an underground shaft. Here you may stick your head and hands through a model of an old-fashioned pillory, but it provides ample space to avoid feeling confined, and you stroll away freely and unscathed after your photo has been snapped.

Gold Reef City's depiction of the mining industry barely hints at the exploitation of its black workers, the dangers and humiliations they endured, or the prolonged forced separation from their families that deposited them into foul, single-sex hostels. This is "history lite": no finger pointing, and nothing to make patrons uncomfortable. Inside the casino, life-sized statues of a white prospector and a black miner dutifully cradle vintage slot machines in their outstretched arms, as if all their physical toil and risk taking was done solely for the sake of the modern-day gambler.

The Apartheid Museum directly owes its existence to this carnivalesque space, whose Ferris wheel dwarfs it: the developers were required to "give something back to the community" in order to retain their gaming license. And those men, Solly and Abe Krok, have a checkered local reputation. An enraged writer angrily noted, "A great deal of New SA amnesia is at work in the euphoric reception accorded the newly opened Apartheid Museum . . . Has it been forgotten that under apartheid, the museum's 'angels,' the Krok brothers, peddled pernicious skin-lightening products?" This writer wonders, "Is the Apartheid Museum an atonement for the defunct Twins Pharmaceutical's past collusion in propping up apartheid's hierarchy of colour? I think we should be told."[20]

In spite of this questionable genesis from gaming profits, and the fact that the building was designed and erected and the displays readied with breakneck speed (within only 18 months), the museum is notable in many respects. For one, dozens of video screens bring apartheid to life: it is remarkable that so much footage was shot, and equally amazing that it could be salvaged. It was sourced from various South African archives, the ANC, and overseas agencies, and includes images filmed by news organizations as well as by the police.

The apartheid government did not allow television to be broadcast in South Africa until 1975, and then heavily censored it. (Gambling, incidentally, was prohibited before 1994.) Much of this material is therefore previously

unseen by the general public. Christopher Till, both the curator and a prime mover behind the museum, reports that visitors to the Apartheid Museum commonly confess to him, " 'We didn't know that was happening out there.' They may not have known what was happening in its graphic detail," he concedes. "But it was pretty obvious that this stuff was going on."[21]

The exhibition space might have become monotonous row upon row of monitors, but is instead broken up by maps, news clippings, posters, wall-sized photographs, text blocks, and the seemingly endless, mind-numbing lists of apartheid legislation. The experience is heightened, at times uncomfortably so, by dozens of speakers that blast authentic sounds from the actual events, as they occurred.

Particularly powerful is the presence of a Casspir, an immense armored personnel carrier that once menacingly prowled township streets. Tucked inside it is a video screen that runs police surveillance footage of an angry crowd—its jerky quality mimics the action it captures—framing the 1976 Soweto uprising from an uncommon perspective. And then there is an unnerving space where 133 nooses, closely clustered together, are suspended from the ceiling. Each of them represents one of the political prisoners hanged by the apartheid regime.

But oppression is not the exclusive focus. The Apartheid Museum also depicts the birth of the ANC, the rise of the Black Consciousness Movement, the End Conscription Campaign, and the first democratic elections in 1994. It thereby portrays the resistance to tyranny, as well as showing how South Africa came to the brink of political collapse and yet survived.

Constructing Evil

Interestingly, in the initial stages of discussion, the working name for the project was Freedom Park.[22] The Kroks consulted a number of potential collaborators, and a series of concepts was explored. They ranged from a peace center, to a Sophiatown-type music shebeen, to what Jeremy Rose, an architect/partner of Mashabane Rose Associates, the firm that eventually won the contract, calls a room with terrifying images, "like a house of horrors."

Christopher Till remembers discussions with an Israeli woman early on: "What emerged out of that was a proposal for what one may describe as a 'cultural village,' which was far too ethnically conceived. I realized it was like asking me to go to Jerusalem and do a museum on the complexity of what is there." All of these ideas were rejected.

Till also recalls that he proposed an Apartheid Museum in 1992 or 1993, but the idea seemed premature then. "It wasn't achievable in a society in transition," he concludes. But it did become feasible in the new century, and a team of scholars and artists from a variety of fields contributed to the overall plan and storyline that visitors see today.

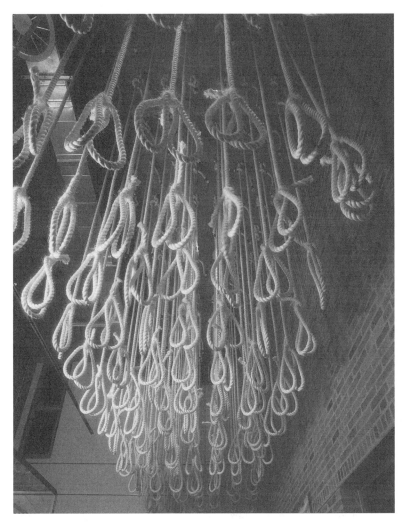

Figure 9 One hundred and thirty-three nooses suspended from the ceiling of the Apartheid Museum in Johannesburg; each represents one of the political prisoners hanged by the apartheid regime

Source: Photo courtesy of the Apartheid Museum.

From the outset, the distinctive nature of the setting figured into what was envisioned. "Ja, I was very conscious of the fact that the thing was pop next door to a theme park," Till says. Moreover, he feared that that might create expectations for something similarly gaudy: "You know, police sirens and [museum] guards dressed up as policemen and all that kind of crap, and so we just said that there is no way that this museum ever moves into that realm." He developed a strategy to dampen suggestions of any such plans, responding to questioners, " 'How would you like the Holocaust Museum to sit in Disneyland?' I mean, it is ridiculous. It is just, it is not to be consumed like a McDonalds."

South African architects along with discerning everyday citizens are increasingly critical of the heavily fortified, faux-"Georgian" and "Tuscan" housing schemes that have sprung up throughout the Johannesburg area, and elsewhere in the country. They are erected defensively, as "safe havens" to drown out the social commotion of the political transition, and to hope-fully block out crime. In marked contrast, according to one journalist, the building housing the Apartheid Museum is "an event." He continues, "The accumulation of photographic and video images works on the heart like a Chinese torture."[23]

For Jeremy Rose, designing a museum "is about taking the place seriously. We are not going to deal with deceptions," he says. To Christopher Till, "The building doesn't try to pretend it is something else. Some of the finishes which were originally planned were consciously left out. I didn't want any floor finishes and I didn't want any suspended ceilings. I said, 'Leave it out,' because it [the harshness] made such a powerful complement to that powerful and extraordinary story."

He continues, "A lot of people arrive at this building and they see these concrete vistas, and they see these concrete pillars, and they see the [wire] caging, and it's very evocative in their minds of a prison." In this regard, Till and Rose are very much in sync with one another's thinking. Rose confirms that the creation of "hard, dark spaces" with grey walls and galvanized metal poles and concrete floors was meant to suggest incarceration.

Such spaces also echo the legacy of mining: the roof slopes and the ground slopes, and indigenous grasses planted around the building echo those that now cloak Johannesburg's numerous mine dumps. Moreover, the architects incorporated "Africanized" influences such as packed stone walls that suggest the monumental ruins of the Great Zimbabwe, and they altered the rectan-gularity of the original blueprint to include rounded, shaped walls that refer-ence native building techniques.

As Rose reflects on his firm's work, "I like the way we've used the steel plate. We've bent it as if it's like a body or something. So in terms of trying to create 'emotional architecture,' you can think of the building as this big body lying in the landscape." What he likes the most about the Apartheid Museum is the fact that the building is integrated into its surroundings, and is not "a hat box in a parking lot." He believes that the building to be a metaphor for buried memory being revealed as it emerges from the landscape.

There are the inevitable comparisons to museums of the Holocaust, but Rose believes that there is a fundamental difference. He feels that Holocaust museums require confined areas into which many people would be crammed. Rose and his associates have built enclosed spaces like detention cells for a single person. But primarily they have created what he calls "apartheid space," which is cold and bare, but more expansive. "It's a very long, big space," Rose notes, "it's like the 'horrible sublime.' " For Rose, this subject matter called for something that was beautiful and ugly, attractive and repulsive, at the same time. And to Christopher Till, "the postmodern feel of its starkness does lend itself to present the exhibition in a particular type of way."

The extreme attention to detail is revealed by the precision with which even the lighting was deliberately planned. According to a trade publication geared to the South African lighting industry, the so-called Hall of Classification in the entranceway "has been provided with stark open channel, fluorescent lighting, to provide a 'clinical' feel."[24] Moreover, Rose and his firm intentionally left out any spaces for visitors to relax in and to temper "museum fatigue." The place is dense with material, multiple images flash continuously, and its cavernous quality can feel overpowering. "The point is to make a strong point" in peoples' minds, Rose argues. "It's not about comfort. It's about discomfort."

ALL THOSE WHO ENTER

The most remarked upon feature is the setup of the museum's entrance, which one journalist described as "a shocking coup de theatre."[25] Every visitor's ticket serves as a *dompas*-like identity card that arbitrarily classifies him or her as "white" or "nonwhite." The two groups pass through different steel turnstiles and are then shunted along separate paths where replicas of signs marked *net blankes* [whites only] or *net nie blankes* [nonwhites only] communicate the daily indignities the apartheid system accorded those it categorized as despised others.

People who are directed along the nonwhite route are confronted by a gigantic blown-up photograph of four white men sitting on the infamous racial classification board, which determined what category people officially fit into. This group administered the notorious "pencil test": if a pencil that was passed through a person's hair stuck in place, it was considered to be a telltale mark of non-European blood.[26] Through such rudimentary practices of racial "science," people were switched from one category to another. Today you may scan the rosters of such changes and appreciate the comic absurdity of the system. At the time, however, these decisions were terribly consequential; they determined an individual's chances in life, and even broke apart families.

The dual passageways merge further on, and thereafter everyone proceeds through the museum proper. According to Christopher Till, "We debated what to do in that first experience: separation, type casting—[there were]

many ideas that we played around with. And our consensus was that you have to give people that real experience of what it was like to be separated. Those of us who grew up here remember that very well. The kids don't know that." Till believes that the average person typically recalls only two or three things from a museum visit. That being the case, he wished for that initial forced division to be seared into people's minds.

But arbitrarily "classifying" people by race at the entrance is beginning to seem obligatory in institutions or exhibitions focusing upon racial oppression and injustice. Visitors to the Holocaust Museum in Washington, DC, are issued similar identity cards from one of several groups of victims of the Nazis. Those attending *Field to factory* (National Museum of American History, 1987) were given the choice to proceed through either the "white" or "colored" entrances to a segregated train station, in an exhibition whose focal point was the Great Migration of African-Americans from the South to the North. And at the second Johannesburg Biennale, artist Coco Fusco put up a mock control point at the foyer where visitors had to buy "passbooks" similar to the *dompas* that black South Africans were once forced to carry.

The question is, "Do a majority of visitors experience this feature as a profound and unsettling encounter, or as a trivializing gimmick?" There is the possibility that this element becomes hackneyed or almost "game like," particularly for the well-traveled museum goer.

Nevertheless, isn't that beside the point? To whom, after all, is this museum ultimately geared?

An American architect who is rabidly critical of the Apartheid Museum finds the two pathways at the entrance "particularly weak" and "trite." She also condemns the "obvious inappropriateness of the site."[27] But to be fair, part of the triumph of the museum is how its designers have worked with the contradictions of the location and with the unusual genesis of the project. As in so many other situations in contemporary South Africa, the more time you spend observing the country, the more paradoxical it becomes, and the less certain you feel about making sweeping statements.

She touts, on the other hand, The Museum of the People's Struggle, which was still under construction in Port Elizabeth at the time she was writing. She applauds the fact that this museum will shun the "master narrative" strategy employed at Johannesburg's Apartheid Museum. In the newer project, a series of room-sized "memory boxes" will present distinctive perspectives on racial segregation, pre-1994. But here's the catch: the Port Elizabeth facility has yet to welcome visitors.

There is no way to be certain in advance if a concept that may be highly satisfying to designers steeped within postmodernist discourse will be suitable, or comprehensible, to the very people whose experiences it is meant to reflect. The Apartheid Museum may disappoint the jaded museologist, the self-righteous architect, or the fiery critic. But it may very well suit those who did not experience apartheid directly, and yet whose lives are nonetheless affected by its long-term consequences. It also likely speaks effectively to those who have had limited exposure to museums.

Under Interrogation

Inevitably, other criticisms have developed as well. According to Christopher Till, "I'm only aware of one guy storming out of the place, and it was a guy who said it was communist propaganda." And a well-known local newspaper columnist has argued, "So what is dead about apartheid? What can you really distil and put in a museum and say: 'That was then: thank God it's all over.' "[28] But that presupposes that museums are exclusively the domain of the defunct and the antiquated, rather being places that can initiate dialogue and stimulate debate about past as well as contemporary issues.

And that is exactly what has occurred with the public controversy that has raged over the relative absence of attention to the antiapartheid activities of white liberals such as former parliamentarian Helen Suzman. An editorial in *Focus*, a publication produced by the Helen Suzman Foundation, mockingly dismisses such displeasure by reassuring its readers that she does indeed appear there—three times, in fact—but "it took an eagle eye and five hours to find her."[29] Christopher Till counters by saying, "We stopped pulling out individuals specifically and making them [into] idols. . . . Otherwise, where do you begin, and where do you end?"

Moreover, because of the inclusion of the history of white settlement in Johannesburg, as well as Southern Africa's precolonial history, the actual focus of the museum is in some ways indistinct. Till admits that there are junctures where it is difficult to understand how to proceed through the exhibition, and how to stick to the narrative. He says that he is 50 percent satisfied with the way the museum has been set up, but he feels that there's "still 50% [of the way] to go until we achieve all that we can, and need to."

To complement its bold architecture and austere interior, the Apartheid Museum has launched a very sleek and brash publicity campaign to promote itself. One series of posters features pairs of kids, black and white, frolicking at the beach, playing soccer, or having fun on swings. Each ad then cautions viewers to "Remember what freedom costs us." One after another, they juxtapose the grim statistics against a contemporary image of carefree childhood: "15 thousand exiled," "10 thousand dead," "22 thousand tortured."

Another set bears such clever mottos as "Race: If someone wins everyone loses"; "Apartheid is exactly where it belongs; Apartheid Museum now open"; and "This time everyone pays." These ads have garnered awards locally and internationally. But their hard-hitting strategy backfired when a provocative television campaign took humor and irony too far for some people's comfort.

Three ads featured a white man, black man, and Indian man, respectively. Each person told a joke. The white man asked, for example, "How do you stop a black man from drowning? You take your foot off his head." The Indian man questioned, "What's the difference between a Jew and a snake? One is a cold-blooded creature and the other is a snake." And the black man suggested, "You've got two Afrikaners; one is fat and the other is thin. If they both jump off a cliff, who will die first? Who cares?"

In each case, the setup ended with the caveat: "If you thought that was funny, we'll show you why it was not." These ads ambushed viewers by setting them up to laugh and then calling them to task for delighting in racist humor. It was a daring approach, but two South African stations banned the spots.[30] Once again, as with both *Miscast* and the peep-show-like art installation that addressed the voyeuristic aspects of Sarah Bartmann's public display, viewers were entrapped in a morally compromised manner. Furthermore, because race is still so freighted with the heavy baggage of the past, many people were offended that it was seemingly being taken too lightly.

Finally, the museum's informational brochure promises that when visitors complete their tours they will "Walk Away Free." But is this not an exaggerated claim that no museum could reasonably fulfill? And is it not just as likely that people will leave with feelings of anger, distress, bitterness, or guilt?

The Whole World Is Watching

Square meter by square meter, Vilakazi Street in Soweto's Orlando West is as saturated with historical significance as any place in South Africa. It is a "must-see" on any tour of this township.

As visitors are continuously told, it is the only street in the world that is home to two Nobel Peace Prize winners, Nelson Mandela and Archbishop Desmond Tutu. Mandela's house has been turned into a museum; Tutu still stays in Soweto part of the time. It is also the site of Orlando West High School and Phefeni Secondary School, and Vilakazi Street therefore became a staging area for the 1976 protests against Bantu education (see below) and the implementation of Afrikaans as a medium of instruction. Echoing what happened at Sharpeville some 16 years earlier, panicked police this time opened fire as students began their march to a rally at Orlando Stadium, setting off an extended period of unrest that seriously challenged the authority and dominance of the National Party. The year 1976 made 1994 possible.

Where Vilakazi intersects with Moema Street, 13-year-old Hector Pieterson was felled by a police bullet.[31] The gut-wrenching photograph taken by Sam Nzima of Mbuyisa Makhubu clutching the limp, mortally wounded body of Pieterson, and with Pieterson's distressed sister Antoinette running in anguish alongside, was reprinted extensively. It propelled the struggle against apartheid onto magazine covers and into newspapers, government chambers, living rooms, and conversations worldwide.

Hector Pieterson became the symbol for the ruthlessness and cruelty of South Africa's power structure. Immortalized as the first fatality of what turned into an extended struggle between South African youth and their rulers, Pieterson's spot in the national pantheon of heroes has been secured for quite a long time.

The Hector Pieterson Museum is located down Moema Street, on a diagonal from where he was murdered. A row of trees, a symbolic "firing line," now visually connects the two places. This is but one way that the museum engages with its environment, powerfully linking history, memory, and place.

Martyrdom and Mythmaking

Mashabane Rose Associates, the architectural firm responsible for the Apartheid Museum, also produced the Hector Pieterson Museum. This place features many of the same design principles as the Apartheid Museum, although in a scaled-down version. By primarily focusing upon an event, it is not as obliged as the Apartheid Museum is to present a sweeping history, or to offer as detailed an analysis of a complicated philosophy of governance.[32]

Mashabane Rose has, in essence, developed a distinctive vernacular for South African sites of memory, including its design for the Robben Island Millenium Structure, and it is also developing an additional site in Durban's Cato Manor, where significant violence occurred between Indians and black Africans in 1949, and where the 1959 Beer Hall Riot occurred (chapter 6). Jeremy Rose states that he hated the early proposals regarding the Apartheid Museum because he felt that they were detached from the lived experience of that time. The ideas were uninspired because they were uninformed by individuals' biographies: the people involved did not have a history of activism, as he did. Rose points out, "We were telling the story of apartheid from our own personal memories of the 1980s, which were very violent, crazy."

Jeremy Rose describes the long process of consultation with community members through workshop after workshop, encompassing large numbers of people, in preparation for a project such as the heritage center in Cato Manor. The architects were interested in the convergence of dual group histories: Indians moving across the ocean, and Africans moving into cities, and the distinctive South African culture that evolved once they had made contact.

But what was once a predominantly Indian area of residence is now primarily black. And the locals were not necessarily interested in the same things that the architects were. Current residents preferred the proposed museum to have "an African feeling" and to feature distinctly "African stories," that is, displays of what was in *their* own living memories.

"You always get criticized for not doing enough," Rose says. "It is an easy punch to say, 'You did not talk to this person.' " No matter how knowledgeable and passionate professionals might be about a particular subject, their target audience may embrace starkly different interests and inclinations. And "balance," "fairness," and "accuracy" may not be a community's priorities.

Ali Hlongwane, curator of the Hector Pieterson Museum, recollects a large number of meetings also leading up to its establishment, and lots of alternative proposals for how to use the land. Black businessmen, for example, floated a plan to construct a service station at the site. At one meeting that sticks in his mind, an elderly lady living in the community stood up during a meeting. Clutching an old press clipping of the shootings, she emotionally blurted out, "They can't build a petrol station there, there can't be a motel, because that is where our children were shot."

As mentioned earlier, this museum traces its beginnings to a display of photos assembled to commemorate the twentieth anniversary of the Soweto

uprising of 1976. The exhibition proved to be enormously popular, and community interest called for something more permanent and distinguished. From origins in shipping containers adapted into makeshift gallery space, therefore, a modern facility eventually emerged.

Researchers and others familiar with the area contributed to the final form of the museum's permanent exhibit, including a now elderly man who was one of the few journalists to whom the students spoke freely because he had won their confidence, and a professional historian who was a Sowetan student in 1976. The June Sixteen Foundation, a group of people who played leadership roles during the uprising, also contributed to its development. And the process continues to unfold: the museum solicits oral histories from people with personal ties to the Soweto uprising, and members of the public sometimes come in with information that is incorporated into changing the narrative.

Hlongwane recalls that in the early stages of planning, there was considerable debate about whether the demonstrations were guided by the ANC, the PAC [Pan African Congress], or the Black Consciousness Movement. In the end, the team working on the storyline reached a consensus that the young people were paramount in this instance—not the political parties, or any acknowledged leaders of the liberation movement. They had not been taking up the same issues that the students were.

Because up to 90 percent of the paid visitors are foreign tourists, the museum continues to conduct focus groups with local residents to discover what the place means to them, why they do not come in large numbers, and how to draw them in more effectively. The museum brings teachers, everyday workers, and young people into these discussions with the hope that they will spread the news about what they have seen. Not surprisingly, since the area suffers from high rates of unemployment, local interest has centered most strongly upon how the museum might generate jobs. In the community's mind, this has been a priority since the project was proposed.

History Is in the Streets

The Hector Pieterson Museum uses basic and unadorned materials: steel, brick, glass, concrete, and stone. A great deal of ambient sound has been incorporated: the chanting and singing of the demonstrating students is heard, "converting religious hymns and choruses to freedom songs," the wall text explains. Blended together against the menacing drone of police helicopters, this conveys some sense of what the estimated 15,000 young people who took to the streets on June 16, 1976, actually experienced. And protest signs made up of odds and ends of cardboard, wood or cloth declare, "To hell with Afrikaans," "Today is the burial of Boere taal [language]," "Kruger, we hate your daredevil language!" and "RELEASE/OUR/DETAIN/ED STUDENTS."

As one contemporary Afrikaner reflects on his language and culture, Afrikaans, along with the languages of many other oppressive powers, "have

blood on their vowels."[33] Up until 1974, children in Soweto were taught in their mother tongues, as part of the separate and unequal Bantu education system. Formalized in 1953, this enterprise was ill funded, staffed by ill-prepared teachers, and designed to channel black African children strictly into unskilled jobs. In 1975, the medium of instruction was changed to English, and then in 1976 they were required to learn math and social sciences (such as history and geography) in Afrikaans. Forced to master these different languages put them at a distinct competitive disadvantage on exams. Students therefore mobilized for a peaceful protest march to voice their displeasure with the new regulations.

Even now it is not clear how many students were killed across the country during the remainder of that turbulent year. Estimates had ranged from 600 to 700, but now it is believed that that many may have lost their lives in Soweto alone. Small bricks in the museum's courtyard are engraved with names of those victims who've been identified with certainty. To date, over 600 of these "headstones" have been scattered across the gravel that carpets the area. More will be added as additional information is uncovered.[34]

Two large video screens present evidence of "apartheid" and "resistance." Elsewhere, monitors juxtapose personal testimony from a frightened policeman with the reminiscences of former protestors. And at another juncture three video displays broadcast period scenes of "Life in Soweto," while only one presents "Life in White Areas." There is no question as to which realm the museum is prioritizing.

Very few three-dimensional items survive: school uniforms and exercise books from that time were typically passed on to younger brothers and sisters and used until they were ragged. Had the police not confiscated the students' placards, writings, minutes of meetings, and other miscellany, even less material would exist. For example, a trash can lid that students used as a "shield" is displayed: what was once collected as "evidence" now provides an unforeseen, and poignant, sort of testimony. And were it not for the police surveillance photos, scant information would have been preserved about what the crowd scenes actually looked like.

Visitors follow a linear narrative as they ascend the interior walkways of the building. It is significantly enhanced by the conversation between the building and its environment: the carefully calibrated placement of spacious windows creates vistas of key places of interest, dissolving the boundaries between inside and outside. Look through one of them and you see Vilakazi Street, and the two schools from which the students mobilized. Through another you spot Orlando Stadium, the proposed endpoint of the march. And one more directs your attention to the Orlando police station, from which officers were dispatched on that fateful day.

The significance of each of these locales and others is explained by text overlaid upon the glass. This deliberate design feature thereby enlarges the perspective the museum presents by pushing it beyond the museum's walls. It integrates the physical landscape with the narrative in a truly compelling way.

EXHUMING SECRETS

If a baby boomer, particularly a male baby boomer born before 1957, could not whistle the jaunty theme from blockbuster movie *The bridge over the River Kwai*, it would raise as many questions about his social aptitude as it would his about his basic skills. Today, the popularity of that story endures, and intrepid sightseers make their way in large numbers through the Thai countryside to view it. In Thailand's pantheon of tourist sites, it shines.

However, not everything is as it seems. The spelling of the river's name is inaccurate; the structure that people see today is largely a reconstruction; and it was originally built on another waterway altogether.[35] But bringing all that to light would significantly dilute the mystique of the story.

So what do you do if you discover that the specific character that draws people to your eponymous heritage site represents an instance of mistaken identity, and that even his name is in dispute? In the case of the Hector Pieterson Museum, you hew closely to the folklore, but make minor adjustments to the legendary storyline.

Was Hector Pieterson in fact the "first fatality" on June 16, 1976? According to Ali Hlongwane, who was himself 11 years old then and recalls an older sister's involvement in the demonstrations, no. A boy named Hastings Ndlovu warrants that distinction.[36] But no photo of Ndlovu's lifeless body was broadcast across the globe. Pieterson has been granted immortality because a keen photographer's eye froze him in time, shortly after a bullet mortally wounded him. *He's* become the icon, irrespective of the actual facts of that day.

Apparently this was previously known amongst some groups of Sowetans. But Hlongwane reports that it was only after visiting the museum that a doctor who had always believed he had attended to Pieterson learned for the first time that he had in fact seen Ndlovu. In 2002, the staff brought both Ndlovu's family and Pieterson's family together for the commemoration of the event. The museum now features testimony from Eliot Ndlovu, the boy's father, validating the oral evidence from that day. Its brochure states in one place that Pieterson was "among the first student victims to die from police shootings," and in another, "Hastings Ndlovu was together with Hector Pieterson, the first casualty in the first encounter between the police and the demonstrating students."

Moreover, various spellings of Pieterson's surname have been accepted at different times. The group monument to the victims of 1976 at Soweto's Avalon Cemetery lists "Peterson," for example, as does the inscription on the memorial square outside the museum, erected by the ANC Youth League: "Hector Peterson and all other young heroes and heroines of our struggle who laid down their lives for freedom, peace and democracy."

But as it turns out, the family name had been Pitso, of Setswana origin. The father changed the name from an "African" to a "coloured" one in order to secure whatever additional advantages might accrue from that status. He transformed Pitso into Pieterson by a simple process of enlargement: PIeTerSOn.[37]

He acted, in essence, as his own personal racial classification board, a gambit taken by others whose skin tone and other physical characteristics could credibly allow them to "pass." Had Hector not been swept into the glare of publicity, the world would not have known what his father had done. But now the family has agreed to the museum publicizing the story. What might have been secretly shameful in an earlier time is now more sympathetically comprehensible as a compromise with a repressive status quo that offered those on the bottom few opportunities.

Beyond validating the individual martyrdom that the media spawned, a curiously nonheroic trope cuts through the museum as well. The families of both Hector Pieterson and Mbuyisa Makubu play down what their sons did on June 16, 1976. Makubu's kin are quoted in the museum as saying that he was acting as "an African brother" by carrying Pieterson's body away from the place where he had been shot. Had he not acted compassionately, they insist that he would have been shunned by the community.

The relationship between social memory and factuality is always dodgy and selective. In this case, the museum has chosen to sustain a mistaken impression in order to tell an important story. This enables a specific, named individual to powerfully personify a much larger event. If it had not adopted this strategy, would people be as likely to come through its doors?

IN THE AFTERMATH

Antoinette Sithole, Hector Pieterson's sister, works as a guide at the museum. Her education, so seriously disrupted in 1976, was never completed. A younger sister is a member of the police force, an accomplishment that would have been unfathomable that day when her brother took to the streets. Sithole rejects any notion that she is a celebrity.[38]

Mbuyisa Makhubu, the boy who carried Hector Pieterson, fled into exile, reportedly to Botswana and then to Nigeria, where he allegedly became mentally ill. There is some mystery regarding his death. His mother succumbed to heart failure at age 71 in 2004, and she never discovered his precise fate or where he was buried.[39]

The famous image that Sam Nzima snapped thrust him into the spotlight and dramatically altered his life. In the immediate aftermath, security police interrogated and harassed the man, threatening him with arrest. Nzima consequently put away his photographic equipment and opened a bottle store in order to sustain his family. It was not until 1998 that he finally won the copyright to his work, thereby bringing him royalties for the first time. And in 2004 he bought a new camera and resumed the career he had abandoned, and plans to develop a museum dedicated to social documentary work.[40]

Afrikaans, once despised in Soweto and other black enclaves as the "oppressor's language," is enjoying renewed popularity. With the fall of apartheid, the language has become uncoupled from its identity as a weapon used by the minority against the majority. In fact, today in Soweto, those

most likely to speak it are over the age of 40, the very group that would have grown up during the time when its use was so hotly contested.[41]

Of the 11 official languages in South Africa, Afrikaans is the third most popular language used at home today, after isiZulu and isiXhosa. One proponent effusively notes, "[I]f you are sitting in a bar [in Soweto], speaking English is seen as elite—but Afrikaans is a bridging language. People might start speaking English, but after two or three drinks, they loosen up and speak Afrikaans. It's in the blood. Afrikaans was born here, it's an indigenous language."[42]

The date June 16, 1976, obviously made an indelible imprint upon the collective South African psyche, altering relations between the generations and amongst different racial groups, and impacting fundamental institutions of education, economics, and politics. One writer bemoans the fact that even basic pleasures were curtailed after June16, irrevocably altering the celebration of holidays: "Christmas . . . became a weapon or arena of struggle," he laments. "Christmas never recovered its lost luster. Just as our education system has yet to recover from June 16. Some things, once broken, are never easy to put back together again."[43]

June 16 is now commemorated as Youth Day. The Hector Pieterson Museum opened on this very date in 2002.

It is widely agreed that today's youth live in a markedly different world than their cohorts did 25 years ago. This generation of teenagers and young adults has come of age in era of freedom; they can take that for granted, and are markedly depoliticized. They enjoy the fruits of that earlier struggle, but only to the extent that economic opportunities have actually opened up.

While glaring inequalities persist, without question, the causes are complex and who the "enemy" may be is not as clear-cut as it was in 1976. Moreover, the generation of 1976 was fighting for the future, but the scourge of AIDS makes it difficult for young people today to imagine having a future. A stunning newspaper headline in 2003 summarizes the threat: " 'Half of boys aged 15 will be dead [from the disease] by 2015.' "[44]

Many South African cultural and political commentators wring their hands that the youth seem to have been seduced by consumer culture, much as kids around the globe have been. The "born-frees" appear to value brand name *tekkies* [sneakers] more than devoting their energies to the struggle for a nonracial and more equitable society. And even the ANC Youth League, allied with the International Union of Socialist Youth, includes a "lifestyle" section on its website that offers advice on décor and personal style, touting the trendiest models of shoes, clothes, and sports cars.[45]

Like other legendary historical figures, Hector Pieterson has been commodified, in this instance by a team of young creators who launched a line of clothing during South African Fashion Week in 2005. Among their designs was a t-shirt featuring an imagined report card bearing Pieterson's name and with "Afrikaans" highlighted by a failing grade, and another that reproduced Sam Nzima's unforgettable photograph.[46]

The challenge for places like the Hector Pieterson Museum is to carefully piece together and preserve the history and memory of a momentous time,

even if the actual facts do not hold much appeal beyond the superficial to many of its direct beneficiaries at present. As an American journalist wryly notes, "History, Karl Marx might have observed had he been more savvy about public relations, repeats itself first as documentary, then as a panel discussion."[47]

Figure 10 In conjunction with the 2000 world conference on HIV/AIDS, the Durban Art Gallery swathed the circumference of the city hall, also the gallery's home, in a 500-meter long red ribbon to promote AIDS awareness

Source: Courtesy of the Durban Art Gallery.

The New South Africa: Old
Routines and Current
Political Realities

Africa's not for sissies.

Art's not for sissies.

popularly attributed to former
President F. W. de Klerk

Leigh, 2002

An eye-catching feature at the Amathole Museum in King William's Town consists of two kudu skulls, their horns entwined in a beautiful, even lyrical sort of figure-eight design. But this is no taxidermist's folly. The splendor of the display masks the brutal fact that these bulls fatefully locked one another in mortal combat. They heaved and jerked themselves to complete exhaustion, a stubborn, sustained seesawing that led them both to inevitable death from starvation and dehydration. Memoirist Alexandra Fuller recalls stumbling upon one of these similarly odd "trophies" from a pair of impala rams in the Rhodesian veld, describing her discovery as "an embrace of hatred that had killed them both."[1]

Without being overly dramatic, it is fair to say that museums of every sort, size, and location in South Africa are themselves engaged in a momentous struggle these days, to redefine and reposition themselves so that they can adapt to and thrive within a changing social and political environment. There is no shortage of new ideas in these venues. But regrettably, transformation has occurred clumsily: for every step forward, there have been forces that have held or even pushed museums backward. The term that South African museum personnel repeatedly use to describe the situation they face today is "transitional."

To the Victors

After the democratic elections of 1994, it was time to divvy the spoils of government posts. The biggest beneficiaries were heroes of the liberation

movement, facilitators of the complex political negotiations that enabled the regime change, and ANC stalwarts.

Both of the highest appointments at the Department of Arts, Culture, Science and Technology were surprises, and they raised questions about how the new government would act in regards to cultural institutions. Dr. Ben Ngubane snared the top post, even though he had a medical background. And the deputy minister position went to Winnie Mandela, the charismatic but controversial wife of the new president.

Her initial reaction was reportedly that she believed the assignment to be "a joke," and she thought it a "weird portfolio." Crediting Deputy President Thabo Mbeki with the match up, some observers considered it an inspired example of co-optation, as "guided by U.S. President Lyndon B. Johnson's observation that it was better to have potential troublemakers 'inside the tent pissing out, than outside pissing in.' "[2]

As events unfolded, this was a relatively short-lived episode in Winnie Mandela's colorful and contested biography. The "Mother of the Nation" worked at odds with her boss; the newspaper headline "No-show Winnie's in the poo again" illustrates her troubled term.[3] Mandela was dismissed from the government in less than a year because of corruption allegations.

But Dr. Ngubane's tenure straddled both the beginning and end of the first decade of democracy, with a chunk of time taken out in middle by serving as the premier of KwaZulu-Natal Province. The policies set during his command fundamentally shaped how museums operated during those first ten years of democratic rule.

There were calls in some quarters for an end to public funding of the arts almost at the outset. Ngubane argued for its continuation by invoking the constitutional right to freedom of expression, and by referencing a clause of the Universal Declaration of Human Rights that affirmed the common right to enjoy art and to participate in cultural life.[4] But this lukewarm interest in the arts was held by many officials, and reflected a relative lack of public enthusiasm for cultural matters in general.

Accurate data is difficult to come by, but in 1996 the director of the Johannesburg Art Gallery pegged the number of museums throughout the country at approximately 500, ranging from major to minor, from art and natural history to banking, medicine, mining, and even Africa's first and only museum dedicated to pigs, the Porcinarium. Another estimate at the time put it at 400 plus.[5] Two years later, the director of the National Cultural History Museum in Pretoria was quoted as saying, "In the last four years, more museums have shut down than in the entire history of South Africa."[6]

Eye-catching newspaper headlines from 1996 through 1999 tell the dismal story: "Art collection at the crossroads," "Museums fight to exist," "Museums hit by cash crisis," "Beggared museums at a standstill," and "Bankrupt Albany Museum closes."[7] When the ANC-led government assumed power in 1994, it was faced with a legacy of massive social problems brought about because the apartheid regime had largely neglected the needs of the majority of the

population for years. Museums would hardly be a priority in the new era; unemployment, inadequate housing, and other critical matters overshadowed cultural issues.

Budget shortfalls became routine for museums, sometimes measured in millions of rands. Invoices for municipal services became seriously delinquent. And government subsidies failed to cover even staff salaries in many instances. Needless to say, activities such as acquisitions, collection management, or even routine facilities maintenance were deferred.

Moreover, as job vacancies occurred, positions were typically frozen and then remained unfilled, triggering a severe downsizing that forced remaining employees to stretch their efforts to cover a broader range of duties. While some "old-timers" buckled under the pressure and left, those who remained have been forced to deal with ever-increased workloads. It has left many museum employees overwhelmed and demoralized.

In 2000 the president of the South African Museums Association reported large numbers of staff vacancies in member institutions. In the case of two Johannesburg locales, the Art Gallery and MuseuMAfricA, merely 73 of the combined 149 posts were occupied.[8] And these conditions did not begin to ease in most places until 2002 or 2003.

These statistics become more real when they are based on actual testimony. Dr. Julia Wells, for example, reports that about a third of the positions at the Albany Museum in Grahamstown were vacant in 2003. And Dr. Manton Hirst likewise estimated that a third of the staff at the Amathole Museum was "nonexistent." The government has been unfreezing positions gradually since the millennium: Hirst notes that his institution got the green light in 2003 to fill an anthropology vacancy that had been open since 1996. These are clearly crisis conditions.

The only museum in South Africa that has an endowment earmarked for acquisitions is the Johannesburg Art Gallery, sponsored by the Anglo American (mining company) Centenary Trust. In 1998 JAG suffered roof damage, foreshadowing the disastrous flood whose effects I witnessed in 2000 (see preface). That left JAG in the difficult situation of being able to grow the collection but not having the capital funds to guarantee the proper conservation of it. Even though JAG could not simply shift monies designated for one domain to another, one person wrote, "galleries countrywide have to flip a rapidly depreciating coin to decide what takes priority: updating collections, arranging exhibitions, developing outreach programmes or repairing leaky roofs."[9]

More recent estimates place the number of museums in South Africa in the range of approximately 350. Taking into account a statement published in 2002 that claims "a large proportion hav[e] been established in the past six years,"[10] the impact of insufficient funding since 1994 has been enormous.

GETTING THERE

The ascent to the top position at a South African museum proceeds along many unanticipated paths. Ali Hlongwane mainly worked as an actor before

becoming chief curator of the Hector Pieterson Museum. The training Sandra Prosalendis received positioned her for a career in dance or film, before she assumed the helm of the District Six Museum. And Ivor Pols, who completed a PhD in the history of art from a university in Holland, started up and ran a piggery for seven years before he became director of the Voortrekker Museum. He feels that managing a large-scale business such as this was immensely helpful in executing his museum duties throughout 25 years.

Jenny Hawke, curator of the Fort Nongqayi/Zululand Historical Museum in Eshowe speaks quite candidly: "I have no [formal] qualifications for this job" she says. "My qualifications are that my family has been here in Africa since 1860, I am an old time resident of the town, I know the people and a lot of the history, and I have always been in the retail business and am a 'people person,' and that is what this job is mainly about."

Sian Tiley, an archaeologist who curates the Mapungubwe Museum in Pretoria declares, "I work on gut feeling, literally." And Ann Pretorius of the William Humphreys Art Gallery in Kimberley disavows having any "high-falutin' academic qualification," and characterizes her training as mostly hands-on. With a fine arts diploma from a technikon, she worked her way up from display artist to junior technician to collections manager, and eventually became director. Over time she has done everything in the museum, including cleaning the toilets. She knows the place "front to back." In a self-deprecating manner, Pretorius reflects, "I think I am probably in a position that astounds many people because I don't have a wonderfully academic background . . . I felt that had there been a really stunning application I wouldn't have gotten the job [of director]."

And although there are, indeed, highly trained professionals working in South African museums and doing precisely the type of work for which they trained, Similo Grootboom admits, "When I joined the Directorate of Museums and Heritage Resources [in the Eastern Cape, as acting director] . . . I literally knew little more about museums and what they stand for, than the average matric student in a township school today."[11]

People become museum directors in many different ways: by persistence or by default, through their racial status or political connections. The last two factors have always been important. Only now, the difference is that the parties who hold the advantage have changed.

MAKING DO/DOING RIGHT

South African museums feel strapped most of the time; museum directors generally continue to grapple with insufficient funds. One of the most significant developments helping to alleviate deficits in recent years is the availability of sizable government grants specifically earmarked to expedite transformation. It is a classic example of using the carrot instead of the stick to motivate change. In this case, it is to further the goal of increased representation and participation in museums by different groups of people.

According to Vusi Ndima, chief director of heritage at the Department of Arts and Culture, the ministry invites museums to change by offering them the funds to do so. Rather than dictating specifics, it allows museums the time, resources, and social space essential to addressing and meeting broad policy objectives. He reports, "There isn't any museum that has said 'Look, we're not going to play.' "

While the department has embraced this noninterventionist policy, its commitment to volunteerism and its wait-and-see attitude could be reevaluated and revised, should institutions seem to be dragging their feet in confronting the inequities of the past. Ndima cautions, "We would have to ask questions to those who are not coming to the party."

But as welcome as transformation funds are, Ann Pretorius does not believe that government officials are very good at communicating what, exactly, they expect to be done. She reflects, "We have been fantastically lucky in this country that things have worked out so well. It has been quite an emotive issue to walk into a museum and say, 'You know, you have to transform this institution.' But then they don't sit down with you and discuss what that is. . . . If things were in fact a little more transparent and better managed, I think maybe we would have been further down the line by now."

Transformation funds, welcome as they are, are not a panacea; they cannot eliminate the chronic scramble for basic operating cash. General John Keene, chief curator of the South African National Museum of Military History, characterizes the resource problem succinctly: "We operate off the fumes from an oiled rag," he declares. And Judy Jordan, curator of the Carnegie Art Museum in Newcastle, admits with a dash of humor, "We are storing half the collection in the loo." Ask to use the museum's facilities and you will discover that this is hardly an exaggeration.

Guy Redman, who directs the Durban Natural Science Museum, says that other museologists would be shocked if they saw the conditions to which its collections are exposed. He reports that temperatures in the storage areas fluctuate widely, humidity is high, and items are stacked one upon another because of inadequate space. Furthermore, people in adjoining offices use the storerooms as thoroughfares; it is not possible to lock the doors because they serve as entrances and exits along certain routes.

The museum's holdings are thus subject to all sorts of risks, including theft.[12] And conditions are continually deteriorating. Even so, "Politicians don't respect and appreciate the value of museum collections," Redman argues. Lacing his comments with a cynicism born from repeated experience, Redman believes that officials only concern themselves with museums as a means to showcase themselves. "Politicians use you to look good," he asserts, observing that they offer enthusiastic support only on special occasions such as Museum Day and Heritage Day, occasions that provide them photo ops and sound bites.

Jenny Hawke grumbles, "I feel that we have actually tried very hard to comply with moving ahead, and not just lying down like dead cockroaches and saying 'What can we do, we have no money?' " But challenges persist.

Other museum directors talk about having to resist throwing their hands up in exasperation. Their jobs increasingly entail networking, building partnerships, cultivating the good will of potential benefactors or businesses or artists or galleries. They must perpetually be on the lookout for money, their eyes always attending to the bottom line. They are forced to hustle.

It is easy to become demoralized. In the words of Sharon Crampton, director of the Oliewenhuis Art Museum in Bloemfontein, "I can lean back and say, 'I don't have money for this, I can't do that. Or you can try and do something." She continues, "I know a lot of people sort of lift their eyebrows and say, 'What now?' I just feel you either do it or you don't. . . . Get the community involved, the business sector, private people, and so on. We do that."

"That" has included hosting jazz and rock concerts, annual "Shed Your Skin" fashion shows that spotlight zany creations by artists, and commissioning the colorful African Carousel, which features fanciful creatures crafted by local talent. When a long-forgotten underground cistern was rediscovered on the property, the museum turned it into The Reservoir, an additional exhibition and events area.

But at the same time that all these activities bring in crucial funds, they also divert staff attention away from the museum's core functions. Oliewenhuis eventually privatized its restaurant: "We couldn't cope with it," Crampton recalls. "I was so distracted by people complaining about stale cake and stuff like that. It was just too much."

I have only run across two exceptions to the general premise that South African museums are unendingly facing severe deficits. General Keene reports that strangely enough, the South African National Museum of Military History has been more successful in securing funds from the current administration than from previous ones. On first glance, that seems to defy logic: a black-dominated government sustaining a museum that celebrates the country's past military might?

But Keene explains that the National Party basically turned a blind eye to its needs because the museum presented the story of South Africa's involvement in World War I and World War II. The Nats disagreed with the country's participation in those conflicts, events that took place before it seized power. In Keene's words, "They had become Nazis, really." As a consequence, he says that they received nothing from the previous leadership. "We probably can't do worse than that," Keene adds drolly.

And Pam McFadden, the indefatigable curator of the Talana Museum in Dundee, boldly pronounces, "When we run out of space we add a new building." It is not a flip remark: the museum consists of more than a dozen buildings spread over a 20-acre heritage park. "Talana" is isiZulu for "the shelf where precious items are stored," and this museum fills them to overflowing. Moreover, after the museum reached capacity within the existing structures on the property, it put up more.

In 2004 Talana erected new buildings to house Zulu beading and weaving projects, for example. These provide job training and marketing skills to local residents. Plans are also being developed for a traditional Zulu village, a restaurant,

gardens, and a hall and amphitheater designed to hold 10,000 people! Moreover, the Talana Museum is remarkably accessible: it is open seven days a week and closes only on Good Friday, Christmas, and Boxing Day. It is the anomaly among South African museums, a "rate buster" in the quest to keep afloat.[13]

An article in a South African art magazine in 2003 brilliantly captured the precarious financial situation that continues to face the majority of this country's museums: an illustration shows an intravenous drip labeled "government funds" jammed into the outstretched arm of one of the fallen figures in Picasso's *Guernica*. Ominously positioned just above the man is a pair of scissors and a "cut on the dotted line" icon.

A quick snip of this lifeline will silence his desperate cries of pain.[14] And as noted earlier, in a country struggling to cope with urgent social problems, museums are an understandably low pocketbook priority. Funds flowing from national, provincial, or local authorities upon which every museum depends remain skimpy and uncertain at best.

At the end of the day, no one seems satisfied with whatever progress has been made toward transformation over the past decade. Museum administrators are caught between the high expectations that government officials have for them, a sincere motivation on their part to alter accepted ways of doing things, and a very real money crunch. The phrases you hear repeated over and over are "unrealistic goals," "no quick fixes," and "no short-term solutions." Transformation is fated to become an ongoing process, continually remaking so many aspects of museum operations that have long been entrenched.

A Titanic Model?

I found a copy of a hand-drawn cartoon in the files at the South African National Gallery [SANG] entitled "The Flagship: A Monster with too Many Heads." It depicts a creature with an elongated body and five scrawny necks. Through a dialogue balloon, the first head orders the others, "Let's cock our collective leg." The next retorts, "No, I don't feel like it," and a third chimes in, "Are we piss artists or piss scientists?" One of them is marked "Ms Martin"; the arrangement of the letters almost simulate a crown resting atop the skull of the director of SANG.[15]

The drawing offers up an image of acute unwieldiness, confusion, and immobilization. When Marilyn Martin reflects on the time period leading up to the establishment of the flagship institution into which the SANG was eventually incorporated, she notes, "Morale deteriorated, and at times it felt like taking slow poison."[16]

The flagship concept merges a variety of organizations under a common administrative structure, somewhat along the lines of the Smithsonian Institution. The idea is to eliminate duplication of support services (e.g., public communications, clerical duties, libraries), and to facilitate sharing collections and expertise across both traditional institutional boundaries and disciplinary lines. In theory, it is a rationalized system that would be cost-effective, while at

the same time creating exciting new collaborative opportunities. But that is in theory.

The Department of Arts, Culture, Science and Technology has created two flagships to date: Iziko Museums and the Northern Flagship Institution [NFI]. As noted in chapter 3, Iziko was formed in 2000, incorporating the SANG, SAM, and over a dozen other cultural institutions within the Cape Town vicinity: historic houses and buildings, art collections, conventional museums, a planetarium, and a fossil park. This reorganization created three broad areas of concentration: art, social history, and natural history. The Northern Flagship Institution was established in 1999, and it encompasses an equally eclectic array of eight establishments in Gauteng province, ranging from the Transvaal Museum, the National Cultural History Museum, the Willem Prinsloo Agricultural Museum, and the Tswaing Crater Museum (all located in or around Pretoria), to the South African National Museum of Military History in Johannesburg.

Proponents, understandably, hype the advantages of the flagship. Vusi Ndima believes the flagships are less cumbersome than expecting all organizations to be responsible for every conceivable task of managing a museum or historic site, and better prepared to conform to a wide and constantly changing variety of government regulations. Makgolo Makgolo, NFI's CEO, emphasizes the ways in which flagships streamline tasks and conserve precious funds: salaries that would otherwise go to redundant activities could be dedicated to core functions instead. And Neo Malao, manager of the National Cultural History Museum, believes that the expertise and network of contacts that she has built up from her previous positions in NGO's and within the government now give her organization a competitive edge when dealing with officials. Having had no prior experience working in cultural institutions—although she worked *with* them while she was employed at the Department of Arts, Culture, Science and Technology—it is much less likely that Malao would have been tapped to head one before the restructuring brought on by the flagship.

Dr. Patricia Davison, director of Iziko's social history collections, has seen constructive outcomes from the reorganization; less stringent boundaries have indeed aided certain joint projects. Iziko's *Democracy X: Marking the present, re-presenting the past* (2004) celebrated South Africa's first decade of democracy. It brought together Iron Age artifacts, fine art, European and native artifacts, photos, and historical documents from throughout Iziko's collections, in a sweeping survey hosted by the Castle of Good Hope.[17] A similar exhibition potentially could have been assembled before Iziko came into being, but the flagship structure obviously makes it simpler to envisage a show of such magnitude, as well as eases its execution.

But Davison also feels that Iziko has generated all sorts of bureaucratic problems, and her portfolio seems unmanageable at times. In addition, the changes have breached peoples' comfort zones and created lots of additional pressures for employees. In some cases, individuals have become defensive about their turf, causing them to resist new arrangements and procedures.

Of course, territorial battles are hard fought in any type of organization, and power and jurisdictions are only ceded begrudgingly. However, the flagship has shaken up long-established divisions of tasks and lines of authority on a broad scale. As Davison's colleague Donald Klinghardt knowingly observes, there have been "a lot of teething problems." Furthermore, the NFI limped along under the command of a number of temporary appointments until a permanent CEO took over in 2003. That created a great deal of insecurity among employees throughout the system in the interim.

Critics of the concept, in fact, seem much more common than proponents. Major John Keene dubs the flagship model "a complete flop," and he argues that the Pretoria headquarters are "grossly overstaffed," creating a "huge, heavy, highly paid top structure" that's unaffordable. He resents the burden of having to help keep certain other sites afloat because of their past mismanagement or bloated staffs. And the head of the Transvaal Museum noted, "All museums are in a serious financial state and amalgamating them will only create one amalgamated financial problem."[18]

From what Gilbert Torlage of the KwaZulu-Natal provincial museum services office has picked up "through the grapevine," flagships do not work too well. There's been a great deal of "bloodletting," he's heard. And while he can understand consolidating such areas as design and display development, he cautions, "Museums develop their own kind of ethos, their own personality, connected to the personalities that are within the museum. And to then kind of try and put museums together into one entity, I could not see that working from the very beginning."

One of the most obtrusive aspects of the flagship model is also one of the most minute: the change in basic terminology. Neo Malao refers repeatedly to "my company"; Mariana Zdara of the Prinsloo Agricultural Museum used the term four times during her interview. Malao and Zdara are "managers," a title that is replacing "director" or "chief curator." And CEOs command both Iziko and NFI. The business model prevails.

Jill Addleson of the Durban Art Gallery feels that equating museums to other forms of commerce is detrimental. They cannot and should not be measured in the same terms, she argues. And Steven Sack, who has worked for many years in government agencies focusing on cultural affairs, believes that the concept has some merit and yet he feels guarded about it just the same: "You have got to add this kind of balance of power between the people who understand the content and people who are managing the administrative process. That is quite key."

Museologists roundly rejected a third proposed flagship for Kimberley and Bloemfontein. In particular, the staffs of the institutions in Kimberley that would have been affected (the William Humphreys Art Gallery and the McGregor Museum) felt that they would be engulfed by their counterparts in the Free State (the National Museum and the War Museum of the Boer Republics). They feared a loss of identity, having to scramble for a fair share of funds, and possibly even a transfer of parts of their collections. What they had observed elsewhere in the country made them shudder.

Perhaps the most unique attitude toward the flagships is that of Mark Read, chair of the NFI's board of trustees. Rather than giving the concept an unqualified endorsement, Read holds some doubts about its underlying logic and efficacy. "The intellectual reason for the founding of it sometimes escapes me," he admits. "I feel that museums are best run by people who are passionate about particular types of material. I am wary of these government decisions to group museums under a big umbrella," he admits.

Read hates the term "flagship." He feels that the greatest museums are "wacky, quirky, noisy places" and not streamlined income generators where the spreadsheet dominates. Read reflects, "I think museums are often best struggling along with passionate leadership, without being grouped together. Maybe the reason why they haven't taken off is because they shouldn't."

STRIKING A BALANCE

NFI CEO Makgolo Makgolo describes a three-tiered distribution of museum positions that persists with few exceptions, reflecting historical restrictions: whites maintain a near monopoly at the top level of administration, they continue to dominate the middle layer, and blacks remain concentrated at the bottom. This has meant that certain people have given many years of dedicated service without much compensation or recognition, simply because of their race.

Dr. Manton Hirst speaks of an old Xhosa man who has been at the Amathole Museum since about 1976. He was hired as a janitor; during apartheid, it would not have been possible to employ him otherwise. But for all intents and purposes he has functioned as a guide and lecturer. And Tshidiso Makhetha, curator of education at the Johannesburg Art Gallery, relates the story of an old man from Swaziland who has been working as a security guard at JAG for the past 37 years. Makhetha views individuals such as this as an extremely valuable asset: "I think that those people are very, very important because they know the history of the museum, they know what happened when, and how it has happened to who[m]."

When I was interviewing museum personnel, I had the same experience time and again. Ask almost any director or curator about black employees, and you are virtually guaranteed to elicit the following response: blacks either work as cleaners or they are pigeonholed into the education department.

Museums are intensifying their efforts to hook up with previously underserved communities, but they must overcome a pervasive unawareness of what museums are and what they do, or the feelings of suspicion and alienation that attach to them when people *are* informed.[19] Black education officers help museums to bridge the gap between themselves and underserved populations. That is why they were able to break into museum work fairly early on. They have the requisite language skills and social capital to draw new people into these places. And given the historical limits that black Africans have experienced in the past, education is one of the few fields that has been accessible for them to train in.

Museums around the world have typically catered to an elite audience, and South African museums are an extreme example of this general tendency. Race and class have been so closely entwined here that black (and thus underprivileged) audiences have been virtually excluded. One survey reports that 87 percent of whites had visited a history museum, as opposed to 30 percent of black Africans.[20] Since whites make up merely 13 percent of the total population, the statistics regarding intentional, voluntary visits are probably even more racially skewed since loads of school children are bused in, many of them nonwhite.

Reflecting upon the enduring concentration of black employees in certain domains, Ali Hlongwane of the Hector Pieterson Museum notes, "What has happened over the years was that museums took a short cut. They employed black people to be educational officers and then said, 'Well, we have changed.' But the philosophy underlying the museums has not." So with the expansion of opportunities to the so-called previously disadvantaged, why don't you see more blacks, Indians, and coloureds in positions of power in museums?[21]

For one thing, people from these communities have not typically received training in fields that could net them professional curatorial positions, at a time when professional credentials are increasingly necessary. And if an ambitious young person wishes to enter administration or management, why would they do it here? Speaking frankly, while museum work can be intellectually exciting and personally fulfilling, it does not offer the high-profile, big-bucks, fast-track jobs that exist in the business sector, the media or government today. As Colin Fortune, director of the McGregor Museum notes, "There are other fields that specifically attract black students at the moment. They don't apply to museums."

Brenton Maart, curator of exhibitions at the Johannesburg Art Gallery, argues, moreover, "I think still now what you have is black students going into safe careers, and arts and cultural heritage are not safe careers. You leave university with a master's and you get slapped with a salary that a blue collar worker would be earning. Literally. So that sucks." Maart speaks to this issue from personal experience: he says his friends and family "think I'm crazy for working and getting paid what I get paid, yeah." Voluntarily choosing to live a life of "genteel poverty" does not hold much appeal to those whose experience of the real thing remains fresh within their minds.

People who were once excluded are gaining access to higher-level museum positions, bit by bit. Tshidiso Makhetha asserts, "When you have people like us coming into the museum scene we will be that little drop in an ocean, but in the long run we will make a difference." But many museums are realizing that unless they themselves energetically cultivate young talent, they will chronically suffer from being rather low on the hierarchy of sought-after jobs. Some method of identifying and nurturing potential new employees is becoming a standard feature of many South African museums.

Oftentimes this begins with programs for volunteers. Once someone's aptitude and abilities are recognized, museums may then try to secure college bursaries so a future job aspirant may receive the appropriate training. Synchronizing their efforts with universities is becoming increasingly

important. Museums may send off new students to them. Museum personnel may also trawl existing student populations in order to identify promising learners in relevant specialties and steer them toward museum-related careers. In at least instance I heard of, a museum expedited a valued volunteer entering a Robben Island program that offers training in heritage-related fields. In other instances individuals may be hired on a provisional basis, and if they demonstrate a knack for the work and perform satisfactorily, they may be offered a more permanent position. These generally remain minor, ad hoc initiatives. The most ambitious program to date was announced by the McGregor Museum in 2004: using government money, the museum will train 25 previously disadvantaged individuals in heritage.

Whether they speak in terms of mentors, understudies, or career partners, many museums have systems in place to acclimatize new employees to a setting that is relatively novel for many of them, and thereby heighten their chances to succeed. People who are professionally established increasingly understand that it is unjustifiable to bring someone aboard for the sake of diversification, but then not to offer them a fair shot at success. Sylvia van Zyl, director of the Port Elizabeth Museum, describes a situation with a number of junior staff members who have no scientific expertise for managing the collection, "but a great deal of passion." The challenge now is to couple that enthusiasm with professional training.

These measures are not exclusively altruistic. Museums frequently have employees who have dedicated long careers to the institution. And many of them thus have a large proportion of staff members who are looking toward retirement in the not-too-distant future. These people understand that once they move on, their beloved establishments will seriously flounder unless they satisfactorily think through succession and prepare for the transfer of skills. Facilitating the success of new employees helps both parties: it makes things easier for those who have just come aboard, at the same time that it helps insure that the adviser's own work will live on.

REALIGNMENTS AND RESISTANCE

There is a great deal of support within museum workforces to become more inclusive. And yet, during the first decade when democratic principles ruled, there have also been many sources of dissatisfaction. On the ground, it is easy to view change as a zero-sum game, where the most established employees feel that they may lose the most. Guy Redman relates an attitude that he commonly confronts, if generally only hinted at: "With our history, once you talk transformation, it is like 'White people out, Black people in.' "

Many museum personnel are predictably dismayed that present-day hiring practices frequently lay emphasis upon racial credentials rather than on expertise. Moreover, government agencies sometimes transfer employees laterally to fill openings, so a person may have reached a certain administrative

level in one department, yet possess no competence in the museum, research, or educational settings where they later find themselves.

So while museum workers are understandably relieved to be able to refill their staff registers, they are apprehensive at the same time about the long-term consequences of personnel decisions that are currently being made far removed from work sites themselves. Kevin Cole, director of the East London Museum, argues, "If somebody doesn't know what a museum is, A, and B, there is no area of interest [for them here], then what contribution is somebody going to make?"

And even though General Gert Opperman of the Voortrekker Monument believes that it is generally a good time to be working within museums, he perceives what he characterizes as "a threat" from the government. He argues, "They are being forced by their constituency as part of representivity [*sic*] to appoint people from the previously disadvantaged communities. That's a good investment in the medium term and in the longer term. But I think the threat is really that in the short term we might lose a lot of very good expertise, skills, experience."

Jill Addleson feels that the historical forms of job discrimination were disgraceful, and she loves the fact that diverse points of view are now being expressed within museums. However, she realizes that mutual understanding requires a great deal of work. "On the down side," she notes, "because of the unequal education in South Africa in the past, you find that you have to deal with that in a very sensitive way. You can't go in [-to discussions] like with a barge pole." Adopting an approach that is both open and pragmatic, she argues, "If you find that staff members need strengthening in some areas you have to be very delicate about how you go about it. And there are areas that need strengthening."

Finally, to the different racial perspectives now represented in museums, we must add a generational difference in outlook, experience, and education. David Brodie, the curator of contemporary art at the Johannesburg Art Gallery when I interviewed him in 2004, noted, "People who have studied at any kind of university in the last ten years received a very different education that specifically has embraced ideas of interdisciplinary understanding of arts and culture." He elaborates, "So all of a sudden, when you're learning about history of art, you're not just learning about South African masters, you're learning about the 'secret history' of South African art that has never been told. In the last decade or so, it's become a more critical discourse."

Young Turks bearing new ideas and government officials introducing different procedures and plans of accountability can be quite discomfiting to established employees who came of age in earlier eras. Even the most progressive thinking individuals can feel threatened and throw up barriers. As Ann Pretorius reflects on how she's seen people react, "It is your life's work. So it becomes a personal thing and a personal criticism. Change implies that there was something wrong."

EXPERIENCE AND EXPEDIENCY

I was once doing research at a major South African art museum, in a space shared by its library and the study collection. While I was looking through some files, a group of perhaps a half dozen people decked out in professional dress walked in. A tall, well-spoken woman perceptively described several of the works to the others, proudly pointing out some of the pieces that had been done by significant South African artists. It was simple to eavesdrop: we were merely a few feet apart, although I was partially obscured behind a partition.

A high-profile art auction had taken place the week before in Johannesburg. And the speaker, whom I later discovered was the museum's director, boasted that while paintings by some of these same people had just sold for extravagant sums, the examples of their work that formed part of this collection were of an even higher quality. She pegged their worth in the hundreds of thousands of rands. Moreover, she emphasized that the museum was fortunate to own more than one painting by several of these big names, among the most important of South Africa's black artists.

This information electrified another woman—the mayor of the city, who was leading an entourage of government officials, as it turned out. "Why can't you sell some of them?" "Why do you need so many?" she demanded to know. "Couldn't that cover a lot of your budget?"

The director was clearly a bit stunned, but carefully explained the importance of keeping a collection intact; owning multiple works can also demonstrate an artist's range or creative growth, she noted. But the mayor would have none of it. "Do you *really* need all of them?" she insisted once again.

The director retained her poise after each of her explanations fell onto deaf ears. The mayor was thinking strictly in monetary terms; to her, the museum was a potential cash cow. She was not prepared to listen to any other considerations, such as maintaining the history of collecting and aesthetic preferences, or even the possibility of censorship occurring should certain works be jettisoned.

Finally, with exasperation in her voice, the director clarified that because the museum was municipally owned, she was forbidden by law to deaccession any works that it owned. Only then did the mayor back off, with an audible expression of disappointment.

A few weeks later I sat down to a formal interview with the director, and reminded her of the encounter I had witnessed. Of course she recalled it. She confirmed her sense of frustration and dismay over that meeting, and stressed that it was the first time that she had been successful in luring public officials to visit in person. In a similar vein, Marilyn Martin remarks, "We have yet to get the president to visit us . . . but come the Spice Girls . . . ,"[22] referring to a moment when the worlds of Nelson Mandela, Prince Charles and Prince Harry, and the world of pop culture all intersected because a musical tour and a royal visit coincided in South Africa in 1997.

The director who had arranged the official visit I just described had hoped to impress her visitors with what a cultural asset the museum was for the city. Looking back, she felt she had failed to get much of anything across.

This sort of clash between the culture of government and the culture of museums is not an unusual one. Recall the distress that artist Sue Williamson experienced when she discovered that workers at Robben Island had tossed out acoustic tiles from the prison visiting block that were so meaningfully inscribed with inmates' scribblings. Bureaucrats and cultural workers often seem to be speaking different dialects or tramping to different sets of commands. But it is a particularly acute problem in postapartheid South Africa, where public officials are increasingly drawn from communities that have been disadvantaged, and have not accrued much prior political or management experience.

Furthermore, when individuals such as these meet unfamiliar environments like museums head-on, there are bound to be misperceptions, misunderstandings, and miscommunication—compounded by the fact that as we know, South African museums are for the most part still heavily staffed by whites in top administrative posts. As Colin Fortune of the McGregor Museum reflects, "Because of their Eurocentic history, many of our politicians fall into that group that have never visited museums. So a museum is a strange or a new concept for them to get used to. So they don't understand museums and what happens here." It's another example of mixing chalk and cheese.

Brendan Bell of the Tatham Gallery has shared the common experience of having politicians and government administrators dismiss complaints about tight museum budgets or a shortage of storage space. He knows they will eagerly resort to using whatever power they can to force curators to "trim" the collections and reinvest the proceeds. "Of course," Bell responds, "as museum people we have a very different perception because what is in your collection is part of the community's history and each work tells its own story."

Bell cites a situation where the Pietermaritzburg city council sought to extend its influence over the museum by demanding representation on its acquisition committee. He stubbornly refused. Bell did, however, open these meetings to council members and encouraged them to participate in discussions. But he drew the line there, saying, "As non-professionals you have no knowledge or very little knowledge of art or aesthetics, and you will therefore not have a vote." Thus deprived of any real influence, council members have not frequented the sessions.

Colin Fortune describes another sort of jurisdictional dispute: his staff is employed by the government, but the property and the collections are owned by the board of trustees. From what he has seen, some officials do not understand that they cannot interfere with a body corporate. But since the government holds the ever-important purse strings, bureaucrats often wish to extend their command. "You know," Fortune muses, "in South Africa it is easy to blame problems in operating museums on the past government. But what the present set of officials has not ever really come to grips with is arms-length

control. So we speak of democracy, but that aspect of democracy still needs to develop."

Brendan Bell reports that he has gained the respect of local officials and has ready access to them. But only rarely do other museum directors describe such a balance of power or easy entrée. In most instances they feel that they are at the mercy of official whims, preferences, and procedures. Many directors describe labyrinthine ordeals that require them to initiate requests through several layers of bureaucracy in order to even be considered to hold a meeting with an incumbent, who may or may not extend them the courtesy of taking their concerns seriously. As Dirkie Offringa, chief curator of the Pretoria Art Museum cautions, "You have to fight for your little place in the sun all the time."

It is fair to say that for many museum personnel, the government in its various guises is seen as a hulking, menacing, and alien creature. Valmont Layne of the District Six Museum does not mince words: "Mechanisms of the state destroy creativity," he asserts. And Jurgen Witt of the Tzaneen Museum cannot resist dredging up a part of his biography to help him understand the current social climate: "Cultural people don't become politicians," he observes, as if they are two totally different species.[23] "[Today] party politics are a priority. I have dealt with Bolshevik countries, and I find so many similarities [with the present government]. It has actually been frightening at times."

RACE CARDS AND NUMBERS GAMES

Justin Nurse, a designer and partner in Laugh It Off, a youth-oriented clothing/promotions/media firm, speaks about race in a self-critically frank manner that is relatively rare in South Africa, and indeed in any contemporary multiracial society. "Apartheid ended dramatically and now we [supposedly] live in this 'Kumbaya' sort of New South Africa," Nurse wryly observes, "and everyone embraced it. But in its immediate about-turn there is a lot that has been swept under the rug."

Nurse and his cronies have made a name for themselves through a type of guerilla branding: they excel in taking well-known corporate logos and slogans and irreverently twisting them. They have produced t-shirts where they transmogrified Standard Bank into Standard Wank ("Simpler, Better, Faster") and reworked its logo to show a hand grasping an erect penis; they also substituted "HIV" for "MTM" in the communications giant's "Hello the Future" campaign. Most famously, Laugh It Off took on SABMiller by reproducing its Black Label—Carling Beer packaging, but with the wording "Black Labour—White Guilt: Africa's Lusty, Lively Exploitation Since 1652; No Regard Given Worldwide." That thrust it into an extended court battle with SABMiller over the nature and limits of parody, alleged trademark violations, and freedom of expression.

Nurse reflects, "It is like, 'Well, I pay my car guards and I look after my maid and I am doing my part.' The issue of 'black labour/white guilt' [persists]. Even though apartheid ended, the economic inequality hasn't changed

a bit." His company has obviously touched sensitive nerves in the collective South African psyche. Nurse points out, "We are still finding ourselves as a young democracy, and I am not sure how far we are prepared as a country to go beneath the surface."

In chapter 1 I noted the biography of one of my interviewees who had been labeled as "black" under the apartheid classification system, and fought for years to maintain a museum position she was not legally entitled to hold. But how did she get hired in the first place?

It was expected that she would direct a house museum that focuses on the history of the Cape Malays, descendants of one of the groups that the Dutch imported to work in the Cape Colony. It was from these former slaves that the woman traced her ancestry. In line with the thinking of the time, her professional expertise would be suitable there, but in that place only. When she did not take over that position, she became an obvious incongruity within the racial hierarchy.

The expansion of opportunities to the formerly disadvantaged draws a mixed reaction from those already entrenched in museums. Jurgen Witt offers what I will call the parable of the long and short grasses, an argument for elitism. "I once had a politician sitting here, and some of the grass was growing high and others [sections were] low," he explains. "Some was slimmer, thinner; other [strand]s stronger, but most of it was about this high [he gestures to demonstrate]."

He continues, "And I say," drawing a hypothetical analogy between nature and people, " 'so now you come with a lawnmower, and you cut it all to the same level. Where will you get the people who are able to think? The people who are able to be creative, people who will be leaders one day? Where will you get them from if you continuously cut it to the lowest level?' "

It is, perhaps, no accident that Witt speaks in metaphoric terms. Talking about collective group differences, or dissenting from the current racial status quo, is sure to raise ire. But many museum personnel feel that the present political dispensation leaves people like themselves at a competitive disadvantage. Asked whether he believed now is a good time or a bad time to work in this field, Ivor Pols responded, "If I am very honest, if you are my color you will not get the opportunities that you should have, no matter what kind of qualifications or aspirations you have."

Mariana Zdara, manager of the Willem Prinsloo Agricultural Museum outside Pretoria says, with a bit of resignation, "There is a lot of pressure on us white people, and ja, that is a challenge. Wherever I go I will face it in this country. That is something you just have to work through and go with the flow and see it through." And Kevin Cole believes that as a white male, he has to accept affirmative action. Otherwise, you develop a negative attitude that ultimately impacts upon both job performance and your mental health.

Ildiko Kovacs, curator of the Empangeni Art and Cultural History Museum, believes that government edicts are "politicizing" museums today

by pressuring them to employ people on the basis of race, and not because of their training. She strongly takes exception to this: "I believe personally if you have the qualifications, apply for the jobs and then do the jobs, but do not be political in that way."

Kovacs' argument seems reasonable—until you reflect on the fact that South Africa's museums have *always* been politicized in regards to race. It was simply accepted as the way the world operated, and not remarked upon publicly in the past. At another moment she expresses a seemingly liberal perspective, but one which nevertheless reveals the basic mindset of an apartheid of art: "I try and support all local artists: Africans with their sculpture work, white people with paintings. I try not to discriminate in any way."

Dr. Manton Hirst at the Amathole Museum reports that everyone they selected to be interviewed in a recent job search was isiXhosa-speaking. "Quite frankly," he says, "a white candidate or a coloured candidate would not be acceptable. Anyway, we knew that in advance." While compliant with present-day reality, Hirst feels that since the fall of apartheid, the demonizing of one group has been switched to another, and that there is a great deal of reverse racism in the country. "I don't think that all this affirmative action stuff and all that has really gotten us anywhere," he grumbles. Whereas previously, one worked one's way up, "Now you just need to be black, have a background in education, and you can be top dog."[24]

But rather than imagining that during the past decade the formerly disadvantaged have captured choice positions within museums with minimal opposition, recall the fate of Dudu Maddnsela at the Nieuwe Republiek Museum in Vryheid (Chapter 2). Taking over as curator in a historic house museum that is important to the story of the Voortrekkers, she has been verbally abused, and members of the museum board have tried to force her out. But resistance to racial change can happen at all levels, and in any direction. Brendan Bell notes that the security positions at the Tatham have long been staffed by black Africans. If he wished to hire a white, Indian, or coloured person for this section he believes that he "would have to be very careful to consider how that appointment would affect the dynamics operating within that group."

Sharon Crampton of the Oliewenhuis Art Museum explains that sometimes people outside the institution, such as corporate supporters, may insist that a racial mix of visitors simulate the Rainbow Nation, expressly for appearances sake. She offers the following example: "I had an exhibition open here a while ago where they actually said to me, 'We need at least 40% black attendance.' I said, 'It is impossible.' What must I go and do, fetch them at the squatter camps?' You can't. And you can't expect these people to pay R22 to come here, and go back. It is ridiculous."

It is not difficult to understand how transformation becomes a "numbers game," especially in the minds of bureaucrats, or to those who wish to curry favor with them, especially in the early years of a momentous political transition. But a greater and more genuine racial mixture is undoubtedly obtainable once a museum presents a diversity of programming, and intensifies its outreach to a broader range of communities.

Ann Pretorius presents a very different scenario, describing current exhibition openings at the William Humphreys Art Gallery in the following way: "We've got affluent Hindu people, people from our community projects who actually come from shanties and have no social skills so to speak of, we've got white people, we've got black politicians and black public civil servants, and students from the Tech are starting to drift in."

No artificial targets for diversity have been set, and yet the complexion of the museum's events has nevertheless changed. "We are starting to form a natural mix of all of these people, not a forced-down-your-throat mix," Pretorius explains. "It is becoming a nice meeting place for anybody from any walk of life, and I think that is partly the value, apart from preserving [the] national estate. A museum could provide this mutual meeting ground."

As much as some people might desire to move beyond established notions of race, their continuing impact cannot be denied. Individuals who work within creative spheres are particularly sensitive to ways in which purported racial differences are reinscribed in the postapartheid era in many of the same ways as they were while the apartheid system was in place. The McGregor Museum's David Morris argues, "It is a scandal that it [race] continues to be used officially for categorising people in South Africa. Because, the more we use the concept, the more we give it credence . . . if we don't get the basics right (i.e., move beyond 'race') it will always come back to haunt us (which it does now)."[25]

And artist Clive van den Berg explains, "For my own creative process I've developed a phrase called something like 'conscious amnesia' or 'select amnesia,' where we have to give ourselves quite knowingly a little period or space of forgetting, which allows us just to imagine in a different kind of way." He concludes, "Otherwise, there is always going to be [re-] articulating of the past, if I can put it like that. It's for me not a particularly interesting creative project."

CULTURE FOR CULTURE'S SAKE?

Museums in South Africa are generally not valued as much for what they are, as for what they can do. Traditional rationales such as being repositories of knowledge, treasures, and creative activity do not carry much weight in a society that is under pressure to refashion itself. All too often, action trumps theory, practical concerns trump symbolic ones.

Museums must justify their existence by linking themselves to social agendas that command broad support. South Africa needs to overhaul its education system, so museums can propose to supplement the curriculum with programs that teachers are not normally equipped to deliver. Job creation is vital, so museums can provide training and skills development, especially in relation to native crafts. They can serve as a vital marketing outlet as well. And with tourism becoming a big money generator, museums can position themselves to become essential stops on travel itineraries. David Brodie recommends implementing the following approach when dealing with public officials: "Convince them that the economy, and people's sense of self, and people's sense of cultural and social

identity are absolutely linked to things like crime levels and levels of unemployment, and really a kind of national sense of self-esteem."

The successful strategy is a symbiotic one: the cultural sector is forced to piggyback upon larger animals that devour substantial portions of the national budget. Museums must hitch their wagons to national initiatives, since whatever allotments they receive from various levels of government are hardly enough to sustain themselves. Brendan Bell observes, "You [can] so quickly slide into the most awful depression and demoralized state, constantly having to justify why your museum ought to exist when there are so many more pressing social issues that need to be dealt with."

Steven Sack notes that whenever the government launches a major new project, the Department of Arts and Culture strategizes how it can secure a piece of the action. He argues, "You just have to get yourself onto that list of departments that give [out] a slice of the cake. They have always given us a very small portion, but for us it is a significant amount." Sack offers as an example a poverty alleviation program that had a R1 billion budget. Arts and Culture captured R5 million to run some pilot projects, and after they proved to be successful, it received R249 million directly from the Department of Labour to continue the work.

Sack estimates that the Department of Arts and Culture needs a budget that is more than five times its current level. But requests for additional funds cannot be made based solely upon the department's primary mandate. He laments, "There isn't a program in government called 'Support for Creativity' or 'Support for the Arts.' " The biggest successes fall under the rubric of creativity to supplement or further another cause.

Sack is the rare example of someone coming from an artistic and politically active background who has successfully moved throughout those parts of the government's bureaucratic system that deal with cultural matters. He notes, "I think for a lot of activists and artists who also ended up coming and working in the civil service it has been a bit of a disaster, and a lot of them have moved out. A lot of them have a passion about the need to deliver a better life. I think people get frustrated when they are unable to do that."

Breaking the Silence

One social issue that South African museums have regularly addressed is AIDS, and not because there are deep wells of money to dip into for support of such activity. More to the point, countless exhibitions have offset the relative lack of official attention paid to this issue. In this regard museums are fulfilling another contemporary role: providing a community forum.

HIV/AIDS bridges what otherwise separates types of museums from one another. Art museums are just as likely to host shows on the topic as are natural science or history museums. One site might emphasize cultural production around the subject, whereas another might focus on basics such as what a virus is, how it is transmitted, and how it functions. But this is false dichotomy: the magnitude and urgency of the pandemic have broken down

what are generally distinct differences between these places, and museums have hosted a number of different approaches to the disease.

The Durban Art Gallery [DAG], for instance, does at least one such exhibition a year; it has made itself well known amongst professionals who work with AIDS. The subject is something that director Carol Brown feels quite strongly about, and it has become a priority in the museum's programming. "We don't see ourselves as being in an ivory tower," she stresses, "and we have to interact with our population, as museums all over the world do. It's important that the arts play their part in these issues." And, in a superbly turned phrase, Brown argues, "It is sort of a soft way of getting a tough message across."

A sampling of DAG's projects range from "body maps" drawn by women with AIDS (they trace their own outlines and then fill them in with images and text about what it feels like to be infected) to mammoth public art displays. An exhibit at the Durban Natural Science Museum, located on the next floor in the same building, discusses how indigenous knowledge about plants and nutrition could help combat the progression of AIDS. And Marilyn Martin of the South African National Gallery believes that addressing AIDS is an important part of that museum's social responsibility as well. She does not pull back from showing images that are critical of the president relative his inaction on combating the disease. For example, the SANG has featured cartoons by the well-known Zapiro that skewer the government in general, and President Thabo Mbeki and Health Minister Manto Tshabalala-Msimang in particular.

Martin notes that with the fall of apartheid, artists enjoyed the luxury of turning away from politics and social issues. In her words, they "briefly smelled the flowers." But that interlude passed all too quickly: "Then the weeds came up," she notes, "the crime, HIV/AIDS . . . so some artists are indeed smelling flowers . . . [whereas] others are looking at broader things." Exhibitions regarding AIDS have become the rule, rather than the exception, throughout South Africa's museums, no matter what their usual focus may be.

The largest such exhibition that DAG has mounted was in 2000, in conjunction with a world conference on AIDS that was held in Durban. DAG swathed the circumference of Durban City Hall, the gallery's home, in a 500-meter-long red ribbon in order to promote AIDS awareness. This bold act had a number of repercussions. By involving over 1,000 participants, it became a populist event extraordinaire. By highlighting one of the country's most urgent problems, it provided a vital public service. And by demystifying the symbol of local government—marble steps, sweeping staircases, and red carpets are not so intimidating once a building has been festooned in such a way—it fostered the viability of democracy.

"It was enormously important in terms of people look[ing] differently at the building," Brown notes. "They suddenly saw, well, you know, this building reads all about HIV/AIDS. The red ribbon around it just broke that, I think, that heaviness and that weight." The AIDS 2000 banner significantly reduced the distance between a once exclusive institution and the general public. A formerly privileged domain became the people's house.

South African museums have greatly amplified the public conversation about AIDS, stepping forward to challenge the silence and shame that still shroud the disease. One of the many reasons is that museums are no more exempt from the impact of AIDS than any other type of institution. One director confided to me that he suspects that a large proportion of his security staff is infected with HIV, although government regulations prohibit employers from asking their workers outright about this. They miss many of their assigned shifts, and they are not as strong and able to carry out their duties as they once were. This not only compromises the safety of the building and its collections, but it also means that Bell must squeeze additional money from an already slim budget to pay overtime rates to other guards in order to cover vacant periods. The proliferation of AIDS thus presents massive challenges to every sector, and every aspect of contemporary life, throughout South Africa.

DISTRESS SALE?

The sort of financial threats that have endangered and hobbled many South African museums are highlighted by a series of incidents in the contemporary history of the Durban Art Gallery. In 1993 the local metro council proposed that work be sold off in order to fund new acquisitions. The Tatham Gallery of Art's Brendan Bell equated the scheme to a company selling off "stock" (inventory), and DAG's director at the time, Jill Addleson, "threatened to chain herself to the permanent collection if council approved the sale of any piece."[26]

The government backed off and allowed the debate to cool, but it was revived in 1996 when the council discussed cutting the museum's entire acquisition trust fund, at the same time that other long-established cultural institutions such as the orchestra and playhouse were also threatened. What would be the potential impact? DAG would be forced to purge works from its existing collection in order to bring fresh material in.

A public outcry ensued: the proposal was called "cultural vandalism" and a "rash proposal"[27] that would sanction "instant amnesia."[28] The council then decided to set up a review committee consisting of two of its own members and eight "experts" to examine DAG, the Natural Science Museum, and the Local History Museums—a so-called Review Commission of 10 Wise Men (although splendidly named, it was never formed). The chairperson of the Durban Metro executive committee made it clear that the powers-that-be did not approve of the art gallery's past policies, and it was not prepared to channel more money its way: "People do not come to Durban to see our Victoria [sic] Collection!" she declared. "Is it still relevant in today's South African society? Should it take the prime position in the Durban Art Gallery?"[29]

This bureaucratic voice was echoed by that of prominent artist Andrew Verster, who supported the council head by declaring, "Her message is Get Your House In Order or Die!" He argued, "The present collection is based on a lie, that white (western) culture is the best. Thus it cannot be used as a resource to tell our history to a new generation."

"My solution is radical but simple," he continued. "Admit that we have failed. SELL OFF THE COLLECTION."[30] In retrospect, his position

sounds like a toadying and relatively non-reflexive burst of postliberation rhetoric, rather surprisingly coming from someone who had reaped the benefits of the art world and had served on DAG's board of trustees. At that time, Durban's museums in toto received less than one half of a percent of the total municipal budget.[31]

Verster backed down after learning that it was illegal to sell off parts of a collection, later suggesting that a museum of contemporary art be developed to showcase present-day work. A letter to the editor during the heat of this dispute argued, "The best strategy . . . is not to obliterate the 'lie' but to actively demonstrate its faulty logic. . . . Future exhibitions could include works from the Victorian collection to highlight the fact that art is ideologically based." To sell off this body of work, on the other hand, would constitute "a form of neo-colonialism which aims to plunder an existing historical resource to create a new, sanitised reality."[32]

Meanwhile, the museum's exhibition policy had not remained mired in the past. In early 1996 DAG hosted *Colonial mutations: Victoria II installations*, a conceptual art piece conceived by an artists' cooperative. Their point was to draw a contrast to the pastoral nature of the Victorian paintings on DAG's walls by filling up the rest of the gallery with the detritus of modern life: found objects including lightbulbs, metal, telephone books, coat hangers, and umbrellas. Here was an urban wasteland that the Victorians could not have imagined. That exhibit represented the same sentiments as a DAG manifesto that asserted the museum's mission henceforth would be "to provide the public with an awareness of, and depiction of, urban African life, residential workplace experiences and struggles, and their role in the making of the city."[33]

When gender-bending Steven Cohen frolicked through the august Edwardian halls of the gallery on colossal, spikey high heels, and with feathers, fur and a see-through codpiece during one of DAG's Red Eye @rt events in 1998, it announced a broad refashioning of what art is, and what a museum does. These often edgy, multimedia, events have featured kwaito dj's, video projections onto the building's façade, performance incorporating the memorial statuary on the plaza, and mural-painting forays into the neighboring streets. These activities, too, have pushed the limits. As a result, public perceptions of the museum glide from hoary to hip with dazzling speed.

In 1997, the Durban council proposed a cutback of over 50 percent from the operating budgets of all the local museums. And that has set the pattern for so many institutions throughout the country, lurching from financial crisis to financial crisis during the past decade. When Carol Brown assumed the post of DAG's director at this time, her major response to the status quo was to rehang the galleries, concentrating on contemporary South African work, and art from KwaZulu-Natal Province in particular. And yes, she shook the dust from the Victorian collection: while accounting for only 2 percent of DAG's holdings,[34] it has attracted a disproportionate amount of attention—during its heyday, as well as since it has lost public and critical favor.

Figure 11 Artist Steven Cohen performs *Living my art my life* at the Durban Art Gallery's Red Eye @rt event, July 1998

Source: Photograph by Colleen Wafer, courtesy of Durban Art Gallery.

CHAPTER 9

Transformation: Models
of Success or Mediocrity?

If that's art, I'm a Hottentot. Harry S Truman,

quoted in Mathews, 1976

Not so long ago, really—a few years before the establishment of democracy—South African museums celebrated International Museum Day in the following manner: "Tea was served in real Edwardian fashion, letters were written with old quill-pens, conversation took place on antique telephones and farm bread baked in clay ovens was served."[1] Moreover, these activities were hyped as dissolving the barriers separating patrons from institutions.

It is difficult to conjure up a more ludicrous scene today. Fast-forward to the same date just a decade later when the theme was "Museums and Globalisation," and 14 institutions in Pretoria participated in a Tourism Toyi-toyi initiative. Toyi-toying, as previously described, refers to the collective, thunderous, and high-stepping dancing, shouting and singing that throngs of (primarily) black South Africans joined in during street demonstrations, funerals, and other public events throughout the liberation struggle. In this instance, the museums planned a marching band and communal entertainment to attract a broad range of visitors to venues across the city.[2]

These two dramatically different celebrations clearly signal that museums in South Africa have awakened from the nightmare of apartheid at long last. Many if not all South African museums have committed considerable time, effort, and expense to ridding their exhibitions of the ideological baggage of colonialist and apartheid-era dogma, and realigning them in accord with the more humanitarian principles that now underpin this society. That has meant posing questions that were quashed before. It has required staffers to examine previously overlooked sources, sound out sectors of the population whose voices have not been heard, and gain expertise in fields beyond their original training. It demands determination. The degree of success museums have attained in these pursuits is where we now turn our attention.

MAKING A STAB AT
TRANSFORMATION

Greytown touts itself as "the last home of the traditional Zulu." The town boasts the sort of scruffy and peculiar local museum that many small old South African settlements do. It inhabits an impressive late nineteenth-century historical structure, made from locally produced bricks of mud and mortar. Originally built as a private home, it was used for many years as a government headquarters.

The collection includes such offbeat prizes as a "100-year-old" bar of soap, one that looks as if it has aged quite a bit more since being acquisitioned; a necklace made from ant eggs, around 1838; a coat hanger once used by a general, which now qualifies as "military memorabilia"; and a tobacco tin for Assegai Cloudy Mixture, whose design features a white man relaxing while smoking in a comfortable chair, while a native warrior standing alongside holds an assegai and traditional shield. The Greytown Museum also features the large apartheid-era sign that reserved one side of a local river exclusively for fishing by whites, and restricted nonwhites to the opposite bank (chapter 1).

In keeping with the changes in the country, and in deference to the significant Indian population in the province, the Greytown Museum organized a room devoted to Islam and Hinduism in 1995. And now it features a room with "native artifacts" as well. Dominating that space is a Zulu hut, handsomely and authentically constructed with traditional materials. But positioned just outside its entrance is an antiquated wooden "dumb waiter" in the shape of an African servant. It incorporates every caricatured, stereotypical physical feature that one can imagine.

Across the room, a 1950s vintage ceramic figurine of a black woman rests in a case chockablock with lovely beaded Zulu dolls. Bare-breasted, and holding a jug, she was likely used as an ash tray in an era when "symbolic slavery" was a common theme in material culture, and blacks continuously served their white masters on this mundane and trivial scale.[3] And the top of a Bushman's skull is displayed nearby a tray that pictures Zulu kings; its metal border is decorated with ersatz leopard spots.

By freely mixing kitsch with craft, human "specimen" with human construction, one could say that the Greytown Museum is at the cutting edge of postmodernism, merrily collapsing venerable distinctions between categories of objects. But instead, it seems as though the curators answered the call for transformation by gathering *anything* that had a connection to Africans, tossed it together in one space, and walked away with the sense of a mission accomplished. They fail to distinguish between objects that signified what Zulu culture has attained, and how Zulu culture has been disparagingly represented by others. One is more likely to let out a sigh of exasperation than to applaud what they have done.

North of Greytown, in the same general vicinity, civic-minded citizens in Utrecht have converted a 150-year-old parsonage into its town museum.

Exhibitions on the Dutch Reformed Church, and period rooms (a kitchen, bedroom, lounge, dining room, and parson's study) dominate the building. Amongst all these European-based displays is a cabinet devoted to African artifacts, although only one is specifically labeled: "Zulu 'Pinch Pot'—Used for Drinking Beer." Other items include a basket woven from telephone wire, a beaded doll (costing approximately R15 at markets), a beaded gourd, and a beer strainer. These are trifling pieces at best.

Topping this pile of common wares is a wooden scale model of a Voortrekker wagon, the sort of home craft project that probably kept some Afrikaner man busy through countless months, and possibly brought him some local acclaim as well. It is an odd juxtaposition of goods. But to be fair, isn't this likely a consequence of the small size of these museums, and the relative lack of expertise to keep up with current museological and more general social trends?

To some extent, perhaps that is true, but even in museums that have a broader scope and a professional staff, some gestures of inclusion can appear to be extremely slipshod. At the McGregor Museum in Kimberley, for example, the portraits of a number of individuals have been added more recently to the gallery of noteworthy "Kimberley personalities," including women (Olive Schreiner) and black Africans (Robert Sobukwe). But their names are printed in a script that differs from the one used for the original selection of significant locals. The expanded display seems cobbled together, not carefully integrated. This failure to attend to detail strongly suggests tokenism rather than genuine inclusion; those who were formally excluded still remain so, to a certain extent.

To a greater or lesser degree, each of these examples demonstrates that heeding the call for transformation with superficial additions and changes hardly connotes a basic transformation in attitude, and does not significantly expand the scope of a museum or its appeal to a broader audience. Moreover, a comparison of two historic house museums demonstrates that innovation is indeed possible in small, traditonal settings, irregardless of the perceived constraints of historical "truthfulness."

The Old House Museum in Durban (c. 1840s) faithfully re-creates the interior of a colonial-era house, with two exceptions only. In a period cabinet filled with dolls, a few examples of African origin just slightly offset the preponderance of European porcelain ones. And in a playroom, vintage toys appear alongside a couple of vehicles made from recycled materials, a common plaything for African children.[4] The visitor is otherwise caught in a time and space warp: this place remains virtually indistinguishable from a cottage somewhere in the U.K. countryside; its location in St. Andrew's Street simply heightens that perception. Moreover, it looks as if the inhabitants mysteriously picked up and left, with no explanation provided as to where they had gone, or how they had gotten there in the first place.

But how much, after all, can be done to "modernize" such settings? A great deal, as it turns out: a surprising and novel example of change is to be seen at the Macrorie House Museum (built c. 1860) in Pietermaritzburg. Its

Victorian interior remains intact, but it is not simply a dusty relic of the past. An informational placard in the parlor shows workers picking tea leaves on a local estate, and one in the dining room describes the crucial role of domestic laborers in running such an elaborate household: "servants were a significant part of many Victorian homes in this city," it reads.

And throughout the house, either poster panels on the walls or free-standing placards enlarge the context of the activities distinctive to each space, providing information that cannot be gleaned from the objects themselves. "Upstairs" meets "downstairs" at long last, straightforwardly incorporated in a manner that enhances rather than detracts from the authenticity of the setting. It looks essentially the same as before, except that now many layers of additional meaning have been excavated.

As one longtime observer of the South African cultural scene remarked shortly after the changeover to democracy, "Collecting anti-apartheid t-shirts and posters doesn't necessarily mean change."[5] Those museums where transformation has succeeded to the greatest degree have been where they have broadened the expanse of their collections, thoroughly integrated the new material with their existing holdings, and generated new ways of understanding all of these things.

Milking the Cow, Stirring the Pot

I once spoke with a South African woman who recalled her honeymoon trip to Lourenço Marques nearly a half century before. She mentioned visiting the Museu da História Natural, with its distinctive Manuelino architecture and lush gardens. This place offers ample illustration of Tennyson's famous adage "Nature, red in tooth and claw": a vast part of its first floor is stocked with animals stalking, fleeing, and leaping upon one another, and hungrily tearing into flesh—all of these scenes staged with stuffed specimens, of course. Located in present-day Maputo, Mozambique, it is not a place for the faint of heart.

When I told her that I, too, had visited this museum, she wondered aloud if the *Fetos de elefante* exhibition still exists. Indeed, it does. It features 14 fetal elephants ranging from 1 to 20 months of gestation, stopping short of showing a full-term infant. The specimens float eerily and gracefully in lighted cubes embedded into a wall.

The text mounted next to the display explains that these samples came from an officially sanctioned massacre of the animals around the time of World War I, when the colonial Portuguese government cleared an area outside the city of all its flora and fauna in order to set up new agricultural projects. Although they failed to carry through with the proposed development, the museum explains, "During the 'clean-up' around two thousands [*sic*] elephants were killed, being the most plentiful species in the area. Fortunately the aforementioned Mr. Carriera [hunt supervisor] had the happy inspiration to preserve in formaldehyde the fetuses he found."

The exhibition's longevity and memorability highlight an extreme human arrogance toward the natural world. Even the wall label admits, "Nowadays

it would be unthinkable to carry out such a slaughter." It also raises uncomfortable questions about museum ethics and collection policies in the past.

Today's natural science and history museums are more likely to comprehensively analyze natural phenomenon within their environmental, social, and spiritual contexts. They are interested in such topics as ecological degradation and despoliation, responsible bioprospecting and ecotourism, the informational, therapeutic, and commercial value of indigenous knowledge systems [IKS] about plants and animals, and looking at the ways in which humans have put their mark on the world, rock art being a good example.

Dr. Jason Londt, director of the Natal Museum in Pietermaritzburg, states, " 'When I arrived [in 1976], there was a very Victorian look to the galleries . . . There were horns and heads of antelope on the walls, like an ancient men's club.' "[6] He further recalls that while the museum was in principle open to all races throughout the years of apartheid, the management was strictly white, and male. Gallery guides were retirees, roaming the corridors in proper white coats. Given that, the atmosphere could have not been equally welcoming to all prospective visitors.

Of course, some alterations occurred prior to 1994. For example, the first black education officer appointed within a South African museum occurred at the Natal Museum in 1988. Moreover, in order to diversify its audience, the education department used that person to draw a wider spectrum of visitors to the place. According to the retired director of that sector, they even circumvented apartheid regulations and screened films to audiences made up of children of different races. "We had to get people from the townships into this great, colonial edifice," she asserts.[7]

But even today, sincere attempts to redress the historical imbalances in museums sometimes smash up against unforeseen walls of resistance. Post-1994, for example, the Transvaal Museum in Pretoria mounted an exhibition portraying daily activities on a typical farm. The museum included a scenario with a black African milking a cow. It seemed logical: after all, farm laborers in South Africa are most typically black.

Some ANC party officials took offense, however, and they pressured the museum to substitute a white man in the display. Dr. Bob Brain, retired director of the museum, says that the objection centered upon presenting a black man doing a "menial task." But that, of course, reflects the reality of work for the bulk of the black population in the country, throughout the largest part of South Africa's modern history.

Colonel Frik Jacobs was dumbstruck, and outraged: "I was president of the Association of Directors of National Collections" he reports. "I went to the director of that museum and I said, 'Now you're making a bloody fool of yourself. Take the exhibition out if you can't live with the truth.' You see, people are taking things too far." It is particularly unfortunate that this occurred at a place that Mark Read, chair of the Board of Trustees of the Northern Flagship Institution, calls "a magnificent, slumbering institution" because past governments did not adequately support it. He notes that the Transvaal Museum has collections stashed away in its basement that "defy belief."

This episode puts the lie to a statement·made by Mariana Zdara of the Willem Prinsloo Agricultural Museum outside Pretoria. She insists that farming is a noncontroversial topic: "It is not about culture that much," she argues. "I mean milking a cow is a very neutral thing." But farming is only "neutral" in so far as you fail to take into account fundamental issues of land ownership and the racial division of labor that have sustained inequality within the country.

Another incident that demonstrates such conflict occurred in November 2002 at the National Museum in Blooemfontein, an institution featuring cultural dioramas, fossils, animals, and astronomy. Dr. Hannes Haasbroek published an article in the museum's journal pinpointing the location of the founding of the African National Congress [ANC] in 1912. He offered evidence that the organizing assembly took place in the Old Wesleyan School for black children; today the building butts up against the colossal cooling towers of a power station.[8]

Oral testimony and public memory had placed the site elsewhere in the area: at Mapikela House, the home of Thomas Mtobi Mapikela, one of the group's originators. In this instance, scientific research collided with public sentiment, in so far as it was expressed by the Mangaung Historical Forum, a local history group. Spokesperson Tefo Manuel Nichocho angrily dismissed Hassbroek's claims, stating, "My serious concern and that of other comrades is the opportunistic people out there who distort our history for their own self-interest and fame."[9] Notably, Nichocho refused to reveal whatever information he possessed regarding where he presumed the site to be located instead.

Haasbroek believes that these objections have "racist undertones."[10] The complainants took their concerns to the premier of the Free State, who then appointed an arbiter within the ANC to take up the matter. Haasbroek's hands are tied; he has no means of arguing his case, beyond making his research publicly available. He hopes that the building, which is in private hands and on offer for sale, will not be demolished in the interim.

The 100-year celebration of the ANC's founding is not many years off. The question is whether or not the ANC will be willing to honor the discovery made by a white museum employee regarding this central aspect of its history.[11] Critical voices are increasingly challenging the ANC's version of events, finding fault with how they feel party stalwarts have nearly monopolized the glory for the success of the struggle against apartheid, to the exclusion of other factions and individuals. That sort of negative assessment transcends race: an editorial in the *City Press*, a newspaper that targets a primarily black audience, editorialized on the eve of June 16, 2003, that the ANC had largely snubbed various heroes who did not hold the "correct" party membership. The title bluntly states, "ANC is not the only hero of our struggle."[12]

Natural science and history museums may find the greatest success in the future by incorporating indigenous knowledge into their displays. This enhances the scientist's understanding of animal and plant species, as well

as a variety of technologies, and makes these places more user-friendly for the general public. In fact, it is one area where they hold a potential advantage over Western museums, which typically do not have such vast local sources of knowledge to draw upon.

Elephants may be classified as *Loxodonta Africana* throughout the scientific world, but they mean so much more when they are seen from a native angle—one that is highly unlikely to result in mounting a sizable series of fetuses on a wall. Moreover, this recognizes the existence of precolonial thought systems, perspectives on the world that were intentionally excluded in the past, as were their believers. In this respect, exhuming such information is not so much a matter of discovery as it is a task of rediscovery. And ideas that may seem simplistic or unsophisticated on first glance may in fact reveal complex patterns of thinking and theorizing that have never been appreciated beyond their communities. This could spur a radical reconsideration of how primitive "primitive" really is.

Novelist Saul Bellow once infamously asked, "Who is the Tolstoy of the Zulus? The Proust of the Papuans?" Admittedly, those individuals might not exist. But that does not prove that communities in the so-called third world are lacking in culture. Far from it: the scope of their cultural insights and innovations has barely been explored, in part because of sweeping, condescending, and dismissive assumptions such as Bellow's.

Guy Redman, director of the Durban Natural Science Museum, is excited at the prospect of incorporating indigenous knowledge into the displays there. It is an initiative that is in the formative stage, dependent upon the complex and time-consuming task of collecting information in the field. From his standpoint, "Some people are going to feel more at home when they see that kind of stuff, and then it will be easier for them to learn the science. At the moment it is quite intimidating for someone who is not really aware of science and did not do biology at school, or who did not even go to school."

This additional information can include native names of various species, the uses they have been put to by humans, and even folklore about them. In some instances, there are myths about certain animals that Redman and his associates feel that they need to dispel for conservation reasons. They would like to juxtapose local understandings with scientific fact: "You know, like 'When you see a millipede, kill it, because it is swearing at your mother when it wriggles.' Simple things. The kids are killing them and it is not good, so we would put all those things [folk beliefs] there and then have our answer to it."

Redman feels that the same general approach can be exploited on behalf of AIDS education. In his experience, many people turn off and turn away when they see AIDS exhibits in a scientific context. It is simply too scary a topic, plus by now they are tired of hearing about it. One such display in 1995 at the Transvaal Museum included frank information about transmission as well as condom use, and prompted outcries of "filth," "disgusting," and "pornographic."[13] But if museums today present units on traditional healing, nutrition, and apothecaries, it can be a short leap to talk about current diseases, their etiology and treatment.

Kevin Cole, director of the East London Museum, also offers the example of putting a pipe typically smoked by Transkei women on display. Today the meaning it holds for a visitor would be expanded by the museum posing and answering a series of questions: What kind of wood was used to make it? Where does the tobacco come from? What is its medicinal value? How does it fit into native culture overall? In this regard, objects are becoming truly three-dimensional.

A key trick these days, from Guy Redman's perspective, is to connect the dots between science and public welfare. In a society where crime is so pervasive, the Durban Natural Science Museum is developing a focus on forensic entomology. As a discipline that studies the sequence by which different insects infest a corpse, in order to determine the time of death—the sort of gimmick that any number of popular television shows capitalize upon—it is of interest to law enforcement, the scientific community, and the public.

Redman states, "As much as we are the third most biologically diverse country in the world, that must mean something, but to the people on the ground, it means nothing." He considers one of his main priorities to be changing the perception that combating poverty and the need to conserve biodiversity are mutually exclusive concerns. He argues, "We need to get to the point where people understand that if your biodiversity is depleted, it is going to result in a great amount of poverty." Moreover, "development, as much as it is good, can result in the loss of various species, important plants, medicinal plants. You need to see it in that light."

Redman believes that today's politicians do not understand the importance of natural science museums as much as they do cultural history museums. The latter are more likely to address social issues that have directly impacted their own lives, such as apartheid. It is a concern shared by Henriette Ridley of the Voortrekker Museum, who worries that individuals ensconced in positions of power within the government or museums since 1994 do not seem to appreciate the value of certain collections, or the need for trained collections managers. She notes, "They think it is ridiculous to have people researching flies and that you could have thousands and thousands of trays of flies. What is the use of all that?" Natural historians, she argues, "get absolutely the heebie-jeebies when they hear that. I mean, our previous [municipal] council couldn't understand the need for a natural science museum."

THE ART OF TRANSFORMATION

Art museums have a number of advantages over institutions such as these others when they wish to implement change. First, new art is continually being produced that addresses the contemporary scene. Art museums can transform in important ways simply by displaying fresh work. In a fundamental sense, artists somewhat obviate the need for museums to initiate ideas for exhibitions; they become the research division, in effect.

In natural science and history museums, on the other hand, it generally takes staff a long time to originate new exhibition concepts, conduct or collect the relevant research, formulate accurate and understandable interpretations of material, assemble the appropriate objects to illustrate these ideas, and then engineer effective ways to display them. It requires a high degree of planning, deliberation, and collaboration to mount something new. For example, it took ten years for the Natal Museum to develop the research and amass the collection for the *Sisonke* ("We are together") gallery, one that combines traditional artifacts and material from the liberation struggle.[14]

Second, it is generally less expensive to construct new exhibitions in art museums. This can oftentimes come down to the costs of hanging (or rehanging) versus additional fabrication. Of course, planning is involved in designing any show, but in art museums plaster and paint go a long way. New exhibitions in natural science and history museums, on the other hand, require both specialized technicians and costly and plentiful materials. So once they have been installed, they are likely to remain. Donald Klinghardt of the South African Museum discloses half seriously and half in jest, "Once exhibitions are in place, they are almost permanent. There is even a joke around here: there is a 'temporary exhibition' put up in 1975 that is still here."

Third, art can be controversial, no doubt, especially when it deals with issues such as race, religion, identity, sexuality, politics, and history. But public uproar can generally dissipate relatively rapidly once an exhibition comes down, typically after a limited period of time. Moreover, interpretation is often left more to the visitor in an art museum as opposed to other venues, where a lay public is being actively instructed about often complicated subjects. And at natural science and history museums, hot-button issues such as race and identity are at the heart of their domains, not simply an occasional focus.

Natural science and history help people to define who they are, to understand what they have done, how they have constructed the world around them, and how they have lived in relation to other groups, and to the environment. When groups perceive omissions or mistakes in the stories these museums have to tell about these issues, or object to even bringing up certain topics, they can raise quite a clamor. At the Natal Museum in Pietermartizburg, for example, an exhibit called *Stories of human origins*, focusing on the four major religious groups in the area, was opened in 2000. It complements an exhibit on evolution already in place. But as it turns out, the original working concept was developed in the 1970s, with the intention of mounting these displays simultaneously, and with sensitivity to peoples' beliefs.

The idea was not fully executed until a present-day scientist at the museum reviewed archival documents and carried out the initial vision many years later, in a time where science and religion can more reasonably coexist.[15] Speaking frankly, not much of a public exists in South Africa that would become upset or offended if a particular painting were left out of an exhibit, or become angry at the way it was interpreted, or feel enraged if different

sorts of work were shown together. Only occasionally does art elicit that much concern.

Finally, natural science and history museums are finding that they need to "jazz up" their exhibitions to successfully compete with other venues. The entertainment offered by theme parks, sports venues, and video games is increasingly enhanced by technological gimmicks, and frequently operates on the plane of spectacle. Visitors, especially young ones, therefore expect to experience all the bells and whistles when they go to a museum. Tatty displays with dry explanations will simply not hold their attention. But features such as interactive technology are expensive to install and costly to maintain. In art museums, on the other hand, the objects themselves comprise the greatest part of the show.

Throughout the 1990s, the talk amongst museum directors revolved around the fundamentally new ways that they and their curators would be doing their work. Deon van Tonder of Johannesburg's MuseuMAfricA hailed the breakaway from the " 'cabinet-object-label' type of exhibition." André Odendaal, the initial director of the Robben Island Museum, predicted a "move from a product focused to a process-oriented activity." And the South African National Gallery's Marilyn Martin contrasted an "old museology" with a "new museology," wherein "[a]esthetic presence is pitted against social purpose, objects against people, curatorial authority against a voiceless community." In all these respects, they were reflecting worldwide trends.[16]

South African museums were also obviously grappling with issues more particular to their country's history. As stated in the introduction, the colonial legacy has been felt most acutely in art museums, where ideology was directly incorporated into traditional works of painting and sculpture, and fortified by collections constructed along doctrinaire lines. The apartheid legacy is most apparent in cultural history, natural science, and natural history museums, where the ideology was interwoven into the narratives that their curators composed, and it dictated the decisions they made about what to highlight, and how they chose which phenomena "innately" belonged where. But as we have seen, these legacies often overlapped, coalesced, and mutually fortified one another.

Rochelle Keene perceptively characterizes an experience that many people have shared, whatever the specifics of the setting: "You know," she says, "you walk into a museum and the feeling is, 'Well now I am going to have to write an exam, and I am sure I am not going to pass.' " The task that she, van Tonder, Odendaal, Martin, and countless other museum directors and curators throughout South Africa have given themselves is to guarantee that that sort of daunting feeling becomes as antiquated as some of the objects in their collections.

PLAYING THE ART WORLD

Where would the art world be without tricksters? In a stunt that reads as part shape shifting, part anarchistic gesture, and part dadaist performance, artist

Wayne Barker created a stir in the museum world in 1990. Using a fictitious alter ego, Barker entered a work entitled "CV can't vote," allegedly by "Andrew Moletse," into the Standard Bank National Drawing Competition. It was described as "three panels of highly decorative, urban ethnic kitsch, frames and mirror mounts."[17] Work that Barker submitted under his own name was rejected, whereas Moletse's was selected as a winning entry.

Barker's subsequent career has proved him to be a gadfly. He has skewered popular images of racism by using a set of plastic swizzle sticks (Zulu Lulu) and black Winky dolls of the 1960s in his work. At the 1995 Johannesburg Biennale he staged an alternative exhibition that he called "The laager," featuring artists not included in the official show, thereby critiquing the amount of influence that foreign curators had had over choosing the participants. His aim in the 1990 episode was to demonstrate that a reverse racism had set into the art world, giving artists from previously neglected racial groups a distinct advantage. Barker was thus protesting the reallocation of interest from the lopsided favoritism traditionally given to white artists and Eurocentric-themed work to a more inclusive focus. In the process, Barker feared that aesthetics were being replaced by a new sort of racial privileging.

In a similar incident that same year, "Bondwell weKapa" took first place in the annual Weekly Mail/Heinemann Literary Award. He was later revealed to be a white poet and academic at the University of Cape Town. And Barker's feat was also echoed in one staged by fellow artist Beezy Bailey in 1991, a man variously described as a "one-man happening,"[18] "artist-as-exhibitionist,"[19] and the self-promoting proprietor of a "art factory" that mixed art, craft, entrepreneurship, and an ongoing sense of celebration. Bailey entered his own work, as well as three linocuts supposedly done by a black domestic named "Joyce Ntobe," to an art competition sponsored by the South African National Gallery.

Ntobe's work reflected domestic life in the township of Khayelitsha. The pieces were entitled "Go home," "Cook supper," and "Go to sleep." As occurred in Barker's case, Bailey's own submission was rejected, whereas Ntobe's was purchased by the National Gallery for R100 each. As Bailey later reflected upon the event, "If you're a black artist and you've got an inkling of talent, you've got a red carpet rolled out in front of you."[20]

After the ruse was revealed, Bailey posed for a photograph dressed like an old-fashioned sideshow he/she: split down the middle, Bailey appears dressed as a man on his right side, but on his left as a woman, with half his face and one hand blackened, and decked out in a striped uniform and matching hat. Bailey kept the idea of Ntobe alive for several years, claiming her to be his "collaborator," and he dressed up as her in 1998 at the opening of his store in Cape Town. Reacting to what Barker and Bailey had done, SANG's Marilyn Martin even kidded about what she called a new genre of art, "split personality works."[21]

Bailey felt that he, too, had exposed hypocrisy, racism, and double standards he believed were taking hold within the cultural community in the waning days of apartheid. He remarked, "Ironic, isn't it? They used a rich

white kid's non-experience of living in Khayelitsha to depict the authentic experience of Khayelitsha, seen through the eyes of a non-existent domestic worker."[22] But others wrote the episode off as the escapade of "a pampered rich kid who can afford, literally, to indulge in an identity crisis."[23]

Marilyn Martin does not regret the decision to buy the Ntobe pieces. "The sadness," she says, "is that it is more than a decade later, and Beezy still has to dine out on it." And some others cite these episodes as providing stark examples of PC: "political correctness," "policing creativity,"[24] or "particularly cuntish."[25]

Martin seems remarkably blasé about "the *skandaaltjie*" [little scandal].[26] "We have exhibited it [the work] since then," she notes, "we do not hide it, and we are not ashamed of it. Beezy played the game and that was it. There were many games being played at the time, because things were changing." Characterizing those heady days when it became clear that a new world was emerging, but before the old regime was actually dismantled, Martin says, "You know, when you want to change things you have to sometimes go to the other extreme to put [them] right. So one can go overboard a little bit, but it was the decision that we took and we stand by it."[27]

Not all of the pre-1994 controversies had the tenor of a silly prank, however. On the morning of January 15, 1992, four uniformed members of the right-wing political group Afrikaner Weerstandsbeweging [AWB, Afrikaner Resistance Movement] entered the SANG. They were accompanied by two associates who had scouted out the satirical ceramic sculpture "Eugène Terre'blanche and his two sidekicks," by Gael Neke, on an earlier reconnaissance mission. They smashed the three-part work with a hammer, after which they were all arrested. Moreover, the AWB members threatened to blow up the gallery if it ever again dared to present what they considered an unflattering depiction of their leader. The SANG was awarded damages, but the work was destroyed.

THE KING BECOMES A PRESIDENT

During a history that spans less than 50 years, a modestly sized institution in Port Elizabeth reflects the changes that have impacted so many of South Africa's museums. Named the King George VI Art Gallery when it opened in 1956, the museum thus commemorated not only the monarch who had died in 1952, but also honored the location of the first British settlement in South Africa. The museum modeled its collection policy after other major establishments throughout the country, concentrating on British art.

Art by white South Africans was first purchased in the early 1960s. But a change of directors in 1987 also brought a shift of emphasis toward local art and crafts. As it turns out, Africana material had in fact had been collected over time, but it was excluded from the recorded art inventories: it was considered to fall into the category of artifacts, stockpiled in anticipation of developing a history museum some day. The change to a democratic government further accelerated the swing toward South African works: in 1995 an

ANC councilor condemned the museum for its British emphasis, and in another example of heated postapartheid rhetoric, threatened to burn those works and convert the building to a chicken coop.

The museum changed its name to the Nelson Mandela Metropolitan Art Museum in 2002. The current director lauds the decision as a signal that "it is not another tombstone marking the burial place of dead things,"[28] symbolically distancing itself from a cemetery and a historical cenotaph commemorating the woman after whom the city was named. She even characterizes the present exhibition policy, which mixes different categories of items, as "post modernist."

Many other South African art museums have resourcefully modernized themselves without abandoning the core of their collections. Both the Durban Art Gallery [DAG] and the Tatham Art Gallery [TAG] in Pietermaritzburg bear the stamp of the British legacy upon the province of Natal by the abundance of colonial and Victorian art and artifacts they each own. The Tatham, for example, was founded with an assemblage of works imported from England in 1903. An English art connoisseur supplemented that initial inventory in 1923 with eighteenth- and nineteenth-century British works, French Impressionist and Barbizon School paintings, and additional British works from La Belle Epoque.

But neither museum has warehoused the old in a wholesale manner in order to showcase the new. They have, instead, integrated the two. DAG director Carol Brown notes that its Victorian collection had been highlighted from the time of the museum's founding in 1910. "That permanent display had never changed even up to 1995," she says. "And that was one of the issues, that not enough art space was being given to contemporary art forms and local art forms." The central exhibition space now highlights the themes of sexuality, spirituality, people/portraits, and the sociopolitical, presenting art works from different eras and by artists of various racial groups.

The sociopolitical section, for example, combines a 1998 Sue Williamson mixed-media piece, "Truth games—Biko testimony," with "Salome with head of John the Baptist" by Frans Francken (1578–1628) of the Flemish School, along with a contemporary photomontage and a cartoon of Madiba (Nelson Mandela). The surprising combination of different eras and media spawns unexpected affinities and insights. "Sexuality" mixes Sir Noel Paton's nineteenth-century monumental nude, angelic figure in "The pursuit of pleasure" with a 1999 nude by Trevor Makhoba, "Jabula Mphumbo Uzogwinya." Andrew Verster's contemporary "Erotic interiors," a scene of two men kissing, shares space with Jules Triquet's 1867 "Winter," a nude in the forest rendered in a pre-Raphaelite sort of manner. And the spirituality section mixes silkscreen and painting, realism and abstraction, and both Western and Eastern cosmologies.

The Tatham Art Gallery has done something similar, only without the explicit labeling of themes. Recall the comment by Brendan Bell in chapter 2 that the museum had not jettisoned its Victorian-era collection because they had discovered that black African visitors found the narrative quality of this

work to be quite accessible. Accordingly, Edgar Hunt's 1903 "A happy family," a barnyard scene with chickens being prominent, flanks Joseph Manana's 1990 "The inyanga" [a traditional healer who uses herbal remedies], where a depiction of rural African life with the *inyanga* treating a client happens to include a few chickens in the overall setting. Phillip Wilson Steer's 1889 "The sofa" hangs nearby M.J. Segogela's 1987 wood carving of a couple carrying a sofa, and Laura Knight's "The end of the dance (Pavlova)" (twentieth-century British) is paired with Trevor Makhoba's 1989 "Song for school children." Once again, these arrangements complement and expand the meaning of each of their parts.

Tatham Director Brendan Bell reflects, "I thought the interactive display technique would be better than try and compartmentalize or keep different sections of the collection apart. I think purists would turn in their graves or be very critical, but we certainly haven't had anything but positive comments." He was particularly wary of a constituency he calls the "granny brigade," a group of older women who attend lunchtime concerts at the museum. But no complaints were forthcoming. The way that the museum has integrated its holdings allows them to "converse with one another," says Bell, and "draws out possibly quite humorous issues."

Another scheme the TAG initiated to desacralize the museum is a series published in the *Natal Witness* called Fotag [Friends of the Tatham Art Gallery] Focus, where staff or members of the general public chose a favorite painting in the collection and analyze it. "I want my public to be involved, to feel a sense of ownership," Bell argues. Vusumuzi Cele, a security attendant at the gallery, selected "Something for growth," an oil painting by Progress Matabaku. The work appropriates part of the famous photo of Hector Pieterson, and brings together the 1976 and post-1994 eras in a spirit of reconciliation. Tatham education officer Mduduzi Xakaza analyzed an oil portrait of King Goodwill Zwelithini, by Heather Gourlay-Conyngham, comparing it with Christian icons and classical architectural structures.[29]

A MARRIAGE OF CONVENIENCE

As described in chapter 1, the Tatham Art Gallery is the place where a mammoth coronation painting of Queen Victoria was paired with one of King Cetshwayo. The competition to produce the portrait of King Cetschwayo stemmed from a staff meeting where education officer (and later the project director) Mduduzi Xakaza remarked that the prominence of the painting made him feel "alienated." He described it as "[a] painting of a foreign monarch who caused so much trouble to my people. I felt it should be hidden away; it was only for one section of the people in the city."[30]

Museum Director Brendan Bell found himself with a dilemma due to the painting's size: "She can't be moved. She can't be stored. She's where she is for eternity," he notes. Besides the goal of "balancing history," the contest was staged for the gallery's centenary celebration.

This work is weighty for reasons beyond its size. The woman after whom the Tatham was named commissioned this copy of the painting of Queen Victoria to be prepared expressly for the museum, using funds collected by women and children throughout Natal. The original was made in 1846, when Natal became part of the British Empire. Of additional significance, Victoria's 1837 coronation occurred in the same year that the colonization of Natal began, by the arrival of Piet Retief and his followers.[31] Bell's tack was not to hide or eradicate the past, but rather to integrate it with a contemporaneous depiction of the reigning monarch of the Zulus.

Cetshwayo was Queen Victoria's counterpart and nemesis: it was his warriors who were responsible for routing the British forces at Isandlwana in 1879. This symbolic pairing had a historical precedent: Cetshwayo suffered defeat at the Battle of Ulundi six months later. Then, in 1882, he dined with the queen in England, contesting his banishment to the Cape and pleading his case to be restored to power.

The competition for the $2\frac{1}{2}$ by $1\frac{1}{2}$ meters work attracted 114 entries by people from across a wide range of training and backgrounds. One entrant was a retired "identikit" artist, a man who drew pictures of suspects for the police before computer simulations became available. In the end, 26 submissions were by "Africans": 22 men and 4 women. The largest group of participants consisted of "English women," one of whom collected the R100,000 commission.[32] But the selection committee was not privy to any demographic information about the competitors while it deliberated.

Bell is insistent that the museum's display policy consistently be one of inclusiveness rather than exclusivity. He does not wish to deny *anyone's* history. One of the factors that influences his resolute stance was the unprecedented deaccession of over 100 works from the Tatham's holdings in 1963, and a subsequent rehanging of the collection.[33] Details of the criteria used for classifying the "suitability" of works were not kept, however. Bell therefore bewails the fact that using then current standards of taste deprived the Tatham of an important record of the aesthetic preferences that reigned in this colonially infused province in the first half of the twentieth century. He is determined that no other historical gaps be allowed to occur, particularly on his watch.

In 2002 a prominent Pietermaritzburg artist proposed that the museum sell off some of its European paintings in order to purchase works that are "more relevant, immediate, powerful and interesting."[34] Bell directly rebuffed the suggestion: "Art museum collections reflect histories and modes of cultural production. They are a collective memory for future generations of both positive and negative histories," he argued, "and as such have to be left intact." Bell concluded, "Censoring a collection is not, in my view, a healthy transformational tool."[35]

There were critics of the process of choosing a winner in the King Cetshwayo competition, to be sure. "Pass the spear. The Tatham Art Gallery needs one to fall on," a scathing newspaper opinion piece led off. "With no disrespect to the individuals [finalists], it doesn't look good, even if their paintings do," he

continued. "Rectifying historical imbalance does not come only through estab-lishing a symmetry of black subject-white subject, king and queen."[36]

But the *Natal Witness* applauded the fact that the Tatham conducted a blind competition and did not cave in to any pressure to chose a winner on the basis of race: "the very fact that a truly representative selection panel did not follow the politically correct, and hence easier, route is itself an indication of the growing maturity of the community."[37]

Brendan Bell was not unaware of the contours of the political landscape, however. He postponed the unveiling until after the national elections in 2004 so the event would not become a political soccer ball.[38]

UNDER THE GUN, OR BENEATH THE SWORD

Even if actual incidents of direct government interference within museums during the apartheid years were rarities, that prospect caused their personnel to exercise a great deal of caution in the way they conducted their business. The fear that the sword of Damocles generates is not because it has fallen, but that by dangling overhead, it *could* come down at any moment. Museum personnel moved gingerly throughout most of the second half of the twenti-eth century in order to avoid fraying the hair that held that blade in place, thereby guarding against it from dropping on them. In other words, they became their own watchdogs and tailored their conduct in ways that accorded with the aims of the government.

During the past decade, the SANG has embarked upon a series of warts-and-all exhibitions to reveal how it once operated, why it once did so, and to demonstrate how it has subsequently changed. This has been a way of putting itself under the microscope for a thorough self-examination. For example, *Contemporary South African art: 1985–1995, from the South African National Gallery permanent collection* (1996–1997) highlighted acquisitions from both during and just after apartheid, showing how the political milieu put constraints on the museum, and how SANG sometimes successfully made an end-run around those limitations.

According to Neville Dubow, the Acquisitions Committee at the South African National Gallery once had the feel of "a gentlemen's club," echoing Dr. Jason Londt's description apropos of the Natal Museum. As the former chair of the group, Dubow argues that consensus, good taste, and decorum typified the way it generally operated. But as the political crisis deepened throughout South Africa during the 1980s, the committee inched toward subverting established hierarchies.

On the aesthetic front, purchasing abstract works was akin to recognizing and certifying the value of foreign perspectives, always a potential threat to a repressive state (recall that the South African government prohibited televi-sion until 1976 for that very reason). And in another regard, some museum personnel played a cat-and-mouse game with government representatives in order to obtain and display a three-part set of drawings in graphite and wax that could be easily interpreted as an indictment of the current regime.

The work in question was by Paul Stopforth. It features large portraits of three men, peering forward and confronting the viewer. Each of their heads is cut off somewhere between the chin line and the forehead, and one of their faces is partially obscured because he is wearing sunglasses. The images are stacked one above the other. Stopforth's original title, *Interrogators*, pointed to the figures being members of the secret police, their likenesses thereby endowed with a sinister presence. Easily overlooked on first glance, the outline of a chair appears next to the middle portrait, suggesting the intense grilling of "suspects."

When the Acquisitions Committee reviewed the work in 1979, its members were split over supporting its purchase. The government's representatives put up some resistance to it, although Dubow believes that they were likely hesitant about revealing too much about what they actually knew concerning men such as these. In point of fact, the men depicted were the officers who had interrogated Black Consciousness leader Steve Biko, who was murdered while in custody.

SANG's entire board considered the work next. It was presented to them under the name of *Triptych*, and this time it successfully moved through the approval process. Dubow calls this "a kind of Trojan Horse tactic": the director deliberately deceived the trustees by muting the work's message.[39] After it was installed, however, the name *Interrogators* was restored, and the education staff used the piece to stimulate discussions about political matters, around which there was otherwise generally silence. As Dubow characterizes the ploy, "[T]he horse slips into the citadel, the horse is opened up, and all sorts of things spill out."[40] But while this indeed constituted a crack in the wall, it was hardly a frontal assault on apartheid's fortifications: Dubow also notes that *Interrogators* would be removed on the occasion of gallery visits from important government officials.

Greater transparency was also the raison d'être for *ReCollections: 130 years of acquiring art for the nation (1871–2001)* [2002–2003]. *ReCollections* demonstrated how museum collections grow in relation to broad historical, political, and economic forces. The exhibition provided an insider's view of why certain works were secured, even if they engulfed meager budgets. It displayed and discussed the egg-on-your-face episode of a prized Impressionist painting that was put on show for nearly 60 years before it was revealed to be a fake. And it clarified the relationship between the SANG and the powers-that-be.

According to the wall text, "The Apartheid Government's 'policy' on the visual arts was at best a mixture of philistinism and neglect. Despite the presence of State appointees on the SANG Board of Trustees, there was no guarantee of adequate funds. There was also no direct interference or interest on what was acquired." In other words, the cultural realm did not warrant sufficient concern to justify a blatant crackdown. It was not credited with that much power or significance.

The museum purchased its first works by black artists in 1964: Gerard Sekoto and Sydney Kumalo. That, too, remained under the radar: "Although the SANG was to create a 'White own affairs institution,' " the wall text

explained, "these purchases elicited no official reaction." So even within a state as repressive as South Africa there was some "wiggle room," as long as one was not too obvious, did not push the status quo too far, and an institution was not operating within what the government viewed to be a particularly strategic realm. "The SANG had quietly avoided applying Apartheid policies," the exhibition explained, "but it was well known by officials that it was acquiring work that was considered to be 'subversive.' "

Since that time, the SANG has branched out even further. *Ezakwantu—Beadwork from the Eastern Cape* (1994) explored an important form of indigenous cultural production. In one reviewer's words, it was "another promising step forward in the SANG's ongoing attempts to move beyond its moribund jail-house of virtual-culture . . . this exhibition is proof that South African cultural institutions are capable of moving with the times and away from the position which presented black people as exotic specimens and curio-mannequins."[41]

Moreover, the SANG's hosting of *Miscast: Negotiating Khoisan history and material culture* in 1996 (Chapter 3) must be seen in this light. By bringing installation art to this otherwise staid setting, and by so pointedly interrogating museum practice, SANG stepped beyond its conventional comfort zone and endorsed a groundbreaking exhibition rife with provocation. *Miscast* pulled SANG even further away from the manner by which it had so recently functioned.

One of the aims of the acquisitions policy adopted that same year was to broaden the collection by exploring both the African and Western roots of South African art. *Isintu—Ceremony, identity and community* (1999), the first exhibition curated by a black person,[42] represented another step forward. And *Ilifa Labantu—Heritage of the people: Acquiring African art, 1994–2004* [2004–2005] cites the SANG's first addition of works of "traditional" sculpture from West Africa to the collection in the 1960s, and its subsequent assembling of all types of related material from throughout the continent. To be completely candid, the commitment to black African art that South African museums have increasingly demonstrated since the 1980s reflects awareness and appreciation of its importance, but at the same time signals that these institutions are not financially able to compete in the world market for either modern Western or older European works.[43]

AND IN THE END

The relative lack of concern that the apartheid government had for what was going on in museums is borne out in the histories of other institutions as well. For example, when the Pretoria Art Museum first opened in 1962, it posted an explicit policy that nonwhites were only permitted to visit on Thursdays, the traditional day off for domestic workers. But it soon took down the signage and opened its doors to everyone at all times, in theory at least. Few nonwhites ever visited, however, so this was far from a radically defiant measure.

The Johannesburg Art Gallery likewise escaped close scrutiny because nonwhites never posed a "danger," both because of their negligible presence in the galleries, and the minimal threat of "contamination" that they posed because displays were nontactile.[44] The critical appraisal that Olivia offered of the character Feste in Shakespeare's *Twelfth night* is equally applicable to museums at that time: "There is no slander in an allowed fool."

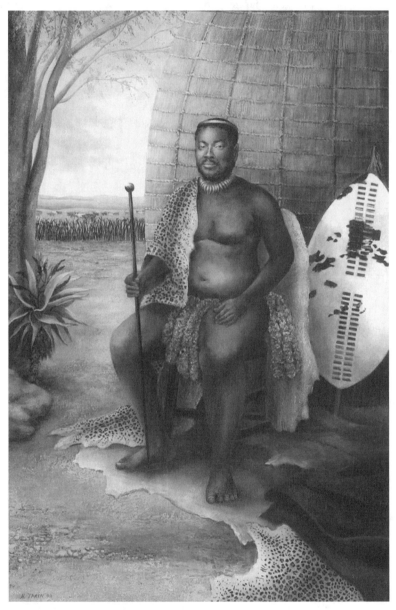

Figure 12 Portrait of King Cetshwayo kaMpande by Helene Train, 2003

Source: Courtesy of Tatham Art Gallery, Pietermaritzburg.

CHAPTER 10

Conclusion: A Bridge Too Far?

The mutual suffering of black and white civilians should be a bridge for all to walk over to the future.

Kanhema, 1996

It is a balmy October day in 2003. Spring smells saturate the air at the Talana Museum and Battlefield outside Dundee, in KwaZulu-Natal province. Enthusiasts rehearse for the annual reenactment of the Battle of Talana, the skirmish that opened the South African (nee Anglo-Boer) War. One man moans "It's another shit day for the Empire": here, after this 1899 encounter, the Brits fled to the town of Ladysmith, which became the site of a famous siege. Among those witnessing the Battle of Talana was a young reporter named Winston Churchill.

The mood is one of raucous horseplay amongst the men, despite the best efforts of the female director to rein in their energies. Maintaining focus is not one of the stronger points of this ragtag group. Clad in their everyday clothes, the men cannot fully shake off the contemporary world. They are clearly more interested in sharing a few Castle lagers and some biltong or dried boerewors on this late Saturday morning, than authentically replicating this important historical incident.

The director repeatedly orders the men to scoot under or clamber over the tops of the train coaches that stand motionless on the museum's grounds. But this is no easy task; prodigious bellies and sedentary lifestyles hamper their movements. And substituting cell phones for guns simply adds to the giddiness.

Cheering them on is a group of camp followers, the type of ladies who once provided "comfort" to the soldiers. They gleefully talk of tarting themselves up by heavily slathering their faces with rouge and dressing in period garb loaned out by the museum. The women brag about their three years of prior experience that enable them to look saucy yet not slutty. A fresh volunteer is quite surprised to discover who these ladies actually purport to be: she is eight and a half months pregnant, and does not easily fit the stereotype of a prostitute.

Across the museum's grounds, and completely out of range of these amateur performers, a group of Zulus resurrect *their* ancestors, practicing traditional dances and chants. Tiny children mix it up with young adults, and even some older folks. Time and again they initiate a pounding battle charge, their fierce approach quickly dissipating at the command of their leader. A few of them sport *assegai* and shields, or wear bits of animal hide. But modern-day fashions predominate. One teenager's t-shirt makes the claim, "Together we can fight crime."

This is history in the New South Africa: by turns seriocomic and simulacra, clear-cut and contradictory. Certain battles are replayed time and again.[1]

MILITARY INTELLIGENCE

The uneasy and highly adversarial state of relations between museums and government officials has calmed since President Mandela maligned them in his infamous 1997 address against exclusivity. The threats of deaccessioning parts of collections or even closure that regularly made headlines in the mid- to late 1990s have cooled to a degree as well. Of necessity, the parties have accommodated to one another's quirks, needs, and demands; each draws whatever it can from the other in order to enhance its cachet and survival.

Nevertheless, that uneasy truce can be easily shattered. A case in point: in January 2005, South Africans were treated to the spectacle of watching a museum's chief and two other curators be arrested, placed in handcuffs, and taken off to jail by members of the South African Police Service [SAPS] and the South African National Defence Force [SADF]. And of all places for this to occur, it was at Johannesburg's South African National Museum of Military History [NMMH], whose own head of command is a retired general.

The allegation was that the museum was in possession of war-capable weapons and vehicles, material that had been illegally obtained. According to military records, this equipment was listed as "destroyed"; the museum's information showed that it had been acquired legitimately, however. The SADF removed four armored vehicles during the raid, damaging the museum's entrance in the process.

This was reportedly part of the SADF's new crime prevention strategy to fight corruption within the military, but it was a show of strength that seemed frightfully out of proportion to any real public threat. The person who stepped in to run the museum after her colleagues had been taken into custody puzzled, "They have accused us of stockpiling, but then of course . . . that is what a museum does, we collect things."[2]

On the face of it, this certainly seemed like a matter that should have been handled at the level of registrars or librarians, records clerks, or quarter masters, and settled through talk rather than by an encounter of this magnitude. The absurdity of the situation was amplified when director-general of the Ministry of Arts and Culture Itumeleng Mosala remarked, "The number of weapons being kept there could raze Soweto within two minutes."[3] This farcical incident became a cause célèbre, repeatedly characterized in the press as a paranoid and embarrassing occurrence.

All three of the museum employees were held overnight and released, and no formal charges were laid. In a country regularly wracked by violent crime, this appeared to be a sorrowfully misplaced show of force. But on closer inspection, it might have been another strategic deployment of the politics of diversion. The SADF has been under increased scrutiny for the improper conduct of its peacekeeping forces stationed throughout Africa, an elevated HIV infection rate among its ranks, and the generally low physical competency of its recruits. It has deteriorated, according to one commentator, from an "iron fist to [an] atrophied paw."[4] The dramatic public gesture may restore luster to a faded image; or it may unluckily turn into farce.

And there was this final irony: NMMH sits next door to the Johannesburg Zoo, home to the late Max the Gorilla. Max became legendary in South Africa in 1997 after a criminal on the run from police jumped into the animal enclosure he shared with his mate. Max charged the intruder and injured him sufficiently to prevent the man's escape. But Max's bravery also brought him two bullets to the chest.

Max survived, and gained entry into the pantheon of modern local heroes. But his adventure serves as a cautionary tale in the jumbled-up New South Africa: not even a caged gorilla is immune from crime nowadays. And by extension, seemingly benign museum curators might in fact be plotting the violent overthrow of the country.

The End of Ideology?

South African museums face a delicate balancing act today: how to shed the ideological corsets of the past without replacing them with similarly restrictive fashions. David Morris of the McGregor Museum observes, "It was actually quite funny in the late 1980s, from within the museum fraternity there were these diagnoses of museums as being bastions of ideology, which undoubtedly most of them were. And everyone applauded. But now in the new order there is almost a call that we must impart the 'right ideology.' "

One of the ways this becomes evident is in breaking away from the authoritative curatorial voice. The core business of museums around the world has long included classifying and categorizing—ordering "reality," in other words. But in the South African experience this has generated significant problems, especially in relation to characterizing and presenting different groups of people. Iziko's Dr. Patricia Davison deeply understands the problem of reifying race or ethnicity: "The classificatory divisions in our collection sort of followed those old apartheid categories like *The* Zulu, and *The* Xhosa, and *The* Bushman. So we used them purely for the convenience of managing the collections, but in fact we did not have to give those categories a new life in [current] exhibitions."

New strategies are being implemented, as Davison explains: "We felt what we should be doing . . . is to integrate the African collections with the other collections. What we are hoping to do when we do future exhibitions is to really take an historical approach, and you would not just be looking at an ethnic group in separation from whatever other things were going on."

In the past, museums were likely to put off many potential non white visitors because of the stereotypical way in which they were being displayed. The irony is that at the same time that scientists, scholars, and curators are increasingly viewing race as a cultural construct, many in the general population are embracing it as a distinct, tangible biological entity around which to mobilize—and to press their claims for spiritual union and common cause, land, status, and power. The more that museums deemphasize race, seeing it as being socially derived, the more likely it is that they will dissatisfy people who now demand to see themselves rightfully occupying certain classificatory boxes.

What are the implications for the "Rainbow Nation"? A rainbow might either be construed to be like a stained glass window, each color separated by solid lead filaments, or as a band of light gradually separating into different shades of color along a continuum. The first model is unchanging, the second is variable. Museums are more likely these days to adopt the supple version, to the disappointment of some of their clientele. As Northern Flagship CEO Makgolo Makgolo notes, "We need to now have some kind of an identity as South Africans, not as someone who is white living here, or a black person there, or another one living there." He continues, "We need to use any available instrument that enhances that oneness and that identity. Museums could serve as one of those instruments."

One of the de rigueur features of contemporary South African museum practice is the avoidance of language that could suggest dogma of any sort. Declarations of "fact" have been replaced by tentativeness, open-endedness, relativity, and deference for multiple perspectives. But what has been gained, and what has been lost in the process? On the positive side, the humanly constructed and interpretive nature of history has become more self-evident, and people are encouraged to exercise (or suspend) their own judgment; museums have become more accessible and less intimidating as a result.

However, by making everything seem partial, provisional, and a reflection of subjective factors, museums may retreat from saying anything definitive and forfeit any distinctive claims to knowledge they may have. In the words of the SANG's Marilyn Martin, "I think the Eurocentric attitude has done an enormous amount of damage. One doesn't want to replace it with another centrism, but we've got to redress the balance."[5]

TEN YEARS IN A NUTSHELL

It is difficult to imagine a more scandalous visual refutation of the classic, Eurocentric orientation than the cover art that the South African National Gallery chose to grace its catalogue for *A decade of democracy: South African art, 1994–2004*. Tracey Rose, a light-skinned woman who was tagged as "coloured" during apartheid, reenacted August Rodin's *The kiss* (1888) with her black art dealer. One of his hands cradles her naked buttock while the other firmly supports her back. They gaze directly into one another's eyes with an equal measure of expectancy, naughtiness, and playfulness.

The pair literally fleshes out a National Party nightmare. One only need recall the 1992 incident when four right-wingers invaded SANG and smashed a satirical ceramic sculpture of their leader to appreciate how much the cultural climate has shifted in this country, within a relatively short time. Recall, too, that these same galleries hosted *Miscast* in 1996, a pivotal moment when the representation of the bodies of nonwhite South Africans triggered a firestorm.

A broad range of institutions marked the first ten years of democratic rule in 2004 with exhibitions, performances, commemorations, and public discussions that took stock of the country's past, present, and future. Robben Island hosted Beethoven's so-called freedom opera *Fidelio*, the story of an innocent prisoner who is heroically rescued from his confinement. It played to an audience that received dinner and a performance for the stiff tariff of R1250 per person.[6] Soweto was the scene of the Decade of Democracy Arts Festival. The writer and director of a play about AIDS commented, "This is a celebration of the great lengths that artists went to in order to aid the struggle. But now we are proud that we don't write protest plays any more."[7]

A well-known curator and writer on the arts argued in her introduction to the catalogue of *Resistance, reconciliation, reconstruction*, an exhibition sponsored by communications giant MTN, that "artists have outlived apartheid-era labels, such as 'art-as-a-weapon-in-struggle.' Today the 'politics of representation,' as it were, has overtaken the 'representation of politics.' "[8] The show contained two works that paid homage to the memory of Sarah Bartmann: *Prospect: Saartjie Baartman*, by Penny Siopis (1993), and *Sarah* (2002), by Kagiso Pat Mautloa. These images bluntly take up the intersection of politics *with* representation. And as mentioned in chapter 8, Iziko mounted *Democracy X: Marking the present, re-presenting the past*, bringing together Iron Age artifacts, fine art, European and native artifacts, photos, and historical documents from throughout its collections, in a sweeping survey hosted by the Castle of Good Hope in Cape Town.

Of necessity, grand assemblages such as these veer toward celebration, boastfulness, and triumphalism, even if some of the work dredges up the pain of the past or pointedly addresses the problems that keep on plaguing this country.

Transformation: The Summing Up

In the final analysis, what does transformation in South African museums actually mean?

Transformation signifies *enlarging* the representation of different ideas within exhibitions, as well as *expanding* the racial diversity of employees and visitors. Transformation means *eliminating* barriers that lead potential visitors to feel that museums are places intended for others, but not themselves. Transformation necessitates *eradicating* narrowly ideological perspectives, but safeguarding against allowing new ones to be substituted in their place. Transformation suggests *engendering* the creation of knowledge. Transformation stands for *enlivening* archaic places with contemporary concepts

and technologies. Transformation dictates *erasing* hierarchical distinctions between types of cultural production, such as "art" and "craft," "elite" and "popular," and "Western" and "indigenous." Transformation occasions *emphasizing* thematic exhibitions over strictly object-based displays.

Transformation acknowledges that cultures are constantly *evolving*; they are not static entities. Transformation demands *engaging* with communities directly, rather than being detached from their interests and lived realities. Transformation involves *establishing* linkages with many sorts of organizations and endeavors beyond the traditional purview of museums.

Transformation entails *educating* people about the histories they have been denied across generations, about themselves and others; this equates with *empowering* them to have an enhanced understanding of their lives, and a potentially greater voice in shaping their own fates. Transformation implies *endeavoring* to produce balanced presentations, but not by eliding real differences between groups, homogenizing their experiences, or failing to acknowledge hard realities. Transformation requires *embracing* difference and bringing people together, but without artificially creating an illusion of consensus. Transformation, if successful, can lead to *easing* intergroup antagonisms and promoting reconciliation.

And finally, to take the edge off all these serious goings-on, museums can become vibrant, *entertaining* venues. Their transformation now means that museums symbolize communal free spaces, *epitomizing* the type of setting where debate can be expected to occur, and the hybridization of ideas, customs, and values will be hastened. Transformation sanctions *envisioning* museums as an essential component of civil society that offers the kind of public forum essential to a healthy democracy.

As critical and distinctive as the transformation of museums has been to the South African experience, however, it is important to note that this is simply one of the more interesting examples of a global phenomenon.

BUILDING BRIDGES

The combative Kudu bulls mentioned in chapter 8 may have shared a common fate, and yet when their remains were discovered, their skulls and skeletons faced away from one another. Though locked in a mortal struggle, one did not directly witness the suffering of the other. Murder and suicide, intransigence and mutual blindness, converged in one awful episode. Regrettably, one final anecdote captures a similar sense of pointless and reciprocal self-destructiveness among contemporary South Africans.

Recall that at the site of the 1838 Battle of Blood River, a museum on one bank commemorates the engagement with a decided bent toward the Voortrekkers' point of view, while on the opposite side of the Ncome River another institution presents a Zulu version of the story. This is the situation that Barry Marshall, director of the South African Heritage Resources Agency, condemned as harkening back to the apartheid doctrine of "separate development."

.A wide discrepancy has existed between those two perspectives, especially in their estimates of the numbers of people killed. Recently, both sides have edged toward resolving those differences, revealing the tentative stage of reconciliation that currently characterizes South Africa. But tourists wishing to visit both places must drive a roundabout road connecting the two. That would become unnecessary, however, by constructing a proposed footbridge that would allow people to conveniently walk from one side to the other in a matter of merely minutes.

The costs for the bridge were incorporated into the Ncome project's initial budget. Barry Marshall claims credit for the idea, and he remembers telling those in charge of the development, "At least put a bridge across the river so that people can go across and see it from both perspectives, from the [standpoint of the] invader and what it is like to be invaded."

Supporting columns have been anchored into place; even so, the bridge has never been completed. Bongani Ndhlovu, manager of the Ncome Museum, argues that some people who revere the Battle of Blood River Heritage Site do not wish to see the bridge installed because regular traffic from one side to the other "could pollute [it] with new influences." And General Gert Opperman, CEO of the Voortrekker Monument and Museum in Pretoria, who also oversees the Blood River Site, candidly admits that this is one of the most difficult matters he's had to confront. He personally advocates bridge building, in both the physical and psychological senses. But Opperman feels he needs to proceed cautiously: "I also have a constituency that I have to take into account, and unfortunately this whole thing was mooted in a very haphazard way, and it nearly led to a revolt. So I will have to be very careful about how I manage this."

Lopsided numbers of visitors to the area choose only to take in the Voortrekker perspective. Relatively few of them take advantage of what the entire location has to offer. This is one of the many situations where the racial divide continues to bedevil South Africans. The opposing parties have remained just that—facing off one another like their ancestors did over 150 years ago—merely sans weapons of war.

These advocates, equipped with their dual perspectives, have not yet figured out how to meet one another half way, to their mutual benefit.

* * *

Daily life in contemporary South Africa vacillates between exhilaration and frustration, hope and cynicism, confidence and anxiety. This society has been reborn, but it has not yet matured. Museums have become a microcosm of this labile state of affairs. They are alternately the best and the worst of settings to be working in today.

Glossary

aantrek	traditional enrobement or dressing ceremony to prepare a body for burial
agterryers	black Africans and Indians acting as "after-riders" or horse tenders and general assistants during the Anglo-Boer War
ANC	African National Congress, political party central to the liberation struggle, and the current ruling party
apartheid	separateness; a system of race-based laws during the rule of the National Party that explicitly regulated the employment, residence, and interaction of nonwhites with whites
assegai	spear
Bantu	a generic and somewhat antiquated term for black Africans, referring originally to language groups
biltong	dried jerky
Boere [pl.]	the Boers, Afrikaner farmers
boerewors	literally, "farmers' sausage"
braai [braaivleis]	cookout or barbecue, grilling meat
buchu	a native shrub whose leaves are burned for ceremonial purposes; also used medicinally
coloured	mixed race
dagga	marijuana
dompas[ses]	an identification book required to be carried by anyone classified "nonwhite" during apartheid
eGoli	City of Gold (Johannesburg)
Ekhulukhuthu	"deep hole" or "isolation cell," Native Prison (Johannesburg)
goa goa	an indigenous musical instrument made from an empty tin can and strings
gogo	female elder
helpmekaar	sharing
iimbongi	praise singers
indaba	meeting convened to discuss an important matter
inyanga	traditional healer who uses herbal remedies
iziko	hearth, or hub of cultural activities; the name of a confederation of museums in the Cape Town area

jelly	gelatin
jol	good time, partying
Kaapse Klopse	Cape Carnival minstrels
Kaapstad	Cape Town
kaffir	archaic epithet for black Africans; from the Arabic for non-Moslem
kanala	to help one another; to do a favor
kappies	traditional bonnets for Voortrekker (pioneer) women
Karoo	a vast semidesert that sprawls throughout the Cape provinces
kgotla	community justice publicaly determined under a tree
Khoekhoesess	KhoeKhoe chief
Khoi-goed	traditional Khoisan herb mixture, including buchu and other aromatics; burned during ceremonies
knobkerrie	club used for striking a person
koeksister	a popular sweet
Kofifi Weety	a dialect distinctive to Sophiatown, from a mixture of languages
koki-pen	marking pen
kraal	homestead, with animal enclosure
KwaMuhle	"the place of the Good-One"; name of a museum in Durban
laager	a circular, self-protective wagon formation used by the Voortrekkers; also refers to a self-imposed, narrow mentality
lobolo	bride wealth
Madiba	isiXhosa clan name of Nelson Mandela
makwerekwere	illegal aliens
mapotos	Ndebele married women's aprons
mealie	corn
mealiepap	see *pap*
mfecane	large-scale internal migration of black Africans in the nineteenth century stimulated by intertribal fighting
moffie	gay man; sometimes an effeminate man, or transvestite
mpepo [mpepho]	aromatic African herb burned ceremonially
muti	traditional medicine
ncome	praised, or welcome; name of river at site of historic battle between the Zulus and Voortrekkers in 1838
net blankes	whites only
net nie blankes	nonwhites only
oom	uncle
ouma	aunt
PAC	Pan African Congress
pap	made from cooked maize meal, an African staple
platteland	literally "flatland"; rural areas or country towns, synonymous with narrow-minded or unsophisticated

potjie	three-legged metal cooking pot, commonly used for stews
sangoma	traditional healer or diviner
satyagraha	passive resistance, as championed by Gandhi
shebeen	illegal drinking establishment, a speakeasy
seshoeshoe	patterned cotton cloth popular with black Africans; also known as "German print," a nineteenth-century import
skandaaltjie	little scandal
skollies	thugs/street hustlers
smouswa	giftshop
stoep	porch, veranda
swart gevaar	the black threat
taal	language
talana	the shelf where precious items are stored
tannie	aunt
tata	term of respect for father, a married man
tekkies	sneakers
toyi-toying	mass high-stepping dancing and singing, popularized during the struggle against apartheid to demonstrate collective strength and to unnerve the authorities
triomf	triumph; the renamed former Sophiatown area of Johannesburg
tsotsi	a petty thief, gangster; a corruption of "zoot suit"
Tsotsitaal	a gangster/towmship argot/patois, developed on the mines and in Sophiatown; "jive talk," derived from isiZulu and blended with other languages
Tweede Nuwe Jaar	Second New Year, January 2, traditionally a day off for slaves in the Cape
ubuntu	group solidarity
ululating	a staccato yowl produced by rapid movement of the tongue
Umkhonto weSizwe [MK]	"Spear of the Nation," armed wing of the African National Congress
veld	open grassy country
volkstaat	literally, a people's state, like the town of Orania
Voortrekker	nineteenth-century Afrikaner pioneer
zonnebloem	sunflower

INTERVIEWEES

NOTE

All interviews were conducted by the author, in person. All but a few of the interviews were taped, and they were professionally transcribed. They lasted from between 30 minutes to over 3 hours. On average, they ran from 45 to 90 minutes. All examples of direct quotations within the text that are not provided with specific attributions come from these interviews. And although not every interviewee is directly quoted, some of the information they provided is used as background material. A number of individuals have changed positions since we spoke, but their identifying information reflects their jobs at that time.

Colin Abrahams, Director, South End Museum, Port Elizabeth, July 3, 2003

Dr. Gabeba Abrahams-Willis, Archaeologist, Iziko Museums of Cape Town, June 11, 2003

Jill Addleson, Former Director, and Curator of Collections, Durban Art Gallery, Durban, November 25, 2003

Dr. Rayda Becker, Artworks Curator, Parliament of South Africa, Cape Town, October 28, 2003

Brendan Bell, Director, Tatham Art Gallery, Pietermaritzburg, August 26, 2003

Hester Booysen, Khoisan community member, Hankey, July 3, 2003

Dr. C. K. (Bob) Brain, Director (retired), Transvaal Museum, Irine, December 20, 2003

Henry (Jatti) Bredekamp, CEO, Iziko Museums of Cape Town, Cape Town, June 11, 2003

David Brodie, Curator: Contemporary Art, Johannesburg Art Gallery, Johannesburg, January 14, 2004

Carol Brown, Director, Durban Art Gallery, Durban, August 21, 2003

Jean Burgess, Khoisan community activist, Grahamstown, July 2, 2003

Margaret Coetzee, Khoekhoesess (KhoeKhoe Chief), Hankey, July 3, 2003

Kevin Cole, Director, East London Museum, East London, July 7, 2003

Sharon Crampton, Director, Oliewenhuis Art Museum, Bloemfontein, October 2, 2003

Pauline Crowe, Former Curator, and Member, Board of Directors, Greytown Museum, Greytown, November 19, 2003

Dr. Patricia Davison, Director; Social History Collections, Iziko Museums of Cape Town, Cape Town, October 27, 2003

Phillippa de Villiers, Actress and writer, Johannesburg, December 18, 2003

Phumzili Dlmini, Education Officer, Durban Art Gallery, November 26, 2003

Prince Dube, Curator: Education, Johannesburg Art Gallery, Johannesburg, December 23, 2003

Noor Ebrahim, Education Officer, District Six Museum, Cape Town, June 10, 2003

Louis Eksteen, Curator, Fort Amiel Museum, Newcastle, November 18, 2003

Haajirah Esau, Head, archives and resource center, District Six Museum, Cape Town, June 10 and 12, 2003

Colin Fortune, Director, McGregor Museum, Kimberley, September 29, 2003

Linda Fortune, Education Officer, District Six Museum, Cape Town, June 10, 2003

Ela Gandhi, Former Member of South African Parliament, and peace activist, Durban, August 21, 2003

Jenny Hawke, Curator, Fort Nongqayi/Zululand Historical Museum, Eshowe, November 27, 2003

Sithembile Haya, Director, The Queenstown and Frontier Museum, Queenstown, July 10, 2003

Dr. Manton Hirst, Principal Human Scientist (anthropology), Amathole Museum, King William's Town, July 8 and 9, 2003

Ali Hlongwane, Chief Curator, Hector Pieterson Museum, Soweto, December 19, 2003

Colonel (retired) Frik Jacobs, Director, War Museum of the Boer Republics, Bloemfontein, October 3, 2003

Shifra Jacobson, Human rights worker and diversity management trainer, Johannesburg, July 17, 2003

Dr. Frank Jolles, Retired Professor of German, and member of the Board of Trustees, Tatham Art Gallery, Pietermaritzburg, and KwaZulu Cultural Museum/Ondini Site Museum, Ulundi, Hilton, November 20, 2003

Judy Jordan, Curator, Carnegie Art Museum, Newcastle, November 18, 2003

Hilton Juden, Architect and former museum designer/developer, Johannesburg, December 10, 2003

Etta Judson, Deputy Manager, National Cultural History Museum, Northern Flagship Institution, Pretoria, October 20, 2003

General John Keene, Chief Curator, South African National Museum of Military History, Northern Flagship Institution, Johannesburg, December 17, 2003

Rochelle Keene, Director, Johannesburg Art Gallery, and past President of South African Museums Association, Johannesburg, November 11, 2003

Donald Klinghardt, Curator/scientist, Iziko Museums of Cape Town, Cape Town, June 12, 2003

Ildiko Kovacs, Curator, Empangeni Art and Cultural History Museum, Empangeni, November 27, 2003

Valmont Layne, Director, District Six Museum, Cape Town, June 12, 2003

Andrew Lindsay, Artist/muralist/gallery owner, Johannesburg, January 12, 2004

June Litterick, Chairperson, Board of Directors, Greytown Museum, Greytown, November 19, 2003

Robert Luyt, Acting Director, Local History Museums, Durban, August 20, 2003

Neo Mbatha, Guide, Mgungundlovu Museum and Historical Site, Mgungundlovu, November 28, 2003

Pam McFadden, Curator, Talana Museum, Dundee, November 18, 2003

Brenton Maart, Curator: Exhibitions, Johannesburg Art Gallery, Johannesburg, January 14, 2004

Dudu Maddnsela, Curator, Nieuwe Republiek Museum, Vryheid, December 12, 2003

Corrine Mahné, Curator, Vukani Collection Museum, Eshowe, November 27, 2003

Makgolo Makgolo, CEO, Northern Flagship Institution, Pretoria, December 2, 2003

Tshidiso Makhetha, Curator: Education, Johannesburg Art Gallery, Johannesburg, December 17, 2003

Dr. Antonia Malan, Historical Archaeology Research Group, University of Cape Town, Cape Town, October 27, 2003

Neo Malao, Manager, National Cultural History Museum, Northern Flagship Institution, Pretoria, October 20, 2003

Carina Malherbe, Director, Transvaal Museum, Northern Flagship Institution, Pretoria, October 20, 2003

Barry Marshall, Director, South African Heritage Resources Agency, (SAHRA), Ulundi, November 27, 2003

Marilyn Martin, Director: Art Collections, Iziko Museums of Cape Town, Cape Town, October 28, 2003

Sibongiseni Mkhize, Director, Voortrekker Museum, Pietermaritzburg, August 25, 2003

Elza Miles, Art historian/researcher/writer, Johannesburg, January 16, 2004

David Morris, Archaeologist, McGregor Museum, Kimberley, September 29, 2003

Bongani Ndhlovu, Manager, Ncome Museum, Blood River, November 19, 2003

Vusi Ndima, Chief Director: Heritage, Department of Arts and Culture, Pretoria, October 24, 2003

Mbongeni Ngema, Playwright and musician, Johannesburg, September 10, 2003

Rick Nuttall, Director, National Museum, Bloemfontein, October 2, 2003

Busi Ntuli, Gallery Assistant, KwaZulu Cultural Museum/Ondini Site Museum, Ulundi, November 28, 2003

Justin Nurse, Designer and Partner, Laugh It Off Clothing/ Promotions/Media, Cape Town, October 30, 2003

Dirkie Offringa, Chief Curator, Pretoria Art Museum, Pretoria, November 7, 2003

General (retired) Gert Opperman, CEO, Voortrekker Monument and Museum, Pretoria, September 10, 2003

Sheryl Ozinsky, Manager, Cape Town Tourism, Cape Town, October 29, 2003

Donald Parenzee, Head, exhibitions, District Six Museum, Cape Town, June 10, 2003

Anton Pelser, Archaeologist, National Cultural History Museum, Northern Flagship Institution, Pretoria, October 20, 2003

Dr. Ivor Pols, Retired Director, Voortrekker Museum (Pietermaritzburg), Cape Town, October 27, 2003

Ann Pretorius, Director, William Humphreys Art Gallery, Kimberley, September 30, 2003

Sandra Prosalendis, Deputy Director Arts and Culture, Human Sciences Research Council, and former Director, District Six Museum, Cape Town, October 29, 2003

Mark Read, Gallery owner and Chair, Board of Trustees, Northern Flagship Institution, Johannesburg, October 10, 2003

Vivian Reddy, Chairman, Edison Corporation, Durban, August 22, 2003

Guy Redman, Director, Durban Natural Science Museum, Durban, November 26, 2003

Henriette Ridley, Assistant Director, Voortrekker Museum, Pietermartizburg, November 21, 2003

Jeremy Rose, Architect, Mashabane Rose Associates, Johannesburg, December 9, 2003

Steven Sack, Chief Director, Cultural Industries and Creative Arts, Department of Arts, Culture, Science and Technology (Pretoria), Johannesburg, December 10, 2003 (currently, Director, Arts, Culture and Heritage Services, city of Johannesburg)

Gillian Scott-Berning, Fine and decorative arts consultant; Former Director, Local History Museums, Durban, and past President of South African Museums Association, November 25, 2003

Allan Sinclair, Public Relations Officer and Curator, Art and Aviation, South African National Museum of Military History, Northern Flagship Institution, Johannesburg, September 12, 2003.

Pippa Skotnes, Professor of Fine Arts, Michaelis School of Art, University of Cape Town, Cape Town, June 10, 2003

Gerhard Snook, Chairperson, Board of Directors, Utrecht Museum, Utrecht, December 12, 2003

Sian Tiley, Curator, Mapungubwe Museum, University of Pretoria, Pretoria, December 2, 2003.

Christopher Till, Director, Apartheid Museum, Johannesburg, October 23, 2003

Console Tleane, Head: Community Media Policy Research Unit, Freedom of Expression Institute, Johannesburg, January 13, 2004

Bokka de Toit, Designer/Developer, Kouga Culutral Center, Humansdorp, July 4, 2003

Gilbert Torlage, Principal Human Scientist, Heritage and Museum Services, Kwa-Zulu Natal Department of Education and Cultural Services, Pietermaritzburg, November 20, 2003

Denmark Tungwana, Deputy Director: Marketing, Protocol and Fundraising, Robben Island Museum, Cape Town, October 30, 2003

Clive van den Berg, Artist, Johannesburg, January 15, 2004

Tim van den Berg, Curator, Thembani Museum, Vryheid, December 13, 2003

Deon van Tonder, Director, MuseuMAfricA, Johannesburg, Decmber 10, 2003

Johan van Zyl, Curator, Military Museum (Fort Bloemfontein), Bloemfontein, October 3, 2003

Sylvia van Zyl, Director, Port Elizabeth Museum, Port Elizabeth, July 3, 2003

Bié Venter, Logistical Coordinator, Creative Inner City Initiative, Johannesburg, January 12, 2004

Dawie Viljoen, Manager, Battle of Blood River Heritage Site, Blood River, November 19, 2003

Dr. Julia Wells, Senior Lecturer in History, Rhodes University, and Member of Board of Trustees, Albany Museum, Grahamstown, July 2, 2003

Dr. Gavin Whitelaw, Archaeologist, Natal Museum, Pietermaritzburg, August 25, 2003

Sue Williamson, Artist, writer and activist, Cape Town, October 31, 2003

Yvonne Winters, Museologist, Campbell Collections (University of Natal), Durban, November 26, 2003

Jurgen Witt, Founder/director, Tzaneen Museum, Tzaneen, September 15, 2003

Mariana Zdara, Manager, Willem Prinsloo Agricultural Museum, Northern Flagship Institution, Pretoria, November 14, 2003

Notes

Preface

1. See Hooper-Box, 2004 and *City Press*, 2005.
2. S. Gordon, 1990:62.
3. See Dubin (2005) for a more thorough exploration of these points.

1 Using War to Put Food on the Table: Reflections on a Decade of Democracy

1. Misser et al., 2004.
2. A "flagship" institution, or confederation of museums will be discussed in detail in chapter 8.
3. Mandela, 1997.
4. Ibid.
5. The South African Museums Association was known as the Southern African Museums Association between 1975 and 1995. I have used the different designations as appropriate to the time under discussion.
6. *Daily News*, 1987a.
7. *Daily News*, 1987b.
8. Wilnot, 1986.
9. Wright and Mazel, 1987.
10. Stuckenberg, 1987.
11. Owen, 1988.
12. Marinier, 1991–1992.
13. Owen and Holleman, 1989.
14. Hofmeyr, 1987.
15. Stuckenberg, 1987:293, emphasis added.
16. Hamilton, 1994:184–185.
17. Marschall, 2000:113.
18. Interestingly, the woman who transcribed the majority of my interviews mistakingly substituted "formerly vanished" for "formerly disadvantaged" in one instance.
19. Workers were brought to South Africa as either slaves or indentured servants, beginning in 1657, from areas of what was then known as the Dutch East Indies.
20. Enwezor, 1997:39.
21. Cameron, 1972.

22. Ernest Cole described the absurd lengths to which regulations extended: "A recent session of the Nationalist-dominated Parliament delved in all seriousness into the question of whether *apartheid* should extend to the high-tide or low-tide mark [on beaches]"; Cole 1967:82.
23. Young, 1994, 2000.
24. Ledgerwood, 1997.
25. Boym, 2001.
26. Sturken, 1997 and Wagner-Pacifici and Schwartz, 1991.
27. See, e.g., LaCapra, 1998 and Landsberg, 1997.
28. Hamilton, 1998.
29. Zerubavel, 1996.
30. The latter was publicized in a case where a defendant failed to appear in court; the newspaper headline read, "Accused named Always Innocent misses court date"; see *Star*, August 25, 2005.
31. Mattera, 1987:151.
32. *Saturday Star*, 2003.
33. Ad for Jonsson Workwear Company in *Visi* 19 (Summer), 2004–2005.
34. Sboros, 2003. Whites were the beneficiaries of "job reservation" during apartheid, virtually guaranteeing work for any white person seeking it. Those protections are now gone, and poverty is increasing among working-class whites. One white woman now performing domestic work remarked in an article on this phenomenon: "I was happy to wash the floors and the dishes, but when they tried to dress me like a *kaffir* [archaic epithet for black Africans], that's when I said thanks, but no thanks." Quoted in Robinson, 2004b.
35. Soweto is actually a confederation of different communities with distinctive characters and sometimes significant status differences. Although the area has been home to black Africans for just over a century, it was only named Soweto in the 1960s. For more information on the 1976 uprising, see chapter 7.
36. See Davids and Fredericks, 2004 and T. Smith, 2004. The same glossy trade magazine that featured Soweto has also devoted a major story to the razed Cape Town area called District Six (see chapter 5).
37. *Star*, 2003.
38. See Day, 2003 and Lanning et al., 2003.
39. Foster, 2003.
40. Gill, 2003. An odd listing in "Time Out Sowetan," the entertainment section of the *Sowetan* newspaper, was for auditions for the Mr. and Miss Crime Prevention Pageant, a rather quizzical approach to tackling the problem; August 8, 2003.
41. Wemyss, 1995.
42. Madondo, 2003. In contrast, one new range of maids' outfits is priced between R160 and R185.
43. G. Smith, 2004.
44. Babich, 2003.
45. Slabbert and Koch, 2004.
46. du Toit, 2003:36.
47. Enwezor, 1997, characterizes the entertainments at cultural villages as "a performative ethnographic surrealism" (p. 28). The scholarly literature on tourism is vast. See the classic MacCannell, 1976 and Adler, 1989, for a discussion of styles of tourism as expressive culture.

48. *Saturday Star Travel*, 2003.
49. O'Clery, 2003:105.
50. Nessman, 2003b. It is worth noting that the tariff for one person at the afore-mentioned battlefield lodge was R1100 per day in August 2003. With an exchange rate of approximately $1 = R7.35 at the time, this intimate encounter with history is for all intents and purposes limited to foreign tourists or prosperous South Africans. As a point of comparison, entrance fees at South African museums can be as little as R2 or R5, with R10 being about top of the range (the R150 entrance fee to the Robben Island Museum—including a ferry ride to and fro—is a notable exception to the rule). Yet even these amounts are prohibitive to many, many poor people. And the aforementioned crowds of jobless men hoping to be picked up for day work, desperate for money, and without other opportunities, may accept daily wages for their manual labor as low as R30 per day.
51. Matshikiza, 2002a. Mandela was captured elsewhere, outside the town of Howick in KwaZulu-Natal province.
52. Mlambo, 2004.
53. The city map distributed by Cape Town Tourism is called "Footsteps to Freedom," echoing the title of Nelson Mandela's autobiography, *Long Walk to Freedom* (1994). By explicitly recapping the history of slavery in the Cape, and locating relevant sites, the map now celebrates what was long hidden, and implicitly links slavery and the resistance to it to contemporary struggles against oppression.

 Both Jatti Bredekamp and Patricia Davison of Iziko Museums told me in 2003 that the museum would primarily be devoted to examining slavery. When I visited in January 2005, however, the bulk of the space was given over to two imported shows, *Hands that shape humanity*, dubbed the "world's largest humanitarian art exhibition," and *Lest we forget: The triumph over slavery*. The first featured large photos of an eclectic array of personalities from the worlds of sport, the arts, and politics, with a short philosophical statement from each. Some of the choices seemed obvious: Nadine Gordimer, Paul Theroux, Chinua Achebe, and Shimon Perez. Others, bizarre: writer Tim Robbins and Douglas Copeland, for example. The second was curated by the Schomburg Center in New York, in conjunction with the UNESCO Slave Route Project, with primary emphasis upon North America and the Caribbean. These exhibitions overshadowed *Human wrongs to human rights*, Iziko's sleek multimedia presentation on slavery.
54. Shell, 1999:52.
55. The so-called born-frees are those who have been born, or come of age, since 1994. Members of the generation of Afrikaner youth that has matured since 1994 are referred to as DNA, Die Nuwe Afrikaner [the New Afrikaner]. They don't repudiate as much as disregard the history of white/black relations in the past. DNA prioritize having a *jol* [good time, partying].

 A good measure of how the salience of certain symbols has changed over the years is the use of the language of Afrikaans during the past quarter century or so. The enforced use of Afrikaans as the medium of instruction in Soweto schools triggered the insurrection there in 1976. At that time, it was viewed as the language of the oppressor. But Afrikaans is being "rediscovered." It is commonly spoken in those same Soweto schools today, more coloured than white people use it at home; and some people believe it is an "indigenous

language" that could bridge social divisions and facilitate reconciliation (see Schmidt, 2003).

56. Masungwini, 2003.
57. Farber, 2003.
58. Van Zijl, 2004.
59. Afrikaans, so-called kitchen Dutch because it was used between early European settlers and natives, is an amalgamation of Dutch, French, German, isiXhosa, isiZulu, and Malay.
60. Explications of South African racial categories are almost obligatory in social science accounts of the country. The various historical meanings will become apparent throughout the text. Suffice to say here that "black" was once a catch-all term for anyone considered to be "non-European" or "nonwhite": black [Bantu-speaking] African, coloured, East Indian, or Asian. Postapartheid, many South Africans from Bantu-speaking groups wish to monopolize the term "black"; others jockey to be included under its purview for contemporary political and economic advantages; and many "coloureds," members of the most deliberately socially constructed racial category, have self consciously promoted a separate identity from the Bantu-speaking majority.
61. This lady overlooked another obvious target, the massive Taal Monument in Paarl that commemorates the Afrikaans language.
62. Keller, 1993.
63. T. Viljoen, 2003.
64. Onverwacht, east of Pretoria, is home to a small community of black Afrikaners, descended from freed Malay slaves who accompanied the Voortrekkers [Boere pioneers] in their journey across country in the nineteenth century. They speak Afrikaans and yes, serve koeksisters to their guests; see Jacobson, 2005.
65. Crockett, 2003; Makhanya, 2002; Sefara, 2003; Letsoko, 2003; Mahamed, 2003.
66. Qwelane, 2003.
67. *City* Press, 2004. At the conclusion of an "opera" I attended dramatizing the saga of the Shangaan people at a "cultural village" in Mpumalanga Province in 2004, the native chorus sang a spirited rendition of *Nkosi* Sikelel'iAfrika, but dropped *Die Stem* from their performance. More than one audience member noted the omission, but also remarked how strange it would have been to hear them complete the Afrikaans segment as well.
68. Keller, 1994.
69. Dubow, 1996. A six-meter bronze statue of Mandela was unveiled in Johannesburg's upscale Sandton area in 2004, in what is now known as Nelson Mandela Square. The former president is depicted dancing his famous "Madiba Jive." Many people who have seen it have not been kind in their evaluation of the work.
70. Star, 2004c.
71. *Citizen*, 2003.
72. Mda, 2003.
73. Roper, 1997.
74. Sowaga, 2003.
75. M. Martin, 1997b:8.
76. Verdal, 1994, emphasis in the original.

77. When the real Veronica passed on in July 2004, she merited an obituary in a major Johannesburg paper, replete with details regarding her humble background, her professional accomplishments, and her next of kin.
78. Mjekula, 2003.
79. von Bonde, 2003.
80. Established names obviously take on a "natural" quality. When changes were proposed for geological attractions in Mpumalanga Province in 2004, an irate local shop owner told me, "God's Window is God's Window; the [Bourke's Luck] Potholes are the Potholes; and Three Rondavels is Three Rondavels [a viewpoint; dramatically scooped-out rock formations; and a series of outcroppings shaped like traditional round huts, respectively]." He couldn't fathom how such seemingly ageless, fitting names could possibly be improved upon. Or why anyone would bother to fool with them. (For the record, these were *proposed* changes; the obligatory public comments will be solicited. Cynics would say the alterations were likely a fait accompli. And, in fact, the process was reportedly "fast-tracked by the provincial government.")

 A particularly interesting example of a proposed change was of the Huguenot Tunnel outside Paarl—the name reflecting early settlers in the region—to Abdullah M. Omar tunnel, honoring a notable name in "the struggle" for liberation.
81. Sithole, 2003.
82. Kenneday, 2003.
83. In this instance, enraged Afrikaners threatened to set up "alternative city councils" and initiate a tax boycott in protest; see *Natal Witness*, 2002.
84. Quoted in Sithole and Arenstein, 2005.
85. Maluleke, 2003b.
86. The matter has become more controversial as some evidence has revealed that elephants from Kruger Park are being sold for "canned hunts" by wealthy foreign clients.
87. In August 2004, a new entrance was proposed for the park: the Mandela Gate. While advocates argued it would allow locals easier access to the park, and thus to the tourist trade, others doubted its necessity, and they feared it could possibly have a negative environmental impact. Also in 2004, the Great Elephant *Indaba* [meeting] was convened at the park to discuss developing a management plan for the elephants and how that would impact upon surrounding communities. Translocation and sterilization are alternatives to culling, but they are costly.
88. Quoted in Philp, 2003.
89. McGreal, 2001a.
90. Swarns, 2001.
91. Waspe, 2001.

2 A White Step in a Black Direction: Inertia, Breakthrough, and Change in South African Museums

1. See, e.g., Bennett, 1995; Berger, 1977.
2. Duncan, 1991. This assumes, of course, that audiences "read" exhibitions as curators intend, which they clearly do not. Audience reception can range from unqualified acceptance to violent rejection, and anything in between.

3. Coombes, 1994.
4. The reconsideration of what the museum presents, and how it presents it, has been largely spurred by the findings reported in the investigative book by Adam Hochschild (1998).
5. This information is derived from an interview I conducted with Gryseels at the museum in Tervuren, Belgium, July 1, 2005.
6. Carman, 2003.
7. Nettleton, 1993.
8. Ibid.:65–67.
9. Another fundamental way that this facility breaks tradition is that it is located in the township of Galeshewe, the only provincial legislature to be found in such a place.
10. Lacey, 2002.
11. "Platteland" is Afrikaans for rural areas or country towns; it has become synonymous with being unsophisticated, narrow-minded. A letter-to-the-editor writer in a local paper characterizes the place as follows: "We live in Kimberley, a small town on the fringes of sanity in a perpetual state of expectation and optimism, hoping for less dust and better things." See Alexander, 2003.
12. The art training historically made available to black Africans during apartheid has been the subject of increased attention. The rural Art and Craft Centre at Rorke's Drift was founded in the early 1960s by the Evangelical Lutheran Church and became renowned especially for its printmaking and weaving. Its accomplishments have been documented by Hobbs and Rankin (2003), and by a traveling exhibition. The urban-based Polly Street Art Centre in Johannesburg, begun in the early 1950s, has been thoroughly investigated and evaluated by Miles (2004).
13. Powell, 1985:45.
14. The doctrine of "separate development" mandated that South African blacks be banished to ten "homelands" or Bantustans, thereby disconnecting them from the white population. These homelands were considered soverign states, although they were run by black Africans carrying out the apartheid government's wishes. The land set aside for these settlements represented only a small proportion of the land available, and typically was the least desirable or productive.
15. For more details on the cultural boycott, see Nixon, 1994.
16. As we shall see in chapter 3, *Miscast* (1996), at the South African National Gallery, shares the distinction amongst South African exhibitions of being groundbreaking, and probably the most controversial.
17. *Land and lives—pioneer black artists* (Johannesburg Art Gallery, 1997), curated by Elza Miles and featuring artists born before 1930, demonstrated that a great deal of artistic output remained to be retrived from relative obscurity.
18. Powell, 1985:45. In 1990, a controversy in San Francisco provided an extremely interesting case of challenging corporate sponsorship of museums. The San Francisco Fine Arts Museums (comprised of two institutions) was scheduled to host an exhibition of seventeenth-century Dutch paintings, sponsored by the Royal Dutch Petroleum Company. One of its subsidiaries, Shell Oil, was then a target of antiapartheid activists. After a tumultuous board meeting open to members of the public, the mayor issued an ultimatum: the museum must seek alternative funding for the show, or Nelson Mandela

would likely skip San Francisco on an upcoming tour. As it turned out, Mandela opted to visit Oakland, across the bay. See Kimmelman, 1990.

19. Powell, 1985:46.
20. Quoted in King, 1995:43.
21. *Citizen*, 1985.
22. "Transitional art" refers to objects made by black Africans that stand somewhere between traditional craft and "client-centered" work done for a Western market. Coming into general usage in the late 1970s, the term has been widely critiqued as overly broad, paternalistic, and ahistorical; see Nettleton (1988) for a thorough assessment of its meanings and shortcomings.

 A clear indication of how accepted crafts have become as part of the South African art scene, and how they are currently marketed in a conscious and savvy way, is a 2005 calendar featuring male crafters from a Cape Town collective as pinups, their bare bodies strategically covered by their creations made from wire, soft drink cans, beads, or fabric.
23. Burnett, 1985.
24. Prendini and Underhill, 1985.
25. The Constitution Hill project, to be discussed in chapter 6, incorporates that tradition directly into the design of the new Constitutional Court.
26. Growing up on a farm, Torlage learned isiZulu from the local laborers and their children, in addition to his native German. At school, he picked up English and Afrikaans. These multiple language skills, which scores of South Africans possess, are definitely a "plus" in connecting to different groups (a white woman told me that she had escaped what she'd feared was certain death at the hands of an angry crowd in the 1980s after she addressed them in isiZulu, which she'd also learned as a child). This demonstrates that as much as apartheid separated groups of people, they connected with various degrees of intimacy across racial lines. (I have noticed that working-class whites, such as cafeteria workers and auto mechanics, frequently speak different languages; they may address black workers personally and playfully in a Bantu-based dialect, and in the next breath curse them in English or Afrikaans.)
27. Cited in Singer, 2001.
28. Bourdieu, 1986.
29. Brain, 1988.
30. E-mail communication, March 22, 2004; quoted by permission. Mazel and Mtshali (1994) indicate that programs on prehistory were instituted at the Natal Museum pre-1994 and presented to children of different races.
31. Owen and Holleman, 1989:251.
32. D. Smith, 1997.
33. Dyanti, 1999, and *Pretoria News Weekend*, 1999. These two articles are virtually the same, and they carry the same publication date. All that distinguishes them from one another is some minor editing. But whereas the first credits a writer by name, the second one simply lists "staff reporter."
34. Geers, 1999.
35. Mackay, 1999.
36. Quoted in Dyantyi, 1999.
37. Ibid.
38. See Salie, 2003 and Hlatshwayo, 2004. It's ironic that the 2002 World Conference on racism and xenophobia was held in Durban. The conference

was a raucous one: delegates supported or rejected competing definitions of racism and resolutions condemning nations supposedly guilty of gross violations of human rights.

39. Dovey, 2003; van der Walt, 2003; Maule, 2003.

3 THE FIRST SHALL BE LAST: PICTURING INDIGENOUS PEOPLES AND THE SINS OF LONG AGO

1. Writers on museums seldom address the basic emotions that museums evoke, or the sexually voyeuristic aspects of some displays, especially for children. Before the sexual revolution of the 1960s and the mass media brought explicit images of the body and sexuality increasingly into everyday life, such material was relatively scarce. Museums were one of those rare places where kids could see human bodies, and sometimes naked ones, at that. My sense is that even in a jaded world, museums still possess this transgressive quality. For an exception to the general rule about the exclusion of emotional considerations in regard to viewing exhibitions, see Boon, 1991. Pippa Skotnes also cites "the compelling visual drama of the [Bushman] diorama itself [Cape Town], encouraging a voyeurism that borders on the erotic" (2002:256).
2. Ngcelwane, 1998:40. The narrator of Richard Rive's *"Buckingham Palace": District Six* offers a similar memory: "On rare occasions [on a Sunday] we ventured downtown to the Museum to see the models of Bushmen with big bums or furtively glance at the nude statues in the Art Galleries" (1987b:6).
3. Ngcelwane, 1998:32.
4. Davison, 1993:165, 171. This is hardly the only expedition at that time centered upon "confirming" the primitiveness of the Bushman. See Gordon (1997) for an account of an American-sponsored journey through South West Africa whose aim was to "capture" the Bushman photographically.
5. Rose, 1961:52, 47, 50, 54. To be completely fair, the book also remarks that Drury felt the Bushmen to be highly moral and responsible toward one another; the victims of immense cruelty at the hands of Europeans; and is even sympathetic to the necessity of them stealing livestock, since Europeans killed off so much of the native game upon which they had depended for food (pp. 57–58).
6. Shaw, 1941:161.
7. Ibid.
8. Ibid.:163.
9. For a detailed description of how the diorama was designed and installed, see Schweizer and Thorn, 1961.
10. Skotnes points out a curious gaffe that underscores the constructed nature of the diorama: designers aimed for a lighting effect that would simulate winter conditions, the season when Bushmen—nay, anyone—would be least likely to be nearly nude, outside; see Skotnes, 1995:15.
11. Davison, 1998:153.
12. Karp, 1991:377. For a history and overview of the South African Museum's practices and classificatory logic over the years, see Davison, 1990.
13. See, e.g., Gosling, 2001.
14. Rose, 1961:45, 47.

15. Kapilevich, 2001:83.
16. Skotnes, 2001:299.
 Some of the "models" were prisoners, who had little discretion over whether to be cast or not. Patricia Davison (1993:169–171) presents evidence to suggest that others were more reluctant to participate.
17. Another "prelude" to *Miscast* was an exhibition for which Skotnes was a co-curator in 1995, at the Oliewenhuis Art Museum in Bloemfontein. Many of the elements in *Miscast* were anticipated in this exhibition mounted the previous year. See Ouzman et al., 1995.
18. See R. J. Gordon, 1992a.
19. Gould, 1985:295.
20. R. J. Gordon, 1998:46.
21. This portrayal is widely attributed to Jan Smuts, the famous Boer War commander, and twice the prime minister of the Union of South Africa.
22. Skotnes, 2001:313.
23. See Dubin, 1999.
24. Skotnes, 2002:263. However, the exhibition catalogue retained Skotnes's original title.
25. To get a flavor of the debate, see A. B. Smith, 1996; R. Viljoen, 1996; and Wright, 1996.
26. *Fairlady*, 2002.
27. Grobler, 2001.
28. Simon, 2003.
29. Skotnes, 2001:313.
30. Skotnes makes the interesting point that the creation of the Bleek/Lloyd archive represents a unique collaboration between the Bushman and the European; SAM's diorama represents the European imposition of a particular perception upon the Bushman; and *Miscast* was a reaction to them both. See Skotnes, 2002.
31. Haraway, 1989:45.
32. Quoted in Willoughby, 1996.
33. Ibid.
34. Haraway, 1989: 29.
35. This hard-nosed idea was duplicated at a Holocaust museum that opened in suburban Detroit in 2004, where visitors trample a Star of David that has been set into the brick when they walk through a courtyard entryway. See Maynard, 2004.
36. A spirited internet discussion took place in 1995 regarding these trophy heads. One writer pointed out that these African items were held by the Natural History Museum, whereas Egyptian material was housed in the British Museum proper, in Bloomsbury. This parsing of races and cultures echoes the split between the South African Museum and the South African Cultural History Museum. <www2.h-net.msu. edu/~africa/threads/ trophyheads.html>.
37. Abrahams, 1996a.
38. Hromnik, 2001.
39. Dubin, 1999:57.
40. Minnaar, 1996. The Griquas are contemporary descendants of Hottentot and European pairings.
41. Anstey, 1996.

42. Roussouw, 1996.
43. C. T. Young, 1993.
44. For an additional example of the collapse of a projected display schedule once an exhibition has become controversial, see Dubin, 1995, 1996.
45. Schildkrout, 1991:17, 20.
46. Abrahams, 1996a.
47. Schrire, 1996.
48. Schuler, 1990.
49. A little more than a year after *Miscast* opened, an historic five-day conference on Khoisan Identities and Cultural Heritage took place in Cape Town, drawing academics and indigenous representatives together to Cape Town to discuss a wide range of issues affecting these first peoples. It was convened by Jatti Bredekamp, who a few years later became CEO of Iziko Museums, the flagship institution incorporating the SANG.
50. De Kock, 2004.
51. *Events @ SAM*, 2001.
52. See Dubin, 1992:174–192.
53. Johnson, 1997.
54. Glaberson, 2001. Interestingly, some Black Seminoles worked as scouts for the U.S. government during the nineteenth-century Indian Wars, just as some San did for the South African government during its fight against liberation movements in Namibia and Angola. See Thybony, 1991, for details about the Black Seminoles.
55. Rohter, 2001.
56. Hoodia, a plant that the San have used for millennia to stave off thirst and hunger during hunts or lean times is being investigated as an antiobesity drug in the West.
57. Sharp and Boonzaier, 1994:409.
58. Ibid.:415.
59. T. Viljoen, 2003:144.
60. Vel, 2002.
61. Geldenhuys, 2004.
62. Clifford, 1997. Clifford draws upon Mary Louise Pratt (1992), who sees museums as "the space of colonial encounters," "usually involving conditions of coercion, radical inequality, and intractable conflict" (p. 192).
63. Pollak, 2000.
64. Viall, 2000.
65. Roper, 2004.
66. Quoted in Sichel, 2004:11.
67. Ibid.
68. Gosling, 2001.
69. Tromp, 2001.
70. *Star*, 2004b.
71. This is a classic problem regarding encounters between the media and groups or social movements that eschew formal leadership. See Todd Gitlin's (1980) discussion of this in regard to Students for a Democratic Society [SDS] in the 1960s.
72. N. Ferreira, 2003 and Howe, 2003.
73. Wilmsen, 1995.
74. C. Pretorius, 2002.

75. Ibid.
76. Ashton, 1999.
77. *Pretoria News*, 2003a.
78. Retief, 2001.
79. Davison, 1993:173–174.
80. Quoted in Lutz and Collins, 1993:82, 65. This technique of "adjusting" photos spans the twentieth century, and it exemplifies encounters between groups of unequal racial or mental status within the same society as well. In 1912, H. H. Goddard surreptitiously highlighted the eyes and mouths of photos of members of the Kallikak family, whom he supposed to be hereditarily "feeble-minded," in order to make them appear more sinister or stupid (Gould, 1981:170–173). And *Time* magazine (October 9, 1995) darkened its cover photo of accused murderer O. J. Simpson; many commentators believed the editors did this in order to match the image to the "look" of a criminal.

 Lutz and Collins also note that the inner lives of dark-skinned people were less likely to be explored in *National Geographic*, and "When dark-skinned people were attributed feelings, they were more often seen in negative ways—as frightened, angry, cannibalistic, or depressed—than were those with lighter skins" (p. 256).
81. Lutz and Collins, 1993:182.

4 PRISONERS TO SCIENCE: SARAH BARTMANN AND "OTHERS"

1. From a report on Hankey nationally broadcast in South Africa by SABC television on August 9, 2002. Additional impressions and quotations from that day, the burial of Sarah Bartmann, are taken from my watching and recording that broadcast as it occurred, and from my notes.
2. For a detailed description, see Strother, 1999:38–39. Photos of Bartmann's actual preserved brain were included in the *Spectacular bodies* exhibition at the Hayward Gallery, London, in 2000, likewise raising issues of voyeurism.
3. Two historical fashion styles in particular exaggerated the female form in ways relevant to this discussion. The eighteenth-century panier (or panniers) were frame hoops that broadened the hips to extreme proportions (in England, they were called "improvers"). By the time Sarah Bartmann was born in 1789, European women's fashion had reverted to a simpler, more "natural" style. And bustles came into style in the 1870s and 1880s. Using metal frames, straw-filled cushions, or layers of horsehair or bunched fabric sewn into the top of a skirt, the bustle created an overstated appearance of "backside." See <www.fashion-era.com>.
4. See Sukhraj, 2002. At about the same time, an article in the *New York Post* showed super model Heidi Klum being fitted for her Halloween costume: "An oversized evening gown with plenty of extra padding in the caboose"; see Hoffman, 2002.
5. Oosterwyk, 2001.
6. Quoted in Ntabazalila, 2002.
7. Williams, 2002.
8. Joseph, 2002.
9. Strother, 1999:48.

10. Kanyane, 2002. As an example of the confusion involved with this name, the title of this piece spells "Saartje," without the "i," but uses it in the body of the text.

11. *South African Press Association*, 2002a.

12. This department split on August 1, 2002 into two separate bureaus overseeing arts and culture, and science and technology. I have adjusted my references to reflect that division according to when specific events occurred, or how journalists or official publications recorded the name.

13. On the other hand, a self-described "gender consultant" commentating on television the morning of Bartmann's burial argued that Saartjie is "a term of endearment," and "a term of resistance against colonial oppressors," although she did not elaborate upon the logic of the latter idea; personal notes.

14. Different sources list her death as either 1815 or 1816. The variation is perhaps clarified by one article that says she died New Year's Day, 1816; see Bauer, 2002.

15. This claim was made by a lengthy published opinion piece in the *Cape Times* that recounted a scenario of defeat and abduction that sounds like a first-person narrative, but failed to note what sources he was drawing upon (J. Marks, 2002). Abrahams (1996b), based on an in-depth discussion of the *Inboek* system, also believes Bartmann was a slave.

16. Koch, n.d.

17. Lindfors, 1999b:175.

18. Strother, 1999:25.

19. The third major element in *Miller v. California* (1973) is that "the work, *taken as a whole*, lacks serious literary, artistic, political or scientific value."

20. Strother claims that "only the most depraved and ludicrous could take Baartman seriously as a woman and as a sex partner," and that she was "comfortingly anti-erotic" (p. 40). But Strother may be thinking too logically, discounting the irrationality of fantasy and desire.

21. Gilman, 1985. As well known as this story has become, it is still subject to distortion, sometimes in the most unexpected places. No less important a work than Ann McClintock's *Imperial leather* misspells her name as Saadjie Baadman, and implies that she was displayed in the eighteenth century, and not the nineteenth (1995:113).

22. Gilman, 1985:90.

23. Gordon, 1992b. The literature on the Hottentot Venus continues to grow; see Fausto-Sterling (1995) for one notable example.

24. Strother, 1999:1, 23; emphasis mine. This attitude is particularly surprising because on page 2 the author announces she will minimize reprinting demeaning illustrations of Sarah Bartmann in order to prevent replicating the original voyeurism inherent in her exhibition! She was both consciously self-reflective and oblivious to her own presumptions. And some journalistic accounts at the time of Bartmann's return to South Africa in 2002 sustained the idea that something was unusual and distinct about Bartmann, rather than simply acknowledging that Khoisan women are built differently from women of other groups; one journalist wrote of "Baartman's grossly large posterior and [supposedly] oversized genitalia," not unlike accounts of the early nineteenth century (Oliver, 2002).

25. *Sunday Independent*, 2002.

26. Pastor (1995) states that Couvier also attributed the possible cause of her death to excessive drinking, smallpox, or an inflammatory illness of some sort (p. 4).
27. Lamb, 1995; emphasis mine.
28. Zilwa, 2002.
29. Dr. Phillip Tobias, quoted in Singer, 2002.
30. Lindfors, 1999b:187.
31. Clifford, 1997:198.
32. Quoted in Simmons, 2002.
33. The abolition struggle was protracted: slavery was not abolished by Parliament until 1833, and not all slaves were freed until 1838.
34. See Lindfors, 1999b:183. This author provides a good overview/ summary of the proceedings.
 In at least one other case, an advocacy group sought legal protection for a person on display. An English stage manager, concerned for the welfare of Franz Taaibosch, a South African Bushman, solicited the Aborigines' Protection Society to intervene between the entertainer and his manager. See Parsons, 1999:209. Corbey (1993) also makes a brief mention of court interventions, without providing details (p. 348).
35. Quoted in Lindfors, 1999b: 185.
36. Abrahams, 1996b:105.
37. Ibid.:112.
38. B. Breytenbach, 1993:141.
39. *New York Times*, 2000.
40. There are many similarities between the fates of the aboriginal peoples of Australia and South Africa: both were hunted for sport, and today they have high alcoholism rates, high incidences of domestic violence, and dire health.
41. *Agence France-Presse*, 1997a. This article is dated September 2; Diana died at 4 a.m., Paris time, August 31, 1997.
 The novel *Talking God* (1989) by Tony Hillerman begins with a worker at the Smithsonian Institution opening a box sent to her by a Native American activist. It contains exhumed skeletal remains of the woman's grandparents. This is in retaliation for her resistance to reburying skeletal specimens of "exotics" because it would compromise the museum's "authenticity."
42. Public statues are commonly the target of such symbolic violence. In the 2003 play *Caroline, or change*, by Tony Kushner, the dawning of the civil rights era in Louisiana in 1963, just after the assassination of John Kennedy, is suggested by the mutilation of a Civil-War era statue of a Confederate hero. Moreover, a new statue of Steve Biko was defaced with white paint by white extremists (Malan, 1997), and vandals decapitated Henry Moore's *King and queen* that looked out from a remote hillside in Scotland toward England, in 1995, provoking what one newspaper editorial condemned as "provoking ancestral fears"; see *Times* [London], 1995. And then there is a classic episode of *The Simpsons* where Bart steals the head from the statue of Jebediah Springfield, the namesake of his town.
43. *Agence France-Presse*, 1997b.
44. Burrell, 1997.
45. Nown and Rosthorn, 1997.
46. Robertson, 1997.
47. See R. J. Gordon, 1999:266.

48. See, e.g., Bogdan, 1988:177, and Corbey, 1993:340. Cabinets of curiosities characteristically featured preserved specimens.
49. Corbey, 1993:353.
50. Ibid.:363–364.
51. Bogdan, 1988:195–196. For the role that international expositions, as well as various other types of public displays and different discourses played in shaping and validating the colonial views of the British, see Coombes, 1994.
52. This, according to Corbey (1993):357: the Musée d'Ethnographie du Trocadéro later became the Musée de l'Homme.
53. See Parsons, 1999:224, for a discussion of Clicko's perfomance.
54. The court documents are appended to Strother (1999); see pages 44–45. Lindfors (1999b) also cites documents of the time that refer to Bartmann's sighs, anxiety, sullenness, and uneasiness (p. 172).
55. She is referring to wives of two legendary Zulu kings, but using modern titles, of course.
56. De Villiers reports that her adoptive parents told her she was "white" until she was 20. When she would be ordered off buses or told to leave a cinema because she "didn't belong," her family assured her it was a mistake, and that she was "Italian."

 Her point about the potential hazards and disappointments of exploring one's roots is underscored in a movie screened during Encounters 5, the Fifth South African International Documentary Film Festival, in 2003. *Motherland: A Genetic Journey* (Archie Baron, director), follows three black Britons as scientists trace their DNA, pinpointing their ancestral origins. When the subjects then visited the designated places, their reactions ranged from exhilaration at finding their "true family," to reconciled confirmation that one of them had significant European roots.
57. Cormick, 1997.
58. The preliminary steps to repatriate Sarah Baartman are detailed by the director of the South African National Gallery, Marilyn Martin, on the first page of the foreword to the catalogue for *Miscast*.
59. Craftsmen in Ghana have become famous for producing elaborate and whimsical hand carved coffins in various shapes: branded commercial products (Mercedes-Benz, Coca-Cola); flora and fauna (fish, roosters, eagles, pineapples); and other significant items (Bibles, guns). The expense and care devoted to making what many people now consider to be works of art (they have been exhibited in numerous exhibitions) underscore the importance of sending relatives to the next world literally enveloped by something that was highly meaningful to them in life. See Secretan, 1995.
60. There is an obvious parallel here with Palestinians who have died during the intifada. Irregardless of what the beliefs, feelings, and wishes of the deceased's family may be, each casualty is immortalized by posters and their burial becomes a symbol of the political struggle.
61. Funerals held by enslaved people of African origin in America had a similar character, and these were rare occasions where they could come together and enact a sacred, traditional ritual. Slave masters tightly regulated these events in order to diminish the probability that collective grief and anger could be channeled into insurgency.
62. De Wet, 2001.
63. Gilbert, 1988.

64. Cohen and Odhiambo, 1992:104.
65. Ibid.:16–17.
66. Ibid.:76–77.
67. See Edgar and Sapire, 1999.
68. Dennie, 1992:85. This article shares some similarities with a Javanese example studied by Clifford Geertz (1973). The issue here was that social change had altered peoples' sense of identity and social allegiance away from geographical proximity, and more toward ideological like-mindedness. The conflict he discusses was not as purposeful as in Dennie's example, where cultural norms were deliberately violated by a stronger political entity flexing its muscle in order to enhance its own power. In Geertz's Javanese case, one side did not have dominance over the other, as in apartheid South Africa.
69. Quoted in Potgieter, 1996:15.
70. Ibid.
71. Ibid.
72. Author's notes, television broadcast of Sarah Bartmann's funeral, August 9, 2002.
73. In Webster, 2000.
74. Quoted in Singer, 2002.
75. Boezak, 2002.
76. Lawrence, 2002. The Herero were the victims of what many people deem to be a colonial-era genocide: in 1904, in what was then Deutsch Süid-West Afrika, the Germans put down an uprising by enslaving and murdering a large proportion of the tribe. By the end of the 1904–1907 conflict, 65,000 Herero had been murdered. On the hundredth anniversary, Germany issued an apology.
77. Hearst, 2002.
78. This quote from Genesis 4:10 was invoked at Sarah Bartmann's funeral, where she was compared with the biblical Abel; both were cited as suffering violent deaths.
79. See the series that begins with *The no. 1 ladies' detective agency* 2002[1998], featuring Precious Ramotswe.
80. As confusing as these terms can be, a multitude of clan names makes even finer distinctions between these closely related groups.
81. All the preceding quotes were taken from a flyer dated March 21, 1997, SAM archives. The skeletal remains of hundreds of indigenous people remain in South African museums. The brutality with which they were collected and the racist theoretical underpinnings of the enterprise are thoroughly documented by Legassick and Rassool (2000). Debate rages over their future. Jean Burgess is adamant that they be reburied: "I just feel that no other human being, no second human being has got the right[s] to the remains of another human being and to own it [*sic*]." But Pippa Skotnes counters, "I think there is an interesting dialogue that remains in play as long as that stuff's in those institutions. I think it should go on show in some kind of way. I think it should be exposed."
82. Oliver, 2002:1.
83. Ibid.
84. Quoted in MacLennan, 2002.
85. Ntabazalila, 2002.
86. Lawrence, 2002.

87. Johns, 2002:11.
88. A second memorial is planned for Cape Town, but details have not been worked out. The reference group included the following people who have been cited in the text: Bredekamp, Burgess, Mabandla, Abrahams, Tobias, and Ferrus.
89. Johns, 2002.
90. Damon and Salie, 2002.
91. Johns, 2002:2.
92. Ibid.
93. Cohen, 2002.
94. MacGregor, 2002.
95. Welz, 2002.
96. Like the funeral, the arrival of Sarah Bartmann's remains back in South Africa was broadcast live on television.

 One of the stranger aspects of the welcoming ceremony was the combination of musical instruments that celebrants used, including both indigenous South African and Western instruments, and an Australian Aboriginal didgeridoo; see *South African Press Association*, 2002a.
97. E. Ferreira, 2002.
98. Bokka de Toit recalls a conversation he had with a local government official, three months prior to the funeral, who was against the reburial in Hankey, which demonstrates that the burial seemed problematic to some bureaucrats: "I remember he says to me, 'Who is Sarah Bartmaan? Do we need this? Who is she? What would this mean? Is this not going to stir up [*sic*] an old wound?' "
99. Philp, 2002:5.
100. Ibid.
101. Hromnik, 2002.
102. Once declared, no part of the site could be removed.

5 "A PUSTULAR SORE ON A QUEEN'S FOREHEAD": DISTRICT SIX AND THE POLITICS OF THE PAST

1. Bickford-Smith, 1990:36. Rosenthal (1966) translates "kanala" similarly, but adds that it connotes "to do a favor," supposedly because groups of friends used to help one another build their houses. I have also seen it translated as "please."
2. Although Jews were once plentiful in District Six—time was that nine synagogues served the locals—most had moved out by the late 1940s. Many of them retained businesses there, however. For an overview of the history of the Jews in this area, see Berelowitz, 1989.
3. Hart, 1990:134.
4. Rive, 1987a: 97. Le Grange (2001:112), drawing upon a lecture by Manuel Castells, notes that "Paradoxically, place-bound identities are becoming more important in a world where spatial boundaries to movement, communication and exchange are diminishing."
5. Layne, 1998:4.
6. Soudien, 1990:163.

7. Fransen, 1996:21.
8. Matshikiza, 2002b.
9. Soudien, 1990:155.
10. Quoted in Maurice, 1995:14.
11. Rive, 1987b:187.
12. Mattera, 1987:16, 59. This description is actually from the government's destruction of Sohpiatown, in Johannesburg, to be discussed in later sections.
13. Delport, 2001c:42; Du Pré, 1997:viii.
14. Schoeman, 1994:70.
15. Battersby, 2002.
16. Du Pré, 1997:90.
17. Swanson, 2001:115.
18. Small and Wissema, 1986.
19. Rive, 1987b:187.
20. Manuel, 1978. In Greek mythology, Nessus was a centaur. He misled the wife of Hercules into believing that if she saturated a shirt with his (Nessus's) blood and then had her husband wear it, this would insure Hercules's faithfulness. Instead, after Hercules put the shirt on, it burned him to death.
21. Omar, 1990:192.
22. Prosalendis, 1995.
23. Soudien, 1990:163.
24. Quoted in Bohlin, 1998:171.
25. Bickford-Smith, 2001:24. The author attributes this quote to writer Richard Rive.
26. Fortune, 1996:np.
27. Prosalendis et al., 2001:89.
28. Ibid.:77.
29. Rassool and Prosalendis, 2001:80.
30. Variations on this story have appeared in several sources. The version I present comes from my interview with Sandra Prosalendis, October 29, 2003, in Cape Town.
31. Delport, 2001a:159–160; emphasis added.
32. The documentary film *Amandla! A revolution in four part harmony* (Lee Hirsch, director, 2002) examines the enormous contribution of South African "freedom songs" to the struggle to bring down apartheid. "Amandla" is isiXhosa for "power."
33. Museums across the country have celebrated these areas in exhibitions, amongst them: The National Cultural History Museum in Pretoria has featured Marabastad; MuseuMAfricA in Johannesburg, Sophiatown; and the District Six Museum, other sites from the Cape Town area.
34. Hart, 1990:127.
35. Du Pré, 1997:93. Alex La Guma is the most detailed of all: he presents the text of an actual suicide note; see Odendaal and Field, 1993:120.
36. Noor Ebrahim states that his family lived in a double-story, four-bedroomed house, which was worth approximately R20, 000 when they were forced to leave it in 1975. The government offered them R1500—take it, or leave it. He estimates that the house, had it not been wrecked, could be worth as much as R1 million today. Du Pré (1997) also discusses the unfavorable financial settlements that owners received, in this instance, in Port Elizabeth (pp. 92–93).

37. Western, 1981:192–193.
38. Swanson, 2001:112.
39. Western, 1981:155.
40. Rive, 1987b: 133, 149, 135, 152. The marginal status of Jews, and the ambivalent relationship between them and nonwhite South Africans, is succinctly captured in a later passage in the book. When two of the tenants pay a visit to their Jewish landlord as he is dying, the hospital receptionist asks them whether they wish to see someone who is "white," or "nonwhite." "He's a Jew," one of them responds (pp. 175–176).

 Lewis Nkosi writes that instances of whites crossing the color line—whether as friends, lovers, political fellow travelers, or sharing cultural tastes—were more likely than not to be done by Jews. In his words, "It was the Jews who tempered this harsh social order of apartheid with a tenuous liberalism and humane values" (1965:19). The complex relationship between these two groups in South Africa corresponds to the American experience in significant ways.
41. Cited in Maurice, 1995: 22.
42. Jeppie, 2001:115–121.
43. The annual Coon Carnival parade, or Kaapse Klopse [Cape Carnival minstrels], takes place on January 2, *Tweede Nuwe Jaar* [Second New Year], when troupes of colorfully dressed minstrels in blackface march through the city. It draws upon celebrations of the Malay slaves (for whom this was traditionally a day off), combined with motifs introduced by the visit of American minstrels in the mid- to late nineteenth century. Marching, music, singing, and costume competitions between the troupes last for nearly a month, and the popularity of the event has increased since the fall of apartheid in 1994 as a unique expression of pride and solidarity on the part of the coloured community; see D. Martin, 1999. The colorful costumes are even sent into prisons to give inmates a sense of connection with their heritage, and perhaps ease their transition back in their communities; see Khoisan, 2004.

 It frequently generates controversy regarding poor organization and rowdy behavior, and in 2005 it was nearly canceled because of a row over claims of inadequate government funding. Because it occurred so soon after the disastrous December 26 tsunami, some people thought it was disrespectful and extravagant to be celebrating in this way, and one letter complained that devout Muslims should not take part in the singing and dancing: "Nothing has changed since 1652 [the landing of Van Riebeeck at the Cape]—you are still entertaining your white masters. We have not fought for our liberation to go back to 1652"; Gamieldien, 2005.
44. Barrow, 1997:60. According to Field (2001:16), "Since the 1840s most of Cape Town's lower-class areas had been racially mixed."
45. In Pieterse, 1971:5. President Mbeki also cited this phrase in a public address; for the full text, see Address by President Thabo Mbeki at the Land Claims Celebration, Cape Town, November 26, 2000. <http://www.sapa.org.za>.
46. Quoted in Du Pré, 1997:91; emphasis added.
47. Rive, 1987b:95–96.
48. Hart, 1990:120.
49. See Ngcelwane, 1998. Swanson and Harries (2001) estimate that in the 1960s, there were over 70 African families living in District Six (p. 70). Western (1981) estimates the district was 95% "coloured" (p. 75), and that in

1948, the population breakdown of Cape Town was as follows: 44% white, 44% coloured, 11% black African, and 1% Indian (p. 96).

The much-touted harmony between racial groups is tested in an interview with the chairperson of the District Six Beneficiary Trust, however, where he addresses how to evaluate and accommodate different claims of oppression and loss; see Nagia, 2001 (esp. p. 176).

I saw a production of the District Six-based musical *Kat and the kings* in Cape Town in 2005. Interestingly, the first time the old shoeshine man/narrator itemizes the neighborhood's inhabitants, Africans are noticeably absent from the list.

50. Western, 1981:72–73. It is important to realize that Sophiatown was a freehold area, unlike District Six. It was destroyed by the apartheid government between 1955 and 1960, not under authorization of GAA, but sanctioned by the 1923 Natives (Urban Areas) Act, and most especially, the 1954 Natives Resettlement Act.

Furthermore, District Six's population was predominately coloured, whereas Sophiatown was predominately black African.

51. Nasson, 1990:48–49.

52. Du Pré, 1997:99.

53. Adams and Suttner, 1988:7.

54. Prosalendis et al., 2001:84.

55. From an interview with Don Mattera in Stein and Jacobson, 1986:14.

56. From an interview with Es'kia Mphahlele, ibid.:55.

57. Purkey and Stein, 1993:2. One of the best known of these "white bohemians" was the young Nadine Gordimer, whose novel *A world of strangers* (1958) captures this transgressive time and place. And the movie *Drum* was first screened in 2004, focusing on the dynamic cultural life of a racially mixed group of writers, editors, and photographers in the 1950s. South African critics roundly denounced its simplistic and negative portrayals of many of the major personalities of the time, condemned it as being historically inaccurate, and resented the "Hollywood" treatment of the story (and, the casting of an African-American heartthrob in one of the pivotal roles). Interpreting an iconic era such as this—especially one that remains fresh in people's memories—is a hazardous endeavor.

58. Nixon, 1994:13, 2–3.

59. Themba, n.d.:14.

60. McEachern, 2001:240; see also McGreal, 2001b.

61. See Dancer, 2000.

62. See, e.g., Douglas, 1970 and Garber, 1992.

63. McEachern argues that white fears of this in-migration was one of the factors that resulted in the National Party's victory in 1948, and that "population control" was expected to be a priority (2001:225).

64. R. Marks and Bezzoli (2000:271) argue that these innovations were actually "imported" from the United States.

65. Delport, 2001c:42.

66. Teaford, 2000:449.

67. Press, 1971:8.

68. Cross, 1975:34.

69. Ibid.:33.

70. Ibid.:18.

71. Jacobs, 1992. She specifically discusses the Hyde Park experience on pages 44–46, and elsewhere.

72. Barrow, 1997:56. Separate bathroom facilities for "whites" and "nonwhites" were, of course, a cornerstone of both Jim Crow and apartheid regulations.

73. There is a much smaller genre of American nonfictional accounts that represents a "literature of longing." See, e.g., Alan Ehrenhalt's *The lost city* (1995) regarding Chicago, and Verlyn Klinkenborg's *The last fine time* (1991) about Buffalo, New York.

74. Reminiscences of District Six typically recall the sights and sounds of the area, but seldom talk about how it smelled. There are some exceptions: one author refers to the insufficient availability of toilets (Bickford-Smith, 1990:40); another quotes passages from authors Alex LaGuma and Richard Rive that refer to the pervasive smell of urine, and buildings that were "damp, dirty and dank" (Hart, 1990:121); and yet another speaks of "sour drains" and "overflowing refuse bins" (Barrow, 1997:17).

75. This linguistic victory was relatively short-lived; however, the area has reverted back to "Sophiatown," although some signage continues to proclaim "Triomf."

76. Crossroads, a self-governing squatter camp outside Cape Town, hit world headlines when the apartheid government stepped in to destroy it and relocate residents elsewhere. A play was produced about life there, a recording was made of a local choir (including a song about demolition that was subsequently banned), photo and art exhibits were mounted, and postcards and bumper stickers highlighting their cause were used to publicize the official threats to this community, far beyond the borders of South Africa; see Kiewiet and Weichel, 1980.

77. White Boy Shebeen, a restaurant in an upscale Johannesburg suburb, similarly capitalizes vicariously on what could be a dodgy milieu for its patrons in an authentic incarnation. Rather inexplicably, in 2004 the place featured specialty nights with Czech and Italian meals. RAU has subsequently been incorporated into the new University of Johannesburg.

78. Rive, 1987a:96.

79. Ibid.:101.

80. Hirsch, 1983:16. It is interesting to note that middle-class suburbs that developed in the Cape Town area after World War II were restricted to white servicemen (Western, 1981:56), paralleling the case of New York's renowned "model community," Levittown.

81. Teaford, 2000:447. As stated, the removal of black Africans from District Six had been accomplished earlier in the twentieth century. The GAA primarily affected people classified within the catch-all term for mixed race and people of Asian origin—"coloured."

82. Hirsch, 1983:116.

83. Zielbauer, 2002. Once the scheme was publicized, it collapsed.

84. Eminent domain refers to government agencies taking private property for public use, presumably with fair compensation to the owners.

85. Gans, 1962:41, 21. A South African memoirist discloses how pervasive this dependence on group experience and group support was by recalling that when she worked as a maid in the upscale Sea Point section of Cape Town, she felt sorry for the single women who lived alone in large flats, weighed against her own tight-knit way of life in District Six (see Adams and Suttner,

1988:63). Neither type of resident would likely be able to fathom the life of the other, nor would they find it desirable.

86. Gans, 1962:299, 289.

87. This study differs in a significant way from the others: what Suttles called "ordered segmentation" speaks to a higher degree of mutual coexistence without social integration between these different groups. Where they lived, and which businesses and churches they patronized, were visibly distinct from one another. Generalizations are also difficult across these examples because not all the neighborhoods that were wiped out were exciting, colorful areas (although Gans does mention a small bohemian scene in West End). Some were simply neighborhoods where people conducted their lives.

88. E. Anderson, 1990:23. Interestingly, Jane Jacobs uses the same image when discussing the urban renewal of Chicago's Hyde Park neighborhood: "[the plan] amputates the existing commerce [from the main body of the district]" (1992:45).

89. A photo of the phrase as wall graffiti appears on the back cover, and an unlabelled version of it is presented inside, which could either be a stencil on a wall, a linocut, or executed in some other medium. It is accompanied by an image that appears to be several men crouching on the ground, raptly involved in a game of some sort (gambling perhaps?).

 Sometimes the slogan reads, "You are now in Fairyland."

 District Six: Image and representation was shown at the South African National Gallery, and was a joint venture with the District Six Museum.

90. Delport, 2001b:11.

91. Barrow, 1997:17.

92. In the face of what can be a chaotic society on a day-to-day basis, South Africans express nostalgia for apartheid—whites more than blacks, of course, but the feeling has intensified for all groups over the years since 1994; see *New York Times*, 2002.

93. Ngcelwane, 1998:14–15. She credits the spirit of *ubuntu* [group solidarity] as providing the glue that kept this community together.

94. Field, 2001:52, 53.

95. Fortune, 1996:97.

96. Field, 2001:87.

97. Barrow, 1997:15. These sorts of reminiscences reach their peak in the following overly poetic description of Sophiatown: "When the leaves were green and moist, how sweet were the grapes of our contentment in the place we called home" (Mattera, 1987:15).

98. Rive, 1990:114, 111, 112.

99. Swanson, 2001:111. The author is quoting from an oral history taken from a woman recalling her experiences in Claremont, a relatively close-in suburban community. Sandra Prosalendis reports that the first oral testimony the museum collected was from a former resident who spoke about the sexual abuse that he had suffered from a local priest.

100. Schoeman, 1994:53.

101. Ibid.:53, 46.

102. Adams and Suttner, 1988:65. Other authors confirm this perspective, reporting that they viewed gangsters as "Robin Hoods" (Soudien, 2001:99) and "gentlemen" (Jeppie, 2001:128).

Whereas communities such as Mitchells Plain and Hanover Park were reserved for "coloureds," black Africans were relocated to separate areas such as Langa and Gugulethu.

103. Hart, 1990:122.
104. Adams and Suttner, 1988:80.
105. Schimke, 2004.
106. Siegfried, 2005.
107. This example dated from around 2001, and prices continue to escalate. Esau reports that her mother receives flyers in her postbox on a weekly basis from estate agents who are interested in buying and selling her property.

　　Cape Town today is a "tale of two cities": one is the world of gentrified neighborhoods in the City Bowl, prosperous suburbs, beach communities, and the Victoria and Albert Waterfront; the other consists of the impoverished and crime-plagued settlements on the Cape Flats.
108. See Merten, 2005.
109. Nasson, 1989:295.
110. See, e.g., South African National Gallery (1995) for a selection of such views. "People" as "verbs" comes from the essay by Maurice in that catalogue (p. 19).
111. Fredericks, 2004.
112. See Friedman, 1997.
113. For a classic statement of the theory of institutional isomorphism, see DiMaggio and Powell, 1983. And for an example of how a cultural organization changes as it is forced to become more accountable; see Dubin, 1987a.
114. The museum does not own the building it occupies, but it pays only a token amount on a multiyear lease.
115. This is a good example of what the social theorist Max Weber called the "routinization of charisma," i.e., the challenge for succeeding generations of any group to sustain the original vision and enthusiasm of who founded their organization or community. Although the museum is a collective and not an individual creation, its organizational history nevertheless represents the transition from Weber's categories of charismatic to rational-legal authority; see Weber, 1978.
116. Jonker, 2003. Many of the foreign governments that were active in antiapartheid activities continue to be involved in social and cultural programs in South Africa.
117. Ntshingila, 2003. Tsostitaal (tsosti = a petty thief, taal = language) was a vernacular that combined bits of other languages and, like languages in general, using it was a way that speakers could instantly identify and connect with others from the same social group. Some argue that it evolved in criminal circles, especially in multicultural areas, and was used to communicate secretly during apartheid without outsiders understanding what was being said (see Molamu, 2003).
118. An oral history project in Charleston, South Carolina in 2002, combined with the work of artists, revived interest in the history of slavery in the area, and in a black residential neighborhood that was virtually destroyed by urban renewal. The co-curators of the oral history and art projects were a white American woman and a black South African man; his sensibility was shaped in part by his own country's past. An associated project, in an area

mansion, involved covering its floors with black carpeting, into which names from local slave inventories had been stitched. The dismay of visitors when they realized what they were stepping upon must have been comparable to the responses elicited by Pippa Skotnes's floor coverings in the exhibition *Miscast* (chapter 3). See Larson, 2002.
119. See Fransen, 1996.
120. Richmond, 1969.
121. Linda Fortune, like Noor Ebrahim, is an education officer at the District Six Museum. She too tells a story of human loss through an animal example in her memoir: "Those two cats were part of our family, but they were luckier than us children: unlike us, they were buried in the place where they were born," Fortune, 1996:69.
122. A contemporary viewer can gather some idea of how importantly pigeons figured into life in District Six by looking at the photo of an expansive, three-level pigeon loft in Shephard Street pictured in Thorne (1996):17.

6 "The History of Our Future": Revamping Edifices of a Bygone Era

1. *Byvoegsel tot Paratus*, 1979.
2. For more information on the End Conscription Campaign and the war resistance movement in South Africa, see Catholic Institute for International Relations, 1989.
3. Dennehy, 1996.
4. Diamond Fields Advertiser, 1997.
5. Leeman, 1996 and Moen, 1997.
6. Contemporary studies conducted in Africa by two humanitarian groups concluded that far more noncombatants die because of the vast disruptions caused by war than do people who are killed outright. Environmental degradation, loss of income, homes and wealth, the nonavailability of medical care, and the multiple traumas associated with being refugees contribute to there being 62 nonviolent deaths to every violent one; Lacey, 2005.
7. Greig, 2003.
8. Jacobs has gone as far as promoting a center for peace and reconciliation at the museum, which could be used for international negotiations.
9. This greater inclusiveness has the advantage of compelling a consideration of previously ignored aspects of the conflict, but universalizing the war also runs the danger of deflecting attention away from its primary causes and the main combatants; see the critique by Witz et al., 1999. A similar situation occurred when the lyrics of "Ol' man river" from the musical *Showboat* were altered from "Niggers all work on the Mississippi" to "Here we all work," in order to protect contemporary sensibilities. In the process, the historical reality of race in America was radically reworked; see Dubin, 1992:51.
10. *Umjelo*, 2001:22, 25.
11. Makobe, 1996:22.
12. *Umjelo*, 2001:26, and Edgar, 1988:35.
13. Webb and Holleman, 1999:18.
14. Ibid.:19.
15. Hooper-Box, 2001.

16. Quoted in Berning et al., 1991:17. The groundwork for the Durban System was laid with the 1909 Native Beer Act, which established a municipal monopoly on the production and sale of beer to "natives."
17. Ibid.:3.
18. Makana, along with other prisoners, escaped the island in a whaling boat. Makana drowned, but because his body was never recovered, his followers long held onto the hope that he would return to lead them again. One of the Robben Island ferries bears his name, and there have even been suggestions that the island be renamed in his honor.
19. C. Smith, 1997:40.
20. Robert Sobukwe formed the Pan African Congress; Walter Sisulu was a close associate of Nelson Mandela and a cofounder of the ANC Youth League; Govan Mbeki, father of president Thabo Mbeki, was one of the founders of the ANC and instrumental in building the South African labor movement.
21. There were competing visions for what Robben Island would become, including proposals to turn it into a resort or nature preserve. Moreover, a controversial government-sponsored celebration of Heritage Day on the island cost taxpayers R1 million, and a millennium party on New Year's Eve, 1999–2000, ran up costs of R40 million! According to former manager of Cape Town Tourism Sheryl Ozinsky, "I think that there are holy cows and I think one definitely needs to be aware of what those holy cows are. I think we would never turn Robben Island into an attraction that would, you know, have big parties on it, and would take thousands and thousands of visitors and have discos in Mandela's cell and that type of thing. So there are holy cows; there is lot of gray area between what is permitted and what isn't permitted." However, she understands that public opinion will likely shift as time passes: "I think as one gets further and further away from particular historical events people are less sensitive and it's important for that sensitivity to be left in place. . . . When Nelson Mandela is long gone, will it still have the same relevance to most tourists who come here is a big question."
22. Hamilton and Marlin-Curiel, 2000:75.
23. Ibid.:73.
24. Coombes, 2003:73–77.
25. Nanda, 2004:381–382.
26. According to Deputy Director Denmark Tungwana, foreign visitors generally outnumber locals, by as much as three to one.
27. Rassool, 2000:113.
28. K. Pretorius, 2004.
29. Tungwana recognized my letter when I handed him a copy of it in person, four months after I had originally mailed it. Surprisingly, two of my other Cape Town interviewees also said they had been made aware of my letter, after I mentioned my experience to them, even though neither has anything directly to do with Robben Island (one works in tourism, however). Whereas the complaint had somehow attracted some notoriety, no one had communicated that to me.
30. Saunderson-Meyer, 1998.
31. Jeremy Cronin, a member of the ANC and the SA Communist Party, is also a poet who was imprisoned by the apartheid regime. In his introduction to the catalogue accompanying *Thirty minutes*, he notes that visitors and inmates evaded detection to some extent by sending coded messages to one another, such as referring to the

"cousins" Alfred, Norman, and Charlie (ANC) and their various exploits; see Cronin, 1997:3.

32. Solani and ka Mpumlwana, 2001:86.

33. Cited in Rassool, 1999.

34. The motto of Constitution Hill in Johannesburg (to be discussed below), and the name of an exhibit on the ramparts there.

35. South Africans recall Hillbrow as one of the most celebrated and "vibey" neighborhoods in the country. In the 1980s it was officially declared a "grey area," the first such place where whites and blacks were allowed to live side by side. It was known for its wide-open, around-the-clock lifestyle, and its atypical mélange of people, including European immigrants, Jews, gay people, artists, musicians, and residents and visitors of all racial backgrounds. Today its inhabitants are virtually all black Africans; it is bursting with people, and with every imaginable urban social ill.

36. The terminology can be confusing, but sections 4 and 5 were collectively known as "Number Four."

37. For Robert Sobukwe, see note 20. Chief Albert Luthuli was a president of the ANC and winner of the Nobel Prize for Peace. The Sharpeville Massacre occurred on March 21, 1960 in a township outside Vereeniging in the Transvaal. Approximately 300 nonviolent demonstrators assembled outside the police station to protest the pass laws that regulated the movement of black Africans. Panicked police fired into the crowd, killing 69. Generally cited as the impetus for the subsequent armed resistance to the apartheid regime, today it is commemorated as Human Rights Day. The Treason Trial was based upon arrests made in 1956 of political activists after they endorsed the Freedom Charter, which mapped out an egalitarian future government. In all, 156 people were charged with high treason; the charges were finally dropped in 1961. The Soweto uprising will be discussed later in this chapter.

38. Mokwena, 2004.

39. Madikizela-Mandela is the well-known activist, former member of Parliament, a leader of the ANC Women's League, and former wife of Nelson Mandela; Albertina Sisulu was a prominent member of the Women's League and other women's political action groups; Helen Joseph was a key figure in the 1956 protest by a large, multiracial crowd of women in front of the Union Buildings in Pretoria; and Ruth First was a leading member of the Communist Party in South Africa and was assassinated by a letter bomb.

40. This quote and other information were obtained during a public talk I attended entitled "The House that Cyril Built" that Judge Sachs presented on June 29, 2003 at the National Arts Festival in Grahamstown. The reference is to Cyril Ramaphosa, a driving force behind South Africa's constitutional negotiations.

41. Two of the central stairwells have been incorporated into the court building while the other two remain standing, solitary and unadorned, on what has become a plaza area.

 An interesting parallel can be drawn with a site in Durban. In 1992, the Community Mural Projects painted the first community mural in that city, on the walls enclosing the former Central Prison. It celebrated each of the clauses of the Universal Declaration of Human Rights. After the 1994 elections, the prison was demolished, but the wall was retained. In 1997, the mural was replaced with one depicting South Africa's new Bill of Rights. See Marschall, 2000 and 2002:67–93.

42. Sachs, 2004.
43. *Star*, 2004a:10.
44. Ibid.
45. December 16 is also the date, in 1961, that Umkhonto we-Sizwe was founded.
46. Moerdijk, 1954:29.
47. This is a source of great resentment for right-wing Afrikaners. A posting on a white nationalist website (December 17, 2001) rages, "the day itself has become nothing more than another instrument in the hands of the terrorists to force Afrikaners to further discard their own traditions, culture and Christian beliefs and accept their barbaric way of life." See <www.stormfront.org/forum>.

 Interestingly, when Don Mattera writes of mid-century Sophiatown, he refers to "Dingaan's Day"; Mattera, 1987:72.
48. Oelofse, 2002. As cited in chapter 1, these young people would likely consider themselves to be members of the generation of Afrikaner youth that has come of age since 1994 who are referred to as DNA, Die Nuwe Afrikaner [the New Afrikaner], who prioritize partying over politics.
49. A writer reports that when his wife visited the monument in 1986 a dress code was posted at the entrance, and a female attendant wrapped a long skirt around her to cover up the pair of culottes she was wearing; see Manning, 1987:234.
50. Hochschild, 1991:186.
51. Nessman, 2003a.
52. Waldner, 2003.
53. Helfrich, 2000b.
54. Helfrich, 2000a.
55. Zeilhofer, 2003.
56. Matshikiza, 2002c.
57. Barron, 1994.
58. Matshikiza, 2002c.
59. Unsworth, 1996.
60. There was talk of imploding the Union Buildings after 1994, just as there was talk of destroying the Voortrekker Monument. Sir Herbert Baker purposely built alcoves into his design so that different governments could decorate them with what they considered appropriate symbols. But a contemporary writer notes that the spaces remain empty; see Barratt, 2004.
61. Ibid. In the exhibition *Democracy X*, mounted by Iziko Museums in 2004 in commemoration of the first decade of the democratic government in South Africa, a wall text offers a different interpretation of the building: "The building consists of two identical administrative blocks joined by a semicircular colonnade. The colonnade was seen as symbolic of the union of the two white cultures (English and Afrikaans). The building was reclaimed for all South Africans in 1994 when Nelson Mandela was inaugurated there as President." Adopting this view, the Voortrekker Monument would then be seen as symbolically severing that linkage between whites.
62. Moerdijk, 1954:34.
63. Matshikiza, 2002b.
64. Louw, 2000.
65. I. Jonker, 2000.

66. Among the best known of this group of scholars are Patricia Nelson Limerick, Daniel Worster, Peggy Pascoe, Richard White, and Richard Slotkin. A revisionist look of art of the American West made in the nineteenth and early twentieth centuries was the subject of *The West as America: Reinterpreting Images of the Frontier, 1820–1920* (National Museum of American Art, Washington, DC, 1991). See my discussion of this controversial exhibition in Dubin, 1999, chapter 5.
67. Moerdijk, 1954:30–31.
68. See Dubow, 1992; Etherington, 1991, 2001; Legassick, 2002; Parsons, 2002; and Saunders, 2002.
69. Grundlingh and Sapire, 1989:19, 34, 25 and B. Anderson, 1991:6.
70. Grundlingh and Sapire, 1989:20, 21. Just as they privilege the role of public ritual in building a sense of community, Van der Watt (1998) privileges the role of visual culture in communicating a sense of common identity. She examines the narrative tapestry displayed in the monument as a gendered counterpart to the primarily masculine narrative of the marble frieze. She conducts a similar analysis of both of these features in the monument in regards to race (1997). In 2000, 15 tapestry panels made by African women, depicting contemporary life in their communities, were displayed alongside the tapestry of Voortrekker life that was completed in 1960 (see Helfrich, 2000a).
71. Silverman, 2000.
72. See Hochschild, 1991. See also Godby (2000) for the very interesting description of the strongly negative reactions by those on the political left to a photographic exhibition that documented these expeditions; such critics felt that the images "glorified" a "fascist" worldview.
73. Ellis, 1977:797.
74. The Voortrekker Monument is becoming a refuge of sorts for sculpture and monuments no longer welcome in their original locations. Its administrators are faced with the task of deciding where to draw the line in sheltering this surplus material. Some have snidely suggested that such archaic collections be christened Boerassic Parks.
75. Quoted in Momberg, 2002.
76. Ibid.
77. General Opperman's fears are not unfounded: in 2004 a major row broke out when the University of Stellenbosch, long been considered a bastion of Afrikaner culture, announced its intention to posthumously honor Fischer with an honorary doctorate.
78. Land ownership is becoming an increasingly contentious issue in South Africa, with blacks making more claims on land where they've lived for generations, and white landowners also reasserting their rights to control property and their tenants. Farm violence is escalating, and people of all races are discovering that it may not be possible for them to be buried where they had hoped. See Steinberg (2002) for a gripping account of the situation in KwaZulu-Natal province.
79. *Rapport*, 2001.
80. Hills, 2002a.
81. Robinson, 2003.
82. *Voortrekker Museum*, 1982:3.
83. According to his successor Sibongiseni Mkhize, a "transitional council" appointed in 1999 had a black majority and a black chairperson. The

subsequent council that he worked with, starting in 2002, was composed of four blacks (primarily representing the Zulu community), four whites (representing the Afrikaner community), and one Indian. He judged the later group to be "more balanced" and "more interesting."

In 2003, controversy broke out when it was discovered that ex-council members had received over R100,000 for the "intellectual properties" they displayed in meetings (members of other councils perform their duties without demanding such compensation). The council was also accused of approving the appointment of incompetent employees, and possible nepotism in hiring; see Naudé, 2003. A *Natal Witness* (2003b) editorial accused councilors of "milking their positions," and of representing a "culture of entitlement."

84. Power, 2002:8.
85. Within the first five minutes of my interview with him, Mkhize used such words as "brave," "courage," "confident," and "strong" in relation to himself six times. As it turned out, he left the museum to become the managing director of the Market Theatre in Johannesburg, and Bongani Ndhlovu, formerly of the Ncome Museum, took over the helm at the Voortrekker Museum.
86. Deane, 2004. The actual infection rate is 37.5%. Even so, by October 2004 only 930 people were receiving antiretroviral treatment throughout the entire province.
87. As is the case in museums throughout the country, the racial composition of visiting school groups has radically shifted from predominately white to predominately black, very often due to implementing programs directly designed to bring these pupils in.
88. Reported in Schildkrout, 1995:76. The history of Namibia, formerly South West Africa, is a chronicle of more than a century of domination by other countries. South Africa, which borders it, most recently controlled this territory, until 1990. While now autonomous, Namibia's culture, politics, and history are closely linked with its neighbor to the south.
89. Turner, 2002.
90. Basic conditions of life such as food and clothing allotments were distributed along racial lines at Robben Island, an attempt to "divide and conquer" the inmates. The degree to which prison administrators were successful in accomplishing this goal is impossible to precisely measure, but it is clear that significant communication and bonding took place across racial lines. For a detailed look at life in the prison, see Buntman, 2003.
91. See Mills, 1959.

7 TÊTE-À-TÊTE: MUSEUMS AND MONUMENTS, CONVERSATIONS AND SOLILOQUIES

1. Quoted in Worley, 1992.
2. Neo Mbatha, a guide at Mgungundlovu, the historical site of the Zulu Kingdom during the reign of King Dingane (1829–1838), estimates that lobolo today would run 11 cows for ordinary folk and 100+/− for royalty.
3. Quoted in Ross, 1998.
4. Raper, 1998:26.
5. The doctrine of "separate development" mandated that South African blacks be banished to ten "homelands" or Bantustans, described in note 14, chapter 2.

6. A number of reasons have been put forward to help explain the Voortrekker's victory, among them: foggy conditions and topographical features prevented the Zulus from accurately assessing the strength of their enemy; cannon fire killed key leaders early on and left the bulk of the warriors without strong leadership; and the Zulus charged in tight formations, meaning that the buck-shot from one rifle firing could inflict multiple casualties.

7. <www.stormfront.org/forum>.

8. Van der Westhuizen, 1999.

9. See Hofstätter, 2004. See, also Steinberg, 2002.

10. *Pretoria News*, 2003b.

11. Maluleke, 2003a.

12. Quoted in Granelli, 2002.

13. *South African Press Association*, 2002b.

14. *Pretoria News*, 2003b.

15. Ibid.

16. Maluleke, 2003a.

17. See *Pretoria News*, 2003b.

18. Phahlane, 2004.

19. Quoted in Hills, 2002b.

20. Accone, 2001.

21. The issue of "what people knew" and "when did they know it" remains con-troversial. An American journalist reports receiving a letter from a South African friend in 1986 asking for details of what was going on in her own country. He quotes her as complaining, "I feel like the cheated wife here . . . That I will be the last to know—if ever"; Manning, 1987:156.

22. Moreover, in 2003 a man sued the Kroks for trademark violation over the use of the name "Apartheid Museum," which he had registered in 1990. He lost his case after the courts decided he had not followed through to actually build a project using that name.

23. Bristow-Bovey, 2002:51.

24. Miller and Miller, 2001:8.

25. Rostron, 2001.

26. One writer notes that inspectors sometimes asked people to show them their buttocks so they could judge the color of their skin that was not exposed to the sun; see Kenny, 2004.

27. Findley, 2004:27, 28.

28. Matshikiza, 2001.

29. Youens, 2003.

30. See Robinson, 2004a. A radio ad also provoked anger and prompted com-plaints to the Advertising Standards Authority.

31. There is inconsistency regarding Pieterson's age; I have seen it listed from between 12 and 14 years. Even in the visitor's brochure handed out at the Hector Pieterson Museum, he is listed as being 13 in one place, 14 in another.

32. The Apartheid Museum opened in 2001; the Hector Pieterson Museum, in 2002. However, it was because of the work Mashabane Rose was already doing in conceptualizing the Pieterson project that it was tapped to work on the Apartheid Museum.

33. Roup, 2004.

34. Many young people fled into exile. The ANC established the Solomon Mahlangu Freedom College (Somafco) in Tanzania, where some of them

continued their educations, while others carried on with their schooling in other African countries, or even further afield.

35. Krouse, 2001.
36. Hlongwane feels that a subject that needs to be explored further was the involvement of girls. At present, he believes, people think of the demonstrations as being predominantly male, to the general exclusion of examining what part females actually played. He says girls "were right in the thick of things."
37. Khumalo, 2004:11.
38. Mawson, 2004. As is the case at Robben Island, people with a personal connection to particular historical sites have later found employment there. In addition to Sithole, former protestors have worked as security guards at the Hector Pieterson Museum. And at the Apartheid Museum, a female receptionist of mixed racial heritage is pictured as a baby in a news clipping that reports her parents' home being destroyed because of their "immoral" relationship, and a tour guide is a former detainee because of her political activities as a student.
39. Ndaba, 2004.
40. See L. H. Smith, 2004.
41. Schmidt, 2003.
42. Ibid. The coloured community, particularly in the Western Cape, commonly speaks Afrikaans. With the country being ruled by a black African-dominated political party, it becomes a strong assertion of group identity. And people today are more likely to note that it has strong roots in the slave, Khoi, and San communities (see Moleko, 2003). Language can still become a flashpoint: in 2004 black students at Stellenbosch, a prestigious Afrikaner university (and formerly all-white), threatened to march in protest against Afrikaans-only lectures; see van der Merwe, 2004.
43. Mthombothi, 2004.
44. Mufweba, 2003:1.
45. See Hooper-Box, 2005.
46. Govender, 2005.
47. McGrath, 2005.

8 THE NEW SOUTH AFRICA: OLD ROUTINES AND CURRENT POLITICAL REALITIES

1. Fuller, 2003:198.
2. *Cape Times*, 1994.
3. Powell, 1994.
4. See Ngubane, 1995.
5. Keene, 1996; Lynch, 1996.
6. Quoted in H. Friedman, 1998.
7. Meijer, 1996a; Gowans, 1996; Altenroxel, 1999; H. Friedman, 1998; *Pretoria News*, 1998. For the record, the Albany Museum in Grahamstown has successfully weathered financial crises and remains a functioning museum.
8. Keene, 2000:3.
9. Friedman, 1998.

10. Greig, 2002.
11. Grootboom, 2001.
12. Theft is a recurring threat at all types of South African museums. In one of the oddest instances, the horn was stolen from a rhino on display at the Transvaal Museum; subsequently, the horns were removed from five other rhino specimens and put into storage; see Shonisani, 2002.
13. Without diminishing the achievements of the Oliewenhuis and Talana Museums, it must be noted that the first is blessed with a beautiful and roomy hilltop site along with the former residence of the South African governor general (later used for the state president), while the latter sprawls across a spacious campus as well. Urban museums, and countless others throughout the country, are unable to duplicate their ambitious visions.
14. Van Bosch, 2003:18.
15. The cartoon is signed by Hayden Proud, a SANG curator, and is dated July 1998.
16. M. Martin, 1999:50.
17. It is worth noting that two controversial exhibitions, *Scurvy* (1995) and *Fault lines* (1996), used the Castle, the oldest building in the country and an obvious symbol of the colonization of South Africa by the Dutch, to address issues of history, memory, politics, and sexuality.
18. Quoted in Altenroxel, 1999.
19. Even so, it must be noted that South African museums are ghostly devoid of guests in scores of instances. This is especially true in the smaller towns and medium-sized cities, as well as in Johannesburg, where there are not as significant a number of tourists as in, say, Cape Town.
20. Van Tonder, 1994:173.
21. Ali Hlongwane reports that the Hector Pieterson Museum faces a different problem from most others: how to attract white staffers. He has found that they are reluctant to work in Soweto.
22. Quoted in Morris, 1998.
23. This overlooks, of course, notable public figures such as Václav Havel, playwright and the first president of the Czech Republic, and Wally Serote, poet and writer and CEO of Freedom Park.
24. SANG's Marilyn Martin takes a different view: "Affirmative action is necessary before we can talk about equal opportunity, and reverse discrimination is not possible in South Africa" (M. Martin, 1993:98). Martin wrote this ten years prior to Hirst's statements. Moreover, she is making a theoretical point, whereas he is giving an experiential account, from the ground.
25. E-mail communication, March 21, 2004.
26. Naidoo, 1993.
27. Durban Art Lover (pseud.), 1996.
28. Hasselgrove, 1996.
29. Meijer, 1996a.
30. Quoted in ibid.
31. Gowans, 1996.
32. Cook, 1996.
33. Quoted in Meijer, 1997.
34. Meijer, 1996b.

9 TRANSFORMATION: MODELS OF SUCCESS OR MEDIOCRITY?

1. van Wyk, 1990:17.
2. Kapilevich, 2002.
3. See Dubin, 1987b.
4. An increasingly popular strategy is a "Family of Man" approach: grouping objects together sharing similar functions, shapes or materials but representing various national groups. An example would be the East London Museum where the display *Beads for everyone* shows an embroidered teapot cover, beaded calabashes and sample cards of Czech beads from the 1950s. And *Democracy X* featured a large fan-shaped display mingling clubs, carbines, spears, an iron axe, rifles, and pistols, an example of native production repeatedly alternating with one of European origin.
5. Odendaal, 1995:10.
6. Von Klemperer, 2001. To this day, the Kimberley Club, where diamond moguls dined, rubbed shoulders, and bivouacked, such trophies dominate the stairway from the bar and restaurants of the first floor to the private accommodations on the second. The plaques bear not only the captured booty, but also feature the bullets that felled each animal.
7. Von Klemperer, 2002a.
8. See Haasbroek, 2002.
9. Quoted in Galloway, 2003. "Comrade" was a popular term during the liberation struggle.
10. E-mail communication with author, September 27, 2003.
11. Recall, too, that some ANC officials opposed the Anglo-Boer War Centennial (chapter 6).
12. *City Press*, 2003. See, also, an article published on the same day that focuses on one particular individual's omission from the record: Mphaki, 2003.
13. *Pretoria News*, 1995.
14. *Natal Witness*, 1998.
15. See Coan, 2000.
16. Van Tonder, 1994:169; Odendaal, 1995:9; Martin, 1999:54.
17. Accone, 1990.
18. Bauer and Pemba, 1991.
19. H. Friedman, 1999.
20. Glancey, 1997.
21. Toffoli, 1993.
22. H. Friedman, 1999. Contrast this with the fact that the first piece of art bought by Marilyn Martin when she became the director of the SANG was Kevin Brand's installation "Nineteen boys running," a provocative work about a 1985 incident where the police killed a large number of people gathered for a funeral in the Eastern Cape Province. Although Brand was not part of this community, his art compellingly captured the pandemonium that broke out once the police started to fire their weapons.
23. Ibid.
24. Glancey, 1997.
25. Kirby, 1997.
26. Vergunst, 1992.

27. In Martin's "Curator's Preface" to the catalogue accompanying the exhibition *Contemporary South African art: 1985–1995*, she refers to the possibility of making mistakes in judgment in the acquisition of new work as a necessary consequence of being "adventurous." And in the only instance of quoting someone else's thoughts to back up her own beliefs, she relies upon the words of a curator at New York's Museum of Modern Art to attest that "sins of omission" are more serious than "sins of commission." All in all, it sounds like a veiled defense of SANG's conduct in the Bailey/Ntobe episode; see South African National Gallery, M. Martin, 1997a:22.

 A critic called these attempts to compensate for past omissions "political overcorrection," and worried that other groups are subsequently ignored, such as white conceptual artists; see Warren Siebrits, quoted in Atkinson, 1997.
28. Hillebrand, 2004:85. All of the information about the Nelson Mandela Metropolitan Art Museum comes from this article.
29. SANG did something similar in 1997: people made selections from the permanent collection, many of them not on regular view. The commentators included security guards and housekeepers. See Thamm, 1997.
30. Von Klemperer, 2002b.
31. Bell, 2003.
32. Vanderhaeghen, 2003. The remaining entrants were broken down as follows: 14 "Afrikaans men," 31 "Afrikaans women," 10 "English men," and 1 "Indian."

 Four finalists received R5,000 each and the ultimate cost was estimated to be around R200,000. The major prerequisite for entrants was that they must be South African, living in South Africa.
33. In 1947, a sell-off of parts of the collection of the South African National Gallery also occurred; see Sampson, 1999.
34. G. Anderson, 2002.
35. Bell, 2002.
36. Vanderhaeghen, 2003.
37. *Natal Witness*, 2003a.
38. As it turned out, there were many delays in completing the project. As this book went into production in fall 2005, nearly two years after the originally scheduled unveiling, the king's portrait had still not been hung, although the Tatham was planning for it to happen soon thereafter. For one thing, there were challenges in sourcing adequate legal supplies of indigenous wood with which to construct the frame. Moreover, ongoing political factionalism in the province compelled the Tatham to glide beneath the radar with their plans, and draw back from what it originally intended to be a public celebration to plan a quiet installation instead.
39. Taylor and Bedford, 1997:27.
40. Ibid.
41. Garner, 1994.
42. Edmunds, 1999.
43. Marilyn Martin discusses this in her essay for *Contemporary South African art*; see M. Martin, 1997a:18.
44. Carman, 2003:248–249. Anecdotal evidence suggests, however, that when non-whites did enter these institutions, they were closely trailed by museum staff.

10 CONCLUSION: A BRIDGE TOO FAR?

1. Reenactments occur at other historical battle sites, including Isandlwana. Nessman (2003b) describes how the contemporary reenactors there "eschewed the Zulus' barefoot tradition for sneakers."
2. Quoted in Visser, 2005.
3. Quoted in Rondganger, 2005.
4. Saunderson-Meyer, 2005.
5. Quoted in Toffoli, 1993.
6. <www.SouthAfrica.info>, 2004.
7. *Star Tonight*, 2004.
8. Hobbs, 2004:2.

BIBLIOGRAPHY

Abrahams, Yvette. 1996a. "Miscast," *Southern African Review of Books*, 44 (July/August):15–16.
———. 1996b. "Disempowered to consent: Sara Bartman and Khoisan slavery in the nineteenth-century Cape Colony and Britain," *South African Historical Review*, 35: 89–114.
Accone, Darryl. 1990. "Art expert slams Barker's ethnic bias allegations," *Star Tonight*, July 4.
———. 2001. "Is the museum an atonement?" *Business Day*, December 10.
Adams, Hettie, and Hermione Suttner. 1988. *William Street, District Six*. Cape Town: Chameleon Press.
Adler, Judith. 1989. "Travel as performed art," *American Journal of Sociology*, 94(6):1366–1391.
Agence France-Presse. 1997a. "Diana death was nature's revenge for warrior death," September 2.
———. 1997b. "Skull burial causing bad luck—Aboriginals," September 30.
Alexander, Sheila. 2003. "City prices are out of proportion," *Diamond Fields Advertiser*, September 30.
Altenroxel, Lynne. 1999. "Museums hit by cash crisis," *Pretoria News*, March 5.
Anderson, Benedict. 1991. *Imagined communities: Reflections on the origin and spread of nationalism*. London: Verso.
Anderson, David M., and Richard Rathbone, eds. 2000. *Africa's urban past*. Oxford: James Currey.
Anderson, Elijah. 1990. *Streetwise: Race, class and change in an urban community*. Chicago: University of Chicago Press.
Anderson, Gavin. 2002. "Taking on the Tatham," *Natal Witness*, March 13.
Anstey, Gillian. 1996. "In the tracks of the Bushmen," *Sunday Times*, May 12.
Ashton, Glenn. 1999. "Simple exploitation at Kagga Kamma," *Cape Times*, July 12.
Atkinson, Brenda. 1997. "The 'neglected tradition' is back home," *Mail & Guardian*, September 4.
Babich, Jacci. 2003. "Soweto Now?" *Northcliff/Melville Times*, October 3.
Barratt, Elizabeth. 2004. "The buildings that unite our past and future," *Star*, April 26.
Barron, Chris. 1994. "The 'big lie' on the hill," *Sunday Times*, April 10.
Barrow, Brian. 1997. *The Spirit of District Six: Photographs of Cloete Breytenbach*. Cape Town: Human & Rousseau.
Battersby, John. 2002. "The district that refuses to die," *Sunday Argus*, December 29.
Bauer, Charlotte. 2002. "Battle for Sarah Bartmann," *Sunday Times Lifestyle*, August 11.
Bauer, Charlotte, and Titus Pemba. 1991. "Two-tone Beezy slips into the Gallery," *Weekly Mail*, September 6–12.

Bell, Brendan. 2002. "The gallery's director responds," *Natal Witness*, March 13.
———. 2003. "One hundred years: The fortunes (and misfortunes) of the Tatham Art Gallery Collection." Draft manuscript.
Bennett, Tony. 1995. *The birth of the museum: History, theory, politics.* London: Routledge.
Berelowitz, I. 1989. "The Jews of District Six," *Cape Argus Weekender*, January 21.
Berger, John. 1977. *Ways of seeing.* London: Penguin.
Berning, Gillian et al. 1991. *Proposal for Kwa Muhle Museum.* Durban: Local History Museums.
Bickford-Smith, Vivian. 1990. "The origins and early history of District Six," pp. 35–43 in Jeppie and Soudien, 1990.
———. 2001. "Mapping Cape Town: From slavery to apartheid," pp. 15–26 in Field, 2001.
Boezak, Willa. 2002. "Saartjie not yet free," *Cape Times*, July 15.
Bogdan, Robert. 1988. *Freak show: Presenting human oddities for amusement and profit.* Chicago: University of Chicago.
Bohlin, Anna. 1998. "The politics of locality: Memories of District Six in Cape Town," pp. 168–188 in Lovell, 1998.
Bonner, Philip, Isabel Hofmeyr, Deborah James, and Tom Lodge, eds. 1989. *Holding their ground: Class, locality and culture in 19th and 20th century South Africa.* Johannesburg: Ravan Press.
Boon, James A. 1991. "Why museums make me sad," pp. 255–277 in Karp and Lavine, 1991.
Bourdieu, Pierre. 1986. "Habitus, code et codification," *Actes de la recherche en sciences sociales*, 64: 40–44.
Boym, Svetlana. 2001. *The future of nostalgia.* New York: Basic Books.
Brain, C. K. 1988. "Human evolutionary themes in museum displays: Some problems and principles," *Southern African Museums Association Bulletin* (shortened hereafter as *SAMAB*), 18(3):125–126.
Breytenbach, Breyten. 1993. *Return to paradise.* London: Faber & Faber.
Breytenbach, Cloete. 1997. *The spirit of District Six: Photographs of Cloete Breytenbach*, with text by Brian Barrow. Cape Town: Human & Rousseau.
Bristow-Bovey, Darrel. 2002. "Another country," *SA Style*, January: 45–46, 50–51.
Buntman, Fran Lisa. 2003. *Robben Island and prisoner resistance to apartheid.* Cambridge: Cambridge University Press.
Burnett, Ricky, ed. 1985. *Tributaries—A view of contemporary South African art.* Johannesburg: Communication Department, BMW South Africa.
Burrell, Ian. 1997. "Hi-tech FBI tools to retrieve aborigine chief's head," *The Independent* [London], June 1.
Byvoegsel tot Paratus [*Paratus* Supplement]. 1979. "Terroristewapens [Terrorist Weapons]," June.
Cameron, Duncan. 1972. "The museum: A temple or the forum?" *Journal of World History*, 14(1):189–202.
Cape Times. 1984. "Winnie 'surprised at getting weird portfolio,' " May 16.
Carman, Jillian. 2003. "Johannesburg Art Gallery and the urban future," pp. 231–256 in Tomlinson et al., 2003.
Catholic Institute for International Relations. 1989. *Out of step: War resistance in South Africa.* London: CIIR.
Citashe, I. W. W. n.d. "Weapon," p. 203 in Hughes, 1960.
Citizen. 1985. "Ricky's search for diversity takes courage," March 23.

———. 2003. "It's official: Happy ad was 'reckless,' " July 11.

City Press. 2003. "ANC is not the only hero of our struggle," June 15.

———. 2004. "Two anthems, one nation can't work," January 18.

———. 2005. "The litchis vs the coconuts," January 16.

Clifford, James. 1997. "Museums as contact zones," chapter 3, pp. 188–219 in *Routes: Travel and translation in the late twentieth century.* Cambridge, MA: Harvard University Press.

Coan, Stephen. 2000. "Delving mysteries of man's origins," *Natal Witness,* October 21.

Cohen, David William, and E. S. Atieno Odhiambo. 1992. *Burying SM: The politics of knowledge and sociology of power in Africa.* Portsmouth, NH: Heinemann.

Cohen, Mike. 2002. "South Africa prepares repatriated remains of indigenous Khoisan woman for burial," *Associated Press Newswires,* August 4.

Cole, Ernest, with Thomas Flaherty. 1967. *House of bondage.* New York: Random House.

Cook, Dan. 1996. "Gallery revisionists risk being judged barbarians," *Natal Mercury,* November 19.

Coombes, Annie E. 1994. *Reinventing Africa: Museums, material culture and popular imagination in Late Victorian and Edwardian England.* New Haven and London: Yale University Press.

———. 2003. *History after apartheid: Visual culture and public memory in a democratic South Africa.* Durham: Duke University Press.

Corbey, Raymond. 1993. "Ethnographic showcases, 1870–1930," *Cultural Anthropology,* 8(3):338–369.

Cormick, Craig. 1997. "The facts of black-white confrontation have largely been ignored or distorted by whites," *Canberra Times,* April 27.

Crockett, Davey. 2003. "Anthem must be acceptable to all," *Herald* [Port Elizabeth], July 5.

Cronin, Jeremy. 1997. "The glass frontier," pp. 2–3 in Williamson, 1997.

Cross, Robert. 1975. "How are things around 55th and Harper?" *Chicago Tribune Magazine,* October 26:18, 33–36, 40.

Daily News [Durban]. 1987a. "Walkout as conference speaker is condemned," May 6.

———. 1987b. "Stand up and be counted!" May 11.

Damon, Judy, and Aneez Salie. 2002. "Sarah Baartman's final resting place to be in the Eastern Cape," *Star,* July 25.

Dancer, Helene. 2000. "Preserving Cape jazz heritage," *Mail & Guardian,* September 22–28.

Dangor, Achmat. 1978 [1995]. *Waiting for Leila.* Johannesburg: Ravan Press.

Davids, Nashira, and Ilse Fredericks. 2004. "Property kings eye township market," *Sunday Business Times,* October 10.

Davison, Patricia. 1990. "Rethinking the practice of ethnography and cultural history in South African museums," *African Studies,* 49(1):149–167.

———. 1993. "Human subjects as museum objects: A project to make life-casts of 'Bushmen' and 'Hottentots,' 1907–1924," *The Annals of the South African Museum,* 102(5):165–183.

———. 1998. "Museums and the reshaping of memory," pp. 143–160, in Nuttall and Coetzee, 1998.

Day, Angela. 2003. "Soweto treats," *Star,* August 7.

Deane, Nawaal. 2004. "Missing the mark," *Mail & Guardian,* October 15–21.

De Kock, Leon. 2004. "Songs of innocence," *Sunday Times Lifestyle,* May 16.

Delport, Peggy. 2001a. "Digging deeper in District Six: Features and interfaces in a curatorial landscape," pp. 154–164 in Rassool and Prosalendis, 2001.

———. 2001b. "Museum or place for working with memory?" pp. 11–12 in Rassool and Prosalendis, 2001.

———. 2001c. "Signposts for retrieval: A visual framework for enabling memory of place and time," pp. 31–46 in Rassool and Prosalendis, 2001.

Dennehy, Peter. 1996. "ANC opposed to Boer War centennial event," *Cape Times,* September 26.

Dennie, Garrey. 1992. "One king, two burials: The politics of funerals in South Africa's Transkei," *Journal of Contemporary African Studies,* 11(2):76–87

De Wet, Hannes. 2001. "HNP begins two-day congress, urges unity against 'genocide' of Afrikaner," *South African Press Association,* March 23.

Diamond Fields Advertiser. 1997. "Right battle, wrong foe," October 10.

DiMaggio, Paul, and Walter W. Powell. 1983. "The Iron Cage revisited: Institutional isomorphism and collective rationality in organizational fields," *American Sociological Review,* 48:147–160.

Douglas, Mary. 1970 [1966]. *Purity and danger: An analysis of concepts of pollution and taboo.* Harmondsworth: Penguin.

Dovey, Colin. 2003. "Shall we bring the race board back?" *Star,* December 5.

Dubin, Steven C. 1987a. *Bureaucratizing the muse: Public funds and the cultural worker.* Chicago: University of Chicago Press.

———. 1987b. "Symbolic slavery: Black representations in popular culture," *Social Problems,* 34(2) April:122–140.

———. 1992. *Arresting images: Impolitic art and uncivil actions.* New York: Routledge.

———. 1995. "How I got screwed by Barbie: A cautionary tale," *New Art Examiner,* November:20–23.

———. 1996. "*That* girl! The saga continues," *New Art Examiner,* January:9.

———. 1999. *Displays of power: Memory and amnesia in the American museum.* New York: New York University Press.

———. 2005. "Incivilities in civil (-ized) places: 'Culture wars' in comparative perspective," pp. 477–493 in MacDonald, 2005.

Dubow, Neville. 1996. "Arms and the man," *Mail & Guardian,* April 12–18.

Dubow, Saul. 1992. "Afrikaner nationalism, apartheid and the conceptualization of 'race,'" *Journal of African History,* 33:209–237.

Duncan, Carol. 1991. "Art museums and the ritual of citizenship," pp. 88–103 in Karp and Lavine, 1991.

Du Pré, Roy H., ed. 1997. *South End [as we knew it].* Port Elizabeth: Western Research Group.

Durban Art Lover [pseud.]. 1996. "Verster's sell-the-artworks proposal dangerous," *Mercury,* December 3.

du Toit, Julienne. 2003. "Art of Africa," *SA Millionaire,* May/June:34–37.

Dyantyi, Aurelia. 1999. "Africans wary of this master," *Saturday Star,* June 26.

Edgar, Robert. 1988. *Because they chose the plan of God.* Johannesburg: Ravan Press.

Edgar, Robert, and Hilary Sapire. 1999. "Dry bones: The return of Nontetha, an Eastern Cape prophet," *South African Historical Journal,* 40:95–113.

Edmunds, Paul. 1999. "Shedding light on 'blackness,'" *Mail & Guardian,* April 16–22.

Ehrenhalt, Alan. 1995. *The lost city: Discovering the forgotten virtues of community in the Chicago of the 1950s.* New York: Basic Books.

Ellis, William S. 1977. "South Africa's lonely ordeal," *National Geographic*, 151(6):780–819.

Enwezor, Okwui. 1997. "Reframing the black subject: Ideology and fantasy in contemporary South African representation," *Third Text*, 40:21–40.

Etherington, Norman. 1991. "The Great Trek in relation to the Mfecane: A reassessment," *South African Historical Journal*, 25:3–21

———. 2001. *The Great Treks: The transformation of Southern Africa*. London: Longman Pearson.

Events @ SAM. 2001. "Debating the Diorama," 2(3):n.p.

Fairlady. 2002. "What's PC—Bushmen or San?" September 25:22.

Farber, Tanya. 2003. "Political passion a thing of the past," *Star*, September 10.

Fausto-Sterling, Anne. 1995. "Gender, race, and nation: The comparative anatomy of 'Hottentot' women in Europe, 1815–1817," pp. 18–48 in Terry and Urla, 1995.

Ferreira, Emsie. 2002. "Hottentot Venus honored in cultural ceremony," *Agence France Presse*, August 4.

Ferreira, Naas. 2003. "Make yourself at home in the great Kalahari," *Saturday Star Travel*, April 26.

Field, Roger, and David Bunn, eds. 2000. *Trauma and topography: Proceedings of the second colloquium of the landscape and memory project*. Johannesburg: University of the Witwatersrand.

Field, Sean, ed. 2001. *Lost communities, living memories: Remembering forced removals in Cape Town*. Cape Town: David Philip.

Findley, Lisa. 2004. "Red and gold: Two Apartheid Museums and the spatial politics of memory in 'New' South Africa," *Architecture South Africa*, July/August: 26–32.

Forbes, Andrina Dashwood. 1992. *Birds on a ledge*. Cape Town: Buchu Books.

Fortune, Linda. 1996. *The house in Tyne Street: Childhood memories of District Six*. Cape Town: Kwela Books.

Foster, Craig. 2003. *Shack chic: Art innovation in South African shacklands*. London: Thames and Hudson.

Fransen, Hans. 1996. "The architecture that Cape Town lost," pp. 19–21 in Thorne, 1996.

Fredericks, Ilse. 2004. "Fronds of hope for resettled District Six residents," *Sunday Times*, August 8.

Friedman, Hazel. 1998. "Beggared museums at a standstill," *Sunday Independent*, November 1.

———. 1999. "Beneath the hype, it's beeziness as usual," *Saturday Argus*, October 30.

Friedman, Roger. 1997. "All District Six needs now is plan of action," *Cape Times*, August 6.

Fugard, Athol. 1983. *Tsotsi*. New York: Viking.

Fuller, Alexandra. 2003. *Let's not go to the dogs tonight: An African childhood*. New York: Random House.

Galloway, Andy. 2003. "ANC's founding place disputed once again," *Express*, January 29.

Gamieldien, S. 2005. "Singing, dancing in the streets against Islamic principles," *Cape Argus*, January 6.

Gans, Herbert J. 1962. *The urban villagers: Group and class in the life of Italian-Americans*. Glencoe: Free Press.

Garber, Marjorie. 1992. *Vested interests: Cross-dressing and cultural anxiety*. New York: Routledge.

Garner, James. 1994. "SANG takes another step forward," *Cape Times*, February 24.

Geers, Kendall. 1999. "The wrong Renaissance," *Star Tonight*, May 4.

Geertz, Clifford. 1973. "Ritual and social change: A Javanese example," chapter 6, pp. 142–169 in *The interpretation of cultures*. New York: Basic Books.

Geldenhuys, Henriette. 2004. "Aids and alcohol a deadly combination," *Sunday Times*, July 25.

Gilbert, Michelle. 1988. "The sudden death of a millionaire: Conversion and consensus in a Ghanaian kingdom," *Africa*, 58(3):291–314.

Gill, Gwen. 2003. "Tourism chiefs rock out in Soweto," *Sunday Times*, August 17.

Gilman, Sander L. 1985. "The Hottentot and the prostitute: Toward an iconography of female sexuality," chapter 3, pp. 76–108 in *Difference and pathology: Stereotypes of sexuality, race, and madness*. Ithaca: Cornell University Press.

Gitlin, Todd. 1980. *The whole world is watching: Mass media in the making and unmaking of the New Left*. Berkeley: University of California Press.

Glaberson, William. 2001. "Who is a Seminole, and who gets to decide?" *New York Times*, January 29.

Glancey, Jonathan. 1997. "How do you get into South Africa's National Gallery if you're white? Just find yourself a black alter ego," *New Statesman*, August 22.

Godby, Michael. 2000. "Dismantling the symbolic structure of Afrikaner nationalism: Gideon Mendel's 'Beloofde Land,' " *Nka: Journal of Contemporary African Art*, Fall/Winter:72–79.

Gordimer, Nadine. 1958. *A world of strangers*. New York: Simon & Schuster.

———. 1981. *July's people*. New York: Viking.

Gordon, Robert J. 1992a. *The Bushman myth and the making of a Namibian underclass*. Boulder: Westview.

———. 1992b. "The venal Hottentot Venus and the Great Chain of Being," *African Studies*, 51(2):185–201.

———. 1997. *Picturing Bushmen: The Denver African Expedition of 1925*. Athens, OH: Ohio University Press.

———. 1998. "The rise of the Bushman penis: Germans, genitalia and genocide," *African Studies*, 57(1):27–54.

———. 1999. " 'Bain's Bushmen': Scenes at the Empire Exhibition, 1936," pp. 266–289 in Lindfors, 1999a.

Gordon, Sheila. 1990. *The middle of somewhere*. New York: Orchard Books.

Gosling, Melanie. 2001. "San shocked at closure of exhibition," *Cape Times*, March 30.

Gould, Stephen Jay. 1981. *The mismeasure of man*. New York: W. W. Norton.

———. 1985. "The Hottentot Venus," chapter 19, pp. 291–301 in *The flamingo's smile*. New York: W. W. Norton.

Govender, Sholain. 2005. "History through language of fashion," *Star*, July 26.

Gowans, Jill. 1996. "Museums fight to exist," *Sunday Tribune*, December 15.

Granelli, Marco. 2002. "Green light for Freedom Park," *Star*, February 15.

Greig, Robert. 2002. "New museums are places for human experiences rather than repositories for objects," *Sunday Independent*, June 23.

———. 2003. "War creates victims, victims become bullies," *Sunday Independent*, November 9.

Grobler, John. 2001. "The Khoi don't share our culture, say San," *Mail & Guardian*, April 26–May 3.

Grootboom, Similio. 2001. "Editorial," *Umjelo* [Magazine of the Eastern Cape Museums], 1(September):1.

Grundlingh, Albert, and Hilary Sapire. 1989. "From feverish festival to repetitive ritual? The changing fortunes of Great Trek mythology in an industrialising South Africa," 1938–1988, *South African Historical Journal*, 21:19–37.

Haasbroek, J. 2002. "Founding venue of the African National Congress (1912): Wesleyan School, Fort Street, Waaihoek, Bloemfontein," *Navorsinge van die Nasionale Museum Bloemfontein*, 18(7):126–159.

Hamilton, Carolyn. 1994. "Against the museum as chameleon," *South African Historical Journal*, 31:184–190.

———. 1998. *Terrific majesty: The powers of Shaka Zulu and the limits of historical invention*. Cambridge, MA: Harvard University Press.

Hamilton, Nan, and Stephanie Marlin-Curiel. 2000. "Reconciling history in the living museum: Robben Island in transition," pp. 72–96 in Field and Bunn, 2000.

Haraway, Donna. 1989. *Primate visions: Gender, race, and nature in the world of modern science*. New York: Routledge.

Hart, Deborah M. 1990. "Political manipulation of urban space: The razing of District Six, Cape Town," pp. 117–142 in Jeppie and Soudien, 1990.

Hasselgrove, R. 1996. "Don't indulge in political correctness," *Natal Mercury*, December 2.

Hearst, David. 2002. "Colonial shame—African woman going home after 200 years," *Guardian*, April 30.

Helfrich, Kim. 2000a. "Tapestries depict women's role in SA," *Pretoria News*, November 15.

———. 2000b. "Upgrade for city monument," *Pretoria News*, November 30.

Hillebrand, Melanie. 2004. "The collections of the Nelson Mandela Metropolitan Art Museum (formerly 'The King George VI Art Gallery')," *de arte*, 69:84–91.

Hillerman, Tony. 1989. *Talking God*. New York: Harper and Row.

Hills, Carol. 2002a. "Zion rightists evicted," *Citizen*, March 27.

———. 2002b. "Voortrekkers' covenant reaffirmed in Pta," *Citizen*, December 17.

Hirsch, Arnold R. 1983. *Making the second ghetto: Race and housing in Chicago, 1940–1960*. Cambridge: Cambridge University Press.

Hlatshwayo, Riot. 2004. " 'Illegal' pupil 'too black to be a local,' " *City Press*, July 25.

Hobbs, Philippa, ed. 2004. *Resistance, reconciliation, reconstruction*. Johannesburg: MTN Foundation.

Hobbs, Philippa, and Elizabeth Rankin. 2003. *Rorke's Drift: Empowering prints*. Cape Town: Double Storey Books.

Hochschild, Adam. 1991. *The mirror at midnight: A journey to the heart of South Africa*. London: Collins.

———. 1998. *King Leopold's ghost: A story of greed, terror and heroism in colonial Africa*. New York: Houghton Mifflin.

Hoffman, Bill. 2002. "Heidi butts out," *New York Post*, October 31.

Hofmeyr, J. 1987. "Serving the people: Museums as instruments of mediation in South Africa," *SAMAB*, 17(7/8):311–323.

Hofstätter, Stephan. 2004. "The war that never ended," *Thisday*, August 3.

Hooper-Box, Caroline. 2001. " 'Place of pain must become a place of hope,' " *Sunday Independent*, December 16.

———. 2004. "Colours don't run in the rainbow nation," *Sunday Independent*, November 7.

———. 2005. "Roaring for freedom—And trendy trappings," *Sunday Tribune*, January 16.

Hope, Marith, ed. 1997. *Contemporary art from South Africa*. Oslo: Riksutstillinger.

Howe, Graham. 2003. "Kalahari dreaming," *Saturday Star Travel*, January 25.

Hromnik, Cyril A. 2001. "Pippa Skotnes's exhibition helped close the Kung diorama," *Mail & Guardian*, April 26–May 3.

———. 2002. "What's in a name," *Cape Argus*, August 14.

Hughes, Langston, ed. 1961. *An African treasury*. London: Victor Gollancz Ltd.

Jacobs, Jane. 1992 [1961]. *The death and life of great American cities*. New York: Random House.

Jacobson, Lana. 2005. "Encounters with the unexpected," *Sunday Tribune*, January 16.

Jeppie, Shamil. 2001. "Modern housing for the district: The Canterbury and Bloemhof Flats," pp. 113–130 in Rassool and Prosalendis, 2001.

Jeppie, Shamil, and Crain Soudien, eds. 1990. *The struggle for District Six: Past and present*. Cape Town: Buchu Books.

Jonker, Ingrid. 2000. "Hofaansoek oor Ronge se uitatings oor monument [Court appeal about Ronge's statements over monument]," *Beeld*, March 4.

Jonker, Julian. 2003. "Preserving memories of that blue district," *This Day*, December 19.

Johns, Lynnette. 2002. "Tug-of-war over Saartjie Baartman," *Cape Argus*, May 8.

Johnson, Anthony. 1997. "Standing on the brink of extinction," *Diamond Fields Advertiser*, July 11.

Joseph, Burton. 2002. "Indigenous names are vital," *Star*, May 8.

Kanhema, Newton. 1996. "How Boer War historians tore out the page on blacks," *Saturday Star*, September 14.

Kanyane, Chris. 2002. "Who named her Saartje?" *Star*, May 8.

Kapilevich, Ami. 2001. "Iziko Museums: Out with the old," *SA Citylife*, July:80–83.

———. 2002. "Museum Day," *SA Citylife*, May:31–32.

Karp, Ivan, 1991. "Other cultures in museum perspective," pp. 373–385 in Karp and Lavine, 1991.

Karp, Ivan, and Steven D. Lavine. 1991. *Exhibiting cultures: The poetics and politics of museum display*. Washington, DC: Smithsonian Institution Press.

Keene, Rochelle. 1996. "Museums of South Africa: New directions," *Vuka SA*, May:14–16.

———. 2000. "Presidents [*sic*] report," *Semantics* [Newsletter of the South African Museums Association], 37:3–4.

Keller, Bill. 1993. "South Africans fight over national symbols," *New York Times*, October 8.

———. 1994. "Nelson Mandela on a mug? It's the rage in South Africa," *New York Times*, April 13.

Kenneday, Brian. 2003. Letter to the editor, *Independent* [KwaZulu-Natal], August 23.

Kenny, Andrew. 2004. "A racist law worthy of apartheid," *Citizen*, February 3.

Khoisan, Zenzile. 2004. "Heroic figure in a carnival of colour and tradition," *Cape Argus*, December 31.

Khumalo, Fred. 2004. "When colour had a name," *Thisday*, June 28.

Kiewiet, Keith, and Kim Weichel. 1980. *Inside Crossroads*. Johannesburg: McGraw-Hill.

Kimmelman, Michael. 1990. "Museums hear a knock on the door: Politics," *New York Times*, July 15.

King, T. H. 1995. "Tributaries and the Triennial: Two South African art exhibitions," *Critical Arts*, 5(3):39–57.

Kirby, Robert. 1997. "A draught of stale air," *Mail & Guardian*, October 17–23.

Klinkenborg, Verlyn. 1991. *The last fine time*. New York: Knopf.

Koch, Eddie. n.d. "Bring back the Hottentot Venus," article in SAM file on Hottentot Venus, no date or source listed.

Krouse, Mathew. 2001. "Hate for sale," *Mail & Guardian*, April 26–May 3.

LaCapra, Dominick. 1998. *History and memory after Auschwitz.* Ithaca: Cornell University Press.

Lacey, Marc. 2002. "A ticklish issue: Colonial-era wigs," *New York Times*, April 17.

———. 2005. "Beyond the bullets and blades," *New York Times*, March 20.

LaGuma, Alex. 1986. *A walk in the night.* Cape Town: David Philip.

Lamb, Christina. 1995. "Venus casts spell over South Africa," *Sunday Times*, June 25.

Landau, Paul S., and Deborah D. Kaspin, eds. 2002. *Images and empires: Visuality in colonial and postcolonial Africa.* Berkeley: University of California Press.

Landsberg, Alison. 1997. "America, the Holocaust, and the mass culture of memory: Toward a radical politics of empathy," *New German Critique*, 71(Spring/Summer):63–86.

Lanning, Mark, Neila Roake, and Glynis Horning. 2003. *Life Soweto style.* Cape Town: Struik.

Larson, Kay. 2002. "Art becomes an instrument to unearth buried history," *New York Times*, June 23.

Lawrence, Johannes. 2002. "These are the facts," *Diamond Fields Advertiser*, March 4.

Layne, Valmont. 1998. "Whom it may, or may not, concern, but to whom this appeal is directed anyway," pp. 4–5 in Soudien and Meyers, 1998.

Ledgerwood, Judy. 1997. "The Cambodian Tuol Sleng Museum of Genocidal Crimes: National narrative," *Museum Anthropology*, 21(1):82–98.

Leeman, Patrick. 1996. "Boer war camp atrocities revealed," *Natal Mercury*, December 23.

Legassick, Martin. 2002. "The Great Treks: The evidence," *South African Historical Journal*, 46:283–299.

Legassick, Martin, and Ciraj Rassool. 2000. *Skeletons in the cupboard: South African museums and the trade in human remains, 1907–1917.* Cape Town and Kimberley: South African Museum and McGregor Museum.

Le Grange, Lucien. 2001. "District Six: Urban place and public memory," pp. 106–112 in Rassool and Prosalendis, 2001.

Leigh, Valerie T. L. 2002. "Who has the right to alienate our heritage?" *Natal Witness*, March 16.

Letsoko, Stanley. 2003. "National anthem is absolute joke," *Star*, July 2.

Lindfors, Bernth, ed. 1999a. *Africans on stage: Studies in ethnological show business.* Bloomington: Indiana University Press.

———. 1999b. "Courting the Hottentot Venus," pp. 169–190 in *The blind men and the elephant and other essays in biographical criticism.* Trenton, NJ: Africa World Press.

Louw, Eric. 2000. "Paint Barry pink and put him on a koppie . . ." *Citizen*, July 3.

Lovell, Nadia, ed. 1998. *Locality and belonging.* New York: Routledge.

Lutz, Catherine A., and Jane L. Collins. 1993. *Reading National Geographic.* Chicago: University of Chicago Press.

Lynch, C. D. 1996. "The importance of museums in South Africa," *Culna* [Magazine of the National Museum, Bloemfontein], April: 4.

MacCannell, Dean. 1976. *The tourist: A new theory of the leisure class.* New York: Schocken.

McClintock, Anne. 1995. *Imperial leather: Race, gender and sexuality in the colonial conquest.* New York: Routledge.

MacDonald, Sharon, ed. 2005. *A companion to museum studies.* London: Blackwell.

McEachern, Charmaine. 2001. "Mapping the memories: Politics, place and identity in the District Six Museum," Cape Town, pp. 223–247 in Zegeye, 2001.

McGrath, Charles. 2005. "An X-rated phenomenon revisited," *New York Times*, February 9.

McGreal, Chris. 2001a. "Bard barred for being too boring," *Guardian*, April 18.

———. 2001b. "Time to go home for Cape Town's refugees," *Guardian*, May 17.

MacGregor, Karen. 2002. "A noble end for South African icon," *Globe and Mail* [Toronto], August 10.

Mackay, Ian. 1999. "Art altercation," *Star*, May 25.

MacLennan, Ben. 2002. "Saartjie Baartman's return home joyfully welcomed," *Cape Times*, January 31.

Madondo, Bongani. 2003. "Not just a pretty face," *Sunday Times Lifestyle*, August 24.

Mahamed, M. F. 2003. "It is shameful that *Die Stem* is part of new South Africa," *Star*, July 8.

Makhanya, Mondli. 2002. "Give the people an anthem they can be proud of," *Sunday Times*, September 22.

Makobe, D. H. 1996. "The Bulhoek Massacre: Origins, casualties, reactions and historical distortions," *Militaria*, 26(1):22–41.

Malan, Andre. 1997. "Statues stand up to abuse," *West Australian*, September 16.

Maluleke, Elias. 2003a. "In memory of a struggle for humanity," *City Press*, August 3.

———. 2003b. "Rates, not renaming of city, concern Tshwane residents," *City Press*, August 17.

Mandela, Nelson. 1997. "Address by President Nelson Mandela on Heritage Day, Robben Island," September 24 [typescript, Johannesburg Art Gallery library, "Heritage Day Box"].

Manning, Richard. 1987. *They cannot kill us all: An eyewitness account of South Africa today.* Boston: Houghton Mifflin.

Manuel, George. 1978. "Thanks for the memory," *Cape Times Magazine*, March 31.

Marinier, S. 1991–1992. "The public of Durban and their natural history museum: A public survey," *SAMAB*, 20:13–18.

Marks, Joe. 2002. "We pay our respects to the kidnapped slave, Sarah Baartman," *Cape Times*, May 8.

Marks, Rafael, and Marco Bezzoli. 2000. "The urbanism of District Six, Cape Town," pp. 262–282 in Anderson and Rathbone, 2000.

Marschall, Sabine. 2000. "A postcolonial reading of mural art in South Africa," *Critical Arts*, 14(2):96–121.

———. 2002. *Community mural art in South Africa.* Pretoria: Unisa.

Martin, Denis-Constant. 1999. *Coon Carnival, New Year in Cape Town: Past to present.* Cape Town: David Philip.

Martin, Marilyn. 1993. "Restoring our otherness—Reflections on the meaning of Eurocentrism and its effects on South African culture," *South African Journal of Art History*, 11:93–100.

———. 1997a. "Introduction," pp. 17–25 in South African National Gallery, 1997.

———. 1997b. "The now South Africa—Facing truth and transformation," pp. 1–19 in Hope, 1997.

———. 1999. "The horn of art's dilemma," *Leadership*, 18(1):44–56.

Masungwini, Norman. 2003. "Where's the booze?" *Sowetan Sunday World*, September 28.

Mathews, Jane DeHart. 1976. "Art and politics in Cold War America," *American Historical Review*, 81(4):762–787.

Matshikiza, John. 2001. "History in the making," *Mail & Guardian*, November 30–December 6.

———. 2002a. "Time for a cultural revolution," *Mail & Guardian*, January 11–17.

———. 2002b. "Reminders of evil and redemption," *Mail & Guardian*, May 3–9.

———. 2002c. "An epitaph of smoke and mirrors," *Mail & Guardian*, June 21–27.

Mattera, Don. 1987. *Memory is the weapon*. Johannesburg: Ravan Press.

Maule, D. M. 2003. "Forget skin, my blood is as red as the African sunset," *Star*, December 5.

Maurice, Emile. 1995. "The sore on the Queen's forehead," pp. 14–24 in South African National Gallery, 1995.

Mawson, Nicola. 2004. "A living memory," *Mail & Guardian*, February 27–March 4.

Maynard, Micheline. 2004. "In suburbs, reminder of horror," *New York Times*, March 16.

Mazel, Aron, and Mabongi Mtshali. 2004. "Reaching out: Introducing archaeology to children from disadvantaged communities in KwaZulu-Natal, South Africa," unpublished paper presented at the British Council "Heritage, education and archaeology" seminar, Southampton, UK, September.

Mda, Lizeka. 2003. "You may well snigger but I'm a shameless Big Brother fan," *Sunday Times*, June 15.

Meijer, Marianne. 1996a. "Art collection at the crossroads," *Natal Mercury*, November 12.

———. 1996b. "Cultural revolutionary vs. cautiously conservative," *Natal Mercury*, November 28.

———. 1997. "Recognition for Durban gallery," *Natal Mercury*, April 30.

Merten, Marianne. 2005. "Muslim council issues fatwa against property development," *Mail & Guardian*, July 1–7.

Miles, Elza. 1997. *Land and lives: A story of early black artists*. Cape Town: Human & Rousseau.

———. 2004. *Polly Street: The story of an art centre*. Johannesburg: Ampersand Foundation.

Miller, Allan, and Monty Miller. 2001. "Lighting the Apartheid Museum," *Lighting in Design*, December:6–10.

Mills, C. Wright. 1959. *The sociological imagination*. New York: Oxford University Press.

Minnaar, Melvyn. 1996. "Fresh display of long-neglected San artefacts stirs cauldron of emotions," *Sunday Independent*, April 21.

Misser, Francois, Kate Duvall, and Peter Fabricius. 2004. "Madiba turns water into wine in his second miracle," *Star*, April 28.

Mjekula, Luvuyo. 2003. "Slow death upsets," *Wordstock* [Grahamstown National Arts Festival], July 2.

Mlambo, Israel. 2004. "Row over hotel at heritage site," *Sunday Times Metro*, December 19.

Modisane, Bloke. 1986. *Blame me on history*. New York: Simon & Schuster.

Moen, Lineke. 1997. "How thousands of blacks died in Boer War camps," *Cape Argus*, January 9.

Moerdijk, Dr. Gerard. 1954. "Design and symbolism of the Voortrekker Monument," pp. 29–37 in *The Voortrekker Monument, Pretoria*. Pretoria: Voortrekker Monument.

Mokwena, Steve Kwena. 2004. "Inside Number Four," *Mail & Guardian*, March 12–18.

Molamu, Louis. 2003. *Tsotsitaal: A dictionary of the language of Sophiatown*. Pretoria: University of South Africa.

Moleko, Mokhosi. 2003. "Let us reclaim Afrikaans," *Sunday Times*, November 2.

Momberg, Eleanor. 2002. "Mandela tribute to 'freedom fighter,' " *Citizen*, March 7.

Morris, Michael. 1998. "National Gallery 'stagnating' for lack of cash," *Cape Argus*, September 21.

Mphaki, Ali. 2003. "Mashinini remains a forgotten hero," *City Press*, June 15.

Mthombothi, Barney. 2004. "Politics stole all the Christmas joy," *Star*, December 15.

Mufweba, Yolanda. 2003. " 'Half of boys aged 15 will be dead by 2015,' " *Saturday Star*, October 18.

Nagia, Anwah. 2001. "Land restitution in District Six: Settling a traumatic landscape (interviewed by Colin Miller)," pp. 166–178 in Rassool and Prosalendis, 2001.

Naidoo, Prakash. 1993. "Outrage over art treasure 'plot,' " *Sunday Tribune*, May 23.

Naipaul, Shiva. 1980. *North of south*. Harmondsworth: Penguin.

Nanda, Serena. 2004. "South African museums and the creation of a new national identity," *American Anthropologist*, 106(2):379–384.

Nasson, Bill. 1989. " 'She preferred living in a cave with Harry the snake-catcher': towards an oral history of popular leisure and class expression in District Six, Cape Town, c. 1920s–1950s," pp. 285–309 in Bonner, 1989.

———. 1990. "Oral History and the reconstruction of District Six," pp. 44–87 in Jeppie and Soudien, 1990.

Natal Witness. 1998. "Research results in new gallery," August 20.

———. 2002. "Afrikaners protest renaming," February 16.

———. 2003a. "King's portrait," March 1.

———. 2003b. " 'Intellectual properties,' " April 18.

Naudé, Christi. 2003. "Ex-council members 'drained museum funds,' " *Natal Witness*, April 15.

Ndaba, Baldwin. 2004. "Hope beat eternal in a mom's breast," *Star*, April 13.

Nessman, Ravi. 2003a. "Breaking out of the stone laager," *Star*, May 8.

———. 2003b. "Replaying history helps the present," *Saturday Star Travel*, May 17.

Nettleton, Anitra. 1988. "Myth of the transitional: Black art and white markets in South Africa," *South African Journal of Cultural Art History*, 2(4):301–310.

———. 1993. "Arts and Africana: Hierarchies of material culture," *South African Historical Journal*, 29:61–75.

New York Times. 2000. "Spain to return stuffed body of Bushman," July 1.

———. 2002. "Rising nostalgia for apartheid," December 12.

Ngcelwane, Nomvuyo. 1998. *Sala kahle, District Six: An African woman's perspective*. Cape Town: Kwela Books.

Ngubane, Ben. 1995. "Art's balancing act," *Daily News* [Durban], October 9.

Nixon, Rob. 1994. *Homelands, Harlem and Hollywood: South African culture and the world beyond*. New York: Routledge.

Nkosi, Lewis. 1965. "The fabulous decade: The Fifities," pp. 3–34 in *Home and exile*. London: Longmans.

Nown, Graham, and Andrew Rosthorn. 1997. "After 160 years, it's time for Yagan to go home." *The Independent* [London], May 11.

Ntabazalila, Eric. 2002. "After 186 years, Saartjie Baartman will be home soon," *Cape Times*, April 26.

Ntshingila, Futhi. 2003. "Kofifi night," *Sunday Times Metro*, March 2.

Nuttall, Sarah, and Carli Coetzee, eds. 1998. *Negotiating the past: The making of memory in South Africa*. Cape Town: Oxford University Press.

O'Clery, Cathy. 2003. "Design history," *House and Leisure*, April:102–107.

Odendaal, André. 1995. "The challenges of transformation for South African museums," *SAMAB*, 22(2):8–10.

Odendaal, André, and Roger Field, eds. 1993. *Liberation chabalala: The world of Alex La Guma*. Cape Town: Mayibuye Books.

Oelofse, Louis. 2002. "Old meets the new," *Pretoria News*, December 17.

Oliver, Lenore. 2002. "Saartjie's remains back on home soil," *Cape Argus*, May 3.

Omar, Dullah. 1990. "The murder of District Six: Some thoughts and reminiscences," pp. 192–196 in Jeppie and Soudien, 1990.

Oosterwyk, Trevor. 2001. "New dispute over Saartjie Baartman," *Cape Argus*, May 3.

Ouzman, Sven, Pippa Skotnes, Stefan Hundt, and Sarah Schutte, curators. 1995. *The wind blows dust . . . traces of the /Xam and other San of the central interior: An exhibition of San visions, dreams and objects*. Bloemfontein: Foundation for the Creative Arts.

Owen, David. 1988. "Cultural history museums in developing countries: Expensive luxuries or vital institutions?" *SAMAB*, 18(4):149–154.

Owen, David, and Wouter Holleman. 1989. "Grey history: A pox on general and own affairs," *SAMAB*, 18(7):251–254.

Parsons, Neil. 1999. " 'Clicko': Franz Taaibosch, South African Bushman entertainer in England, France, Cuba, and the United States, 1908–1940," pp. 203–227 in Lindfors, 1999a.

———. 2002. "Reviving the Treks debates," *South African Historical Journal*, 46:308–312.

Pastor, Juanita. 1995. "Power/knowledge and museums: The cast [*sic*] of Saartjie Baartman," unpublished MA thesis, University of Leicester (museum studies).

Phahlane, Charles. 2004. "Sowing the seeds of remembrance," *Star*, March 10.

Philp, Rowan. 2002. "Mbeki shocks crowd at Bartmann's burial," *Sunday Times*, August 11.

Philp, Rowan. 2003. "Government organ has officials in stitches," *Sunday Times*, May 25.

Pieterse, Cosmo. 1971. *Seven South African poets*. London: Heinemann Educational Books.

Pollak, Lloyd. 2000. "Artist's view of San," *Cape Times*, December 1.

Potgieter, Johann. 1996. "Saartjie Baartman—Symbol of exploitation," *Cape Times*, February 9.

Powell, Ivor. 1985. "Killing the father: Some thoughts on South African art and the BMW show," *de arte*, 32:45–47.

———. 1994. "No-show Winnie's in the poo again," *Mail & Guardian*, July 29–August 4.

Power, Megan. 2002. "New bridge to span old divide," *Sunday Argus*, July 27.

Pratt, Mary Louise. 1992. *Imperial eyes: Travel writing and transculturation*. London: Routledge.

Prendini, Hilary, and Glynnis Underhill. 1985. "Art of the state," *SA style*, March:116–121.

Press, Valetta. 1971. "Hyde Park/Kenwood: A case study of urban renewal," occasional paper published by The Center for Policy Study, University of Chicago.

Pretoria News. 1995. "Educational exhibit 'is pornographic,' " November 23.

———. 1998. "Bankrupt Albany Museum closes," November 24.

Pretoria News. 2003a. "San, a gentle people of thrift and kindness," March 15.
———. 2003b. "Freedom Park," April 28.
Pretoria News Weekend. 1999. "Is da Vinci relevant for blacks?" June 26.
Pretorius, Cornia. 2002. "Go, !Gubi, go!" *Sunday Times Lifestyle*, September 22.
Pretorius, Karen. 2004. "Tying the knot on Robben Island," www. SouthAfrica.info, February 16.
Prosalendis, Sandra. 1995. "Salted earth," *Vuka SA*, November:78–80.
Prosalendis, Sandra, Jennifer Marot, Crain Soudien, and Anwah Nagia. 2001. "Punctuations: Periodic impressions of a museum," pp. 74–94 in Rassool and Prosalendis, 2001.
Purkey, Malcolm, and Pippa Stein, eds. 1993 [1986]. *Sophiatown* [a play by the Junction Avenue Theatre Company]. Johannesburg: Witwatersrand University Press.
Qwelane, Jon. 2003. "Anthem a song that belongs to the past," *Sunday Sun*, July 6.
Raper, Ian. 1998. "A nation's building site: Ncome," *Vuka SA*, 3(6):24–26.
Rapport. 2001. " 'Kaal paartjie' laat die fone sing ['Naked couple' has the phones ringing]," September 9.
Rassool, Ciraj. 1999. "Stories of life sentences," *Mail & Guardian*, November 26–December 2.
———. 2000. "The rise of heritage and the reconstitution of history in South Africa," pp. 97–127 in Field and Bunn, 2000.
Rassool, Ciraj, and Sandra Prosalendis, eds. 2001. *Recalling community in Cape Town: Creating and curating the District Six Museum.* Cape Town: District Six Museum.
Retief, L. W. 2001. "The Khoisan were not perfect," *Cape Argus*, March 27.
Richmond, Derek. 1969. "Population could be re-housed in half the area," *Cape Times Week-End Magazine*, January 18.
Rive, Richard. 1987a. "Always Friday night," *Leadership*, 6(4):96–98, 101.
———. [1986] 1987b. *"Buckingham Palace," District* Six. Cape Town: David Philip.
———. 1990. "District Six: Fact and fiction," pp. 110–116 in Jeppie and Soudien, 1990.
Robertson, Christine. 1997. "Huge task to return heads, says expert," *Evening Post*, August 19.
Robinson, Vicki. 2003. "Blood feud on the banks of the river," *Mail & Guardian*, December 19–31.
———. 2004a. "Furore over race ads," *Mail & Guardian*, June 18–24.
———. 2004b. "Strangers in a new land," *Mail & Guardian*, July 9–15.
Rohter, Larry. 2001. "Brazil's former slave havens slowly pressing for rights," *New York Times*, January 23.
Rondganger, Lee. 2005. "Three held after military and police raid museum," *Star*, January 14.
Roper, Chris. 1997. "Brawl mars African show," *Mail & Guardian*, August 8–14.
———. 2004. "Body of work," *Mail & Guardian*, March 5–11.
Rose, Walter. 1961. *Bushman, whale and dinosaur: James Drury's forty years at the South African Museum.* Cape Town: Howard Timmins.
Rosenthal, Eric. 1966. "District Six over the last century," *Cape Times*, March 8.
Ross, Keith. 1998. "A symbol of reconciliation between old foes," *Pretoria News*, November 12.
Rostron, Bryan. 2001. "Welcome to our torture chamber (tourist attractions in South Africa)," *New Statesman*, September 17.

Roup, Julian. 2004. "Lost for words," *Financial Times*, May 8.

Roussouw, Rehana. 1996. "Setting history straight—Or another chance to gape?" *Mail and Guardian*, April 19–25.

Sachs, Albie. 2004. "Every picture tells a story," *Mail & Guardian*, February 27–March 4.

Sachs, Albie and respondents, edited by de Kok, Ingrid, and Karen Press. 1990. *Spring is rebellious: Arguments about cultural freedom.* Cape Town: Buchu Books.

Salie, Igsaan. 2003. "Would-be air-hostess 'not African enough' for SAA," *Sunday Independent*, December 14.

Sampson, Lin. 1999. "The sorry state of the art in SA," *Sunday Times*, July 25.

Saturday Star. 2003. "No fingerprints, no ID, gogo," March 8.

Saturday Star Travel. 2003. "Win a getaway to the Eastern Cape," February 22.

Saunders, Christopher. 2002. "Great Treks?" *South African Historical Journal*, 46:300–307.

Saunderson-Meyer, William. 1998. "Save Robben Island before tourism dies," *Saturday Argus*, May 23.

———. 2005. "From iron fist to atrophied paw," *Weekend Natal Witness*, March 19.

Sboros, Marika. 2003. "New look for domestic workers," *Star*, August 1.

Schildkrout, Enid. 1991. "Ambiguous messages and ironic twists: *Into the heart of Africa* and *The other museum*," *Museum Anthropology*, 15(2):16–23.

———. 1995. "Museums and nationalism in Namibia," *Museum Anthropology* 19(2):65–77.

Schimke, Karin. 2004. "Catch of the day," *Sunday Times Lifestyle*, July 4.

Schmidt, Michael. 2003. "The rediscovery of Afrikaans," *Sunday Times*, October 26.

Schoeman, Chris. 1994. *District Six: The spirit of kanala.* Cape Town: Human & Rousseau.

Schrire, Carmel. 1996. "Miscast," *Southern African Review of Books*, 44(July/August).

Schuler, Catherine. 1990. "Spectator response and comprehension: The problem of Karen Finley's *Constant State of Desire*," TDR [*The Drama Review*], 34(1):131–145.

Schweizer, A., and C. E. Thorn. 1961. "Bushman diorama," *SAMAB*, 7(10):230–236.

Secretan, Thierry. 1995. *Going into darkness: Fantastic coffins from Africa.* London: Thames and Hudson.

Sefara, Makhudu. 2003. "Anthem gets some off on the wrong note," *Star*, June 18.

Sharp, John, and Emile Boonzaier. 1994. "Ethnic identity as performance: Lessons from Namaqualand," *Journal of Southern African Studies*, 20(3):405–415.

Shaw, E. M. 1941. "The new ethnology gallery at the South African Museum," *SAMAB*, 2(7):161–168.

Shell, Robert C. H. 1999. "From diaspora to diorama: The UNESCO feasibility study for the cultural amplification of the memory of slavery and the slave trade in Southern Africa, part one: the Lodge," *Quarterly Bulletin of the National Library of South Africa*, 54(2):44–56.

Shonisani, Tshifhiwa. 2002. "Horn stolen," *Rekord Noord*, November 22.

Sichel, Adrienne. 2004. "Deconstructing through dance," *Star Tonight*, June 15.

Siegfried, Krsity. 2005. "Arabian days in the mother city," *Sunday Independent*, January 30.

Silverman, Melinda. 2000. "Cool, kitsch and collected," *Sunday Times Millennium Souvenir*, January 2.

Simmons, Ann. 2002. "A South African native's homecoming history," *Los Angeles Times*, May 4.

Simon, Chedza. 2003. "Uprooting the natives," *New African*, March:30.

Singer, Rena. 2001. "After apartheid, museums rewrite South Africa's history," *Christian Science Monitor*, June 8.

———. 2002. "In South Africa, painful past reclaimed: Many see their story in return of remains of woman held captive," *Boston Globe*, May 4.

Sithole, Sipho. 2003. Letter to the editor, *Independent* [KwaZulu-Natal], August 23.

Sithole, Zinkie, and Justin Arenstein. 2005. "Witbank is next big city to change name," *Star*, August 16.

Skotnes, Pippa. 1995. "Cast naked: Exhibiting the Bushmen in South African museums," pp. 13–21 in Ouzman et al., 1995.

———, ed. 1996. *Miscast: Negotiating the presence of the Bushmen*. Cape Town: University of Cape Town Press.

———. 2001. " 'Civilised off the face of the earth': Museum display and the silencing of the /Xam," *Poetics Today*, 22(2):299–321.

———. 2002. "The politics of Bushman representations," pp. 253–274 in Landau and Kaspin, 2002.

Slabbert, Denise, and Eddie Koch. 2004. "Weird and wacky," *Mail & Guardian*, October 15–21.

Small, Adam, and Jansje Wissema. 1986. *District Six*. Linden: Fontein.

Smith, Alexander McCall. [1998] 2002. *The no. 1 ladies' detective agency*. New York: Anchor Books.

Smith, Andrew B. 1996. "The Kalahari Bushmen debate: Implications for archaeology of Southern Africa," *South African Historical Journal*, (35):1–15.

Smith, Charlene, 1997. *Robben Island*. Cape Town: Struik.

Smith, Dianne, 1997. "Joemat enters row," *Diamond Fields Advertiser*, October 6.

Smith, Gail, 2004. "Urbanised African energy," *Mail & Guardian*, September 24–30.

Smith, Heidi Lee, 2004. "The return of an icon," *Mail & Guardian*, June 25–July 1.

Smith, Tymon, 2004. "So, where to now?" *Property magazine*, 7(October):31–38.

Solani, Noel, and Khwezi ka Mpumlwana. 2001. "Memory, identity and representation: Possibilities of new models of representation in a transforming environment," *SAMAB*, 25(2):83–86.

Soudien, Crain. 1990. "District Six: From protest to protest," pp. 143–183 in Jeppie and Soudien, 1990.

———. 2001. "Holding on to the past: Working with the 'myths' of District Six," pp. 97–105 in Rassool and Prosalendis, 2001.

Soudien, Crain, and Renate Meyers, eds. 1998. *The District Six public art project*. Cape Town: District Six Museum Foundation.

South African National Gallery. 1995. *District Six: Image and representation*. Cape Town: South African National Gallery.

———. 1997. *Contemporary South African art: 1985–1995, from the South African National Gallery permanent collection*. Cape Town: The Gallery.

South African Press Association. 2002a. "Saartje a symbol, says Tobias," May 3.

———. 2002b. "Mbeki unveils plaque at Freedom Park," June 16.

Sowaga, Dulile. 2003. "*Idols* of racism still rule our thinkwaves," *City Press*, July 27.

Star. 2003. "Slip on a bikini for Soweto-on-sea," November 29.

Star. 2004a. "Old Fort turns trendy as tourist haunt," June 21.

Star. 2004b. "Bushman says God gave land," July 28.

———. 2004c. "Bubblegum mosaic of Madiba sets record," December 19.

———. 2005. "Accused named Always Innocent misses court date," August 25.

Star Tonight. 2004. "South African stories," November 4.

Stein, Pippa, and Ruth Jacobson, eds. 1986. *Sophiatown speaks.* Johannesburg: Junction Avenue Press.

Steinberg, Jonny. 2002. *Midlands.* Johannesburg: Jonathan Bell.

Stewart, Susan. 1984. *On longing: Narratives of the miniature, the gigantic, the souvenir, the collection.* Baltimore: Johns Hopkins University Press.

Strother, Z. S. 1999. "Display of the Body Hottentot," pp. 1–61 in Lindfors, 1999a.

Stuckenberg, Brian. 1987. "Stating the case: A synoptic view of the position of museums and the problems they face, in the changing and divided society of contemporary South Africa," *SAMAB,* 17(7/8):293–299.

Sturken, Marita. 1997. *Tangled memories: The Vietnam War, the AIDS epidemic, and the politics of remembering.* Berkeley: University of California Press.

Sukhraj, Penny. 2002. "Sarah inspires fashion fundis," *Sunday Times,* September 8.

Sunday Independent. 2002. "Baartman burial heals a legacy of inhumanity," August 11.

Suttles, Gerald D. 1968. *The social order of the slum: Ethnicity and territory in the inner city.* Chicago: University of Chicago Press.

Swanson, Felicity. 2001. " 'Mense van die Vlak': Community and forced removals in Lower Claremont," pp. 100–116 in Field, 2001.

Swanson, Felicity, and Jane Harries. 2001. " 'Ja! so was District Six! But it was a beautiful place': Oral histories, memory and identity," pp. 62–80 in Field, 2001.

Swarns, Rachel L. 2001. "A dispute over books unsettles Africa," *New York Times,* April 23.

Szymborska, Wislawa. 1998. "The end and the beginning," pp. 228–229 in *Poems: New and collected, 1957–1997.* Translated by Stanislaw Baránczak and Clare Cavanagh. New York: Harcourt Brace.

Taylor, Jane, and Emma Bedford. 1997. "Conversation with Professor Neville Dubow," pp. 27–37 in South African National Gallery, 1997.

Teaford, Jon C. 2000. "Urban renewal and its aftermath," *Housing Policy Debate,* II(2):443–465.

Terry, Jennifer and Jacqueline Urla, eds. 1995. *Deviant bodies: Critical perspectives on difference in science and popular culture.* Bloomington: Indiana University.

Thamm, Marianne. 1997. "In the eye of the beholder," *Top of the Times,* September 5.

Themba, Can. n.d. "Requiem for Sophiatown," pp. 10–15 in Hughes, 1961.

Thorne, Colette. 1996. *The last days of District Six: Photographs by Jan Greshoff.* Cape Town: District Six Museum.

Thybony, Scott. 1991. "Against all odds, Black Seminole won their freedom," *Smithsonian,* 22(5):90–101.

Times [London]. 1995. "Fragile monuments," March 23.

Toffoli, Hilary Prendini. 1993. "Rebel with some Xhosa," *SA style,* November: 40–44.

Tomlinson, Richard, Robert A. Beauregard, Lindsay Bremner, and Xolela Mangcu, eds. 2003. *Emerging Johannesburg: Perspectives on the postapartheid city.* New York: Routledge.

Tromp, Beauregard. 2001. "Display infuriates Khoisan," *Saturday Argus,* March 31/April 1.

Turner, R. R. 2002. "Street renaming," *Natal Witness,* February 8.

Umjelo [magazine of the Eastern Cape Museums]. 2001. "Bulhoek: Tragedy, the visions, battle, background," 1(September):22–26.

Unsworth, Andrew. 1996. "Tokyo's groot trek," *Sunday Times City Metro,* December 15.

Van Bosch, Cobus. 2003. "South African museums and government funds," *Art News South Africa*, 4:18–20.

Vanderhaeghen, Yves. 2003. "The past is another canvas," *Natal Witness*, March 1.

Van der Merwe, Jeanne. 2004. "Ceasefire in language war," *Sunday Times*, February 22.

Van der Walt, R. 2003. "My sweat has earned me a piece," *Star*, December 12.

Van der Watt, Liese. 1997. " 'Savagery and civilisation': Race as a signifier of difference in Afrikaner nationalist art," *de arte*, 55:36–47.

———. 1998. "The comradely ideal and the *Volkmoeder* ideal: Uncovering gender ideology in the Voortrekker tapestry," *South African Historical Journal*, 39:91–110.

Van der Westhuizen, Gert. 1999. "Bloedrivier moet nou Ncome heet—Koning [Blood River should now be called Ncome—king]," *Beeld*, November 27.

Van Niekerk, Marlene. 1999 [English translation, 2004]. *Triomf*. London: Little, Brown.

Van Tonder, Deon. 1994. "From mausoleum to museum: Revisiting public history at the inauguration of MuseumAfrica, Newtown," *South African Historical Journal*, 31(November):165–183.

Van Wyk, Anna-Marie. 1990. "Placing the past in perspective," *South African Panorama*, November/December:70–75.

Van Zijl, Johan. 2004. "The Riddle of Orania," *South African Country Life*, November:50–53.

Vel, Brian. 2002. "Do we have the right to self-determination?" *Mail & Guardian*, April:12–18.

Verdal, Garth. 1994. "Praise singers in parliament a 'culture shock' to new minister," *Cape Argus*, May 26.

Vergunst, Nicolaas. 1992. "Fulfilled obsession," *Vryweekblad*, May 22.

Viall, Jeanne. 2004. "Pipes of peace lit as SA salutes San forerunners," *Cape Argus*, April 25.

Viljoen, Russel. 1996. "Khoisan heritage and identity," *South African Historical Journal*, (35):140–145.

Viljoen, Taslima. 2003. "Symbols of hate," *Sowetan Sunday World*, April 13.

Visser, Mark. 2005. "Tanks for nothing," *Citizen*, January 15.

Von Bonde, John. 2003. "Tradition not an excuse for cruelty," *The Herald* [Port Elizabeth], July 5.

Von Klemperer, Margaret. 2001. "No longer gloom and crocodiles," *Natal Witness*, November 10.

———. 2002a. "Using stuffed animals to stretch young minds," *Natal Witness*, April 1.

———. 2002b. "A king in oils," *Natal Witness*, September 21.

Voortrekkker Museum [museum pamphlet guide] [1952] 1982. Pietermartizburg: Voortrekker Museum.

Wagner-Pacifici, Robin, and Barry Schwartz. 1991. "The Vietnam Veterans Memorial: Commemorating a difficult past," *American Journal of Sociology*, 97:376–420.

Waldner, Mariechen. 2003. "The black face of Afrikanerdom," *City Press*, May 25.

Waspe, Tom. 2001. "There are more things in heaven and on earth, Horatio," *Sunday Independent*, April 29.

Webb, Denver, and Wouter Holleman. 1999. "The sins of the fathers," *SAMAB*, 23(1):16–19.

Weber, Max. [1925] 1978. *Economy and Society*. Berkeley: University of California Press.

Webster, Paul. 2000. "France keeps a hold on Black Venus," *Guardian*, April 2.

Welz, Carmen. 2002. "Saartje wasn't so unwilling," *Star*, May 15.

Wemyss, Diana. 1995. "The littlest house on the block," *SA Garden & Home*, February:48–50.

Western, John. 1981. *Outcast Cape Town*. Cape Town: Human & Rousseau.

Williams, Brian. 2002. "Power of poetry freed Saartjie," *Cape Argus*, February 6.

Williamson, Sue, ed. 1997. *Thirty minutes: Installations by nine artists*. Cape Town: Robben Island Museum.

Willoughby, Guy. 1996. "Arresting look at our tangled past," *Star*, April 19.

Wilmsen, Edwin. 1995. "Primitive politics in sanctified landscapes: The ethnographic fictions of Laurens van der Post," *Journal of Southern African Studies*, 21(2):201–223.

Wilnot, B. C. 1986. "Ringing the changes: A call to South African museums," *SAMAB*, 17(1):1–3.

Witz, Leslie, Gary Minkley and Ciraj Rassool. 1999. "No end of a [history] lesson: Preparations for the Anglo-Boer War Centenary commemoration," *South African Historical Journal*, 41: 370–387.

Worley, Terry. 1992. "Isandlwana's new war on poverty," *Northern Natal Courier*, January 24.

Wright, John. 1996. "Sonqua, Bosjesmans, Bushmen, abaThwa: Comments and queries on pre-modern identifications," *South African Historical Journal*, (35):16–29.

Wright, John, and Aron Mazel. 1987. "Bastions of ideology: The depiction of pre-colonial history in the museums of Natal and KwaZulu," *SAMAB*, 17 (7/8):302–309.

<www.SouthAfrica.info>, 2004. "Fidelio on Robben Island," March 23, 2004.

<www.stormfront.org/forum>

Youens, Britt. 2003. "In search of Helen Suzman," <www.hsf.org.za/ focus>, July 10.

Young, James E. 2000. *At memory's edge: After-images of the Holocaust in contemporary art and architecture*. New Haven: Yale.

———. 1994. *The texture of memory: Holocaust memorials and meaning*. New Haven: Yale.

Young, T. Cuyler. 1993. "*Into the heart of Africa*: the director's perspective," *Curator Magazine*, 36(3):174–188.

Zegeye, Abebe, ed. 2001. *Social identities in the New South Africa*. Cape Town: Kwela Books.

Zeilhofer, Cindy. 2003. "Voortrekker—the busiest monument of them all," *Pretoria News*, July 2.

Zerubavel, Eviatar. 1996. "Social memories: Steps to a sociology of the past," *Qualitative Sociology*, 19: 283–299.

Zielbauer, Paul. 2002. "Poverty in a land of plenty: can Hartford ever recover?" *New York Times*, August 26.

Zilwa, Obed. 2002. "South Africa buries remains of indigenous woman who had been displayed as oddity in Europe," *Associated Press Newswires*, August 9.

Index